CANON® EOS DIGITAL PHOTOGRAPHY PHOTO WORKSHOP

Serge Timacheff

CANON® EOS DIGITAL PHOTOGRAPHY PHOTO WORKSHOP

Serge Timacheff

Wiley Publishing, Inc.

Canon® EOS Digital Photography Photo Workshop

Published by
Wiley Publishing, Inc.
10475 Crosspoint Blvd.
Indianapolis, IN 46256
www.wiley.com

ISBN 978-0-470-11434-6

Manufactured in the United States of America

10 9 8 7 6 5 4 3 2 1

For general information on our other products and services or to obtain technical support, please contact our Customer Care Department within the U.S. at (800) 762-2974, outside the U.S. at (317) 572-3993 or fax (317) 572-4002.

Wiley also publishes its books in a variety of electronic formats. Some content that appears in print may not be available in electronic books.

Library of Congress Control Number: 2008924087

About the Author

Serge Timacheff is an author and professional photographer who focuses especially on world championship and Olympic fencing. His work also includes photographing numerous dignitaries, celebrities, and world figures as well as a wide variety of commercial and individual clients. As the official photographer of the International Fencing Federation (FIE), he founded FencingPhotos.com; it is a part of Tiger Mountain Photo, a Pacific Northwest studio co-owned with his wife, Amy. The author of five books, his most recent titles with Wiley include *Total Digital Photography* and *Digital Sports Photography*. He also teaches and lectures frequently on various aspects of digital photography.

Credits

Acquisitions Editor
Ryan Spence

Senior Project Editor
Cricket Krengel

Technical Editor
Michael Guncheon

Editorial Manager
Robyn Siesky

Vice President & Group Executive Publisher
Richard Swadley

Vice President & Publisher
Barry Pruett

Business Manager
Amy Knies

Senior Marketing Manager
Sandy Smith

Project Coordinator
Patrick Redmond

Graphics and Production Specialists
Andrea Hornberger
Jennifer Mayberry
Brent Savage

Proofreading and Indexing
Laura Bowman
Sherry Massey

Cover Design
Daniela Richardson
Larry Vigon

Book Designers
LeAndra Hosier
Tina Hovanessian

Special Help
Jama Carter

Acknowledgments

This book has been complex and challenging in a number of ways, and it absolutely could not have been accomplished without the support, participation, and relentless hard work of a number of people.

First and foremost, thank you to my family, Amy, Alexander, and Tatyana, for putting up with me during the unexpected twists and turns this book has taken. Cricket Krengel, the book's editor, and Michael Guncheon, its technical editor, were tireless in their efforts to ensure the book was accurate, readable, and up-to-date with everything from current Canon technology and products to correcting me on various topics and concepts of photography. This team could not have been more stellar.

Several professional friends helped tremendously in the book's progress and development, as well. Michael Johnson of New Era Photography came through at the last minute with badly needed images as did Jackson Reed, one of my photography students, and Harry Haugen was ever-obliging as a sounding board. My gratitude also goes to the gang at Glazers Camera in Seattle (thanks, Dave!) for their knowledgeable advice and allowing me to use their products and part of their store as a makeshift studio. And Margot Hutchison, my agent, has been there to represent me in virtually every situation a writer might encounter — and to entertain any wild idea and crazy view of the world with calm logic and reason.

Kevin Mar, Jo Rorberg, and Rob Calem have been exceptional friends, sanity checks, and supporters in the process of writing this book, as they have been for past titles. Their individual talents and support were unfailing and invaluable.

To Amy, for your love, partnership, and support.

Contents

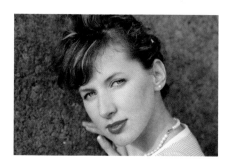

CHAPTER 7 Lens Accessories and Care 137

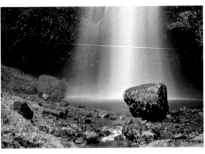

CHAPTER 9 Integrated Workflow with Your Canon dSLR 183

Preface

Filled with passion, obsession, and excitement, my love affair with Canon SLR cameras began in 1977 when I spent hard-earned money on an AE-1 and a simple lens. With that modest but incredibly versatile "automatic" camera, I forged my way into photojournalism and a new way of expressing my interests to the world.

That camera, and the Canon bodies and lenses to come, served as a passport to virtually every corner of the world along with the people, places, and things I've been privileged to encounter, and a way for me to keep the memories of them alive. Even as I've pursued other interests, my Canon has always been a best friend ready to go anywhere at any time.

While working at Logitech in the early 1990s, I participated in launching one of the first digital consumer cameras, *Fotoman,* and it became apparent that the world of digital photography was looming large on the horizon. Then, when my professional life turned back to full-time photography in 2001, I realized that digital photography's proverbial ship had arrived in port loaded with goods and treasures.

I first used a Canon digital SLR, a 10D, at the 2003 World Fencing Championships in Havana, Cuba. Trading back-and-forth with an EOS film camera (which could handle fast action shots much better than my 10D), I kept working with the digital SLR and exploring its remarkable capabilities. That event in Havana was the last time I shot film, ending more than 25 years of reliance on slides and negatives.

I quickly acquired and grew into using the Canon 1D Mark II, which I knew was necessary for shooting a high-speed sport such as fencing. With it I captured thousands of images at the 2004 Athens Olympic Games, including one that has become quite famous (see figure 9 in chapter 11). I knew then that digital was no longer an option or a possibility, but the reality and future of photography. Clearly, the products and technology of Canon were leading the charge and their announcements and developments promised to do everything possible to tempt me into spending as much time, money, and creativity as I had to explore and keep up with what they had to offer.

The world of Canon dSLR photography is one where you can never stop learning, where you will never find an end to your journey of passion, and where your own love affair will remain as alive each day as the day you first pressed the shutter release button. I am pleased to share the details of this romance with you in the form of this book, which is but a punctuation point in the living history of Canon and its remarkable contribution to photography.

BUILDING A PHOTOGRAPHY SYSTEM

©Serge Timacheff

You may have read the long, heated debates on photography Web sites and in photography magazines about which digital SLR (dSLR) camera is best. They range from debating the speed and construction of different cameras to their ease of use and image quality. But few discussions concentrate on the fundamental consideration: When you buy a dSLR, it is the first step in building a photography system you will continue to invest in for many years to come.

So what is a photography system, and what considerations are important when you add components to your system? This chapter helps to answer those questions, and it provides evaluation criteria to help you decide which elements you need for a basic system based on your photography interests and shooting preferences.

WHAT IS A PHOTOGRAPHY SYSTEM?

From a broad point of view, a photography system includes all the components that are offered by the camera manufacturer and third-party companies and that are compatible with your camera. From this perspective, a system includes the camera body, lenses, flash units, battery chargers, extension tubes, interface cables, and so on. In other words, the photography system encompasses the universe of components that are compatible with your camera. Your current system may be as simple as one basic body and several lenses, as shown in 1-1.

ABOUT THIS PHOTO *A camera system can range from simple to complex. Here the Canon 1D Mark IIn and five Canon lenses make a powerful combination for a variety of photography applications. ©Amy A. Timacheff*

1-1

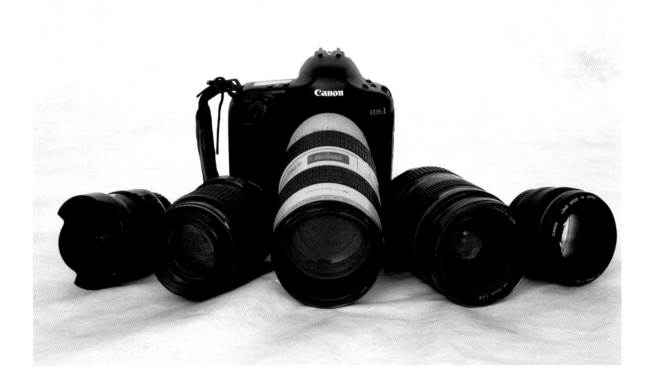

CHAPTER 1

If you're reading this book, you probably either already own or are considering buying a Canon dSLR. As one of the oldest camera manufacturers in the world, Canon offers a photography system that reflects the company's long heritage of understanding the needs of photographers by supplying professional equipment and pioneering new technologies.

CANON SYSTEM OVERVIEW

From the broad view, Canon offers a complete range of cameras, lenses, Speedlite flashes, and accessories. There are so many options, in fact, that choosing among them is a challenge. Throughout this book, you get detailed information on individual components of the Canon photography system as well as help in choosing components based on your shooting preferences and needs. For now, it's worthwhile to review the overall scope of Canon's photography system.

x-ref More details on each camera are provided in Chapter 2.

note Have you ever wondered what EOS stands for in the Canon digital lineup? It is for electro-optical system (although the reference to Greek mythology's Goddess of Dawn is not necessarily accidental). EOS refers to the standardization of an electronic interface between the lens and camera to control functions such as focusing and aperture.

PROFESSIONAL DSLRS

Canon professional dSLRs are distinguished by both advanced features and build quality. For example, the shutter mechanism of the professional cameras is rated at 100,000 to 300,000 actuations (shutter releases) to account for heavier use. In addition, the design of the Mark III series dSLRs includes extensive weatherproofing to protect the camera against the elements and demanding use.

- **EOS-1Ds Mark III.** Professional-build camera with a 21.1-megapixel full-frame sensor with a capture rate of up to 5 frames per second (fps) for 56 JPEG or 12 RAW images per burst.

- **EOS-1D Mark III.** Professional-build camera with a 10.1-megapixel sensor with a capture rate of up to 10 fps for up to 110 full-resolution JPEG or 30 RAW images per burst.

CANON PHOTOGRAPHIC LEGACY Originally started in a Tokyo apartment in 1933, Canon's first commercial camera was built and released between 1935 and 1936 by Saburo Uchida and his brother-in-law, Takeo Maeda. Originally called "Kwanon," Canon today is not only known for its cutting-edge technology, but also for working closely with photographers to solve problems and to create innovative new approaches.

In 2005, Canon ranked second in the world in filing patents, after IBM. The company's technology pursuits range from developing an optical sensor for earth observation satellites — capturing light from a galaxy 2.8 billion light years away — to developing super UD (Ultra Low Dispersion) lenses to improve optical quality.

Canon designs, develops, and manufactures its image sensors and image processors in-house. Canon was the first to develop and offer a full-frame 35mm sensor in its digital SLR cameras — a sensor capable of both high-speed processing and very high resolution images.

- **EOS 5D.** Professional-level camera with a 12.8-megapixel full-frame sensor with a capture rate of up to 3 fps for 60 JPEG or 17 RAW images per burst.

- **EOS 40D.** A semiprofessional camera with a 10.1-megapixel sensor with a capture rate of 6.5 fps for up to 75 JPEG or 17 RAW images.

CONSUMER DSLRS

Canon's consumer dSLRs provide excellent durability and offer shooting modes similar to the professional cameras, as well as programmed point-and-shoot modes. Canon offers the following cameras in its line of consumer EOS dSLRs:

- **EOS Digital Rebel XT (350D).** Offers an 8.0-megapixel sensor with a capture rate of up to 3 fps for up to 14 JPEG images per burst.

- **EOS Digital Rebel XTi (400D).** Offers a 10.1-megapixel sensor with a capture rate of up to 3 fps for up to 27 JPEG or 10 RAW images per burst.

- **EOS Digital Rebel XSi (450D).** Offers a 12.2-megapixel sensor with a capture rate of up to 3.5 fps for up to 53 full-resolution JPEG or 6 RAW images per burst.

Sensor sizes and frame rates are discussed in more detail in Chapter 2.

CANON LENSES

For years, the exceptional quality of Canon lenses, such as those shown in 1-2, has drawn photographers to the Canon brand. As any photographer can tell you, a camera is only as good as the lens that's mounted on it. Certainly more factors figure into image quality with digital photography than with film photography, but the lens remains an essential component in image quality.

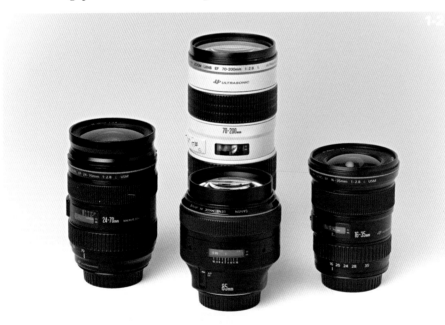

ABOUT THIS PHOTO
The excellent quality of its lenses is one of the things that make the Canon system the choice of so many photographers. ©Jim White

Each year, Canon adds new lenses to an already extensive selection that covers the range from fisheye to super-telephoto. Here is the Canon EF (electrofocus) lens lineup:

Ultrawide Zoom Lenses

■ EF-S 10-22mm f/3.5-4.5 USM

■ EF 16-35mm f/2.8L II USM

■ EF 17-40mm f/4L USM

■ EF 20-35mm f/3.5-4.5 USM

Wide-Angle Prime (Single-focal-length) Lenses

■ EF 14mm f/2.8L USM

■ EF 14mm f/2.8L II USM

■ EF 15mm f/2.8 Fisheye

■ EF 20mm f/2.8 USM

■ EF 24mm f/1.4L USM

■ EF 24mm f/2.8

■ EF 28mm f/1.8 USM

■ EF 28mm f/2.8

■ EF 35mm f/1.4L USM

■ EF 35mm f/2

Standard Zoom Lenses

■ EF-S 17-55 f/2.8 IS USM

■ EF-S 17-85mm f4-5.6 IS USM

■ EF-S 18-55mm f/3.5-5.6 USM

■ EF-S 18-55mm f/3.5-5.6 IS

■ EF 24-70mm f/2.8L USM

■ EF 24-85mm f/3.5-4.5 USM

■ EF 24-105mm f/4L IS USM

■ EF 28-80mm f/3.5-5.6 II

■ EF 28-90mm f/4-5.6 II USM

■ EF 28-105mm f/3.5-4.5 II USM

■ EF 28-105mm f/4.0-5.6 USM

■ EF 28-135mm f/3.5-5.6 IS USM

■ EF 28-200mm f/3.5-5.6 USM

■ EF 28-300mm f/3.5-5.6L IS USM

Standard and Medium Telephoto Lenses

■ EF 50mm f/1.2L USM

■ EF 50mm f/1.4 USM

■ EF 50mm f/1.8 II

■ EF 85mm f/1.2L II USM

■ EF 85mm f/1.8 USM

■ EF 100mm f/2 USM

Telephoto Zoom Lenses

■ EF 55-200mm f/4.5-5.6 II USM

■ EF 70-200mm f/2.8L IS USM

■ EF 70-200mm f/2.8L USM

■ EF 70-200mm f/4L IS USM

■ EF 70-200mm f/4L USM

■ EF 70-300mm f/4-5.6 IS USM

■ EF 70-300mm f/4.5-5.6 DO IS USM

■ EF 75-300mm f/4-5.6 III USM

■ EF 75-300mm f/4-5.6 III

■ EF 80-200mm f/4.5-5.6 II

■ EF 100-300mm f/4.5-5.6 USM

■ EF 100-400mm f/4.5-5.6L IS USM

 x-ref

For details on lens categories and individual lenses, see Chapter 3.

Telephoto Prime (Single-focal-length) Lenses

- EF 135mm f/2L USM
- EF 135mm f/2.8 with Softfocus
- EF 200mm f/2.8L II USM
- EF 300mm f/2.8L IS USM
- EF 300mm f/4L IS USM

Super-Telephoto Prime (Single-focal-length) Lenses

- EF 400mm f/2.8L IS USM
- EF 400mm f/4 DO IS USM
- EF 400mm f/5.6L USM
- EF 500mm f/4L IS USM
- EF 600mm f/4L IS USM

Macro Prime Lenses

- EF 50mm f/2.5 Compact Macro
- EF-S 60mm f/2.8 Macro USM
- MP-E 65mm f/2.8 1-5x Macro Photo
- EF 100mm f/2.8 Macro USM
- EF 180mm f/3.5L Macro USM

Tilt-Shift Lenses

- TS-E 24mm f/3.5L
- TS-E 45mm f/2.8
- TS-E 90mm f/2.8

Extenders

- Extender EF 1.4x II
- Extender EF 2x II

ADDITIONAL CANON SYSTEM COMPONENTS

The most expensive components of a photography system are camera bodies and lenses, but a variety of accessories increase your creative options. Additional components include Canon Softmat filters and close-up lenses, teleconvertors to increase the effective focal length of lenses, Speedlite flashes, circular polarizing and haze filters, a variety of remote control accessories, a wireless file transmitter, a data verification kit, a variety of eyecups and extenders, angle finders, and focusing screens.

For lighting on the go, Canon offers the 580EX II, 430EX, and 220EX Speedlites. The ST-E2 transmitter allows control of slave flashes for up to 33 feet outdoors and almost 50 feet indoors. Macro photographers can benefit from the Macro Twin Lite MT-24EX or the Macro Ring Lite MR-14EX. In addition, you can add a variety of battery packs and magazines, hot-shoe adapters, TTL (through-the-lens) distributors, and off-camera shoe cords. A body, lens, and flash made a complete system for this wedding photographer, with great results (see 1-3).

x-ref

For a more detailed description of Speedlites and accessories, see Chapter 9. For more on lenses, see Chapters 3 through 7.

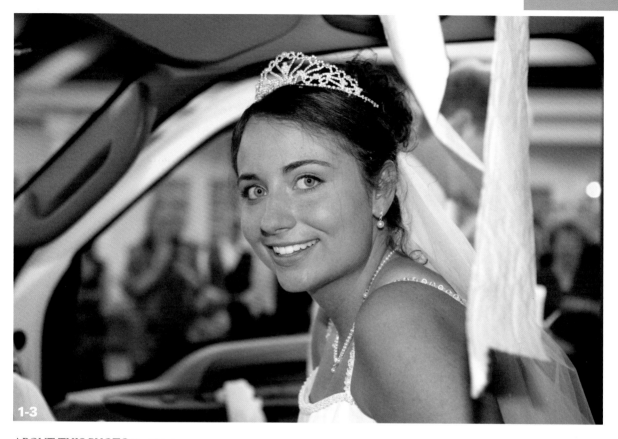

1-3

ABOUT THIS PHOTO *The EOS 1Ds with 24-70mm L lens and 580EX Speedlite make up a high-quality camera system to take lifelike, high-quality professional images such as this wedding shot at ISO 100, 1/60 second at f/4. ©Jim White*

PERSONAL PHOTOGRAPHY SYSTEMS

Whether you started with an entry-level camera such as the Digital Rebel XTi, shown in 1-4, or went with a professional dSLR, from a photographer's point of view, a photography "system" includes the camera gear that you currently own. And in a larger sense, a digital photography system also includes the components of your studio and digital darkroom, such as computers, stand-alone hard drives for storage, printers, and image-

editing programs. From this perspective, a system includes everything that's necessary to capture, process, and print/fulfill images.

For hobbyists and advanced amateurs, photography systems run the gamut from minimal to extensive. In addition to a computer and an image-editing program, a basic photography system might include the following, as shown in 1-5:

■ A digital camera body

■ One or more zoom lenses

■ One or two memory cards

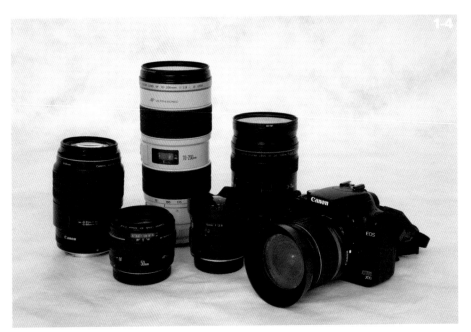

1-5

For professional photographers, it's critical to not only have the primary camera bodies and lenses, but also to have backup gear to ensure that shooting assignments proceed on schedule. Thus a professional system can include several bodies, numerous lenses, and flash equipment, such as the studio lighting equipment shown in 1-6. Because it is impractical to duplicate all components of a professional system, working professionals often rent backup components on location, a strategy that is popular with many event and wedding photographers. Renting backup gear lightens the travel load as well.

A professional photography system may include a wide variety of components:

- One or more primary camera bodies and secondary or backup camera bodies
- Multiple zoom and single-focal-length, or prime, lenses with multiples of the most often used lenses as backups
- One or more Canon Speedlites or third-party flash units, brackets, stands, and light modifiers such as softboxes
- Filters
- Multiple high-capacity, fast media cards
- Portable image storage and display units for offloading images during travel
- Tripods and monopods with heads
- Remote or cable releases
- One or more incident light meters
- A wireless file transmitter
- Cleaning accessories for the camera sensors and lenses
- A laptop computer for traveling
- Studio lighting, power packs, and backdrops, as in figure 1-6
- Padded camera bag and/or hard case suitable for shipping
- An extensive desktop computer system including large-screen and calibrated monitors, stand-alone hard drives, and archival-quality printers

Regardless of how much or how little your photography system comprises, the most important aspect of any photography system is having the gear that allows you to capture the range of images that you enjoy or need to photograph.

In addition to cameras, if you have a studio, you will need additional types of professional lighting as well as backdrops. You might consider something like a softbox, which provides softened and diffused light that wraps around subjects to provide even illumination — an essential tool in every professional studio.

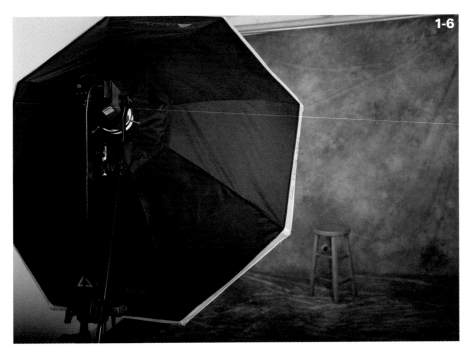

ABOUT THIS PHOTO
A Photoflex Octodome softbox mounted on a Manfrotto tripod and boom, with a Bowens studio light, provides an adjustable modeling light and powerful flash that is triggered wirelessly from the camera. The back of the softbox (seen here) is black; the front of it is a white translucent material. ©Serge Timacheff

BUILDING YOUR PHOTOGRAPHY SYSTEM

Buying a new camera body or a backup body requires careful consideration of what your current photography system lacks and how to balance those needs with your budget. Lenses, especially Canon's high-end L-series professional lenses and specialized lenses such as for macro photography, are expensive, and it's often difficult to decide which lens or system component that you need next or need most.

Unless you have unlimited resources, it's best to have a plan for building your system. Even if your interests include more than one type of photography, such as the macro and portrait work shown in 1-7 and 1-8, this will ensure that you invest wisely and help you arrange your purchases around equipment that will enhance your own creative vision.

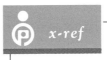 **x-ref** | For more on L-series and fast lenses, see Chapter 6.

1-7

ABOUT THESE PHOTOS

The versatility of a good camera system allows you to pursue multiple photography styles and techniques; with a limited budget, you can get a lot out of a single body and lens. Both 1-7 and 1-8 were taken with an EOS 5D and an EF 100mm f/2.8 Macro lens. 1-7 at ISO 320, f/22 at 1/60 second. 1-8 at ISO 100, f/16 at 1/160 second.
©Amy A. Timacheff

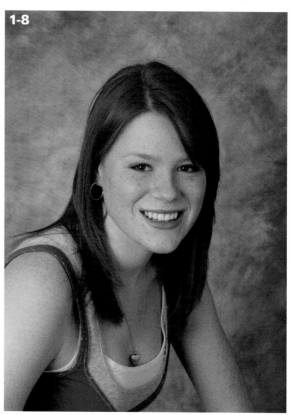

1-8

The starting place for any photography system involves having the basic components you need for everyday photography. While you may want and think that you need five, six, or even ten lenses, remember that many great photographers made great pictures using a single lens. Their work testifies to the fact that you can do much more with a single lens than you might imagine. The goal is to exploit your current gear to its greatest potential.

Many of Canon's dSLRs are available as kits that include a zoom lens that provides a focal range suitable for common shooting needs — from landscapes to portraits. For example, Canon offers consumer-quality lenses, including the EF-S 18-55mm f/3.5-5.6 USM, designed for optimized performance on the Digital Rebels and EOS 40D cameras.

While a kit lens ensures a focal range adequate for photographing landscapes and portraits, a single lens typically won't meet all your shooting needs. And if you didn't buy a kit or you bought a professional-level camera, then the question is what lenses you need to buy — lenses that will become the foundation of your system.

But what are the goals for a basic photography system, and what would a basic system include? Assuming that you already have a Canon dSLR, my recommendations for a basic photography system include the elements shown in the following list. With this system, you have a focal range that allows you to photograph everyday family photos as well as travel, landscape, portrait, and wildlife images. In addition, the basic system allows you to travel light while not missing photographic opportunities. A typical basic system would include:

- ■ **A wide-angle zoom lens.** A wide-angle lens in the range of 17-40mm allows you to capture a landscape image (see 1-9), group portraits, and even individual portraits at the 40mm setting. On the Digital Rebel XTi and EOS 40D cameras with an APS-C-size sensor, a lens in this range is equivalent to 27-64mm. On the EOS-1D Mark III, with an APS-H-size sensor, this range is equivalent to 22-52mm. On full-frame-sensor cameras, such as the EOS-1Ds Mark III and the EOS 5D, a 17-40mm lens, for example, operates precisely as a 17-40mm lens.

- ■ **A telephoto zoom lens.** A telephoto lens in the range of 70-300mm enables you to capture portraits, wildlife, birds, sports, and distant landscapes, such as the scene shown in 1-10. On the Digital Rebel XTi and EOS 40D cameras with an APS-C-size sensor, a lens in this range is equivalent to 112-480mm. On the EOS-1D Mark III with an APS-H-size sensor, a lens in this range is equivalent to 91-390mm.

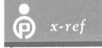 **x-ref** For a more complete explanation of sensor size and crop factor, see Chapter 2.

- ■ **UV haze filters for all lenses.** These filters absorb ultraviolet light to reduce haze on a sunny day and protect the front lens element from dirt and scratches.

- ■ **Circular polarizing filters for one or both lenses.** These filters allow rotation to reduce reflections and glare on water and other shiny surfaces as well as increase color saturation.

■ **Lens hoods.** Lens hoods prevent stray light, which can create flare in images, from entering the lens. They also offer protection to the front element of the lens.

■ **Canon Speedlite (optional).** I list this as optional because using a flash depends a lot on what subjects you like to photograph. Also, if you have a Digital Rebel or EOS 40D with a built-in flash, then you may find that it is adequate for your immediate needs.

ABOUT THIS PHOTO
With a good wide-angle zoom lens, you can crop your scene exactly as you want. Taken with an EOS-1Ds Mark II, EF 16-35mm f/2.8L lens, ISO 50, 2 seconds at f/16. ©Jim White

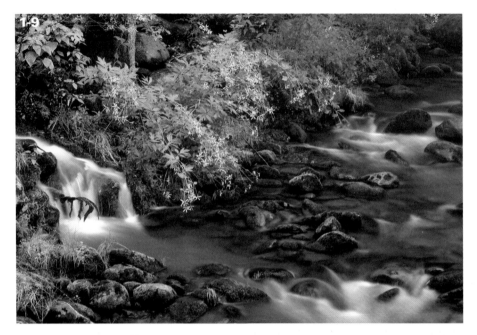

ABOUT THIS PHOTO
By remaining quite still and using a good telephoto zoom lens, I was able to capture this early morning image of a young deer crossing the road. Taken with an EOS-1Ds Mark II, EF 100-400mm IS L lens, ISO 400, 1/320 second at f/6.3. ©Jim White

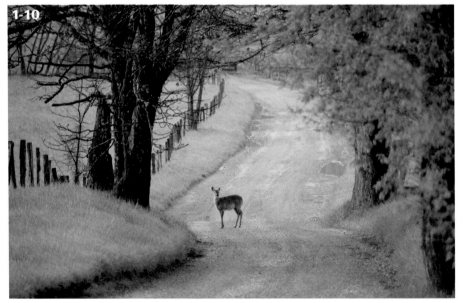

This is a do-it-all approach that works well for general shooting. The basic system is, however, not as well suited for specialty shooting, such as for macro images and sports photography. If you have a specialty shooting area identified, then the composition of your basic system will be weighted toward the lenses you need for that specialty.

CHOOSING THE GEAR THAT'S RIGHT FOR YOU

While no one can tell you what is exactly right for you, you can evaluate your shooting history and preferences to better determine the photography system components that work for you. While reading over the list of Canon photography system components, you may have the overwhelming urge to buy one or two new lenses or accessories. Just seeing the list is like the ultimate wish list for the great camera store in the sky.

Patience, however, is a virtue, and so is developing a solid plan to help you build a system that's right for you. From personal experience, I can tell you that there are few things more aggravating than having an expensive lens or Speedlite gather dust in a gear bag. I've also learned that the loss on the resale price of gear I didn't really need or use is sobering enough to keep my personal wish list carefully prioritized.

PLANNING

To plan your photography system, think carefully about your areas of interest, and then try to look ahead to future needs and desires. You may be interested in flower macro shots (see 1-11), natural scenes, or portraits (see 1-12). To get you started, here are some general questions to help you create a plan for building your photography system:

■ **Is photography your passion, a current or future profession, or a hobby and a way to keep family snapshots current?** If you are serious about photography, then the type of gear you buy will be different from the gear you'd buy for family snapshots.

■ **What subjects do you most enjoy photographing?** If you shoot sports or fast-moving children, then you should factor camera features such as a high burst rate and fast focusing into your planning. But if you do fine-art shooting, portraits, or landscapes, a slower frame rate and high-quality lenses become more important.

x-ref See Chapter 2 for more on frame and burst rates.

■ **Who uses the camera?** If you and other family members intend to use the camera, you may want a camera that includes point-and-shoot modes such as the Digital Rebel and EOS 40D.

■ **How important is it to you to get the highest-possible quality with every image you make?** If you tend to examine every detail of your images, your needs will be significantly different from the photographer who is happy with the average snapshot.

■ **At what size do you print images?** Answering this question helps you determine the camera *resolution* you need. But also think ahead to the time when your photography skills are better — that's when you may want bigger enlargements from images. It is also a good idea to buy with the future in mind rather than settling for what you can get by with or afford today.

■ **Do you often shoot in low light or need the ability to handhold the camera in moderate to low light?** If you shoot indoor volleyball games in a dimly lit gym, then a fast lens such as an f/2.8 with image stabilization (to counteract movement while handholding the camera) gives you an edge. If most of your shooting is outdoors in good light, then a slower lens should be adequate.

■ **Is weight important?** In considering this question, factor in the combined weight of the camera body, the battery or battery grip, and the lenses.

■ **Do you have specialized needs?** Shooting macro images, for example, may require a ring-type flash. Or perhaps you may want to try different types of filters to soften or enhance colors in your images (such as warming filters, which come in a variety of tones and shades for optimizing color in your images). Or perhaps you need a monopod for stabilizing your camera while still being able to move around and shoot.

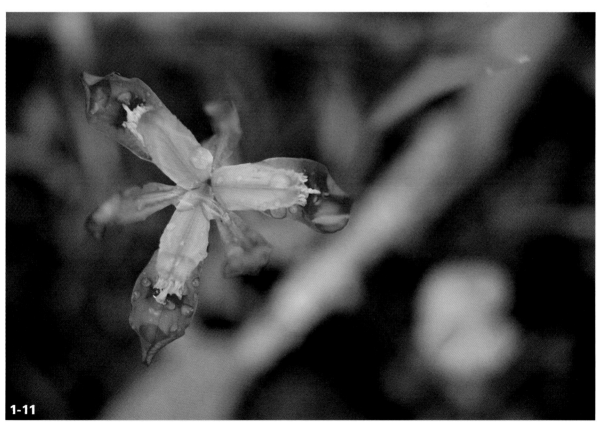

1-11

ABOUT THIS PHOTO *This photo of a dwarf iris shows the versatility of a sharp, fast telephoto lens. Taken with an EOS-1Ds Mark II, EF 70-200mm f/2.8L lens, ISO 100, 1/80 second at f/2.8. ©Jim White*

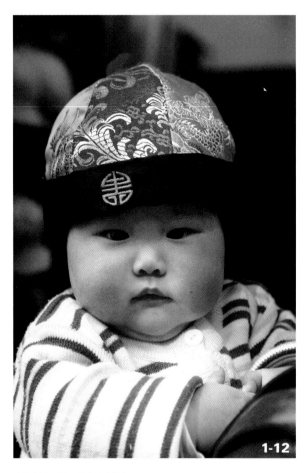

1-12

ABOUT THIS PHOTO *A normal-range lens helps capture fine details across a wide range of tonality in natural-looking portraits — especially with RAW images. I photographed this child in a Shanghai marketplace. Taken with an EOS-1D Mark II with an EF 24-70mm f/2.8L lens, ISO 640, 1/250 second at f/5. ©Serge Timacheff*

COST

As you learned earlier in this chapter, Canon offers both cameras and lenses in consumer and professional categories, and the price difference is significant. For example, if your answers to the previous questions indicate that you care intensely about image quality and the ability to make enlargements from your pictures, then you'll get the best image quality and biggest enlargements with a high-resolution camera such as the EOS-1Ds Mark III, the EOS 5D, or, in the consumer category, the EOS Digital Rebel XTi (400D).

For lenses, the highest image quality comes from Canon's L-series pro lenses, although many of the consumer lenses also offer excellent image contrast while providing excellent sharpness and speedy focusing.

Using the basic photography system and high image quality as the criterion, approximate costs for a basic system at the time of this publication are as follows:

> Canon EOS 5D 12.8-megapixel digital SLR: ≈$2,000
>
> Wide-angle telephoto EF 24-105mm f/4L IS USM lens: ≈$1,000
>
> 77mm UV haze filter: ≈$50
>
> 77mm circular polarizer: ≈$125
>
> Canon EF 70-200mm f/4L IS USM lens: ≈$1,000
>
> 67mm UV Haze-1 filter: ≈$70
>
> 67mm circular polarizer: ≈$95

Total: $4,340

If, on the other hand, you enjoy photography as a pastime, and you don't tend to lose sleep over getting the biggest enlargements or fret over minute image details, then the basic system cost would look a little more like this:

> Canon EOS Digital Rebel XTi (400D) 10.1-megapixel dSLR with Canon EF-S 18-55mm f/3.5-5.6 USM lens: ≈$600

58mm UV haze filter: ≈$25

Canon EF 75-300mm f/4.0-5.6 III USM lens:≈$180

58mm UV haze filter: ≈$15

58mm circular polarizer: ≈$85

75-300mm lens hood: ≈$25

Total: $930

These examples clearly show that knowing your priorities for a photography system makes a big difference in the amount of money that you spend. And, of course, there are many variations on the system components.

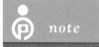

note

Other chapters later in the book detail specific criteria for purchasing lenses, Speedlites, and accessories, but this overview helps you evaluate the factors that are most important in building a photography system.

TIMING

Another consideration is timing. If you are new to photography, the idea of acquiring many more lenses and accessories may seem overwhelming, but remember that you can acquire the lenses and accessories that you need over a period of months or years.

At the most basic level, all you need is a camera and a good walk-around lens that provides a focal range for wide-angle to moderate telephoto shooting. For the EOS Digital Rebels, a kit lens such as the EF-S 18-55mm meets that requirement for many people. The EF-S 17-55mm f/2.8 IS USM or EF-S 17-85mm f/4.5-5.6 IS USM lenses are also ideal walk-around lenses. For the other EOS cameras, the 24-105mm f/4.0L IS USM lens provides a great focal range and excellent image quality.

Then as you can afford to buy lenses, you have the advantage of additional time to think about your shooting needs and preferences, and you can choose the best lens to add to your system.

It is also important to think ahead. As your photography skills increase and the range of your photography evolves, the core pieces of your photography system — the lenses — should stand the test of time and change.

For example, you may spend several years shooting with a Canon EOS Digital Rebel. As you add lenses, the EF-S lenses may seem to be the best buy for the money and you may add a couple more EF-S lenses to your system. But if three years from now, you decide to replace the Digital Rebel with an EOS 5D, then you'll have to replace the EF-S lenses because they are incompatible with the 5D. This is only one example of why it's a good idea to think and plan for the future even if it means delaying a purchase until you can afford the item.

SHOULD YOU BUY NEW OR USED EQUIPMENT?

Certainly, used equipment can represent substantial savings over the cost of new gear. Used camera gear is sold online on eBay, on KEH.com, on www.robgalbraith.com forums, and on Web sites of major camera stores. Used camera bodies and lenses are usually rated by condition such as scratches, dents, the amount of wear, and so on. Pristine gear may be rated as "Mint," which is defined as factory-new condition with original documentation and packaging. At the bottom of the scale is "Bargain," which means that the item has 50 percent or less of the original finish, it is well worn, may have missing parts, or may not be fully functional. In most cases, you have to rely on the honesty of the seller to accurately rate the gear.

DEVELOPING YOUR PHOTOGRAPHIC VISION AND STYLE For new photographers, the idea of a photographic vision and personal style seems elusive and perhaps limiting. Many new photographers are absorbed by the overall concept and practice of photography in general, and do not have a clear idea of where the photographic journey will take them.

But after months or years of general shooting, more specific interests begin to emerge, and a sense of creative excitement and satisfaction emerges when you shoot certain scenes or subjects. For example, you may get the most joy from making portraits or from exploring the intricacies of nature. And sometimes the interest areas that emerge are not what you would have predicted at the beginning of the journey. But when you begin to envision images — images that sit restlessly inside your mind — and you know how you want the images to look and feel, you have the beginnings of a personal photographic vision. As you pursue your vision, a shooting and image-processing style may emerge as well.

Developing your vision and style is part instinctive and intuitive, and, for most, it takes time. As you read magazines and newspapers, pay attention to the images you are drawn to most often. Visit local galleries and make a note of images and art that resonate with you.

The time that you spend nurturing your vision is time well spent. From an artistic perspective, your vision and style can set your images apart from everyone else's. And from a practical perspective, your vision and style help you target the photographic gear that you need and will use most often.

You also want to focus on the working condition of an item rather than base its value strictly on appearance. Many picky customers pass over perfectly good equipment because it looks "used." If the glass on a lens is clean and it performs well, then the aesthetic value should be secondary. A camera store I used to frequent was a great source for used equipment. Whenever the owner encountered a shopper obsessed with appearance over functionality, he would invariably ask, "Are you going to take pictures with it, or of it?"

I prefer to buy used gear from sources that accurately rate their equipment. The downside of buying used professional gear is that it likely has more miles of use on it than if you buy from a photography enthusiast who may not be as good at rating the gear, but will likely have used the gear less and in less demanding conditions. The same cautions apply to buying used camera equipment as to other used gear — if the price seems too good to be true, then it probably is. One way to ensure you don't throw money away is to buy from camera stores that provide a warranty with the used equipment. The warranty is usually limited and of a short duration, but if you use the gear right away to ensure its functionality, you have some recourse if it doesn't perform as described.

Assignment

Your Favorite Equipment

You may just be getting acclimated to your new Canon dSLR, or you may have had it for a few years and are just now ready to expand your gear collection. Regardless of which category or place that you fall, you no doubt have some combination of equipment that is your favorite.

Show your love to the other readers by taking a photo using your favored gear and post it on the Web site to share with other readers. Who knows? Maybe you will find a kindred spirit!

My favorite "Canon combo" is the EF 70-200mm f/2.8L lens with a fast camera, such as my 1D Mark IIn. In this emotional sports image, taken by my 15-year-old son using my equipment, he captured one of his favorite fencers (Italy's Andrea Baldini) moments before a gold-medal match for a world title. Taken at the 2006 World Fencing Championships in Torino, Italy, at ISO 500, 1/320 second, and f/2.8.

©Alexander Timacheff

Remember to visit www.pwassignments.com when you complete this assignment and share your favorite photo! It's a community of enthusiastic photographers and a great place to view what other readers have created. You can also post comments and read other encouraging suggestions and feedback.

©Michael A. Johnson

Whether you already own a Canon digital SLR, or you're considering upgrading or buying a backup camera body, Canon provides a lineup of dSLR cameras that have a logical progression of features and resolution for primary and secondary shooting needs. Behind the scenes, Canon's trusted digital imaging technology ensures you get consistent results, whether you are an individual photographer with a single camera body or you own a studio with multiple dSLRs at different resolutions. Also, historically Canon has led, and continues to pioneer, digital imaging technology, so you can expect the highest image quality and can't-live-without features from all of Canon's dSLRs.

This chapter provides an overview of the technologies that are common to Canon's dSLR cameras, technologies that are specific to camera categories or models, as well as the exposure, metering, and focusing features of each camera.

CONSIDERATIONS FOR BUYING A CANON DSLR

My photography students often ask me which camera they should buy. The truth is that no one can tell you what camera to buy, but if you understand the commonalities and differences among Canon's dSLRs, then you can make informed decisions when it's time to buy a new camera, upgrade your existing camera, buy a backup camera body, or add another camera to your existing system.

Regardless of which camera you are thinking about, many considerations go into selecting a camera:

- **Image quality.** What size and quality of images do you need to produce? Do you need a full-frame camera, or are other attributes more critical? Will a slightly lower-priced dSLR suffice so that you can spend more money on professional lenses?

- **Lens quality and selection.** What mix of lenses are necessary, versus ones that you can put on your "wish list"? Do you need a "fast," wide-aperture lens that will hold its aperture at any zoom level? Do you need to shoot close-up images with a dedicated macro lens, or distant images? Will you benefit from a very wide aperture, exceptionally narrow-depth-of-field portrait lens?

- **Exposure.** What camera features are necessary/important to your work? You may want to consider an external flash (or two) if you do lots of indoor, low-light shooting so as to expand your capabilities. Do you need the ability to shoot low-light, nonflash images that would require low-noise, high ISO capabilities and very wide aperture lenses?

- **Speed.** If you're shooting sports or anything high-speed, you'll want to consider a fast camera and lens combination, such as the EOS-1D Mark III with its fast frame-per-second ability along with an f/2.8 lens.

■ **Burst rate/buffer.** If you shoot multiple images without stopping, your camera has a limit; that limit is the "burst" rate. Images are held in a "buffer" as they are downloaded to the storage media in the camera. A camera such as the 1D Mark III has a burst rate of 30 RAW or 110 JPEG images—far greater than that of most dSLRs—so if you need to shoot lots of images in a short amount of time, this is an important consideration.

■ **Overall camera handling.** What body style and lens(es) feel good to you? Do you need a lighter, but professional-quality, camera such as the 5D, or is your arm strong enough to handle an EOS-1D camera (which is much heavier)? Does the "chording" system of changing settings in the EOS-1D series work better for you, or do you prefer the rotating wheel for operating a camera such as the 40D?

■ **Budget.** Obviously, money is a consideration for your gear lineup. The question is where do you spend it — on camera body, lenses, flashes, studio equipment, or digital darkroom gear? You must consider what you need to operate with right now and how your needs might change and expand as your skill and interests change. Additionally, you should be aware of new product releases that pertain to your specific needs and interests and understand how these new items can impact your spending and budget.

I am frequently asked what the single most important factor in selecting a camera is. For me, there are two primary considerations in selecting a camera — both based on my professional shooting needs, priorities, and preferences. These are image resolution of the camera and the quality of the lens and optics. Resolution is important because my images must meet the minimum resolutions standards required by stock agencies, which is 11 × 14 inches. For my gallery clients, I want to be able to offer prints at 11 × 14 inches or larger. I have also sold prints as large as 3 × 5 feet, so for me high resolution is a must! On the other hand, some labs are able to print larger prints from smaller-resolution images using sophisticated technologies.

Historically, lens quality was the foundation professional photographers used when choosing among camera manufacturers. Photographers have debated for years whether Canon or Nikon offer the best lens quality. Ultimately, you have to decide for yourself, but if you're reading this book, you've probably already chosen or at least are seriously considering Canon. From my experience, which includes using a variety of different lenses and cameras from different companies, Canon lenses provide consistently superb optical quality, and the selection of lenses, such as those shown in 2-1, gives me complete creative freedom as a photographer.

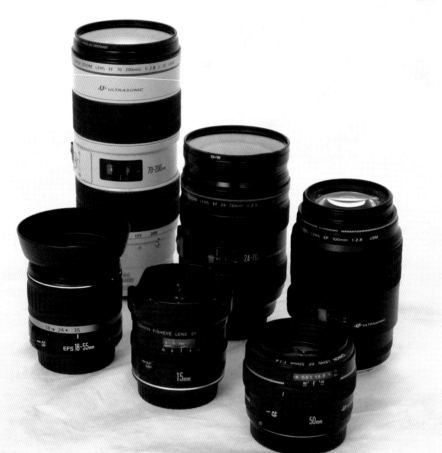

WHAT RESOLUTION IS RIGHT FOR YOU?

While most photographers focus on the number of megapixels to gauge a camera's resolution, the actual resolution is more complex than the number of pixels on an image sensor. For example, the camera may not use all the pixels in the digital image; some pixels may be used for other imaging tasks. Other factors come into play as well, such as sensor size and *digital noise*, which is the grainy quality of a low-light digital image.

Sensor size must be a consideration in evaluating megapixel count. Many point-and-shoot digital cameras boast an excess of 10 megapixels, but these 10 million pixels are crowded onto a sensor less than half the size of your fingernail! The 10 million pixel sensor on a Digital Rebel XTi is much larger physically than a 10 megapixel sensor on most, if not all, point-and-shoot cameras

boasting the same megapixel resolution. Larger photo sensors can gather more light, have less digital noise, and have better *dynamic range*. In this case, bigger is better.

Each pixel in a camera sensor contains one or more light-sensitive receptors that convert the incoming light into an electrical signal. This signal is then processed into the colors used in the final image, and the brightness of individual pixels is amplified or decreased. A common cause of digital noise is overamplification of the signal coming from the photosite. If the same pixel is exposed several times by the same amount of light, the resulting color values are not always identical but have small variations, resulting in digital noise.

Even with no light present, the electrical activity of the sensor itself will generate some noise (think of it as the photographic equivalent to the background hiss in audio equipment).

Noise in digital images, similar to film grain, is most visible in uniform surfaces (such as blue skies and shadows). Digital noise increases with ISO (sensitivity), and as pixel size decreases. This is why digital compact cameras generate much noisier images than dSLRs. Professional cameras, such as the EOS-1Ds Mark III and EOS-1D Mark III, have higher-quality components and more powerful processors that allow for more advanced noise reduction; subsequently these cameras display significantly less noise even at high ISOs.

If you only plan to have 4 × 6 or 5 × 7 prints made at your local drug store kiosk, then you can be less concerned with differences in sensor size. If you plan to make 8 × 10, 11 × 14, or larger-size prints, then the dSLR's larger sensor provides a bigger payoff. As you can see in 2-2 and 2-3, bigger pixels can be enlarged or upsized, with much less noise and better results. When a digital image

ABOUT THESE PHOTOS *Notice the differences in these two images viewed at 100 percent, produced from a Canon G-1 point-and-shoot digital camera and a Canon 30D. Both images ©Jim White.*

is enlarged beyond its native resolution via software, it results in an effect called *pixilation*, an unsightly effect where jagged pixels are very obvious to the naked eye. Some editing programs will attempt to create new pixels to the best of their ability if an image is enlarged; one method for doing this is called *interpolation*. Generally speaking, the results are of less-than-adequate quality.

In general terms, resolution correlates to the size of the prints that you can make at the camera's maximum quality setting. Table 2-1 provides an overview of the general sizes at which you can print images from Canon dSLRs at both 240 and 300 dots per inch (dpi).

 note — Digital images are made up of pixels, which are individual dots of information that combine in a matrix of millions to form a photograph. Zooming in on a digital image in an image-editing program reveals the pixels that fool the human eye into believing it's seeing a fluid, smooth photo. A megapixel is one million pixels, and the term is used to represent a camera's maximum resolution (for example, 6.2 megapixels). For example, the EOS-1Ds Mark III has a maximum resolution of 21.10 megapixels; its maximum RAW file produces images of 5,616 × 3,744 pixels (5,616 × 3,744 = 21,026,304 pixels, which rounds to 21.10 megapixels).

Table 2-1

Sample Printing Sizes at Native Resolutions

Camera Model	Output Size	Print Size @ 240 dpi	Print Size @ 300 dpi
EOS-1Ds Mark III	5,616 × 3,744	23.4 × 15.6	18.72 × 12.48
EOS-1D Mark III	3,888 × 2,592	16.2 × 10.8	12.96 × 8.64
EOS 5D	4,368 × 2,912	18.2 × 12.1	14.56 × 9.7
EOS 40D	3,888 × 2,592	16.2 × 10.8	12.96 × 8.64
EOS Rebel XTi	3,888 × 2,592	16.2 × 10.8	12.96 × 8.64
EOS Rebel XT	3,456 × 2,304	14.4 × 9.6	11.52 × 7.68

TECHNOLOGIES AND FEATURES COMMON TO CANON DSLRS

Regardless of which dSLR you have or are considering, Canon has a long track record of employing consistent technologies within their dSLR lineup. Since digital photography came into its own, a defining characteristic of the progression of the industry has been the gradual addition of more and more high-end (professional) functionality to consumer models. The EOS Digital Rebel XT and the Digital Rebel XTi offer shooting modes, exposure features, speeds, and more importantly results that rival their more expensive counterparts, as evidenced in 2-4. Certainly this trend of adding advanced features at consumer-level prices is an advantage for photography enthusiasts.

2-4

ABOUT THIS PHOTO *Canon's Digital Rebel XTi is quite capable of producing professional results under demanding shooting situations. Taken with a Canon 24-105mm L lens, ISO 100, f/5.6 at 1/4000 second. ©R. Jackson Reed*

But more importantly, as Canon's ongoing research and development continues to refine camera features, Canon has progressively applied new and improved technologies throughout its camera lineup. As a result, photographers can rely on a consistently high level of quality as well as overall similarity of features and functionality from one Canon dSLR camera to another. And as a result, as photographers move from one camera to another, the learning curve is lower, allowing quick integration of the new camera into the system.

In addition, functionality that is common to multiple camera models is a boon for photographers who use more than one camera body. For example, Canon's Picture Style feature, a set of preprogrammed and customizable settings that set the color tone, contrast, saturation, and sharpness of images, means that photographers can set up multiple cameras to produce consistent image "looks" across all cameras. And with consistent image results, postcapture editing becomes consistently more standardized, which increases efficiency.

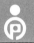
Canon's Picture Style feature had its beginnings as the Parameters feature in the EOS Digital Rebel cameras. Like Picture Styles, Parameters provided a set of preprogrammed and user-definable settings for contrast, color tone, saturation, and sharpening to achieve a look, much like different films offered different looks. Currently, the EOS Digital Rebel XT still uses Parameters, while the EOS Digital Rebel XTi (400D), the EOS 5D, the EOS 40D, the EOS 30D, and the EOS-1D Mark III and EOS-1Ds Mark III offer the newer Picture Style feature.

While the evolution of digital technology means that some newer cameras offer technologies that previous cameras could not, certain core technologies are common to all Canon dSLR cameras, as explained in the next sections.

SENSOR TECHNOLOGY

There are two primary types of digital image sensors: CCD, or charge-coupled device, and CMOS, or complementary metal-oxide semiconductor. Both are types of chip technology; Canon uses CMOS sensors in their cameras. Both types of sensors absorb light and convert it into digital information (electrons), but accomplish the task differently in terms of how and where they process the light-to-electron conversion.

Canon is one of the few camera manufacturers that use CMOS sensors and that produce and market full-frame, 35mm-size image sensors — sensors that are used in the EOS-1Ds Mark III and the EOS 5D. Canon is also one of the only companies that design and manufacturer its sensors in-house for all of its dSLRs. This marriage of the camera and sensor technology has been instrumental in making Canon the leader in dSLR technology.

Here are current advantages and limitations of each type of sensor.

■ **CCD sensors.** CCDs are the oldest image sensor technology, proven in image scanners

and other optical devices; in general, they offer low image noise but they have inherent limits. The sequential processing of electrical charges limits the speed at which CCDs can process images. Also, the voltages needed to initiate the relay of charges across the CCD require more power than CMOS sensors. This demand for more power at longer shutter speeds creates more heat and, subsequently, more digital noise in the image. In addition, CCD-based camera batteries must be larger and they require longer recharge times.

■ **CMOS sensors.** CMOS sensors work in a similar fashion to CCD sensors but use less power and can process images much more quickly due to differences in design. While the CMOS architecture offers the advantages of low power consumption and high speed, the technology has inherent disadvantages in that it produces more noise. Canon has, over the course of several years, addressed this problem with their extensive in-house technology. The result: Canon's CMOS sensors now provide both faster operation and less digital noise.

DIGIC IMAGE PROCESSOR

After image capture but prior to the recording stage, camera image processing determines how the signals from the sensor are translated into a viewable image. In Canon dSLRs, this function is performed by the DIGIC Image Processor chip.

The DIGIC II Image Processor provides quick but high-quality image processing, as well as enhanced color and white balance, and optimized camera performance — all with relatively low power requirements. Newer Canon dSLRs feature the new DIGIC III Image Processor with even better performance.

SIMULTANEOUS RAW+JPEG RECORDING

All of Canon's dSLR cameras offer the option of recording both a JPEG and a RAW image simultaneously. Simultaneous RAW+JPEG recording offers the best of both worlds — a preprocessed JPEG digital proof to quickly preview your shots, and the highest quality RAW images for those of you desiring the quality of the RAW format. This also translates into a considerable timesaver if you don't want to convert RAW images to JPEGs before posting or e-mailing them.

New to the EOS 1D Mark III, the EOS 1Ds Mark III, and the EOS 40D is the sRAW format, with the s standing for small. Instead of RAW photography always producing full-sized files that occupy lots of storage space, these smaller files are great options if you like the advantages of RAW but don't need the full resolution of a full-sized RAW file; they are about one-quarter the size.

There are of course situations where you may only need small JPEGs, such as for e-mail, the Web, or other online applications. Also you may need the extra frame rate provided when shooting just JPEGs (smaller files mean faster write time). In these cases just select which JPEG you need.

A BIT ABOUT DIFFERENT FILE TYPES If you use Photoshop or other image-editing programs, you may have noticed a number of different file types. Here are few of the more common types to consider:

JPEG/JPG. This is the most common image format. It's very compressible (meaning small file size) and universally supported in print, by image labs (sometimes exclusively), and on the Web. However, it is a *lossy* format and will lose quality when saved and resaved multiple times. It supports eight bits per color (RGB) for a 24-bit total. Supported by all Canon dSLRs.

TIFF. A high-quality, *lossless* (the image data doesn't degrade over time with multiple saves) format that is very common among graphic artists, high-end photo labs, and most applications — but very few digital cameras offer it as a direct storage format. TIFF files support Photoshop layers (a great advantage), and they have up to 16 bits per color (RGB) for a 48-bit total. TIFF files can be very large.

RAW. A camera-specific image file that is the closest possible representation of what the camera's image sensor actually perceived and recorded. You normally must store a RAW file as a TIFF or JPEG image; TIFF is usually preferable to take advantage of the 16 bits per color (RGB). RAW is supported by most Canon dSLRs.

BMP. Originally used by Microsoft Windows to manage images, it is now a less-common image format although still widely supported. BMP files tend to be quite large.

PNG. A very portable image file type, meaning it is supported by a wide variety of operating systems and computing platforms. This was the follow-on format to GIF. PNG files, in addition to JPEG files, are used widely for Web images.

PICTURE STYLES AND PARAMETERS

Canon dSLRs also offer the ability for photographers to modify image settings, including contrast, color tone, saturation, and sharpness. The controls for adjusting these settings vary by camera. On the EOS Digital Rebel XT, the settings are called Parameters.

On the EOS-1D Mark III, EOS-1Ds Mark III, EOS 5D, EOS 40D, and the EOS Digital Rebel XTi, the settings are called Picture Styles. In either case, they include a group of programmed settings that modify the look of pictures and offer the ability to modify the programmed settings as well as create user-defined settings. You can see an example of using the Portrait Picture Style in figure 2-5. Picture Styles and Parameters are discussed in more detail later in the chapter.

CUSTOM FUNCTIONS

From the outset of introducing its mainstream dSLRs, Canon provided the ability for photographers to customize camera functionality by modifying custom functions via the camera menu. This feature allows you to modify the camera to suit your needs. For example, you can change the function of the cross-keys of the EOS Digital Rebel XT or set a Custom Function on the EOS-1Ds Mark III to turn on safety shifting in Shutter- or Aperture-priority AE modes. Custom functions are a boon to all photographers, and especially to those with specific shooting preferences, such as having the ability to set autofocus (AF) point selection on the EOS-1Ds Mark III. The number of custom functions varies by camera model, ranging from 9 on the Digital Rebel XT to 57 on the EOS-1Ds Mark III. Knowing the potential complexity of the Custom Function

2-5 ABOUT THIS PHOTO
The Portrait Picture Style was applied to this image to enhance the portrait look. Taken with an EOS-1Ds Mark II, Canon 24-70mm L lens, ISO 100, f/10 at 1/125 second. ©Jim White

options, particularly on the EOS-1Ds Mark III, Canon gives you an option to set Custom Functions back to their default settings. On cameras with automatic modes, modifications to Custom Functions operate in all except Full Auto mode. Some of the more useful Custom Functions are explained later in the chapter.

LOOKING AT THE CANON DSLR LINEUP

Lining up the Canon dSLR models on a camera store counter creates an impressive array of choices. If you put the lenses of your choice on each camera body, the lineup quickly becomes a photographer's ultimate toy store. Each camera presents a unique opportunity that satisfies the shooting needs, requirements, and credit limit of one or another photographer.

This section gives you an overview of Canon's dSLRs, with insights that you're unlikely to learn while browsing at a camera store. In the last year, I've shot with each of these cameras, and I've talked to other photographers who have or are currently shooting with them.

Your priorities may include overall weight, speed, features, or a balance of all these factors against total system cost. Ultimately, you have to decide which camera to buy, but this chapter can help you evaluate the camera you currently own or are looking to buy against the lineup that Canon offers.

THE CANON EOS-1DS MARK III

The big-boy leader of Canon's dSLR lineup is the EOS-1Ds Mark III, a workhorse of a camera built to endure the rigors of the field in very rigorous and demanding applications such as outdoor assignments, but optimized for studio use with its large megapixel size and full-frame sensor.

A photographer I know of uses an EOS-1Ds Mark II, for example, which is constructed similarly to the Mark III. He accidentally dropped it on a concrete floor from standing height. Though he caught it on first bounce, and there was a small dent on the corner of the body, the camera's operation wasn't affected in the least. I certainly don't recommend dropping any camera, but it is nice to know that if it happens, you're still potentially in business!

Not only is the crash impact rating very high on the EOS-1Ds Mark III, the weather sealing is equally impressive. I recently saw a photographer shooting with this camera unprotected in a drenching rainstorm. I was shooting in the same rainstorm with the same camera and lens, but I'd judiciously covered my rig with a plastic bag made for that purpose. Sealed or not, it simply doesn't make sense to tempt fate with an expensive camera and lens. However, the EOS-1Ds Mark III is sealed around compartment doors and offers rubber grommets around all controls to provide excellent weatherproofing. The camera sports 76 environmental seal points. Add to this the rubber O-ring on Canon's L-series lenses and the camera is well suited for inclement weather shooting.

The defining characteristic of the EOS-1Ds Mark III is the full-frame, 21.10-megapixel CMOS sensor, allowing for superb detail, as shown in 2-6 and 2-7. At the time of this writing, the EOS-1Ds Mark III is the highest-resolution dSLR on the market. Built for durability that can withstand heavy use, this camera is tested to 300,000 actuations (shutter releases). The EOS-1Ds Mark III is compatible with all EF-mount Canon lenses. While not particularly built for speed and therefore probably not the first choice for sports or news photography (unlike the EOS-1D Mark III), this camera can produce incredible, large images in a wide variety of settings and applications.

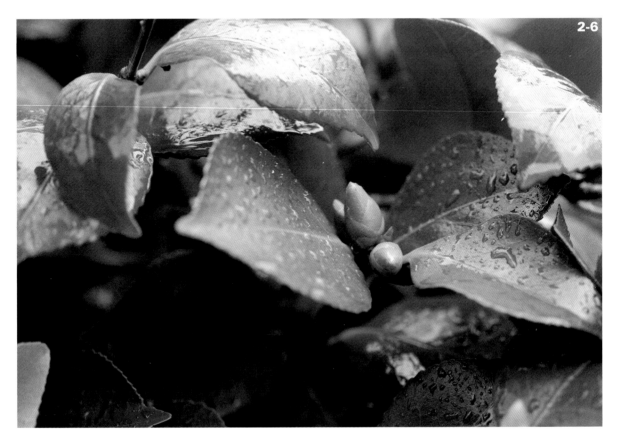

No question about it, the EOS-1Ds Mark III feels substantial and unquestionably solid. Based on the Canon EOS 1 series bodies, the EOS-1Ds Mark III with battery is heavy. Throw in a lens such as the EF 70-200mm f/2.8 L IS USM and the package gets heavier! Packing around that weight for a long shoot is not for the faint of heart. But the image quality, body quality, and the excellent in-hand balance make it worth it.

While many photographers lust after this top-of-the-line camera, the price alone is reason for a long, sober pause (the EOS-1D Mark III, by comparison, has actually been optimized to be priced for news agencies). For working photographers, the question is how quickly the camera can pay itself off and begin making a profit, and whether the resolution and camera features are justified by the work that clients need. For most photographers, it comes down to how badly they want the advanced features and whether they can afford the camera.

ABOUT THESE PHOTOS *2-7 is a detail of 2-6, which was taken with an EOS-1Ds Mark III. Seeing the cropped portion of the original attests to its great resolution. Taken with a Canon 100mm Macro lens, ISO 320, f/3.2 at 1/125 second.*
©Serge Timacheff

2-7

Here are the EOS-1Ds Mark III specifications at a glance:

- 21.10-megapixel full-frame CMOS sensor

- 5 frames-per-second (fps) continuous shooting

- Large buffer — burst of 12 RAW and 56 JPEG images

- 3-inch, high-resolution LCD with zoom and review modes

- 19 cross-type AF points/26 assist AF points

- Customizable Picture Styles

- DIGIC III Image Processor

- Dual high-performance memory card slots (CompactFlash and SD)

- ISO speed range: 100–1600; expandable to L:50 and H:3200

- Shutter durability of 300,000 cycles

- Water- and dust-resistant, magnesium alloy body

- USB and Video for complete connectivity

- WFT-E2A accessory for wireless and wired LAN compatibility

- Complete compatibility with all Canon EF lenses and Speedlite EX flashes

THE CANON EOS-1D MARK III

The EOS-1D Mark III has the same body, build quality, and most of the advanced features of the EOS-1Ds Mark III with more emphasis on speed than resolution, not to suggest this camera is in any way a substandard. On the contrary, Canon's new EOS-1D Mark III can record 10 fps for up to 110 JPEG frames in one burst—making it the standard in high-speed photography assignments

such as for sports and journalism. It has a new 10.1-megapixel CMOS sensor (with Canon's EOS Integrated Cleaning System) and a 3.0-inch LCD monitor with Canon's Live View technology, combined with the speed and intelligence of the DIGIC III Image Processor. Adding the ability to record RAW and JPEG images on different memory cards, a larger 3.0-inch LCD, Canon's Picture Style technology, and more, the EOS-1D Mark III makes for an impressive professional camera.

Here are the EOS-1D Mark III specifications at a glance:

- 10.10 megapixel CMOS APS-H sensor

- 10 fps continuous shooting

- Large buffer — burst of 30 RAW and 110 JPEG images

- 3-inch, high-resolution LCD screen with 10x zoom

- 19 cross-type AF points/26 assist AF points

- Customizable Picture Styles

- DIGIC III Image Processor

- Dual high-performance memory card slots (CompactFlash and SD)

- ISO speed range: 100–3200; expandable to L:50 and H:6400

- Shutter durability of 300,000 actuations

- Water- and dust-resistant magnesium alloy body

- USB and Video for complete connectivity

- WFT-E2A accessory for wireless and wired LAN compatibility

- Complete compatibility with all Canon EF lenses and Speedlite EX flashes

THE CANON EOS 5D

The EOS 5D (see 2-8) was an instant hit upon its release and it is no wonder, considering that it offers a full-frame CMOS sensor with 12.8 megapixels and currently sells for less than $3,000. It has become a fast favorite of many professional photographers, due to the high resolution and lighter weight of previous full-frame dSLRs. Price has also contributed to its popularity. As I mentioned previously, the overriding difference aside from higher resolution is the build quality. The Mark III is designed to withstand abuse and inclement weather extremes, while the 5D is not. If your primary use will be under normal everyday conditions, the lower price and lighter weight are a plus — for example, my wife, who is a portrait/commercial photographer, uses the camera especially because it weighs so little in comparison to the EOS-1D series. As with the EOS-1Ds Mark III camera, you are looking at an extremely high-resolution camera, so lens quality is paramount for optimum results.

The 5D is what some consider the ideal camera. It is lightweight, offers high resolution, and, like all the Canon dSLRs, the menu, controls, and dials are intuitive and easy to master. Many professionals prefer its smaller profile particularly for candid or street photography. Unlike the Mark III, this camera doesn't scream "professional," which can quickly rule out candid people shots. This isn't to suggest in any way that this camera's construction is subpar, as the magnesium alloy body makes it a sturdy performer.

ABOUT THIS PHOTO
The 5D has become one of Canon's most popular dSLRs as it appeals to advanced amateurs as well as professionals.
©Serge Timacheff

2-8

The 5D is a sturdy dSLR that uses all of Canon's EF lenses to their fullest potential. The full-frame high-resolution CMOS sensor, combined with Canon's DIGIC II Image Processor, a high-precision 9-point AF system with six assist points, and Picture Style color control, delivers images of superior quality with enough resolution for almost any application. With its wide-angle capabilities, 2.5-inch LCD and magnesium-alloy body, the 5D is a great addition to the digital EOS lineup.

Here are the EOS 5D specifications at a glance:

- 12.8-megapixel, full-frame CMOS sensor

- 3 fps continuous shooting

- Buffer/maximum burst of 60 large JPEG images, 17 RAW

- 2.5-inch, high-resolution LCD screen

- High-precision, 9-point wide-area AF

- Customizable Picture Styles

- DIGIC II Image Processor

- ISO range: 100–1600; expandable to L:50 and H: 3200

- Shutter durability of 100,000 cycles

- Magnesium alloy body and stainless steel chassis

- USB 2.0 Hi-Speed and Video Out interface

- Compatible with all Canon EF lenses and Speedlite EX flashes

- Supports wireless file transmitter WFT-E1A

THE CANON EOS 40D

The EOS 40D is the successor to the 30D, which was the successor to the hugely popular EOS 20D, and is without question one of the most popular dSLRs of all time. The 20D is responsible for many of the recent converts to the Canon system. The 40D features Canon's proven 10.1.-megapixel CMOS sensor with a 1.6x conversion factor, combined with the speed and intelligence of the DIGIC III Image Processor. With the 40D, several more professional features were added, including a magnesium body, a heavy-duty shutter rated for 100,000 plus actuations, true spot metering, and the incorporation of the Picture Styles technology.

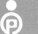 *note* If an image sensor is full-frame, it is the equivalent to a 35mm frame of film that uses 100 percent of a lens's potential. Most sensors, however, are smaller than full-frame, so a conversion factor indicates how this affects the smaller area the lens is taking in. For example, if you use a 50mm lens on a camera with an image sensor with a 1.6 conversion factor, it would act like an 80mm lens in terms of its full angle of view and the amount of focal width you have in your photograph (1.6 x 50mm = 80mm).

The camera controls and the menu are intuitive and easy to use. Even for those who have never used a dSLR, this camera will make you a fast learner. It's a snap to change modes, ISO, white balance, and so on; and the large, bright three-inch LCD makes menu choices and image review a pleasure. The 40D is lightweight compared to many dSLRs but still maintains good build quality with its magnesium construction. Although the camera isn't marketed as being weatherproof, it

does have upgraded weather and dust seals. I have been caught by a fast-moving thunderstorm on a bald mountaintop, and although the camera did get wet, it was no worse for wear. I dried it off and kept on shooting.

The 40D accepts the complete line of Canon EF mount lenses, as well as the EF-S mount lenses designed for non-full-frame Canon digital cameras. The 40D also sports user-selectable high-speed or low-speed continuous shooting at 6.5 fps or 3 fps with a fast 0.15-second startup time.

Here are the EOS 40D specifications at a glance:

- 10.1-megapixel CMOS APS-C sensor
- 6.5 fps continuous shooting
- Buffer/maximum burst of 75 large JPEG images, 17 RAW
- 3-inch, high-resolution LCD screen
- High-precision, 9-point wide-area AF
- Customizable Picture Styles
- DIGIC III Image Processor
- ISO range: 100–1600; expandable to 3200
- Shutter durability of 100,000 actuations
- Magnesium alloy body
- USB 2.0 Hi-Speed and Video Out interface
- Compatible with all Canon EF and EF-S lenses, Speedlite EX flashes
- Supports wireless file transmitter WFT-E3A

note Outside the USA, Canon sometimes uses different model numbers for the same camera. The Rebel XTi is the EOS 400D in some countries. The XSi is the 450D.

THE CANON EOS REBEL XSI

Just announced as this book was going to press, the EOS Rebel XSi does to the Digital Rebel XTi what the XTi did to the XT: It takes a great camera even one step further towards perhaps being the perfect consumer dSLR, capable of producing astounding near-professional results. With 12.2 megapixel capability, a DIGIC III Image Processor, a three-inch LCD screen, and a huge buffer (up to 53 large JPEGs) for this consumer-class of camera, it offers today what very few *professional* cameras were able to offer only a few years ago.

Here are the EOS Rebel XSi specifications at a glance:

- 12.2-megapixel CMOS sensor
- 3.5 fps continuous shooting
- Buffer/maximum burst of 53 large JPEG images
- 3-inch high-resolution LCD screen
- High-precision, 9-point wide-area AF with selectable autofocus tracking modes
- Supports SD and SDHC memory cards
- Customizable Picture Styles
- DIGIC III Image Processor
- ISO range: 100–1600
- Compact and lightweight body
- USB 2.0 Hi-Speed and Video Out interface
- Compatible with all Canon EF and EF-S lenses and Speedlite EX flashes

THE CANON EOS DIGITAL REBEL XTI

The EOS Digital Rebel XTi takes the XT one step further with a great lineup of features designed and priced as a very competitive consumer dSLR. In this case, bigger is better: The sensor is bigger (10.1 megapixels) and the LCD is now 2.5 inches — both great changes that make an already easy-to-use camera even easier. Add to that support for Picture Styles, compatibility with Canon's vast selection of lenses, and a self-cleaning sensor, and you've got a camera capable of producing near-professional results in just about anyone's hands. Plus, you can get the lightweight, ergonomic dSLR in black or silver — a choice you don't have in higher-end dSLRs.

Here are the EOS Digital Rebel XTi specifications at a glance:

- 10.1-megapixel CMOS sensor
- 3 fps continuous shooting
- Buffer/maximum burst of 27 large JPEG images, 10 RAW
- 2.5-inch, high-resolution LCD screen
- High-precision, 9-point wide-area AF with selectable autofocus tracking modes
- Customizable Picture Styles
- DIGIC II Image Processor
- ISO range: 100–1600
- Compact and lightweight body
- USB 2.0 Hi-Speed and Video Out interface
- Compatible with all Canon EF and EF-S lenses, and Speedlite EX flashes

THE CANON EOS DIGITAL REBEL XT

For ease of use combined with great dSLR performance, as an entry-level dSLR you need look no further than the EOS Digital Rebel XT. It's available for a remarkably low cost — in fact, less than some high-end point-and-shoots — and yet makes use of the incredible selection of Canon lenses and accessories. As you increase your photography skills, you'll keep your lenses and accessories and simply upgrade camera bodies. Featuring Canon's 8-megapixel CMOS sensor, and Canon's own DIGIC II Image Processor, the Digital Rebel XT has a lightweight and compact body, as well as updated firmware and features over its predecessor, the EOS Digital Rebel.

Here are the EOS Digital Rebel XT specifications at a glance:

- 8.0-megapixel CMOS sensor
- 3 fps continuous shooting
- Buffer/maximum burst of 14 large JPEG shots
- 1.8-inch, high-resolution LCD screen
- High-precision, 7-point AF
- Customizable Picture Styles
- DIGIC II Image Processor
- ISO range: 100–1600
- Compact and lightweight body
- USB 2.0 Hi-Speed and Video Out interface
- Compatible with all Canon EF and EF-S lenses, and Speedlite EX flashes

EXPLORING DIFFERENT IMAGE SENSOR SIZES

In the world of digital imaging, you constantly hear or read the term "full-frame sensor." What exactly does this mean and what are the advantages and disadvantages?

A full-frame sensor is designed to capture the full size of the film frame. In the case of Canon, this is 36×24 mm, or the full size of the 35mm film format. The chief reason that all dSLR sensors are not full frame has to do with the cost of manufacturing the larger sensors combined with the physical size of the camera body and its ability to accommodate a chip that large. As chip sizes get larger, the yield gets drastically lower and, subsequently, the price increases. The semiconductor industry's advances in affordability have been driven by the ability to make circuits smaller and smaller, but an imaging chip must remain large, and such large chips get cheaper much more slowly. Owning its own chip-making facility has made Canon a leader in full-frame sensor technology.

Consider several of the more popular sensor sizes and the cameras that use them:

- **APS-C sensor.** This is named for the now-all-but-defunct film format introduced and popularized by Kodak. This is the sensor size used in the Canon EOS Digital Rebels, the EOS 30D, and the EOS 40D. This smaller size results in what is known as a *crop factor*. In the case of Canon, this is 1.6x, meaning a 100mm lens now has the effective focal length of 160mm, a 200mm lens has the effective focal length of 320mm, and so forth.

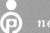 *note* APS stands for Advanced Photo System, which is a film format size standard developed primarily by Kodak but cooperatively with Nikon, Canon, Fuji, Minolta, and other camera manufacturers. It was introduced in 1996, and used primarily for point-and-shoot cameras. The standard relates to film frame dimensions, and has been carried over to digital image sensors. There are three categories, including APS-C (the classic, with an aspect ratio that relates to a 4×6 print), APS-P (the panoramic, with an aspect ratio that relates to a 4×12 print), and APS-H (the high-definition, a larger sensor/film size that relates to a 4×7 size). Kodak's APS products are sold under the Advantix brand.

As you have probably already surmised, this is an advantage for those wanting more of a telephoto effect but a big disadvantage to those needing a wide-angle lens.

- **APS-H sensor.** This sensor is slightly larger than the APS-C sensor but is not quite full-frame. This sensor has a 1.3x crop factor so the telephoto effect is less pronounced. This sensor is used in the EOS-1D Mark III.

- **Full-frame sensor.** As the name implies, this sensor is the full size of 35mm film and consequently there is no crop factor. This lack of a magnification factor is considered an advantage by many: Your lens "is what it is," meaning a 100mm lens is a 100mm lens. This sensor is used in the EOS 5D and the EOS-1Ds Mark III.

Just how much difference does sensor size make? There's a great deal of attention paid to pixel count in the world of digital cameras. Cameras are often categorized by the number of pixels they have in their image sensor. However, as mentioned

earlier in this chapter, not all pixels are equal, and size does matter. From Canon you get a pretty good explanation of why. A large CMOS sensor offers better image quality than a smaller one because the larger sensor contains bigger-sized pixels. The relationship between image quality and pixel size can be readily understood if you imagine the pixel as a kind of bucket used to collect not water but light. This micron-sized bucket not only gathers light but also has a photodiode that produces a voltage when photons (light) strike it. A regular bucket with a larger opening can collect more water in a shorter time than a smaller one. This is similar to the larger CMOS sensor compared to the smaller one: The large one gathers more light in a shorter time and therefore can respond more sensitively.

For your purposes, it helps to know that larger pixels enlarge better, called *upsizing*. You can increase the size of a photograph with bigger pixels through interpolation and get a much smoother image with noticeably less noise.

CROP FACTOR

If you were to put the same lens onto different camera bodies with different image sensor sizes — full-frame and smaller—you would notice that what you see through the viewfinder is a smaller physical area in the cameras with the smaller sensors, as seen in 2-9 and 2-10.

The term *crop factor* refers to the fact that the imaging area is physically smaller. Less of the image circle projected by the lens is used; therefore, it is in effect cropped. The image remains the same size at the film plane for a given lens and subject distance — it is in no way "magnified." This is also why a telephoto lens appears so much more powerful — the field or angle of view has

been reduced. This is great for nature and sports photographers, as the net result is more-apparent telescopic magnification with no tradeoff of maximum f-stop loss. The opposite is, true, however for wide-angle shots, because there is a lessening of wide-angle viewing.

WHAT DIFFERENCE DOES FRAME RATE MAKE?

The *frame rate* of a camera is the speed at which images can be continuously recorded and saved. Frame rate is governed by several factors, including the resolution (number of pixels), the buffer size, the speed of the image processor, and the write speed of your memory card. Obviously, higher-resolution cameras such as the 5D and the 1Ds Mark III have more information to transfer, which takes more time. The buffer size in a digital camera is basically the amount of memory or storage the camera has available, which temporarily stores images until they can be written to the memory card. In turn, this dictates how many images you can take in rapid succession. Once the buffer is full, you are out of the picture-taking business until some images can be written to the storage device, in this case your memory card. As the buffer frees up space by downloading to the card, the camera is able to shoot photos to the capacity of that space. Normally it takes several seconds for the buffer to completely clear, depending upon how large it is, how large the images are, and how fast the camera processes the images.

Obviously frame rate is more of an issue for sports, news, and action shooters than it is for landscape photographers. How important it is to you as a photographer once again comes down to your particular style of photography.

ABOUT THESE PHOTOS *These two images were taken from the same position with exactly the same lens and focal length, but on two different cameras: the Canon 5D and the Canon EOS-1D Mark IIn. While the Mark IIn is a higher-end professional camera, it does not have a full-frame sensor; the 5D does. Note how the full-frame image in 2-9, taken by the 5D, takes in more of the scene. Both shot with a Canon 100mm Macro lens, ISO 250, f/7.1 at 1/100 second. ©Serge Timacheff*

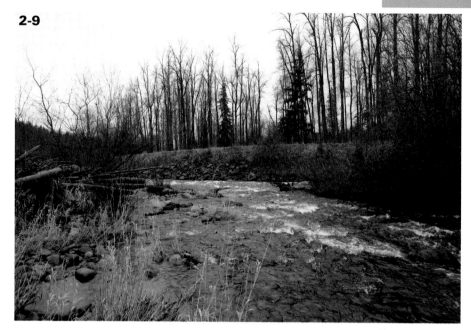

2-9

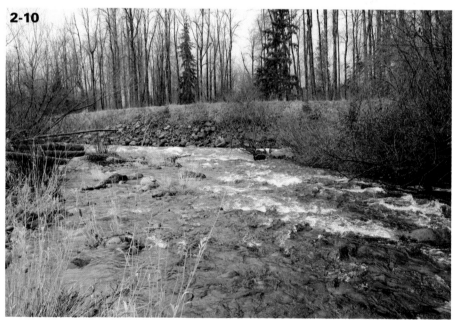

2-10

SHUTTER LAG: A THING OF THE PAST With the release of the first generation of digital cameras came the bane of all photographers, from point-and-shoot amateurs to seasoned professionals — shutter lag. The first dSLRs had a significant delay between pressing the shutter release button and taking the picture, and this is still an annoying characteristic of many point-and-shoot models. Combined with a limited buffer size, it was easy to see why many fast-shooting photographers chose to wait to convert to digital until the technology was sufficiently able to effectively eliminate the shutter-lag effect.

I well remember at birthday parties and holidays the frustration of trying to anticipate the release of the shutter at the proper time. Sometimes I would get it right, but most times not, and waiting for the camera was annoying at best and caused me to lose the moment at worst. Fortunately technology has all but erased that problem, so now "what you see" when you press the shutter is very close to "what you get." Today's digital cameras have more efficient image sensors, faster image processing, larger built-in memory (buffers), and faster write speeds.

GETTING THE MOST FROM YOUR CANON DSLR

At this point you may be asking yourself, "What settings should I use with my camera?" In addition to your settings for exposure and composition, your Canon dSLR image will look best when you take full advantage of your camera's color, image size/resolution, Picture Style, and custom function settings. These can make all the difference in producing great images more easily, but you need to spend some time understanding what they do and why they're important.

COLOR SPACE SETTING

Which color space setting to use is a frequently asked question, and for good reason. The manual usually contains little or no guidance or tutorial covering this topic, only the name of the color spaces and how to set them. Think of color space as all the colors that can be represented in a given image, or all the shades of red, green, and blue that your camera can capture and reproduce. Color space options on Canon's dSLRs enable you to maintain a consistent color workflow from capture through printing. Color management is important because the choice of color space, or gamut, defines the range of colors that can be reproduced in your images. And, as you might suspect, having more colors is preferable to having fewer colors, especially when it comes to printing images.

Canon dSLRs offer two color space options:

- **sRGB.** Used extensively on the Web and designed especially for image display on personal computers, the sRGB color space appears brighter and more saturated. As Web browsers and e-mail programs are optimized to display images in the sRGB colorspace, it is a better choice for images displayed on the Internet or delivered via e-mail.

■ **Adobe RGB.** The Adobe RGB color space supports a wider range of colors, but the colors often appear a bit more subdued and less saturated. This color space is optimized for inkjet and commercial printing.

SETTING THE RESOLUTION

The resolution you choose is directly related to your intended use of the images you take. If destined for print, I always shoot in RAW or use the highest JPEG resolution my camera offers. To my way of thinking, I can always reduce the size of a high-resolution image, but if I am shooting low res and happen to get a great shot, I'm limited in what I can print. If, however, you are shooting a series of product shots for eBay, or real estate for the MLS (multiple listing service) Web site, it is definitely overkill to capture and deal with large files that will have to be significantly downsized anyway.

RAW VERSUS JPEG?

What's so great about RAW? Why shouldn't I shoot everything in JPEG — isn't it easier to work with? These are the most common questions asked about the two primary options you have for file recording in your camera. Of course, there are more decisions to make, such as JPEG file sizes, what application you should use to process your files, and whether or not the image you're taking is destined as a large, super-high-quality gallery enlargement. First, you need to understand the difference between JPEG and RAW.

■ **JPEG.** A JPEG image is processed, or edited, inside the camera; images are converted to 8-bit images, and then are compressed to save space on the memory card. During the internal camera processing, critical image parameters are set, including the black and white points in the image, overall contrast, white balance, color saturation, and sharpening. If you are using Picture Styles in your images, these are applied in the camera. While you can edit JPEG images in an editing program, the latitude to modify contrast, saturation, and color is significantly less than with a RAW image file.

■ **RAW.** RAW files can produce better high resolution images with wider tonal range than a JPEG; however, for many applications the differences are not so significant that a client, or even a professional photographer, can tell the difference. RAW files end up as 16-bit files, while JPEG files are 8-bit files. An 8-bit file contains 256 shades of red, green, and blue, while a 16-bit file contains more than 32,000 shades of each color.

This means that while a JPEG file can support more than 16 million colors per pixel (red × green × blue, or $256 \times 256 \times 256$), a 16-bit file supports exponentially more ($65,536 \times 65,536 \times 65,536$, or more than 280 trillion colors per pixel!).

So you can readily see that the 16-bit file will have much better color gradation and finer detail, particularly in the shadow and highlight areas. Further, the conversion from 16 bits to 8 bits discards image data in an effort to pack more images on a memory card while the compression introduces artifacts that degrade the overall image quality.

The best thing about RAW images is that the data they contain from the sensor have a minimum of internal camera processing and no

RGB The RGB color model refers to red, green, and blue colors produced by light sources and combined in various ways to reproduce other colors. For print purposes (meaning sending your photos to a lab for printing), pigment primary colors are defined by CMYK, or cyan, magenta, yellow, and black (K). RGB images can be converted to CMYK for print purposes in application such as Adobe Photoshop. If you're printing images yourself on an inkjet printer, you don't need to convert to CMYK, however, because their print engines are designed to accept RGB images.

At a basic level, if you're sending your photos out for printing at a lab, you want to establish a color profile that consistently applies to your images — and that maintains that consistency at the lab. Many labs can provide you with color profiles that you can install in your image-editing application.

Many photographers whose photos may end up on the Web or in print simply select and stay in one RGB mode, and then convert it if necessary once the images are downloaded. If you're shooting in RAW mode, it won't matter because no specific color space is used — the image is precisely what your camera sees.

You'll probably want to use the same color space, optimally the color space that supports the widest range of colors, throughout your workflow — from capture through editing and printing. As a result, I think Adobe RGB is the best choice for high-quality images featuring full, rich reproducible colors. Of course, for online images, you can convert a copy of the images to sRGB during the image-editing process.

loss of data or introduction of artifacts from file compression. As a result, RAW conversion offers unprecedented control over image data, including corrections to image brightness, white balance, contrast, and saturation — all of which can be modified after the image is captured. In addition, you can often recover over- or underexposed images with the control RAW processing affords. RAW capture is really the single best way to preserve all the information inherent in the image while maximizing the way in which this information is interpreted.

The most difficult factors about RAW files are that they are physically large, they require camera-specific support in any application you use with them, and they require more processing than a JPEG file.

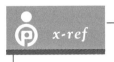 *x-ref* Also see Chapter 9 for more information on working with the various image file formats.

This isn't to say there is no place for the JPEG file; it definitely has its own set of advantages. The smaller file size means less storage, a faster write time, and a faster frame rate. This is an obvious advantage to those interested in a needed combination of speed and a large number of images — essential at a championship soccer game, for example. The last thing you need is to have the camera stall while your daughter is scoring the winning goal! Because of the smaller file size, JPEGs cut way down on post-processing time (time spent editing at your computer). As I mentioned earlier, if your images are destined for Web use, or if outside agencies request that format, then JPEG is the way to go. Consult Table 2-2 for print sizes you can obtain from each file format; this is a general guideline based on the EOS-1D Mark III; pixel dimensions for files will vary from camera to camera, so they are not listed. Now, also, the 1D Mark III, 1Ds Mark III, and 40D support sRAW, which is a smaller RAW-format file size. Some cameras, such as the 5D and the Rebel series, also support Large/Normal and Small/Normal as well as Large/Fine and Small/Fine sizes.

Table 2-2

Image-Recording Quality Settings

Image-Recording Quality	Image Type	Print Size (at 300dpi)
L (Large/Fine)	JPEG (.JPG)	11 × 17 or larger
L (Large/Normal)		
M (Medium/Fine)		11 × 17 or smaller
M (Medium/Normal)		
S (Small/Fine)		8 × 10 or smaller
S (Small/Normal)		
RAW (Raw)	RAW (.CR2)	11 × 17 or larger
sRAW (sRAW)	sRAW (.CR2)	5 × 7 or smaller

47

CUSTOM FUNCTIONS

With the Custom Function feature you can customize your camera for a personalized style of shooting, or for a particular type of shooting situation. Not every Custom Function is covered here, but rather those the camera models have in common and which might prove most useful to you. Consult your camera's manual for the specific functions and how to use and apply them.

- **Long-exposure noise reduction.** This definitely reduces digital noise in time exposures (anything 10 seconds or longer). The tradeoff is that processing time is slowed, but most of the time this type of photography doesn't demand the faster frame rate.

- **Shutter button/AE Lock button.** This allows you to interchange the camera's method of exposure and focusing. It can be quite helpful to have autofocus and the camera's metering system working as separate units. For example, you may want to meter for a sunset and then recompose focusing on infinity without the desired exposure values changing. Or you may want to stop the AF from functioning so some object passing between the subject and camera has no effect, which is why a majority of sports and action photographers, myself included, use this function. It is also known as back-focusing or thumb-focusing (because you use your thumb to focus).

- **Exposure-level increments.** This allows you to choose either 1/3 or 1/2 stop increments for shutter speed, aperture setting, or exposure compensation.

- **ISO expansion.** This allows you to expand the ISO range from as low as ISO 50 to as high as ISO 6400 depending on the camera model.

- **Auto-Bracketing Sequence.** Here you can change the bracketing sequence used with shutter speed, aperture, and even White Balance.

- **Mirror lockup.** This is useful for macro photography, long exposures, slow shutter speeds, or when using larger, heavier lenses. The mirror is "locked" into position with the first press of the shutter release and then the shutter is fired with the second release. This minimizes movement and the vibration from the mirror movement inherent in all dSLRs.

SETTING PICTURE STYLES OR PARAMETERS

Parameters and Picture Styles allow you to set certain guidelines for how your images are processed by the camera. You can select from numerous styles or looks, depending on the effect you are after. For example, on the EOS Digital Rebel XT, Parameters are available in automatic shooting modes, and they include two preset parameters for either standard color and sharpness or more subdued color, a Black and White (B/W) parameter, and three user-definable sets of parameters. On newer cameras, Picture Styles replace Parameters. Picture Styles include:

- **Standard.** This is the default Picture Style. Images are rendered with vivid color and good sharpness with higher contrast and saturation.

- **Portrait.** This setting produces enhanced skin tones for babies, children, and women; a soft texture; and lower sharpness. You can adjust the red-to-yellow color range using the Color Tone parameter under the Detail settings for this Picture Style to tweak skin color.

- **Landscape.** This setting renders images with vivid blues and greens, higher sharpness, contrast, and saturation.

- **Neutral.** This setting creates images with natural but subdued color with low saturation, contrast, and sharpness. This style allows photographers ample latitude to set their preferred levels of saturation and contrast during image editing.

- **Faithful.** This setting creates images that are colorimetrically adjusted to match standard daylight. Like the Neutral style, Faithful renders images with low contrast and saturation and allows good latitude for editing to the photographer's preferences.

- **Monochrome.** This setting creates images that are black and white or toned with slightly high sharpness, higher contrast, and low saturation. To control rendering of specific colors in black-and-white images, you can apply a yellow, orange, red, and green filter for pictures taken using the Monochrome style.

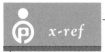

x-ref See Chapter 9 for more information about Canon Picture Styles.

An advantage of Parameters and Picture Styles is you can standardize image looks across multiple cameras, or when you purchase a new camera, you can replicate the look that you got on your previous camera.

tip A conversion table is available on the Canon Web site at www.canon.co.jp/imaging/picturestyle/qa/index.html#q4.

If you capture RAW images, you can apply a Picture Style during the image conversion in Canon's Digital Photo Professional program. And you can apply Picture Style to RAW images shot with earlier dSLRs such as the EOS 10D, D60, D30; the EOS 20D, 30D; and the original EOS Digital Rebel.

You can download additional Picture Styles from Canon's Web site, and then install them on the EOS-1D Mark III , EOS-1Ds Mark II, EOS 5D, EOS 40D, EOS 30D, and the EOS Digital Rebel XTi cameras that support Picture Style. With the style installed on the camera, you can then also install and use the supplementary styles in Digital Photo Professional version 2.2 or later. At the time of this writing, additional Picture Style files are offered the Canon Web site: Nostalgia for muted color, Clear for dramatic night skies, Twilight to transform normal blue skies to purple hues, Emerald to render clear blue water in vivid emerald colors, Studio Portrait for applying more delicate tonality and translucent skin tones, Snapshot Portrait for achieving good portrait/skin and contrast results both outdoors and indoors, Reference Portrait for radiant and translucent skin tones especially outdoors, and Autumn Hues for natural but vibrant earth tones and colors.

note You can visit the Canon Web site for instructions on downloading the supplementary Picture Style files at www.canon.co.jp/imaging/picturestyle/index.html.

USING MIRROR LOCKUP FOR PERFECT IMAGES

One problem that affects all dSLR cameras is the mechanical action of the mirror as it is raised and lowered to allow light to pass from the lens to the image sensor. The physical motion of the mirror, in some sensitive situations, is enough to cause the camera to move ever so slightly, but that movement is sufficient to cause some blurring of the image. While your camera contains some motion-baffling elements to act as shock-absorbers while this is happening, occasionally you may want to eliminate the mirror movement altogether. The images at greatest risk for this occurring are ones that involve a longer exposure with a long lens.

To get truly blur-free images, start by using a tripod, your camera's mirror-lockup feature, and a Canon remote shutter release. The mirror-lockup feature is a Custom Function, which you must set using the Custom Function menu. On the 1D Mark III, there is also a new option that allows you to keep the mirror locked up for multiple shots.

Using the mirror-lockup function, you need to press the shutter release on your remote control twice to take the photo: once to raise the mirror and a second time to expose the image. You can also use the mirror-lockup feature with the self-timer, but this can be a little tricky so be careful! Using mirror lockup, the photo is taken while the camera is perfectly still, so there is absolutely no vibration or motion, assuming your tripod is stable. Obviously, a stiff breeze might be an issue.

Assignment

Parameters and Picture Styles

Parameters and Picture Styles give you the ability to customize your images for a particular look or feel you are after in your work. While you can certainly shoot a photo in color and then convert it to black and white or sepia later in your digital studio, which provides a lot of flexibility, sometimes actually *shooting* in that mode has an effect on how you compose and think about your images as you're taking them. For example, try shooting an image in black and white and then the same image in color. Or, try the sepia tone effect. Choose the Picture Style or Parameter whose effect you like the best and post and image using that style and briefly explain your preference.

Here you see a landscape image from Great Smoky Mountains National Park with the Landscape Picture Style applied. This Picture Style emphasizes overall color *balance* throughout the image, instead of color *correction*. Notice how the image's contrast, color tone (hue), and color density (saturation) are well balanced between the road, trees, vegetation, and sky. Taken with an EOS-1Ds Mark II, EF 70-200mm f/2.8L lens, ISO 400, 1/3 second at f/32.

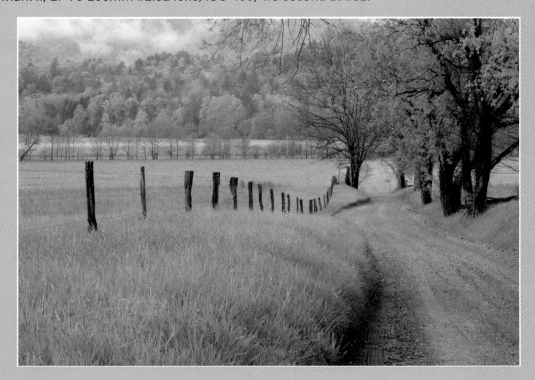

©Jim White

Remember to visit www.pwassignments.com when you complete this assignment and share your favorite photo! It's a community of enthusiastic photographers and a great place to view what other readers have created. You can also post comments and read other encouraging suggestions and feedback.

©Michael A. Johnson

You have already seen several references in this book regarding the importance of good-quality optics with high-resolution Canon dSLR cameras. It stands to reason that the more sensitive your capture device is, the more important it is to have top-quality lenses to deliver information to that device. I have seen more than one student purchase one of the higher-end Canon cameras and then a lesser-quality lens because of a shortage of funds. A Digital Rebel XTi with a top-notch Canon L-series lens, as shown in 3-1, produces a notably better image than a Mark III with a cheap aftermarket lens. There's a reason lenses are the backbone of your camera system.

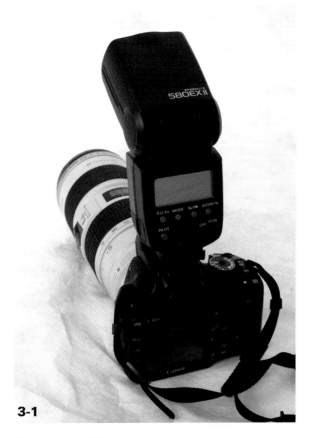

3-1

ABOUT THIS PHOTO *This Digital Rebel XTi with the Canon 70-200mm f/2.8 IS L lens and Speedlite 580EX II delivers professional-quality results. ©Serge Timacheff*

BUILDING THE BACKBONE OF YOUR SYSTEM

You should treat your camera system as you would a good-quality audio system: Purchase great speakers and work back toward the amplifier. As you upgrade other equipment, the system will continue to get better; if you start with inferior-quality speakers, the other components don't matter as much. Consider lenses in the same manner: Concentrate on getting good glass before you purchase a top-of-the-line digital SLR camera.

Lenses range in focal length from fisheye to super-telephoto and are usually grouped into three main categories: wide angle, normal, and telephoto. There are also lenses classified as macro, although these lenses can also serve as a telephoto or normal lens depending on focal length, as 3-2 demonstrates.

To build a really good system, you need to have at least one of each of these lenses in your bag at all times. You may have already decided you don't need a telephoto or a wide-angle lens, but the fact is you do if you plan to have a solid, well-balanced camera system.

 x-ref See Chapter 6 for a more detailed comparison of various types of lenses.

A good set of lenses is something that's dynamic: You may be changing and adding to it over time as new lenses are introduced, the type of photography you do changes, and so on. But most photographers will agree that no matter how great your camera body is, the images you take will only be as good as the lenses you use with them. So determining what lenses are right for you, and then buying the best quality you can afford, will always pay off in the long run, in my opinion.

ABOUT THIS PHOTO
The EF 100 f/2.8 Macro lens can also be used in a normal or telephoto range. Taken with a Digital Rebel XTi, 1/250 second at f/8. ©Serge Timacheff

3-2

LEARNING THE BASICS OF LENSES

Camera lenses cost from less than $100 to as much as $6,000 or more. Yet they all basically do the same job: create an image on the digital sensor. As a rule, however, better-quality lenses, such as the 70-200mm f/2.8L used to take the photo shown in 3-3, are more likely to produce higher-quality results. I love the texture and small features of the wall captured so well by this lens. They are only really visible close-up, such as the small plant growing out of it. The graffiti, however, is a bit of an optical illusion, and is best seen by not looking too closely to get the 3-D effect of the face.

For many of you, your experience with lenses may be limited to film or digital cameras with fixed lenses, so the following sections explore some of the characteristics of photographic lenses. This will enable you to better understand how lenses work and which ones might be right for your style of photography.

FOCAL LENGTH AND ANGLE OF VIEW

Usually expressed in millimeters, the *focal length* of a lens is the distance from its optical center to the image plane (digital sensor), where theoretically it produces the sharpest image. The *angle of view* of a lens is how much of the scene, side to side and top to bottom, the lens includes in the image. The angle of view of a lens is determined by the size of the film or sensor and the focal length of the lens. So it stands to reason that for a lens projecting a photographic image, the size of the film format or image sensor determines the angle of view for a particular focal-length lens. This is why the angle of view of the same focal-length lens changes as sensor size gets larger or smaller, thus determining the crop factor (called *lens focal length conversion factor* by Canon) of your APS-size sensor.

The focal length of a lens is probably the major determining factor in deciding which lens to

purchase. One key point is to understand the differing focal lengths and how this will affect the depth of field (DOF) and perspective, in turn controlling the perceived image.

The focal length is an easy way of referring to the angle of view of a lens. The angle of view is denoted in degrees (as in a 360° circle), while the

focal length is in millimeters. The relationship between these two numbers is an inverse one: the smaller the focal length in millimeters, the larger the angle of view. An easy way to grasp the concept is to imagine yourself standing in the middle of a 360° circle and the angle of view of a lens as a slice of a pie. Lenses are usually referred to in terms that express their angle of view as listed:

- **Fisheye lenses.** A specific type of wide-angle lens, which covers up to a 180° (or even wider in special cases) angle of view, often with significant distortion.

- **Wide-angle lenses.** These lenses generally cover between 100° and 60°.

- **Normal, or standard, lenses.** These lenses generally cover between 50° and 25°.

- **Telephoto lenses.** These lenses generally cover between 18° and 10°.

- **Super telephoto lenses.** These lenses generally cover from 8° to less than 1°.

Wider-angle lenses allow you to see more in your angle of view while allowing greater DOF between the viewer and the subject. Fisheye lenses have the most distortion, especially at the outer edges of the image.

PERSPECTIVE AND DEPTH OF FIELD

In photography, *perspective* is the way in which an object appears to the camera, based on its size and the position of the camera relative to the object. As objects become more distant, they appear smaller. For example, the Sun and Moon appear to be roughly the same size to our eye because the Sun, although much larger, is much farther away. The relationship between distance and apparent height of objects is not linear. If an object actually touches the eye, thus is no distance away, it appears infinitely tall. You can also think of the way railroad tracks appear to converge as they approach the horizon. Different lenses show the world with different perspectives, depending on whether they are magnifying distance, compressing a wide area onto a smaller one, or simply giving a clear, natural representation of

FIXED OR PRIME? No, it's not about your mortgage! This is an important consideration you'll want to make about whether to use a fixed-focal length (prime) or a zoom (variable focal length) lens. This has been an ongoing debate among photographers for years. Many relish the versatility zoom lenses offer, as it is like having several lenses rolled into one. I know wedding photographers that shoot entire weddings using one or two zoom lenses with great results. They like the ability to concentrate on the event without changing lenses and risking losing a great shot in the process. I also know purists who only shoot with prime lenses, as they insist the quality is better.

There was a time when this was indeed a valid argument. In the not too distant past there was a discernable difference in image quality when one compared images from a zoom and a prime lens. Today's professional zoom lenses, however, are another story. Modern zoom lenses offer optical quality in many cases almost equal, if not equal, to prime lenses. Often the difference is only noticeable upon close inspection. A more important factor here is that the relationship between price and image quality is in no way linear. If you compare the price of one zoom Canon L lens to the cost of three prime L lenses, it becomes apparent that you really pay for any extra edge the prime lenses offer. If you have the budget, then it may be worth it to you, but be sure to purchase a pack mule as well to carry your equipment!

a subject. And whether they're magnifying or expanding, they will behave differently with different optical effects and distortion.

Perhaps the the most important consideration of how a lens will represent a subject is *depth of field* (DOF). The depth of field is the distance in front of and beyond the subject that appears to be in focus. There is only one distance at which a subject is precisely in focus, and focus falls off gradually on either side of that distance, but there is a region in which the blurring is imperceptible under normal viewing conditions.

Essentially, DOF literally refers to the area of a photograph that appears in focus. As you can see in 3-4 and 3-5, an image with a deep DOF has very few areas out of focus, while an image with a shallow DOF has areas out of focus in front of and behind the subject. As a photographer you can control this, and a good photographer knows how to use DOF to control the perception of an image.

The two elements that control depth of field are aperture setting and lens focal length. The wider the aperture (the lower the f/number) the more shallow the depth of field, the narrower the aperture (higher f/number) the deeper the depth of field. Longer lenses magnify the subject more while compressing distance and having a deeper DOF. Zoom lenses are different and a special case because the focal length, and hence the angle of view, of the lens can be altered mechanically without removing the lens from the camera.

F/NUMBER

For a given subject framing, the depth-of-field is controlled by the aperture diameter, the measurement of which is identified by the lens f/number. Each f/number represents one stop. Increasing the f/number (reducing the aperture diameter) increases the DOF, while decreasing the f/number (increasing the aperture size) reduces DOF.

WHAT'S A STOP? In photography, a *stop* refers to a unit of measurement for how your image is exposed, and how much light is being allowed to reflect onto your image sensor. You might have heard of an f-stop, which refers to your aperture setting and has specific numerical values on your camera for the different settings. Stop numbers increase or decrease by a factor of two (1/2) depending on whether you are setting your aperture to a narrower or wider opening. Each progressive f/number corresponds to one-half of the light of the number before it: f/1.4 (very wide), f/2, f/4, f/5.6, f/8, f/11, f/16, f/22, f/32, f/45, f/64, f/90, f/128 (very narrow), and so on.

Incidentally, depth of field and aperture settings are directly related, but they get rather confusing. A wide aperture, such as f/2, will produce a shallow (sometimes called narrow, to make things worse!) depth-of-field image. A narrow aperture produces a deep depth-of-field image.

The slash in an f/number can be treated as a division sign that defines the aperture size. For example, a 50mm lens at f/4 would mean that the aperture is 12.5mm wide (50mm/4).

ABOUT THESE PHOTOS *Both 3-4 and 3-5 were taken with a Canon 30D set at ISO 100 and 1/125 second at 100mm focal length. However, 3-4 was taken with a deep DOF aperture setting of f/16, while 3-5 was taken with a shallow DOF setting of f/2.8. ©Jim White*

3-4

3-5

CROP FACTOR

If you've already studied some about digital camera technology, you may have run into the much-discussed crop factor. You might be wondering exactly what it is and what it means. You need to know the sensor size of your camera to begin to figure this out and understand it because it not only affects the size of the image, but also affects the angle of view of the lens you use. For example, both of the Digital Rebels and the 40D use an APS-C-size sensor, which is approximately two-thirds the size of a full-frame, 35mm sensor.

 x-ref

See Chapter 2 for more about image sensors and different sizes.

With an APS-C sensor, the angle of view is approximately 1.6 times narrower than the actual focal length of the lens. That means that, for example, a 100mm lens on a Digital Rebel XTi (which uses an APS-C sensor) will have the field of view of a 160mm lens and a 50mm lens will appear to have the field of view of an 80mm lens. On a full-frame sensor camera, such as the EOS 5D, the lenses will behave at their specified focal length (meaning a 100mm lens will appear as a 100mm lens). That said, while most people say when you mount a 100mm lens on an XTi it becomes a 160mm lens, it's important to realize that the lens's focal length doesn't actually change by mounting it onto cameras with different sensor sizes — it's the angle of view that changes.

Figures 3-6 and 3-7 demonstrate how a full-frame image sensor helps you get a wider field of view without having to use a wider-angle lens, which is especially helpful with architectural shots. If you have a camera without a full-frame sensor, to include the full scene you'd have to move farther away from the subject (which may not be possible) or use a wider-angle lens.

BOKEH

Bokeh (from the Japanese word, *boke*, meaning blur) refers to the out-of-focus areas in a photograph. Bokeh is directly related to depth-of-field, but the nature and limits of this direct relationship are not necessarily obvious and are somewhat hard to measure or quantify scientifically. Photography enthusiasts, particularly in Internet chat groups and blogs, discuss the quality of bokeh, but without any well-established, formal system of scientific assessment. A given person may view a certain image as having pleasing depth-of-field, and often this assessment is attributed to "good lens bokeh." The terms *good lens bokeh* and *bad lens bokeh* are frequently employed, and sometimes it is not made clear in the context that these are to some degree subjective assessments. Any assertion that the lens is the reason why the out-of-focus parts of an image are good or bad is subjective and can be argued given many factors — including the angle and framing of the shot, which is largely in the control of the photographer.

For lenses with differing focal lengths that are used to photograph the same scene at the same aperture, if the subject is made the same apparent size, technically the depth-of-field will be the same. However, assuming the camera is all that moves to alter the apparent subject size, the longer lens produces less distracting detail in the background. It provides a subjectively greater degree of bokeh because the long lens has a narrow field of view, meaning that a smaller portion of the background will be in view behind the subject.

 note

The Canon EOS-1D Mark III uses an APS-H-size sensor that has a lens focal length conversion factor of 1.3x.

ABOUT THESE PHOTOS *3-6 and 3-7 illustrate where a wide-angle lens would have potentially caused some distortion. Using a camera with a full-frame sensor, in this case an EOS 5D, allowed the photographer to get more of the scene into a normal-range image. Both taken with an EF 24-70mm f/2.8L lens. 3-6 taken at ISO 100, 1/50 second, f/8; 3-7 taken at ISO 250, 1/100 second, f/13.*
©Michael A. Johnson

A shorter lens shows a wider angle of view of the background, so even though the details individually have the same degree of blurring, there are typically many more such details filling the same area of the image, and the eye perceives this as more detail. If the background has almost no detailed features, it would be hard to notice the difference in either regard.

So science attempts to prove what makes good lens bokeh a part of optical engineering, but the fact remains that I know what my eyes tell me. The image in 3-8 is an example of a narrow DOF silhouette image using the EF 24-70mm f/2.8L lens, which in this case shows, in my opinion, very good lens bokeh.

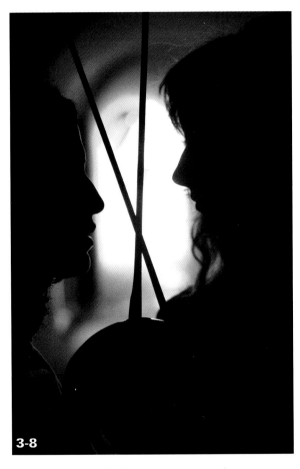

3-8

ABOUT THIS PHOTO *Depth-of-field is an important considera-tion in shooting silhouette images, and this L-series Canon lens has the bokeh to handle the job such as in this image that was taken in the Casbah of Algiers, Algeria. (ISO 100, 1/250 second, f/2.8, taken with a 1D Mark II and an EF 24-70mm f/2.8L lens.) ©Serge Timacheff*

EXPLORING FOCUSING OPTIONS

Today's modern lenses offer photographers amazing optical quality, and whether you choose to focus using one of the automatic focusing modes or to focus your lens manually, you can obtain razor-sharp images with the lineup of Canon lenses. *Focus* can be defined as the point at which light rays from the lens converge to form a sharp image. This is achieved by adjusting the lens or the distance between the lens and the subject. I usually use some sort of autofocus (AF) as I know my eyes aren't as accurate as Canon's AF, but I do manually focus in some situations where AF tends to fail or become a hindrance. In 3-9, you see how AF can render even a fast-moving subject tack sharp; in 3-10, I used manual focusing as the closeness of the subject and the shallow DOF made using AF mode impractical.

AUTOFOCUS SYSTEMS

Autofocus (AF) systems rely on one or more sensors to determine correct focus. Some AF systems rely on a single sensor, while others use an array of sensors. Most modern digital SLR cameras use through-the-lens optical AF sensors, which also function as light meters.

The speed and accuracy of through-the-lens optical autofocusing is now more precise than what you can achieve manually with an ordinary viewfinder. Autofocus accuracy within a third of the depth of field at the widest aperture of the lens is not uncommon in professional AF dSLR cameras. There are, of course, some situations where manually focusing provides better results than the AF system and I explore these as well.

ABOUT THIS PHOTO
Autofocus made the difference in getting this shot of the U.S. Navy Blue Angels. Taken with an EOS-1Ds Mark II, EF 100-400mm f/5.6L lens at 400mm, ISO 100, 1/1000 second at f/5.6. ©Gregory Wigg

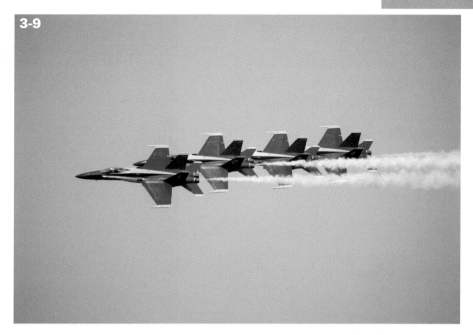

3-9

Most multisensor AF cameras allow manual selection of the active AF sensor, and many offer automatic selection of the sensor using algorithms that discern the location of the subject. Most AF systems are now able to detect if the subject is moving towards or away from the camera, including speed and acceleration data, and stay focused on the subject (AI Servo mode) — a function used mainly in sports and other action photography. Take a look at your autofocus options with the Canon dSLRs.

■ **Focusing points.** All of the Canon dSLRs have focus points (ranging from 7 to 45 depending on the model) that you can manually select. By selecting the AF point(s), you can decide what part of the image will be selected for sharpest focus, which can change depending on the shooting situation.

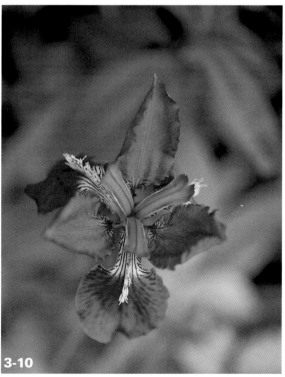

ABOUT THIS PHOTO *The 24-70mm f/2.8L also serves as a great macro lens as evidenced by this photo of an Iris. Taken with an EOS-1Ds Mark II, ISO 800, 1/320 second at f/2.8. ©Jim White*

3-10

On the EOS 40D, the center AF point is a high-precision cross-type sensor that is twice as sensitive to both horizontal and vertical lines of the subject as the rest of the AF-assist points. This combination assures extremely accurate focusing in most situations. The other Canon dSLRs use different combinations of the same technology depending on the model.

The Mark III features 26 AF-assist points that help pinpoint areas for increased focusing accuracy. Also, with its greatly increased low-light capabilities, it can lock on to objects and focus on them with much less light than other cameras, including the previous Mark II series.

■ **Focus lock.** All of the Canon dSLR cameras are equipped with a focus-lock feature. This allows you to lock the focus on a particular subject or subject area, and then recompose prior to releasing the shutter. Different cameras have different numbers of AF points. You accomplish this by selecting the desired AF point (as shown in figure 3-11), focusing on the subject, and then pressing the shutter release halfway to lock the focus. Once focus is locked, keep the shutter pressed halfway to maintain focus, recompose, and shoot; it is that easy.

: Cross-type AF points

: Assist points

: f/2.8 sensors
(Center AF point is f/4)

: f/5.6 sensors

3-11

ABOUT THIS FIGURE *A diagram of the 45 AF points as seen in a 1D Mark III viewfinder; this wide array of points allows you to lock in on virtually any aspect of a subject to ensure a sharp image.*

MODES

By selecting different AF modes, you can further fine-tune the AF operation of your camera for specific shooting situations. You would rarely want the same AF style for a hockey game as you would for landscapes or product photography.

■ **One Shot AF.** Used primarily for still subjects. Pressing the shutter release halfway activates autofocus and achieves and locks focus. With evaluative metering, the exposure setting (aperture and shutter speed) is set when focus is achieved. The focus and exposure setting is locked as long as you continue to keep the shutter release pressed halfway. One Shot AF was used to get a tack-sharp image with the stationary subject shown in 3-12.

■ **AI Servo AF.** Used when dealing with moving subjects where the focal distance keeps changing. When the shutter release is pressed halfway, the AF mechanism is activated and the camera focuses continuously. The exposure is set at the moment the shutter is released. I used AI Servo AF to make sure I got the shot in figure 3-13.

■ **Predictive AF.** If your camera has Predictive AF, you have even more fine control over your camera's AF operation. If the subject approaches or retreats from the camera at a constant rate, the camera tracks the subject and predicts the focusing distance immediately before the picture is taken. With a manually selected AF point, the selected point tracks the subject and refocuses as needed.

MANUAL FOCUSING

You may wonder why you should ever bother using the manual focus (MF) feature when your digital camera has such a sophisticated autofocus system. Isn't AF much easier to use and doesn't it always provide the right focal distance for your photos? The fact is, autofocus isn't perfect. Because an autofocus system looks for patterns onto which it can lock on to focus (such as contrasting lines, patterns, etc.), difficult lighting situations, subjects that are very far away, macro photography, or conflicting focal points may result in your digital camera autofocusing incorrectly or being unable to focus at all. Often you have to compensate by using your manual focus ring. Also, you may want to intentionally blur a

3-12

ABOUT THIS PHOTO *This unusual sign for a sardine factory sits right on the highway outside of Prospect Harbor, Maine. Taken with an EOS-1Ds Mark II, EF 70-200mm f/2.8L lens, ISO 100, 1/400 second at f/9. ©Jim White*

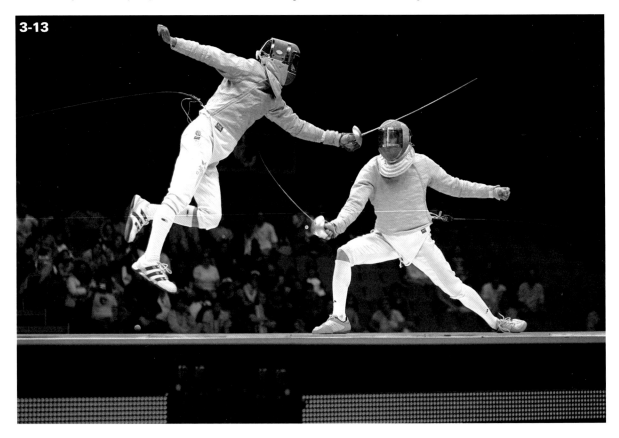

3-13

photograph for artistic effect. In this case, you need to slightly defocus manually. Here are some of examples where MF is apt to deliver better results:

- **Low contrast subjects.** Blue skies, solid-color walls, and so on

- **Subjects in low light.** Night ballgame or a concert

- **Extremely backlit or reflective subject.** Car with a reflective body

- **Repetitive or conflicting patterns.** Skyscraper windows, computer keyboards, and so on

- **Overlapping near and far objects.** Animal in a cage

- **Macro photography.** Close-ups of flowers, stamps, insects, and so on

In situations such as these you can change from AF to MF by using the switch located on the lens barrel. I preferred to use MF for the image in figure 3-14.

CONSIDERING THE DEPTH OF FIELD FACTOR

Learning depth of field and how to control it is one of the single most important aspects of photography. This is what separates you from the point-and-shoot crowd, and this is what allows you to control the exposure rather than allowing the

3-14

ABOUT THIS PHOTO *I wanted more of a soft focus effect in this image of a bride looking out the window just before her wedding. Taken with an EOS-1Ds Mark II, EF 24-70mm f/2.8L lens, ISO 400, 1/60 second at f/8, 580EX Speedlite. ©Jim White*

camera to do it. One of the first steps in becoming a serious photographer is to get that camera out of full Auto mode and learn to use DOF. Here are several important concepts to remember:

- **The smaller the aperture, the deeper the DOF (the other two factors remaining the same).** For example, if the lens focal length and the shooting distance stay the same, the DOF is much deeper at f/16 than at f/1.4.

- **The shorter the focal length of the lens, the deeper the DOF (the other two factors remaining the same).** For example, comparing a 28mm lens with a 50mm lens at the same aperture and shooting distance, the DOF is deeper with the 28mm lens.

- **The greater the shooting distance, the deeper the DOF (the other two factors remaining the same).** For example, if the same subject is photographed from 10 feet and then from 20 feet away, the zone of sharpness in the foreground and background is greater at 20 feet.

- **Your Canon dSLR features a Depth of Field preview button that can help you see what you're about to shoot.** When you focus through the viewfinder, you're not necessarily seeing the image you're going to get, in terms of DOF. This button lets you see the DOF as it will be shot. Pressing the DOF button stops-down the aperture to the f-stop you set, so that you can see the depth of the image you're about to shoot. Although a 50mm lens may provide the crop factor of an 80mm lens, for example, the DOF remains the same. This is why you might hear or read that photographers insist DOF is different with digital: They are judging DOF by the effective focal length of a lens rather than by the actual focal length.

ARTISTIC CONSIDERATIONS

Depth-of-field can range from a fraction of an inch to infinity. For example, a close-up of a person's face may have shallow DOF with some of the background blurred — a common technique in portrait photography. In a mountain landscape, you want a deep DOF, with both the foreground and background in focus. The same is true of a group portrait, such as a high school football team with players tiered in bleachers, where you want all the players' faces sharply focused. In a close-up still photograph, such as in a product photo, you might employ a very shallow DOF to isolate the subject from a distracting background.

The amount of DOF is an important creative treatment that can be used to emphasize drama in composition, isolating a subject from its surroundings

TIPS FOR SHOPPING FOR LENSES

I have one steadfast piece of advice I give to all prospective lens buyers: Evaluate the lens with your intended use in mind. It's very common in today's online-driven economy for photographers to spend hours reading photography Web site reviews, blogs, and chat groups that extol the virtues of one particular lens and deem another unworthy, but they never actually get to try the lens out before they shoot it! That isn't to say that the Internet isn't a good source to look for information on a particular lens: It is potentially one of the best. It's just that among all the charts, graphs, and backfocus testing, you can lose sight of your real goal: determining whether or not a particular lens can do the job you have in mind.

However you plan to acquire a particular lens, and particularly if it's an expensive piece of glass, if possible it's a good idea to find a local camera store where you can rent one for the day or weekend and try it out. Some stores will even let you apply some or the entire rental price to a purchase. If you plan to buy the lens from that store, they will most likely let you bring in your camera and memory card and take some test shots.

If you are considering two lenses, take some shots with both, trying as much as possible to mimic your intended use. If you want the lens to shoot architectural interiors, then take some shots of the inside of the store. If you plan to shoot sports, then go outside if possible and get some shots of a car driving by. Then it's a simple matter of going back and pulling up the images on your computer and making evaluations or comparisons. Bottom line: If you are happy with the performance of the lens and the price is within your budget, it's a good lens.

Insofar as buying used lenses, you can save a great deal of money and find some great deals on used equipment, lenses included. Again, if you have a local store where you can actually see and put your hands on the equipment, then by all means do so as there is no substitute for this. If you elect to buy through mail order or online, just make sure you are dealing with a reputable dealer or individual. Large online dealers such as B&H Photo (www.bhpoto.com) or Adorama (www.adorama.com) also sell good-quality, reliable used equipment. Read or ask about the return policy prior to purchasing. If the dealer has no return policy on used equipment, then don't buy from them. Any business or person worth your dollars should accept returns so long as the item is returned in good condition.

If you turn to auctions at eBay, Amazon, or Yahoo!, which millions of people do, just make sure you do your homework first. You can often find good deals on used equipment, but I have also seen many bidders get caught in the frenzy and pay more than the current street price of a new lens for a used one. Be especially wary of foreign sellers, particularly if they want you to send money outside of the standard auction policy under the guise of offering you a better deal. I have a student who, against my advice, a few years ago sent a money order to someone in Spain for a camera she saw on eBay; she still has never received the camera — and her money's gone.

Assignment

Evaluating Depth of Field

One of the best ways to really learn about DOF is to find an interesting subject, preferably one that is stationary, and photograph it using any one of your lenses. Take one shot at the widest possible aperture (for example, one at f/2.8, one at a mid-point aperture such as f/8, and another at f/16), keeping your camera and your distance from the image constant. Notice how the DOF varies in each of the three images. Which one do you like best and why? Post your results to the Web site.

I took this image of a garden sculpture with a 1D Mark IIn and an EF 100mm f/2.8 Macro lens. Note how the quality differs among the images, as well as the depth-of-field.

From left to right: ISO 250, 1/640 second at f/2.8; ISO 250, 1/200 second at f/8; ISO 1250, 1/50 second at f/32.

©Serge Timacheff

 Remember to visit www.pwassignments.com when you complete this assignment and share your favorite photo! It's a community of enthusiastic photographers and a great place to view what other readers have created. You can also post comments and read other encouraging suggestions and feedback.

©Bob Schilereff

Without a lens, a camera is little more than a light-absorbing machine incapable of producing anything really useful. In comparison to a camera's extensive and complex technology and mechanics, you might think a lens is relatively simple; however, lenses encompass a tremendous history of technological and scientific research and application that dates back to the first telescopes and microscopes invented in the 1600s.

This chapter is all about the science and technology behind how lenses work, and why they work so well. Having a basic understanding of these ideas can help you as you expand your photography skills and select new and/or better lenses for your collection.

HOW LENSES WORK

The lens acts as the eye of your camera, and, like the human eye, some lenses focus better than others. Some are better at seeing distances; others are better at reading fine print. Camera lenses are typically made of many individual polished glass elements. For the camera, the function is the same: to focus light rays onto a light-sensitive surface, or in this case, a digital sensor. The better the lens does the job, the sharper your picture. The simplest type of lens is a single-element convex lens, the same kind used in a magnifying glass. In profile, it is thick in the middle and tapered at the ends, as in 4-1.

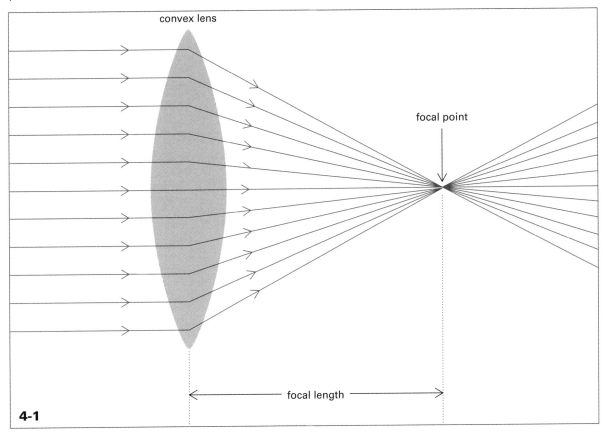

4-1

ABOUT THIS FIGURE *A lens takes incoming light and focuses it on a single point of convergence, called the focal point; from there, the light continues on until it strikes the image sensor.*

The lens is the optical component of the camera, the part that actually absorbs and bends light. At its simplest, a lens is just a curved piece of glass; at its most complex, it involves numerous elements that are measured, ground, and arranged with subatomic precision. In either case the purpose is the same: to gather beams of light reflecting from an object and focus them to form a real image — an image that looks like the scene in front of you.

How a lens works is surprisingly simple. As light travels from one medium to another, it changes speed. Light travels more rapidly through air than glass, so a lens slows the movement of light waves. When light enters a piece of glass at an angle, one part of the wave reaches the glass before another and consequently starts slowing down. As the light wave enters the glass at an angle, it bends, or refracts, in one direction. It bends again when it exits the glass because parts of the light wave enter the air and speed up before other parts of the wave. In a standard or convex lens, one or both sides of the glass curve out. This means rays of light passing through the lens bend toward the center of the lens on entry. The image is turned upside down after passing through the lens; this is accounted for by your camera so that you see a normal image through the viewfinder.

A lens with a rounder, more convex shape (a center that extends out farther) has a more acute bending angle. Basically, curving the lens out increases the distance between different points on the lens. As a result, the light makes a sharper turn which means that wide, normal, and telephoto lenses bend light differently. The wider the angle, the more the light must bend through the lens to reach the image sensor — and, consequently, why wide-angle photos look so much more distorted.

In 4-2, notice how an ultrawide-angle fisheye lens bends and distorts this image of a pickup truck, while in 4-3, even a normal 50mm lens — which is capable of taking very nondistorted, natural portrait — bends and distorts light when focused extremely close to the subject, although to much less of a degree.

At a basic level, convex lenses force light to converge at a specific point, which is called the *focal plane*. From there, the light travels to your image sensor. At that point, the image is cast upside-down, which the camera's firmware flips right-side-up before displaying on your LCD. Similarly, your camera's mirror flips the image so that it looks right-side-up when viewing it through the viewfinder.

Lenses are designed so that the distance from the focal plane to the image sensor is exactly correct in order for the image to fit the sensor's size — which, for most detachable lenses, assumes that it is the same as a 35mm film frame or a full-frame image sensor. Most digital cameras, however, have image sensors smaller than full-frame. As a result, part of the image is cropped out (the crop factor).

x-ref | For more about crop factor and image sensor sizes, see Chapter 2.

The distance from the front of the lens, where light enters it, to the focal plane, where light converges, and then from the focal plane to the image sensor, is much longer on a telephoto lens than on a wide-angle lens. When you adjust the zoom ring on a zoom lens, you change the configuration of the lens elements to alter the focal length to accommodate the distance between lens elements. Your zoom lens contains multiple glass elements (each a lens itself) that work together to magnify and converge light in just the right way so that your image passes through the lens precisely.

ABOUT THESE PHOTOS *The photo of the pickup truck in 4-2 was taken with an EOS 5D and a Canon 15mm f/2.8 Fisheye lens at f/8. ©Jim White. The photo of the swimmer in 4-3 was taken with an EOS-1Ds and a Canon 50mm lens at f/5. ©Scott Stulberg*

The magnification power of a lens is determined by focal length. A longer focal length means greater magnification. Using different lenses allows you to photograph the same scene with different angles of view, such as seen in 4-4 and 4-5. While their focal lengths aren't all so very much different (one ranges from 16 to 35mm, taken at the 16mm position, and the other is

ABOUT THESE PHOTOS *This moving carousel in the first image was shot with an EF 16-35mm f/2.8L lens; in the second, an EF 15mm f/2.8 Fisheye lens was used. 4-4 taken at ISO 50, 1/1 second, f/18 ; 4-5 taken at ISO 100, 1/13 second, f/8. Both images taken with an EOS 5D. ©Jim White*

4-4

4-5

15mm), the lens design, configuration, and elements are nonetheless significantly different—creating an equally significantly different effect.

Telephoto, normal, and wide-angle lenses are suited to different situations and subjects. If you're taking a picture of a mountain range, you may want to use a telephoto lens with an especially long focal length in order to see distant subjects closer up. Telephoto lenses allow you to focus in on specific elements in the distance, so you can create tighter compositions. If you're taking a close-up portrait, you might use a normal lens. This lens has a shorter focal length and wider angle of view, but won't let you magnify distant objects.

A standard 50mm camera lens doesn't significantly magnify or shrink the image, making it ideal for shooting objects that aren't especially close or far away and providing a natural look and feel. Compare the same image when shot with a normal 50mm lens and a telephoto 200mm lens (see 4-6 and 4-7).

 x-ref

See Chapter 6 for a complete discussion of lens types.

4-6

4-7

ABOUT THESE PHOTOS *These photos were taken with the same camera (an EOS 5D) and at the same exposure (ISO 320, 1/60 second, f/22), but with different lenses: 4-6 was taken with an EF 50mm f/1.4 prime lens (a normal lens), and 4-7 was taken with an EF 70-200mm f/2.8L zoom lens fully extended to a 200mm focal length. ©Amy A. Timacheff*

HOW THE LENS COMMUNICATES WITH THE CAMERA

Most modern lenses have the ability to communicate electronically with the camera. All Canon EF mount lenses contain a microprocessor within the lens providing a set of information to the camera. When you turn on an EOS camera, the camera and lens communicate. The camera knows the focal length of the lens, and if it is a zoom lens, it knows the actual current zoom setting, the maximum and minimum aperture, and a host of other factors. When the camera is activated, all this information is transmitted to the main processor in the camera body. This allows you to get accurate exposure information from the lens through the camera so you can correctly choose shutter speed and aperture, even under difficult situations such as shown in 4-8, shot in Shutter-priority mode.

Communication between camera and lens takes place in a number of ways. Pressing the shutter release halfway activates the lens's autofocus and metering, then the metering information is processed within the main camera body, and autofocus control of the lens is initiated. A zoom lens's focal length, for example, is communicated to the camera, and then the camera communicates through the hot shoe to the flash — effectively establishing electronic communication among three distinct, but connected, devices.

If the camera is set to one of the Auto or Creative Zone modes, the camera electronically controls aperture and shutter speed based on the metering of the scene. For anything involving the focusing and aperture aspects of your composition,

ABOUT THIS PHOTO *Even under difficult lighting situations such as this freeway at night, EOS digitals deliver. Taken with an EOS 5D with an EF 24-105mm L lens, 15 seconds at f/14. ©Scott Stulberg*

information is passing between camera and lens; this is combined intelligently in the camera with your ISO (image sensor light sensitivity) and shutter speed (how long the image is exposed).

Because of this sophisticated electronic communication, you will have problems adapting significantly older Canon lenses to modern dSLRs; at best, they will run manually — assuming you can find a way to adapt them to the modern Canon

lens mount. The same can be true of using third-party lenses, which may not communicate as efficiently or accurately, even though they are rated to work with the Canon dSLR.

CANON LENS TECHNOLOGIES

Canon's lens technology leads the industry in producing supersharp, high-resolution pictures. Optical engineering plays a fundamental role in the design of a dSLR camera, and consequently, lenses must also be engineered to even greater levels of precision. Through the development and use of such technologies as diffractive optics, fully electronic mounts, and image stabilization, just to name a few, Canon has stayed at the forefront of the digital market.

FLUORITE AND UD GLASS

How light is refracted depends on the wavelength of the light; this means that where the lens focuses can actually change depending upon specific colors/wavelengths. When the different wavelengths, or colors, are focused at different points, the resulting color can be rendered inaccurately in a phenomenon known as *chromatic aberration*, and it's especially a problem with longer (telephoto) lenses. Lenses often contain a nonchromatic element that helps to correct chromatic aberration — think of it as a sort of filter. This solution, however, is limited to being used for only two primary (spectral) colors, so without additional optical engineering, at least some chromatic aberration may still exist.

 x-ref For more about chromatic aberration, see Chapter 5.

The mineral *fluorite*, it turns out, has very low refractive and dispersion qualities — something beyond that of plain optical-quality glass. As a result, Canon has developed a way to integrate fluorite with the optical glass in the manufacturing process. This glass, then, is much better at refracting the three primary colors (red, green, and blue) accurately and producing a much higher quality image.

Canon also uses a similar concept in its UD glass lenses. The UD glass is a proprietary type of optical material exhibiting properties similar to that of fluorite-integrated glass. This comes in regular and super-UD versions, the latter of which is even more efficient and requires less glass to correct chromatic aberration.

ASPHERICAL LENSES

Most lenses are *spherical*, meaning their surfaces comprise parts of spheres. Generally speaking, these very accurately mimic the curvature of the human eye. They take a three-dimensional image and convert it into a two-dimensional, flat image on your camera's sensor. However, with wider-angle lenses, a purely spherical lens is insufficient to avoid distortion — especially at the outer edges of the image. To remedy this, an aspherical lens was developed, which is, as indicated by the name, not purely spherical in order to correct the areas of the glass where light is not refracted accurately.

Canon uses extremely high precision machines that mold aspherical lenses to exact specifications; in some cases, the glass is then treated with an ultraviolet-hardened resin film to perfect the shape and eradicate spherical flaws.

Distortion and lens flare are both minimized with aspherical lenses, along with contrast being

maximized. A good number of Canon's mainstream lenses incorporate aspherical qualities, including such popular models as the EF 24-70mm f/2.8L and the EF 14mm f/2.8L II USM.

Of course, in some cases spherical aberrations can be used to artistic effect even if they do not provide a completely natural or accurate representation of the image being photographed. Take, for example, the image in 4-9, where slightly distorted edges help to pop out the color and dimensionality of the main subject.

ABOUT THIS PHOTO *Taken in Tokyo's famous Tsukiji fish market, these shellfish almost jump off the page when taken with a fisheye lens, emphasizing their color and texture even more. The areas around the side of the image are clearly distorted by the spherical 15mm lens. Taken with an EOS-1D Mark IIn with an EF 15mm f/2.8 Fisheye lens, ISO 640, 1/80 second, f/4.5. ©Serge Timacheff*

DIFFRACTIVE OPTICS

Lenses do not form perfect images, and there is always some degree of distortion or *aberration* introduced by the lens that causes the image to be an imperfect replica of the object. Careful design of the lens system for a particular application ensures that the aberration or distortion is minimized. Telephoto and super-telephoto lenses are especially susceptible to chromatic aberration, which is an optical color defect. Diffractive optics (DO) technology, which was designed to correct these problems in telephoto lenses, uses the principle of diffraction, which is to change the direction of a light wave's path, to create lenses with a strong diffractive element. They also have optical qualities that help to correct color fringing. If you are not sure how to tell if the diffraction of your lens is good, try examining the straight edges of a subject in a photo you've taken. If there is a crisp clear edge without prismatic color fringing, then your lens has good diffractive optics. Figure 4-10 shows how different colors can be refracted through the lens in different ways, resulting in fringing.

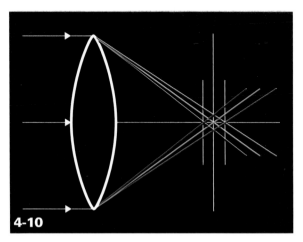

ABOUT THIS FIGURE *Prismatic color fringing occurs when lenses fail to diffract different colors precisely, as shown here. Note how the focal plane is where all parts of the lens — from the center to the edges — must accurately point rays of light to produce a crisp image.*

While only a few lenses today use Canon's DO technology (the EF 400mm f/4 DO IS USM and the EF 70-300mm f/4.5-5.6 DO IS USM), none of their professional lenses exhibits significant distortion. However, the longer the telephoto shot, the more susceptible your shots will be to various aberrations of long-range shots such as fringing and blur.

The net result of Canon's optical engineering and technology are lens designs that are lighter and smaller with higher image quality. DO technology takes this a step farther, meaning lenses can be even more efficient than comparable focal-length lenses that incorporate conventional glass optical elements.

> **note** Long telephoto shots are especially sensitive to movement, so they often need to be taken on a tripod or monopod, at least. Additionally, telephoto lenses are highly susceptible to distortive effects such as fringing. Wildlife photographer Bob Schilereff has to use very high-quality lenses mounted onto a tripod to acheive the best quality, such as his photo shown in the opening of this chapter. The image of a sow grizzly bear (with a barely visible cub standing beneath her) was taken in Yellowstone Park using an a Canon 1D Mark II with an EF 600mm f/4L IS USM lens and an Extender EF 1.4x II for increased telephoto range.

FLOATING SYSTEM

Lesser-quality lenses often produce acceptable results when focused in a mid-range, common focusing distances. However, they can and do produce image aberrations at extreme focal ranges — especially the closer ones. This is generally the result of inaccuracies between lens elements that work well when positioned together for common ranges, but are less accurate when at their least-common configurations.

Canon lenses employ a floating system of optical elements, which automatically adjusts gaps between lens elements in relation to the focusing distance. This works to correct any aberrations at any range. This also limits the telescoping distance of the lens elements, which helps to eliminate them from fluctuating in their position. Because closer ranges are more severely affected by lens aberrations, the floating system is particularly helpful with macro and wide-angle lenses.

ULTRASONIC MOTORS (USM)

An *ultrasonic* motor is one that operates using the principle that a stator (elastic body) subject to vibration results in friction that turns the rotor in a specified direction. This very precise, quiet technology also generates a nearly insignificant amount of camera shake — making it perfect for driving the lens's autofocus feature. Lacking gears, it is direct-drive and very efficient, which means it consumes very little power from the camera's battery. Canon has two different USM types, one that is used in lenses with very wide apertures and super-telephoto models (a ring USM) and another designed for compact lenses (micro USM).

IMAGE STABILIZER

No one likes blurry shots, and they so often seem to occur with the images that you think are going to be the best ones. However, an unsteady hand, the wind, shooting from a vehicle, or any number of things can cause the camera to shake and result in a blurred image. Being able to hold a camera steady is a skill in which many photographers pride themselves. It's been said that an average amateur photographer can hold a camera steady for a photo taken down to about 1/125 second; a more experienced semipro or enthusiast, down to

about 1/60 second; and a pro photographer down to 1/30 second. This is assuming optimal conditions with a normal or wide-angle lens, both of which are more forgiving than a telephoto lens.

If you've ever watched a space shuttle launch on TV, the video cameras being used have very long telephoto lenses. They have to be tilted as the rocket soars towards space, and the longer the focal range, the less steady the image becomes — which is very visible. It's the same with still photography: The longer the lens, and the more you have to move to get the shot, the more likely it is to be blurred by camera shake.

Shooting at a faster shutter speed, when possible, is one way to eliminate camera shake. Another is to use a tripod or monopod. Of course, that's not always possible, and to aid in keeping the images steady, Canon has developed a very sophisticated, gyroscopically driven image-stabilization system used in a number of its long prime lenses and several zoom models. These lenses are identified with an IS, for example, EF 28-300mm f/3.5-5.6L IS USM.

This in-lens system (which, by the way, you can hear quietly whirring if you put your ear to an IS lens with your finger depressing the focus button) allows perfectly stable images to be taken down to as slow as 1/15 second for most pro photographers, and for the less experienced shooters down to 1/30 second. Most IS lenses include settings such as optimized modes for image stabilization during a panning (side-to-side) motion. The super-telephoto lenses, such as the EF 300mm up to 600mm models, also employ a mechanism that enhances IS functioning while mounted to a tripod. I tend to use the IS feature of my EF 70-200mm lens all the time, even for fast shutter-speed shots — just for added security that long-range images will be as crisp as possible, such as in 4-11.

4-11

ABOUT THIS PHOTO *I took this photo while standing in the Saudi Arabian Desert in Qatar where conditions are harsh and footing is unstable. My 1D Mark II was well suited for this environment, with its exceptional protection from the elements, and my EF 70-200mm f/2.8L lens's IS system served me well even while fully extended at its maximum focal length. Taken at ISO 50, 1/800 second, f/5.6. ©Serge Timacheff*

note Every now and then photographers new to dSLR shooting ask me if older-model lenses can be mounted to modern cameras, and if any automatic features will work. For sure, the older mechanical models will not operate automatically because there's nothing mechanical in today's cameras to control the functions (these were designed before lenses were controlled electronically); at best, a custom adapter only lets you mount the lens to the camera and would still require that you operate the lens manually.

ELECTRONIC MOUNT

Until the advent of electronic control of lenses, they operated mechanically using a control mechanism that connected to the camera at the mounting ring. The mechanics were more subject to failure and also caused considerably more noise and rattle, which can affect sensitive exposures. The mechanical controls have since been replaced by a series of electronic connections, shown in figure 4-12, that communicate with the camera and carry information to mechanical elements in the lens controlled by microprocessors.

As many as 50 different information signals pass between camera and lens, covering and controlling everything from aperture and focus to different types of image stabilization as well as minimal focusing distances. Because the standard Canon lens mount is 54mm (which is amply large), special lenses with extra-large apertures and controls can easily be accommodated, too, such as tilt-and-shift models.

DUST- AND WATER-RESISTANT CONSTRUCTION

Like the Mark III camera series, certain longer-range Canon lenses are constructed to be dust- and water-resistant. Specifically, the EF300mm f/2.8L USM, EF 400mm f/2.8L IS USM, EF 500mm f/4L IS USM, and EF 600mm f/4L IS USM lenses all feature rubber linings for key points where unwanted elements can enter the camera. Moving parts, such as the focusing ring and switches, are sealed, as are switch panels, exterior seams, and drop-in filter compartments. You might notice that the extra rubber sealing rings leave very fine abrasion marks on the outside of your camera's lens mount; Canon assures customers that this has no adverse effect on operation.

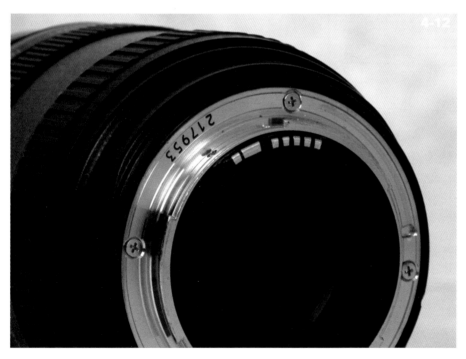

ABOUT THIS PHOTO
This is a photo of the back of a Canon lens where it mounts to the camera body. Note the electronic contacts, through which information passes to and from the camera. ©Serge Timacheff

TILT-AND-SHIFT LENSES

Canon tilt-and-shift lenses, designated with a TS-E in the product name, are designed to let you control the angle of the plane of focus in a lens, which allows you to manipulate perspective in an image. For example, if you stand at the bottom of a building and take a photo pointed upward, the straight vertical lines of the walls appear to converge. Taken from farther away, they appear much straighter. Photographers can use tilt-and-shift lenses to virtually eliminate convergence and control perspective in their photographers, which is especially useful for applications such as architectural photography.

A TS-E lens has control knobs for physically altering the X and Y axes of its main elements, which float so that they can be positioned for optimal effect. Tilting the lens changes the angle of the plane of focus between the lens and film plane, while shifting the lens adjusts its optical axis in parallel.

No autofocus is available for these lenses.

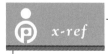

x-ref See more about Canon's tilt-and-shift lenses in Chapter 6.

FOCAL LENGTH AND APERTURE EFFECTS

While some photography technologies relate only to your camera's internal operation, and knowing them won't necessarily make you a better photographer, understanding some others can have a direct impact on your compositional skills and your ability to control your camera more completely.

FOCAL LENGTH AND IMAGES

Knowing the relative behavior of lenses, how focal length works with them, and how they will work with and be effectively applied to various subjects is essential to producing good photography. The relative sizes and perceived distance between objects change as focal lengths change, whether in a zoom lens or by using different lenses. Of course, to achieve a similar photo with a wide-angle versus a telephoto lens — say, for example, an image of a house that shows the entire building — you need to physically change your position to get closer or farther depending on your lens's focal length. A telephoto lens will make a row of racing cars, viewed head-on, look far closer to one another than they really are, while with a slightly wide-angle lens you might need to have a family pose closer together than might seem natural because the lens will spread them apart somewhat.

Other factors are affected by focal length, as well; telephoto lenses, for example, are susceptible to camera shake and can produce blurry images with minimal movement because their focal length is so long (which, once again, is why image stabilization is helpful). And aberrations at the edge of wide-angle lenses occur with such a wide field to be compressing into a small aperture and onto a focal plane.

tip Here's an old photographer's trick that will help you determine your shutter speed to avoid a blurry image, depending on your focal length: Your shutter speed should be at least as fast as the numerical value of your focal length. So, if you're shooting a lens with a 100mm focal length, your shutter speed should be set to at least 1/100 second. While this isn't an absolute law, it's a good rule of thumb from which you can fine-tune your shot. Plus, the rule is generally applied to a full-frame sensor or 35mm film frame; for smaller sensors, you'll need to up your shutter speed a little to account for the crop factor.

APERTURE AND IMAGES

How wide or narrow your aperture is set for a given exposure affects your image in more ways than just providing more or less light. It is your aperture setting that controls depth-of-field and makes the difference in the artistic effect in a nature shot or whether a row of athletes is blurry in a bleacher-filled team photo. So understanding how apertures work is essential for the working photographer just as it is for the artist or the enthusiast.

It's important to note that lenses with larger maximum apertures provide significantly brighter viewfinder images — possibly critical for night and low-light photography. Lenses with larger apertures also often give faster and more accurate autofocusing in low light. Manual focusing is also easier because the image in the viewfinder has a narrower depth of field, thus making it more visible when objects come into or out of focus.

A smaller aperture setting, such as f/22, creates an image with deep depth of field, such as is ideal for a large group of people or a landscape where you want to see foreground and distance both in focus. A larger aperture setting, such as f/2.8, produces a shallow depth of field, with much of the image out of focus, other than your subject, as in 4-13.

Some zoom lenses are not capable of holding a maximum aperture width as they are zoomed out and as their focal length increases. If you are using such a lens, it's good to know this if you have the aperture set wide and the lens at a minimum zoom and you decide to zoom in on something. The aperture will change automatically because the lens is incapable of holding that aperture width; however, you might have an underexposed image as a result. "Fast" zoom lenses are those that will hold the same aperture at any focal length; they are typically more

4-13

ABOUT THIS PHOTO *Here, the photographer used a shallow depth of field to place the emphasis on this beautiful little girl. Taken with an EOS 1Ds using an EF 70-200mm f/2.8L lens, 1/100 second at f/4.5. ©Scott Stulberg*

expensive because of the complex optical engineering it takes to accomplish this feat.

Using deep depth of field is common among photographers shooting groups of people, crowds, architecture, and landscapes, where not having areas out of focus is very practical or helpful to the shot. A shallow depth of field has more artistic and dramatic value, such as in a macro photo of a bumblebee on a flower, or to isolate a quarterback about to pass the ball with a blurred, colorful

crowd behind him. Obviously these are general examples, and it's ultimately up to you, the photographer, to understand how the aperture you choose will make your images winning shots.

WHAT MAKES A LENS GOOD?

What makes a good lens can be argued on a scientific basis or according to aesthetic considerations. Most people want a lens that produces a tack-sharp image with great color rendition for superior image quality. Certainly, how the lens handles mechanically is also important; it has to function as the photographer's instrument and be able to be "played" without disrupting the creative process with limited functionality.

Canon outlines six primary characteristics of an ideal lens:

- **Complete photographic quality.** Truly great lenses feature both superior resolution as well as contrast across their entire surfaces. By using a more-than-sufficient amount of high-quality glass and optical coatings backed by sophisticated technology and engineering, resolution and contrast (which often work *against* each other) are optimized.

- **Consistent color reproduction among all lenses.** A primary goal of Canon optical engineering is consistency and uniformity of color reproduction no matter which interchangeable lens is being used.

- **Out-of-focus quality.** For photographers, what's *out* of focus is often as important as what's in focus. This natural "blur" effect using narrow depth-of-field is critical to representing a three-dimensional subject in a two-dimensional image, so it has to look believable and natural — which is yet another factor that's part of lens design and engineering.

- **Ergonomic functionality.** A lens needs to be comfortable, functional, and easy to use. While an attractive design is nice to have, cameras and lenses need to follow a function-before-form rule of industrial design. Canon EF lenses are built to provide sensitive, smooth manual focus and zoom functions, as well as accessible and logically positioned and intuitively operated features and functions.

- **Quiet functioning.** dSLR cameras are notoriously noisy, with so much mechanical operation. This has diminished steadily, first because of solid-state electronic operation (instead of levers and gears) and second because of increased precision engineering of components as well as innovative technologies such as USM. This has enabled very quiet autofocusing as well as other camera and lens operations.

- **Reliability.** Being completely portable, cameras must endure a variety of rigorous conditions, such as weather, vibration and shocks, dirt and dust, and other factors, and keep operating precisely and producing high-quality images. Canon cameras are tested extensively in many situations and are subjected to many types of physical torment before they are rated for different types of use.

WHAT IS AN MTF CHART?

A Modulation Transfer Function (MTF) chart represents basically how a lens is evaluated. You can find these charts, for example, on the Canon Web site where lens descriptions are found; simply go to the product page for one of the specific lenses, and in the overview section they generally present an MTF chart for it. These charts are created from data based on how well the lens transmits evenly

spaced lines of black and white as measured precisely in line pairs per millimeter: 10, 20, or 30 line pairs per millimeter (lp/mm). The closer the lines are together, the more blurry and noisy the image will be because the black and white will average together into a grayish tone instead of being clearly defined.

Essentially, differences between black and white lines equate to contrast; this, in turns, helps define an image's sharpness. For example, if you have ever applied an Unsharp mask in an image-editing application such as Photoshop, you are increasing the contrast between dark and light lines in the image — giving the appearance of a sharper, more focused image.

While optical glass manufacturing is very precise and exacting, no lens is perfect. Aberrations and areas of blurriness or defocus occur even in the most expensive L-series lenses. MTF charts define the amount of imperfection in a given lens by evaluating two different types of line categories. One type measures radial lines that point towards the center of a lens like spokes on a bicycle wheel; the other type are tangential lines, which measure different specific parts of the lens at a right angle to the radial lines with varying distances between them and line thicknesses (kind of like the hub or rim of a wheel).

Reading MTF charts, including the charts found on the Canon site, can be challenging and confusing for the average person (different manufacturers have different types of MTF charts). However, they're interesting if you're seriously researching how different but similar lenses perform — especially if you're considering spending a considerable sum on one over the other. There are a few basics that you need to keep in mind when viewing Canon MTF charts — the lines and the numbers.

■ **Lines.** Upper lines are blue; lower lines are black.

> The upper set of lines represents how a lens performed when measured with an aperture of f/8.0 (typically).

> The lower lines represent how a lens performed when measured with the aperture wide open (to the maximum that the lens is capable, such as f/2.8 or f/1.4).

> Dotted lines represent tangential measurements.

> Solid lines represent radial measurements.

■ **Numbers.** MTF charts for zoom lenses include two graphs: one for the lens at maximum range, and one for minimum range.

> The numbers on the horizontal axis of the chart, written at the bottom, are the distance from the center of the image frame as measured in millimeters.

> The numbers on the vertical axis of the chart, along the left-hand side, are the MTF values, which equate to percentage of contrast: 1.0 is maximum (100-percent) contrast (good) and 0 is no contrast at all (not good).

Just as it's easier for a doctor to read an x-ray than it is for the patient, it can be difficult to relate a specific MTF chart to a photograph unless you're an optical engineer. But, like an x-ray, you can still interpret some things from MTF charts if you study a little. Generally speaking, you want to keep contrast even and not to have significant rises or falls as the distances increase. The lines will naturally fall off as the distance increases, but the smoothness and evenness of the fall-off is what will tip you off to a lens with less quality.

Assignment

How Lenses Work

Photograph a scene or subject using the widest angle lens you own, and then photograph the same scene using the longest (telephoto) lens you have. If you are using a zoom, just zoom all the way in and then all the way out. What differences in the scene or subject can you see? Which image do you prefer and why? Are you able to keep the same settings to expose the image, or do you have to change them? What did you change, and why? Also, did you change your physical position to achieve a similar perspective, or did you simply stand in one place and have one wide and one narrow shot? Post your photos to the Web site.

For this assignment, I used a 1D Mark IIn with EF 24-70mm f/2.8L at 24mm (left) and EF 70-200mm f/2.8L at 200mm (right) lenses. For the full extension on the 70-200mm lens, I had to move all the way to the other side of the studio to get the shot. Both images taken at ISO 125, 1/200 second, f/9.

 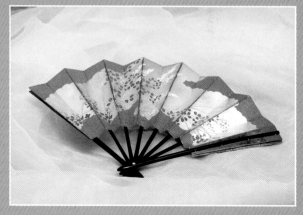

©Serge Timacheff

Remember to visit www.pwassignments.com when you complete this assignment and share your favorite photo! It's a community of enthusiastic photographers and a great place to view what other readers have created. You can also post comments and read other encouraging suggestions and feedback.

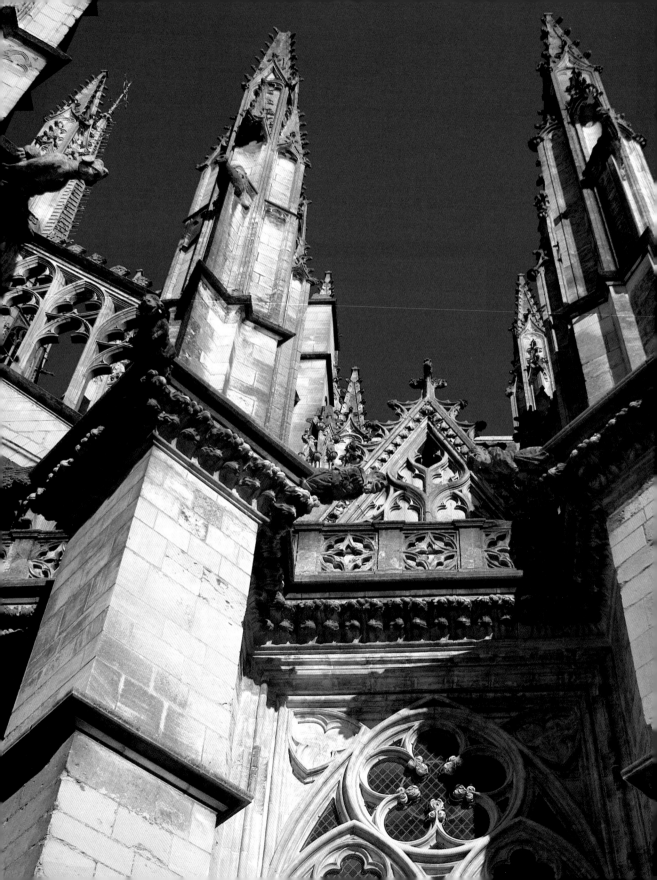

©Serge Timacheff

One of the best things about dSLR photography is the tremendous variety of lenses available to capture virtually any subject. However, with such a diversity of glass, there are many phenomena and characteristics affecting how lenses perform depending on light as well as optical design, complexity, and quality. Some of these effects can have artistic value under the right conditions, while others can be avoided by using lenses and light according to standards and practices that optimize their best application. This chapter explores these factors, how they apply to the kind of photography you want to pursue, and how to work with them for best results.

GHOSTING

Pointing a camera and lens toward a bright light of any kind can produce *ghosting*, which has two prominent features: an area of overexposure that is completely white and a part of the image that is streaked and patterned. It is caused by strong light reflecting from the image sensor back to the lens of your camera, and can also occur with inexpensive filters or smudged, unclean optical surfaces. While less expensive lenses, those with lesser-quality multicoatings and optics, suffer from this effect more than better-quality lenses, it can happen with any lens given the right conditions and a strong-enough light source. The reason it's called ghosting is because often the effect produces almost a figure-like shape that is partially, if not completely, transparent, and more than a few people have confused optical ghosting for a real apparition.

Another reason for its name is that ghosting tends to occur more frequently in night shots where there is a lot of contrast between a light source and the rest of the image. It also happens more commonly when you're using a telephoto lens with an add-on lens component, such as a UV or haze filter.

Moving the light source, using a lens hood, and shielding the light are all possible solutions for eradicating ghosting in your photos. Using one of Canon's large diameter Image Stabilizing (IS) ultra-telephoto lenses, which have a meniscus lens element (which is shell-shaped and has two spherical, curved sides, convex and concave), can also greatly reduce the problem of ghosting.

LENS FLARE

Lens flare is the result of unwanted light entering the lens and hitting the image sensor. How the effect occurs depends upon various factors such as the number of internal lens components, lens focal length, aperture size and width, and the type of light source and its brightness (such as the sun, a spotlight, etc.).

 tip Sometimes the effect of lens flare can be interesting, providing an artistic quality to the photo.

Many higher-quality lenses have features that help deter flare and disperse light within the lens before it reaches the sensor, but, as with ghosting, virtually any lens is susceptible to flare given the right conditions. The appearance in the image is that of a series of geometric bright shapes that extend from a corner of the image toward the center, gradually increasing in size. They can look like starbursts, rings, or polygons that are a direct reflection of the lens's aperture shape. Sometimes, it can simply be the effect of a hazy quality to the lens (see figure 5-1). Longer lenses and lenses with more complex optical systems and multiple elements tend to suffer from flare more severely than simpler, shorter ones; however, it can happen in virtually any lens given the right light conditions.

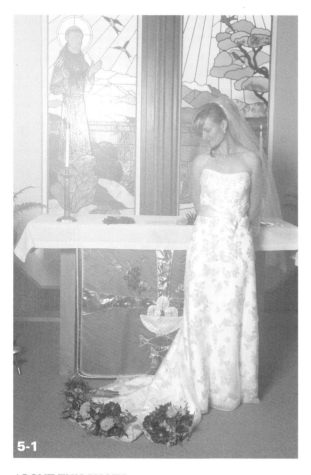

5-1

ABOUT THIS PHOTO *Lens flare and ghosting can both have similar effects caused by unwanted light entering your lens at an extreme angle. This type of hazy look is a typical problem that is easily remedied by simply blocking the light or moving your position. (ISO 400, 1/160 second, f/10, taken with an EOS 20D and an EF 24-70mm f/2.8L lens.) ©Amy A. Timacheff*

5-2

5-3

ABOUT THESE PHOTOS *I adjusted a panel on a studio light to block the light causing the flaring in the upper-right corner of image 5-2, resulting in a much more evenly lighted image of this Shih-Tzu. (Both images taken with a 1D Mark IIn and an EF 24-70mm f/2.8L lens at ISO 50, 1/160 second, f/22.) ©Serge Timacheff*

As with ghosting, using a lens hood or shading a bright light source can help avoid flaring. Sometimes it may be that you simply need to use your hand as a shield from the light, placing it just beyond the image border of your shot. Studio lights can also produce flare, but are easily moved or shielded by a hood or leaf (a flat panel) on the light housing. In figures 5-2 and 5-3, I had noticed that the studio light I was using caused some minor flare to enter the photo on the upper-right side; I was able to close a panel on the light to block the light to eliminate the effect. Using a lens hood, even in studio shots, can also be helpful.

CHROMATIC ABERRATION

While not very common with Canon's current, superior lens technology, some lenses, such as very wide-angle and long telephoto lenses, can occasionally suffer from an effect known as

chromatic aberration, or color fringing. This is when the lens elements do not converge the colors of refracted light precisely onto the focal plane (see figure 5-4), which acts a little like a prism. The light then is dispersed instead of converged, resulting in misplaced colors in your image. For example, you might see a light area of magenta, green, or red alongside a person's face, or you might see a light area of color along the side of a building — especially at the periphery of the image. The effect can also cause an image to look soft or blurry, which is the result of contrasting areas of color being dispersed and converging incorrectly. Color fringing is least likely to occur at the center of the photo.

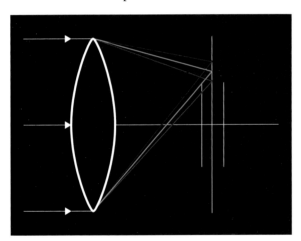

5-4

ABOUT THIS FIGURE *Chromatic aberration is caused by poor-quality optical elements that refract light inaccurately onto the focal plane.*

There are two types of chromatic aberration: *lateral* and *longitudinal*. The lateral type (also known as transverse), which is the most common type, manifests itself especially on sharply contrasting regions of an image, such as the color lines alongside a person's face. Longitudinal (also known as axial) chromatic aberration is the inability of the lens to focus all the colors exactly at the focal

plane — some are focused before it, while others are right on it, and others are focused beyond it. The result is that some colors are absent or incorrectly presented in your image.

MOIRÉ PATTERNS

Have you ever seen a distracting pattern on a person's jacket or shirt when watching television? This effect, known as a *moiré pattern*, is caused by geometric elements of a subject and image sensor conflicting with one another. It's one reason that portrait photographers generally advise clients not to wear geometric patterns in clothing when being photographed.

In dSLRs, moiré occurs because pixels are arranged in a specific matrix pattern that can, on occasion, conflict with patterns on a subject. The patterns aren't visible through the viewfinder, because you're not looking at what the image sensor is picking up. If you have a subject with a tight geometric pattern on an article of clothing, then you should shoot a test shot. When you download the test shot to a computer, make sure to view it at 100 percent and at the final size you'll be using for the image because these are where a moiré is most likely to present itself — different magnifications of the digital image in image-editing software may represent it differently.

 note Occasionally, a moiré pattern may be visible on the monitor but not in print form.

FALSE COLORS

False colors can occur when photographing subjects with detailed, high-contrast geometric patterns — whether it is clothing or the pattern on an object in a product shot. Your camera's image processor

THE LOW-PASS FILTER Canon uses a combination UV and "low-pass" filter on the imaging sensor to reduce false colors and moiré patterns to negligible levels, in most cases. The filter sits directly in front of the image sensor and contains three layers that separate image data horizontally and vertically and optimize sharpness. Often, however, you may find that your photos need to be sharpened a little, even if you think your focus was perfect; this is a result of the filter causing a minute amount of blur to the image.

The UV filter serves to cut infrared (IR) light, which can cause ghosting and color "fogging." Some photographers have the entire low-pass filter removed professionally to shoot images revealing the stark, almost sci-fi look of an image showing the IR spectrum.

can misinterpret the signals from the image sensor and add colors to the image that are not actually there. False colors are not a common occurrence in Canon dSLRs. Images with false colors are simply ones that are not true color, meaning the average person's vision (and, obviously, someone who is not color blind) would find the image colors to be incorrectly represented. Color variations frequently occur between camera, computer, and print, although the differences are often still within a range of normal perception — in other words, a green leaf would not appear to be purple, for example, but it may range within what most people would call green. Certain features, such as Canon's Picture Styles, have been implemented to try to maintain color consistency from camera to software, and from software to printer.

 x-ref For more details on Canon Picture Styles, see Chapter 9.

DIFFRACTION

When light travels through lens elements and through your aperture opening, some small amounts of it are diffracted, meaning dispersed and essentially no longer a part of your image. Usually the amount of light diffracted is negligible under normal conditions; however, it can

occur when you are shooting with an exceptionally small aperture setting, such as f/32, which can result in a slightly softer or blurry image. If you're trying to achieve a very deep depth-of-field image and you take a photo with a very small aperture setting, it is possible, especially with some lesser-quality lenses, to experience this effect that is known as diffraction-limited optics. Basically, when you have a lot of light passing through a very small space, the rays can interfere with one another if the lens elements are not carefully engineered optically to optimize light's pathway to the image sensor.

You may not want to assume that your lens is experiencing diffraction-limited issues, however, unless you've eliminated all extraneous variables such as ensuring you're using a good-quality tripod, mirror-lockup (to avoid camera shake), and a very good-quality lens. Many photographers avoid shooting at the extreme, high limits of their apertures to avoid an potential softness—with any lens, even if it's a very high-quality model.

EVALUATING COLOR AND CONTRAST

Understanding and judging color and contrast in your images are essential to producing good photography. Your lenses are where color and

contrast begin and, to some extent, where they are controlled as they are processed as an exposure before being converted into a digital image.

Histograms are available for you to use as an evaluative tool on your camera's LCD, as well as later in software image-editing applications. These graphs, which give you information about shadows, highlights, midtones, and colors in your images, provide a quick view as to your overall exposure quality and insight on how to adjust it, if necessary. There are two types of histograms: luminance and RGB.

LUMINANCE HISTOGRAMS

Every digital image has a tonal range that includes all the colors from the brightest to the darkest in red, green, and blue (RGB). Histograms more commonly come in a black-and-white mode where red, green, and blue are averaged; these are called *luminance* histograms. Your camera shows luminance histograms on the LCD, and your image-editing software often defaults to this mode.

The *luminosity* of an image refers to the overall distribution of brightness in a digital photo, and it takes into account your eye's sensitivity to different colors (for example, red and blue appear less bright than green to the human eye). Luminance histograms calculate a weighted average of RGB colors in an image to create a single representation of the image that is simple to read and interpret.

RGB HISTOGRAMS

An RGB histogram shows shadows, midtones, and highlights for each of the three color channels (red, green, and blue) — essentially, it's three histograms in one. Viewing a histogram in color, where each RGB color is shown in a range from 0 to 255 (assuming an 8-bit JPEG file), gives a far more detailed look into your image's exposure. Yet while there's more information in an RGB histogram, it can be more difficult to read because you're trying to compare individual colors with a full-color image and there is triple the amount of data to interpret.

Using the typical sliders in your image-editing software, you can make on-the-fly adjustments to individual color channels, which can be useful for tweaking images where specific color attributes may be off. Figure 5-5 shows an image where the red histogram has been isolated and displayed in ACDSee, an image-editing software.

While you can take time to fully read a histogram, frequently just a glance can help you quickly adjust an image. Generally speaking, a properly exposed image where all colors are included and the histogram is in black and white (such as what you see in your camera's LCD screen) appears as a gentle bell curve where the midtones are higher (shown in the middle of the graph) and the shadows and highlights taper off on each side. Of course, when you begin to look at individual colors, such as in figure 5-5, there will be significant variations to the bell curve — even in a well-exposed image. However, strong spikes to the left or right may indicate under- or overexposure in an image — or, at the very least, significant portions of the image where this is occurring (which may or may not be what you want in a specific shot). And, while most typically a properly exposed image will have a histogram that is very reflective primarily of the main subject, there are photographs that lack

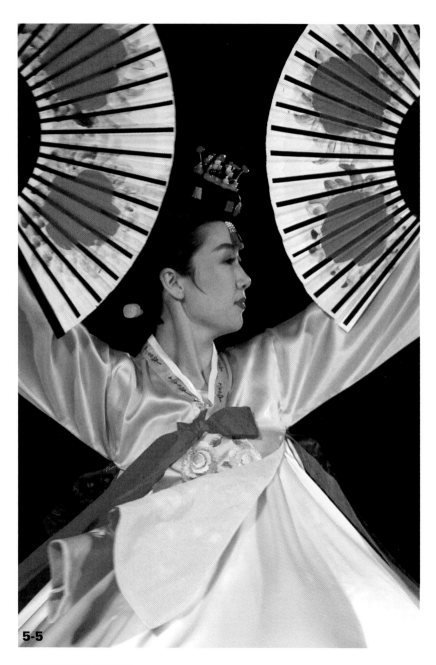

5-5

ABOUT THIS PHOTO *This colorful image of a traditional dancer in South Korea is represented by the histogram showing red shadows, highlights, and midtones. These tones can be selectively adjusted in software. Taken with a 1D Mark IIn with a 70-200mm f/2.8L lens at ISO 640, 1/400 second, f/4. ©Serge Timacheff*

enough midtones or a pronounced-enough subject that you won't see a strong bell curve. This is where your subjective judgment as a photographer and artist is important; rarely would you rely solely on the histogram to decide if an image is correctly composed and exposed.

HIGH AND LOW KEY IMAGES

Images where lighting is shadowed and unevenly lit, such as in an artistic black-and-white nude, are called *low key*; these images emphasize the

range of shadows and, partially, midtones of a histogram. Conversely, *high key* images are more evenly lit and feature stronger highlights and midtone ranges. They might be the result of bright sunlight as in figure 5-6 or they could be for a studio cover shot for a glamour magazine that features very few shadows and even bright lighting.

For the most part, you can judge whether your image is high key or low key before you take the photo. In the studio, photographers specifically determine whether lighting should be high key,

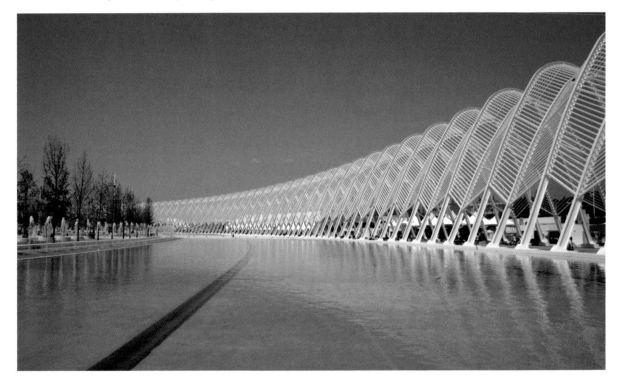

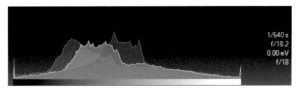

5-6

ABOUT THIS PHOTO *This high key image has few shadows and a large number of midtones and highlights (shown in ACDSee Pro histogram, but with the full RGB color view). Taken with an EOS-Mark IIn at ISO 160, 1/640 second, f/18. ©Serge Timacheff*

such as in the case of a family portrait, or low key, such as if they want to produce an artistic or more dramatic effect. Depending on your exposure settings, you can make an image darker or lighter and achieve, to some degree, effects of high key and low key; however, most often the amount and type of light in your photo determine your shadows, midtones, and highlights. Unless you have full control over the scene, such as in a studio, only your position and whether you use a flash determine what the image will be.

Looking at the histogram after you take a photo also tells you if your image is high key or low key. From there, you may be able to make adjustments. For example, if you take a photo in a program (automatic) setting and the histogram shows it to be lower key than you would like, you can shift to a manual mode and adjust the settings on your camera to shoot a brighter exposure.

Significant engineering in digital cameras has been focused on helping them to reproduce low key, low-light images where few areas of the image are overexposed. Low-light images possess more information that can be adjusted — especially if shot in RAW where there is a very detailed tonal range — than do images with over-exposed areas. You can always take information out of an image, but you can't add it in. Areas of overly highlighted images, where there are solid-white sections, are referred to as being blown out.

While underexposing images is generally safer than overexposing, you can of course take it too far; I generally don't suggest underexposing more than one stop in situations where you're uncertain about the light. Too much underexposing can result in a noisier image when it has been edited to a correct exposure, so you'll want to be careful.

A histogram can help you by showing an area has too much data on the far right, which is the high-light section — meaning you may have at least parts of your image that are overexposed. You can also turn on the highlight alert feature in your Canon dSLR, which shows you over-exposed areas of your image in the LCD preview by flashing those parts of the image. Unless you actually want that part of the image to be overexposed, this tells you that you should manually adjust the image to be lower key by reducing the aperture size or increasing the shutter speed (or both); you could also lower studio lights if you are shooting in a controlled-lighting situation. While some blown-out areas are acceptable in certain images, such as in a reflective area on water or the center of a streetlight, determining the correct amount is a subjective artistic decision made by you.

CONTRAST

A logical aspect of a histogram, because it shows highs and lows of shadows, midtones, and high-lights, is that it also displays *contrast*, which is the difference between dark and light areas in an image. A low-contrast image has a more narrow histogram curve and includes flattened areas, while a high-contrast image has a broader curve. Histograms are complex, of course, so you may have an overall low-contrast image with one part of it that is high contrast, or even have several areas with high contrast even though the rest of the image is low contrast.

Figures 5-7 and 5-8 show the same scene taken with slightly different exposures. After taking the shot in 5-7 and viewing the in-camera histogram, it seemed to not have enough contrast. So, I adjusted the exposure from 1/125 second to 1/250 second.

5-7

5-8

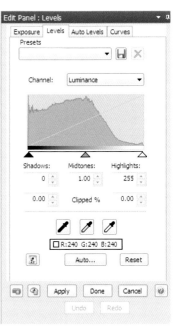

ABOUT THESE PHOTOS *These dried fish, shot in a Kuwait marketplace, were a bit overexposed with too little contrast, as shown in 5-7. After adjusting the exposure to 1/250 second to add more shadowing, it had better contrast. Photos taken with a 1D Mark IIn, 24-70mm f/2.8L lens at ISO 640, f/5.6. Figure 5-7 at 1/125 second and 5-8 at 1/250 second. ©Serge Timacheff*

Reading a histogram is like following a GPS unit in your car: You can't just blindly use it without giving some thought to the real world. You may have an image that shows low contrast or odd peaks in shadows and highlights, or that seems too flat, and yet artistically it may be just what you want. However, you should be generally familiar with the parts of a histogram that relate to a specific image, as shown in 5-9, which connects related areas of the histogram to specific parts of the image. Using the histogram and looking at your photo, you can decide how to adjust subsequent images and determine which areas of the image have more or less contrast, and whether the shadows, midtones, or highlights need to be emphasized or lessened.

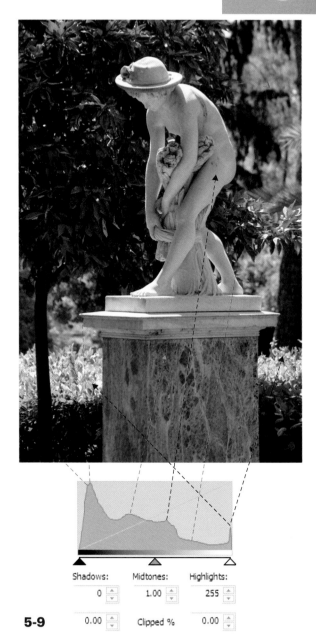

Shadows: Midtones: Highlights:

0 1.00 255

0.00 Clipped % 0.00

ABOUT THIS FIGURE *The arrows connect the related points of the histogram to the image. You can see how shadows, midtones, and highlights are represented differently, and how you might interpret the histogram when taking a photo, and then make adjustments for the next shot. Photo taken with a 1D Mark II and a 70-200mm f/2.8L lens at ISO 250, 1/250 second, f/7.1. ©Serge Timacheff*

5-9

PINCUSHIONING AND BARREL DISTORTION

Pincushioning and *barrel distortion* are types of optical aberrations that distort an image from its real-world view as the human eye would see it. Barrel distortion is characterized by a decrease in image magnification as the distance increases from the optical axis — giving the typical fisheye look where it shows a bulging effect and looks like you took the center of the image and pulled it toward you.

Pincushioning is the opposite of barrel distortion — the magnification increases as the distance increases from the optical axis, so it looks like the center of the image was pushed away from you. This effect is less common and very rare in any Canon dSLR lens, and typically only found in poor-quality telephoto lenses.

Some lenses are very true and exhibit virtually no distortion; however, some zoom lenses, in particular, exhibit some distortion at the full extent of their focal range. Some lenses distort an image by design; a fisheye lens is a prime example of this, as shown in 5-10.

5-10

ABOUT THIS PHOTO *Barrel distortion is the most common distortive effect you're likely to get, especially with wide-angle and fisheye lenses. A fisheye lens, of course, gives this effect intentionally; it's less desirable in a standard wide-angle lens. This image of French bread in an Algerian market was taken with an EF 15mm Fisheye lens. Photo taken with a 1D Mark II at ISO 400, 1/100 second, f/5. ©Serge Timacheff*

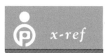

x-ref | For more detail on barrel distortion, see Chapter 6.

VIGNETTING

When light falls off of the edge of a photo, the periphery of the image is darker than the center, which is called *vignetting*. Essentially, light diminishes as distance increases from the optical axis, especially toward the corners of the image. This can be done on purpose as an artistic effect, such as in 5-11, or it can be the result of optical issues with your lens.

Many lenses have some *natural* or *optical* vignetting depending on their focal length and, if they are zoom lenses, to what extent they are zoomed. While often very minimal and virtually unnoticeable, the effect is more pronounced with fully extended zoom lenses. It is even more likely if you're using a converter with the lens. In these cases, you might see darkening in the extreme corners of the image.

Mechanical vignetting can result from improper lens attachments that incorrectly place optical elements so that they cannot fully transmit light to the image sensor. This can happen, for example, if you place too many filters on the lens or if you have a lens hood that's not suitable for the lens. Often this type of vignetting effect is much more abrupt, while a natural vignetting is more gradual.

5-11

ABOUT THIS PHOTO *This image has a vignette effect that is typical of poor-quality lenses when used at full zoom. This example is simulated. ©Serge Timacheff*

tip | Many image-editing programs have options to help you fix barrel distortion if it isn't the effect you intended.

Assignment

Creating Images with Flare

Lens flare can be something you don't want in a photo or it can provide a nice artistic touch. While it can occur by chance, you can also create it intentionally.

Try shooting a scene outdoors on a bright, sunny day, perhaps around mid-morning or -afternoon; you can use any lens you'd like—wide angle, telephoto, or normal. When you select a subject, direct your shot so that the sun is just out of view in the upper-left or upper-right corner of the shot. Then, tilt your view so that the bottom edge of the sun's light enters your lens and your shot.

Take the image with the sun entering your photo. Are you seeing geometric patterns, or a lot of haze? Does the effect help or detract from your photo? A few different angles and perspectives will change how the sun's rays will reflect in your lens, so you might need to experiment before you get exactly the effect you want.

I took a wide-angle, fisheye photo of Rio de Janeiro, Brazil, from atop the famous "Corcovado" mountain. I used the sun on the edge of the photo to create some lens flare to add to the composition, giving it a bit of interest and depth. (Taken at ISO 100, f/14, 1/800 second with an EF 15mm Fisheye lens and a 1D Mark IIn.)

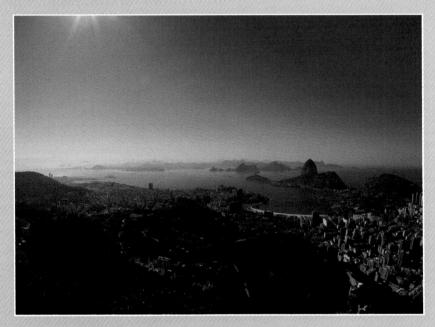

©Serge Timacheff

Remember to visit www.pwassignments.com when you complete this assignment and share your favorite photo! It's a community of enthusiastic photographers and a great place to view what other readers have created. You can also post comments and read other encouraging suggestions and feedback.

CHOOSING AND USING LENSES

©Serge Timacheff

Selecting and building a well-rounded set of lenses suited to the type of photography you do is essential for getting the most out of your dSLR camera. You may have started with a basic zoom lens that seemed to do it all, or you might have realized from the get-go that you needed a variety of focal lengths and lens speeds in order to accomplish your work. Whatever the case, if you're like most photographers, you probably have your eye on a new or different lens or you want to tweak your lens lineup in one way or another.

Canon offers a tremendous variety of lenses for virtually any type of photography imaginable, ranging from inexpensive basic models bundled with entry-level dSLR cameras to high-speed, long telephoto lenses priced more like an automobile than camera

gear. It's very common for photographers to spend more on their lenses than on the cameras themselves, and I very frequently advise photographers who are gearing up, that budgeting for lenses is a bigger consideration than budgeting for cameras.

Every photographer — and I'm no exception — builds a set of lenses and accessories suited to his or her needs. I primarily shoot with 24-70mm and 70-200mm L series f/2.8 lenses, and I always carry an EF 15mm Fisheye for establishment and environmental shots. If I need other lenses, I rent them from professional photography outlets or borrow them from Canon. For fencing championships, for example, I really don't need a super-telephoto lens (my 70-200mm lens suits my needs well) because I can usually get close to the action as in 6-1. My

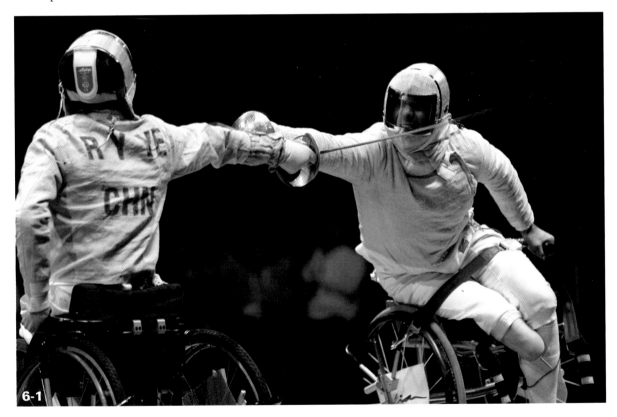

6-1

ABOUT THIS PHOTO *Having a fast lens is almost always essential in any action photography. I took this photo at the 2006 World Wheelchair Fencing Championships in Torino, Italy, at a focal length of 165mm with an EF 70-200mm f/2.8L lens. I used a 1D Mark IIn at ISO 640, 1/500 second at f/2.8. ©Serge Timacheff*

fast, high-quality zoom lenses allow me to cover everything from fast-moving action at quite close ranges to wide shots ranging from medal ceremonies to events and receptions.

Everyone has to determine what their personal needs are when it comes to lenses, and sometimes the most interesting and unique lenses aren't always the most practical. On the other hand, if you get called to do something specific while on a shoot — say, for example, to take a macro shot — you want to be able to accomplish the task professionally.

This chapter looks at the various lenses Canon offers and some related issues so that you can understand better what your options are and evaluate your own lens lineup.

> **note** Sometimes a telephoto lens is mistaken for a zoom lens; while many telephoto lenses are also zoom lenses, these terms are different. A telephoto lens is a lens meant to magnify distance, while a zoom lens is a lens that lets you adjust focal length to suit your composition.

ZOOM VERSUS PRIME LENSES

Overall, lenses are divided into two main groups: prime and zoom (see figure 6-2). A *prime* lens (also called a fixed lens) is one that has a fixed focal length, meaning the specification is a single length, such as 15mm or 200mm. A *zoom* lens has an adjustable focal length, meaning its focal length is a span, such as 24-70mm or 120-300mm. Both zoom and prime lenses can be in virtually any focal length — wide, normal, or telephoto. The following sections look at each type in more detail.

ABOUT THIS PHOTO
Zoom versus prime: Note the difference in how these two lenses are classified. The 50mm prime only has one focal length while the 70-200mm zoom lens has a range. ©Serge Timacheff

PRIME LENSES

Many discerning photographers believe that prime lenses have better quality and produce sharper, crisper images than zoom lenses. This is because there are fewer moving parts and optical elements involved in the lens mechanics. Fewer glass elements means less light and detail are filtered by any optics, and a less complex mechanical infrastructure means more precision.

Prime lenses are generally preferable if you can deal with the inconvenience of not being able to change focal lengths. For example, Canon's 50mm lenses, which provide a very real-world, 1:1 magnification, are workhorses in portrait studios, and many professional photographers choose to move themselves in and out instead of giving up the quality they perceive the lens offers.

I suggest that if you are producing museum-quality images where using a prime lens is realistic (in other words, where you don't have to change focal lengths quickly), then by all means use one. You'll undoubtedly be pleased with the images you produce. And, even if you do need a zoom in your work, you might want to have at least one fixed-length lens, such as a 50mm, as an option for specific situations where its simplicity and quality will be welcome.

ZOOM LENSES

Zoom lenses are very convenient, especially in situations where you don't have the luxury of moving around, or you can't get to a spot fast enough or that is close enough to shoot. A tremendous amount of optical engineering has gone into developing zoom lenses that produce very accu-

rate, high-quality images that can compare favorably with prime lenses of similar focal lengths.

Even in the studio, a number of excellent portrait photographers opt for a zoom lens and being able to conveniently change their focal length on-the-fly — and they still feel that the quality is more than acceptable. With convenience comes a price, however; while not 100-percent comparable, zoom lenses of similar speed and quality are typically more expensive than prime lenses — but you're getting the equivalent of multiple prime lenses with a zoom (at least from the standpoint of focal length).

FAST VERSUS SLOW LENSES

A fast lens is a lens that provides a large aperture — meaning less than f/3.0. Why is it called fast, then? It is because a larger aperture provides more light for the digital sensor, meaning you can use a faster shutter speed in your images where there's less light, as in 6-3. Consequently you can shoot faster, not that the lens itself does anything more quickly. It also means you can achieve better narrow depth-of-field images because you have a wide aperture.

Fast lenses, especially zooms, are generally more expensive and are of higher optical quality. Lower-quality, slower zoom lenses commonly have a wider, variable aperture that narrows as the focal length increases. For example, Canon's EF 70-300mm lens ranges from f/4 to f/5.6 depending upon your focal length; at 300mm, the lens physically does not offer an aperture of f/4, and you won't be able to even manually select that f-stop on the camera.

6-3

ABOUT THIS PHOTO *A stop-action image of men's sabre fencing taken at the 2007 World Fencing Championships in St. Petersburg, Russia. A fast lens is a critical tool for taking this type of photograph. Taken with a 1D Mark IIn, EF 70-200mm f/2.8L lens, ISO 800, 1/1000 second at f/2.8. ©Serge Timacheff*

Variable apertures with settings dependent on focal length are often confusing. If you set a variable aperture lens, such as 70-300mm, at 70mm and set your aperture priority or manual setting to f/4.0, then if you zoom and take the photo, the lens and camera automatically reduce the aperture size — all the way to f/5.6 if you zoom completely — and the result may be an underexposed image. If you don't know that your lens is going to do that, you may only figure out what happened by examining the metadata later to see that the aperture changed — even when you set it wider!

Faster zoom lenses retain the same aperture width no matter what the focal length may be, and this is one reason these lenses are so expensive: It takes very complex and high-precision optical and mechanical engineering to provide a wide focal range that maintains the same amount of light entering the lens tube.

HOW CLOSE IS CLOSE ENOUGH? While virtually every lens can focus to infinity (∞), each model has a minimum focusing distance. If you get any closer, the image becomes blurry and neither autofocus nor manual focusing works. Some lenses let you get closer to a subject than others; any lens that is designed specifically for macro photography, or that includes a macro rating or function, lets you get closer than other ones — with some lenses, as close as .8 foot.

Some lenses, such as the Canon 70-200mm L USM lens, provide a minimum focusing distance switch on the side of the lens barrel. In the case of this lens, the setting difference between 1.5∞ and 3∞ means that if it is set to the latter, then the lens will not be able to focus closer than three feet. This is done to increase the lens focusing speed; if it does not have to attempt to focus closer than three feet, it has less distance between its minimum and infinity, and is consequently faster at focusing (not to be confused with being a fast lens, however, which has to do with aperture).

It's often useful to be able to shoot closely with a lens, so when you buy a new one, you want to consider how it's rated for minimum focusing distance.

L SERIES LENSES

The L in Canon's high-end lenses stands for "luxury." L series lenses are easily identified by the telltale red ring around the end of the lens barrel (shown in 6-4). These flagship optical marvels are expensive, but provide unrivaled quality, speed, and precision. Canon has designated L series lenses for professional use, although many consumers, enthusiasts, and semipros also use them. The L is included in the product name just after the lens speed (aperture) rating, as shown:

Canon EF 500mm f/4L IS USM

Canon EF 28-300 f/3.5-5.6L IS USM

Canon EF 85mm f/1.2L II USM

Canon achieves the quality — and demands the corresponding price — for L series lenses by integrating superior technology in them. Here are some of the advantages:

■ Low-dispersion Ultra Low Dispersion (UD) glass

■ USM operation

■ Aspherical glass

■ Weather resistance

■ Nonrotating front elements (which helps when using rotating filters, such as polarizers)

■ In some models, a fast (large, nonvariable aperture) lens speed

■ Full-time manual focusing (meaning it can operate interactively while using autofocusing)

About 25 of Canon's lenses are rated as L series lenses, although Canon is frequently discontinuing as well as adding models. Many of the lenses are distinctive in their white coloring, which always stands out when you see a group of pho-

ABOUT THIS PHOTO
Notice the telltale red ring on these two Canon L series lenses. ©Serge Timacheff

6-4

tographers at an event. Canon uses the white color on longer lenses that are often used outdoors because it resists heat from the sun, which could affect lens performance.

In addition to knowing what the L in the lens name means, knowing these other labels can help you quickly identify characteristics of a lens.

- **EF.** These are lenses built for Canon's EOS system, and the acronym stands for electro-focus. It is now a standard term for any Canon lens with an electronic focus. If a lens doesn't have an EF in the name, it doesn't offer this feature.

- **IS.** The IS indicates that the lens offers image stabilization. This gyroscopically controlled technology is used in some of the telephoto

lenses to allow photos to be taken at slower shutter speeds without camera-shake blurring the photo.

- **USM.** This stands for ultrasonic motor, which is the autofocusing mechanism in Canon lenses. It is the high-end, ultraquiet motor Canon has developed for higher-end lenses.

> *note* EF-S lenses are only compatible with the new Canon lens mounts on cameras with this specification. EF-S-compatible cameras, which are more consumer oriented, also support EF lenses.

111

CANON LENSES

The world can be shown in a wide variety of ways with the tremendous selection of Canon lenses. The rest of this chapter covers everything from super-telephoto to macro and wide-angle lenses, and how they can work for your particular style of photography.

Figures 6-5 through 6-11 show a series of images taken with Canon lenses at seven different focal lengths. Compare how they reflect the same view in different ways.

ABOUT THESE PHOTOS *A range of focal lengths taken of Washington State's Lake Wilderness and Mt. Rainier from the same location, on a tripod. The image focal lengths, beginning with the wide-angle shot, include 15mm (6-5), 24mm (6-6), 60mm (6-7), 70mm (6-8), 135mm (6-9), 150mm (6-10), and 200mm (6-11). A few things to notice in these images, other than the focal lengths, include the lens flare intruding on the 15mm and 24mm shots; the increase in haze in the longer telephoto shots (even though a skylight/haze filter was used); and the richness of color of the wider versus the longer shots. The images were taken in P (program) mode at IS 400. 6-5: 1/500 sec. at f/11; 6-6: 1/640 sec. at f/16; 6-7: 1/400 sec. at f/8; 6-8: 1/1250 sec. at f/13; 6-9: 1/1600 sec. at f/10; 6-10: 1/1250 sec. at f/8; 6-11: 1/1600 sec. at f/8. All taken with a Canon EOS 5D. ©Amy A. Timacheff*

6-5

6-7

6-6

6-8

6-9

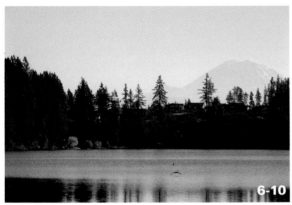

6-10

6-11

WIDE-ANGLE LENSES

A *wide-angle* lens allows you to capture an entire scene, sometimes to the point of distorting elements of the image — which can be used for compositional effect, or it can just make your image look odd. Typically the focal range of wide-angle lenses begins around 24mm (known as *superwide* lenses, although Canon offers some wide-angle lenses up to 35mm) down to *fisheye* (shown in 6-12) and *ultrawide* lenses of 14mm and 15mm.

6-12

ABOUT THIS PHOTO *A front view of an EF 15mm f/2.8 Fisheye lens. The bubble-like qualities of the glass provide a 180-degree angle of view giving images a rounded feel. ©Serge Timacheff*

Wide-angle lenses broaden the angle of view that will be recorded onto your image sensor, and they commonly increase the depth of field and bring more of the image into focus. Furthermore, wide-angle images increase the apparent distance between the foreground and the background (the opposite of what a telephoto lens does), which allows you to create some very interesting compositional effects. Additionally, they tend to be physically smaller lenses, which makes them easy to pack as an extra goody to use for interesting shots at opportune moments.

CANON'S WIDE-ANGLE LENS LINEUP

Not all 14mm or 15mm lenses are considered fisheye; this term refers more specifically to the angle of view (which is 180 degrees on the Canon 15mm fisheye, for example). Fisheye lenses are distinctive in that the lens looks like a bubble, and they tend to distort the image far more visibly (technically known as *barrel distortion*), as shown in figure 6-13. Ultrawide zoom lenses have wider angles than their standard zoom lenses, which are the next level up in terms of focal length.

Canon also includes 28mm and 35mm lenses in their wide-angle lineup, and these lenses are excellent choices for portraiture situations where you need to photograph a large group, for example. Their minimal distortion on the edges of an image, as compared with wider-angle lenses, is very useful.

Canon offers a broad selection of wide-angle lenses with an equally broad price range. If you're looking for a wide-angle lens, you should take into consideration the distorting effects that a fisheye versus an ultrawide creates, which may or may not be what you would want in a photo. Fisheye lenses provide a distinctive distortive effect, such as in figure 6-13 where I wanted to emphasize the cobblestone pattern in the street with its reflective qualities to create an interesting balance to the photo; often the technique of getting low with your image in relationship to the subject provides a dramatic element in a wide-angle shot. I rested my camera on a camera bag to keep it still during the long exposure, and I had to lie down to be able to look into the viewfinder to compose the image.

Canon's wide-angle lens lineup includes the following:

- EF 14mm f/2.8L II USM
- EF 14mm f/2.8L USM
- EF 15mm f/2.8 Fisheye
- EF 20mm f/2.8 USM
- EF 24mm f/1.4L USM
- EF 24mm f/2.8
- EF 28mm f/1.8 USM
- EF 28mm f/2.8
- EF 35mm f/1.4L USM
- EF 35mm f/2

Canon's ultrawide zoom lens lineup includes these lenses:

- EF 16-35mm f/2.8L II USM
- EF-S 10-22mm f/3.5-4.5 USM
- EF 17-40mm f/4L USM
- EF 20-35mm f/3.5-4.5 USM

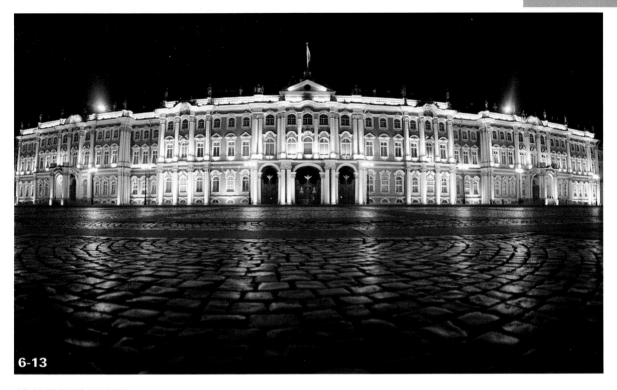

6-13

ABOUT THIS PHOTO *A wide-angle night photo of the Hermitage museum in St. Petersburg, Russia, taken with a Canon 15mm Fisheye lens. Canon 1D Mark IIn, ISO 100, 1/5 second at f/2.8. ©Serge Timacheff*

DEALING WITH WIDE-ANGLE DISTORTION

Wide-angle lenses, with their rounded glass, frequently create an effect known as *barrel distortion*, where what otherwise would be straight lines in your image become bent and the overall image takes on the shape of a barrel. This phenomenon is more noticeable where there are straight lines in the scene you are shooting (such as a city with lots of walls, streets, and so forth), and less noticeable where lines are abstract (such as water, sky, or landscapes). When shooting a portrait of a group of people, a wide-angle lens may distort the shapes of people's faces and bodies, especially if they are on the edge of the frame.

Image 6-14 is an unedited photo, taken in an Algiers marketplace with an EF 15mm f/2.8 Fisheye lens, and it shows some of the positive *and* negative elements of a wide-angle shot. On the positive side, emphasizing the amount of nuts for sale gives a dramatic look to the image. More challenging, however, is the range of exposure, from the dark upper-left corner where the merchant is on the phone, to the nuts in the foreground, which are slightly overexposed, to the upper-right corner that is overexposed beyond repair. Additionally, the bystander on the far right is obviously distorted due to being on the edge of the fisheye image.

6-14

ABOUT THIS PHOTO *Acceptable or not? The exposure can be adjusted a little, and perhaps the barrel distortion could be helped with an image-editing application, but parts of the image would have to be cropped. Taken with a 1D Mark II using an EF 15mm f/2.8 Fisheye lens, ISO 400, 1/320 second at f/7. ©Serge Timacheff*

Sometimes you can use this effect to your advantage, such as to emphasize a foreground element, which makes it more noticeable and interesting in your subject (such as the cobblestones are in the Hermitage image in 6-13). Or, you may want to turn a wide-angle shot into a panoramic image by cropping out the upper and lower parts of a landscape-framed shot.

> **tip** What about creating multi-image panoramic photographs with a wide-angle lens? While it might seem natural to use a wide-angle lens to create a panoramic image comprising multiple digital shots that have been stitched together, you'll need to be careful that you're not shooting *too* wide. If the image is distorted, such as what happens with a fisheye lens, it will not work correctly. You're better off shooting with a lens giving you a 1:1 ratio, and taking more photos.

Often there is a straight line that extends across the center of your image that you can occasionally use to your advantage, such as if you are shooting a road or there is a distinct horizon. In 6-15, I was shooting the 2005 world championships in Leipzig, Germany, and the wide-angle distortion provided a dramatic effect. I was able to use the fencing strip as a point-of-reference for a straight horizontal line. However, I tilted the camera slightly too much, and consequently the strip looks a bit too curved and the photo looks unnatural.

There are some image-editing applications that easily let you adjust barrel distortion. ACDSee Pro, for example, has a lens-correction feature to let you adjust distortion; the only downside to using this is that when you adjust the image using the software, elements of the edges of the photo are cropped out (see 6-16). There are also plug-ins for Photoshop, such as PhotoFixLens from HumanSoftware (www.HumanSoftware.com) and Fisheye-Hemi from Image Trends (www.ImageTrendsInc.com), that let you adjust barrel distortion.

ABOUT THIS PHOTO *The center line of this image is actually the top of the spectators' heads. While not too off, I wanted to make the straight line (the fencing strip) a more obvious part of the subject. Taken with a 1D Mark II using a 15mm Fisheye lens, ISO 1250, 1/125 second at f/2.8. ©Serge Timacheff*

note The opposite of barrel distortion, by the way, is called *pincushion distortion*, where instead of the sides of the frame bulging out, they are pinched.

6-15

6-16

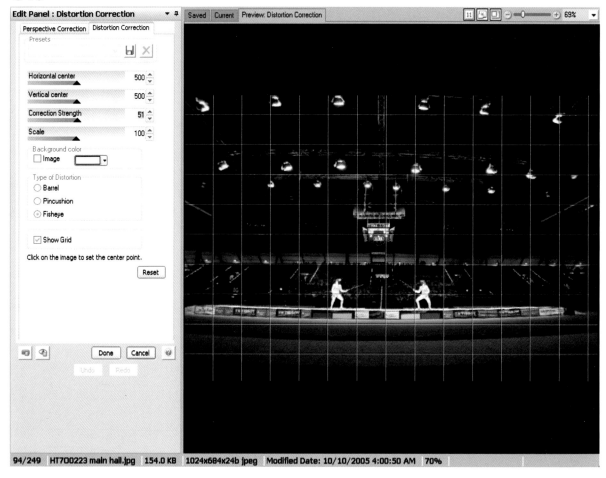

WIDE-ANGLE TIPS

Wide-angle shooting can be very practical whether you're photographing groups of people or a natural landscape. However, because of some of the inherent distortive effects of these lenses, you'll want to know some tips and techniques for making the most of wide-angle shooting:

■ When shooting a group of people with a wide-angle lens, allow for some margin in the shot so that no one looks distorted by being at the edge of the shot.

■ Think about a horizontal centerline in your image, and adjust how you are tilting your composition so that the center line is not bent. If the center of your image seems bent, tilt upwards or downwards (being cognizant of an increased upper or lower area in your shot).

■ When composing an image, if at all possible frame the image with nongeometric components such as sky, grass, water, and so on.

■ Remember that if you plan to use software to correct the barrel distortion, areas of your image will be cropped.

■ **Think about what will appear in the fore-ground, and how you might be able to emphasize that for effect.**

■ **Beware of flare!** With a wide view, you are more likely to have unwanted light intruding into your image as haze or aperture reflection. You may need to shade the light with your hand or a piece of paper, where it is still out of view.

■ **If you're using a lens hood, be sure it's the right shape and size for your camera.** Using an incorrect shade can cover some of your shot, or cause effects such as vignetting.

■ **If you need to use a flash, some of the Speedlites provide a special wide-angle panel.** This panel helps disperse the light over a wider area that can help your image be more fully illuminated, but it is not meant to be used with fisheye lenses.

■ **If you want an interesting way to take macro photos, use a wide-angle lens on natural subjects such as plants or insects.** Wide-angle lenses have very good depth of field and can focus at a very close range.

NORMAL LENSES

A *normal*, or *standard*, lens features a focal range where images look very true to life — what your eyes actually perceive. Neither wide-angle nor telephoto, these lenses are the most common type used for portraits, head shots, events, and general shooting to achieve natural-looking images with limited or no distortion (see 6-17). I use these lenses for taking sports event photos of medal ceremonies and general people shots; wedding photographers use them for receptions and formals;

ABOUT THIS PHOTO *I used a normal lens for this image of the French, Russian, and U.S. women's team sabre medalists from a 2007 fencing world cup in Las Vegas. Taken with a 1D Mark IIn using an EF 24-70mm f/2.8L lens, ISO 640, 1/160 second at f/2.8. ©Serge Timacheff*

school and portrait photographers use them for virtually all their images. A normal lens, whether zoom or prime, is an essential component of any dSLR photographer's set of equipment.

While the focal range of normal lenses can extend from a wide setting of 35mm to a narrow one of 70mm or larger, the most common normal setting and lens size is in the 50-55mm range. While a lens such as Canon's 24-70mm zoom extends from a reasonably wide to a near-telephoto range, its mean is (about) 50mm, which closely reproduces what the eye sees in terms of balance and proportion, as well as expanded/collapsed distance.

CANON'S NORMAL LENS LINEUP

Canon offers a very diverse set of normal lenses that you can get in prime and zoom models. Many zoom lenses that extend well into the telephoto range also have normal focal lengths, such as the EF 28-300mm f/3.5-5.6L IS USM. However, many photographers feel that the wider the focal range of a zoom, the more you end up compromising in various factors; for sure, you compromise in lens speed (for example, f/3.5-5.6) with such a broad range, even though this particular lens, being an L series model, has phenomenal quality. Zoom lenses tend to weigh more and be physically larger, also (see 6-18).

6-18 ABOUT THIS PHOTO
The size and weight differences between prime and zoom normal lenses can be significant. On the left is the EF 24-70mm f/2.8L USM zoom and to its right is the EF 50mm f/1.4 USM prime lens. ©Serge Timacheff

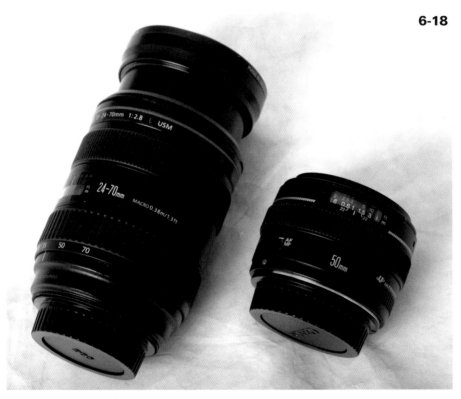

 note | Wide-angle lenses expand the perceived distance in a photo, while telephoto lenses collapse the perceived distance.

The EF 24-70mm f/2.8L USM lens is perhaps the most widely used lens by event and sports photographers working with this focal range; it is a workhorse lens with outstanding quality, speed, depth of field, and versatility. However, some photography purists swear by Canon's 50mm prime lens for ultra-high-quality portrait results; furthermore, you can get great results with low light and very narrow depth of field with the EF 50mm f/1.2L USM prime lens (but it comes at a lofty price!). For many photographers, the EF 50mm f/1.4 lens covers most of what they need to accomplish while still fitting into their budgets.

The Canon normal lenses that fall into the prime category include:

- EF 50mm f/1.2L USM
- EF 50mm f/1.4 USM
- EF 50mm f/1.8 II

The Canon lineup of normal zoom lenses includes the following (note that several of these extend into the telephoto range):

- EF-S 17-55mm f/2.8 IS USM
- EF-S 17-85mm f/4-5.6 IS USM
- EF-S 18-55mm f/3.5-5.6 USM
- EF-S 18-55mm f/3.5-5.6 IS
- EF 24-70mm f/2.8L USM
- EF 24-85mm f/3.5-4.5 USM
- EF 24-105mm f/4L IS USM
- EF 28-80mm f/3.5-5.6 II
- EF 28-90mm f/4-5.6 III
- EF 28-105mm f/3.5-4.5 II USM
- EF 28-105mm f/4.0-5.6 USM
- EF 28-135mm f/3.5-5.6 IS USM
- EF 28-200mm f/3.5-5.6 USM
- EF 28-300mm f/3.5-5.6L IS USM

As you can see, many of the zoom lenses range well into the wide and telephoto categories, so the type and style of images you're shooting, as well as your budget, will largely dictate which lens or lenses you need. If you shoot a variety of types of photography, my suggestion is to begin with the EF 24-70mm f/2.8L USM because it is high quality, fast, and versatile, as shown by the image in 6-19. Here I've used it as a portrait-type zoom lens, but I often shoot fencing matches with it, especially if I have to be very close to the action. It's a bit on the expensive side, but you will be able to do a lot with it. However, if you're specifically interested in serious, very high-quality portrait work, then I would begin by investing in a 50mm lens — preferably the EF 50mm f/1.2L USM model.

ABOUT THIS PHOTO *Normal lenses are great for portraits and have excellent depth-of-field features. This image, taken in natural afternoon light in St. Petersburg, Russia, uses a stone wall as a nonreflective, textured backdrop. Taken with a 1D Mark II, EF 24-70mm f/2.8L lens, ISO 125, 1/400 second at f/4. ©Serge Timacheff*

6-19

NORMAL LENS TIPS

Normal lenses give you the most natural representation of your subject and often become the workhorses of your glass lineup for day-to-day shooting. That said, you'll want to keep in mind some general tips and techniques for making the most of a normal lens:

■ **When possible, shoot with a shutter speed of at least 1/125 second if you're handholding the camera.** This produces the sharpest images — especially given most lenses in this range do not use image stabilization. If necessary, use a tripod and lock up your mirror (see the sidebar on image stabilization later in this chapter for more).

■ **If you don't already, shoot a normal lens with both eyes open.** You'll see that in 1:1 focal ranges, what you see through the lens is what you see through your naked eye. This will help you compose images and will reduce eye strain.

■ **Be very aware of your depth of field, especially with the fast 50mm lenses (f/1.2, f/1.4, and f/1.8).** You can get wonderful results, but if you're not careful, you may have significant areas of your image out of focus when that's not what you set out to shoot.

- **Keep your images simple.** With a 1:1 ratio, your image should have a very obvious subject without being busy. This is intuitive with a telephoto lens, but you might have to think about it when framing at 50mm.

- **Allow extra margin in your image, especially if shooting portraits.** This way, you'll be able to crop and adjust your image later to accommodate the aspect ratios of various print sizes (for example, 5 × 7, 8 × 10, and so on).

- **If you're using a fast 50mm lens, or an f/2.8 zoom, use as low an ISO setting as possible to reduce noise.** These apertures will let in lots of light, so your image quality will be much better with a lower ISO.

TELEPHOTO LENSES

Telephoto lenses are perhaps Canon's most distinctive products, easily recognized wherever they are used. Whether it's a group of photographers at the Olympic Games or on the sidelines of the Super Bowl, photojournalists at a presidential press conference, or camouflaged war photographers in a battle zone, the long, white barrels are ever prevalent and always noticeable in every important and prominent event involving photography.

A *telephoto* lens is not always a zoom lens, although the terms are frequently used interchangeably. A telephoto lens can be a prime, or fixed, device, or it can be a zoom that ranges between minimum and maximum focal lengths. Telephotos, however, always magnify distance to make it seem closer than it is; furthermore, the longer the distance they magnify, the more compressed the images appear. They are excellent at creating narrow depth-of-field shots from far away,

as in 6-20. The amount of telephoto magnification you need depends on how close you can get to your subject. If you're shooting at the sidelines of a football game, for example, you'll need a lens that's at least 300mm or more; pro field sports (for example, football and soccer) and wildlife photographers often use super-telephoto lenses of 400mm or higher because it is more difficult to get close to their subjects. On the other hand, if you're using a telephoto lens at a wedding, you probably won't need it to be longer than 200mm.

6-20

ABOUT THIS PHOTO *Taken at the Great Pyramids in Egypt with a telephoto zoom lens while at least 30 or more yards away. 1D Mark IIn, EF 70-200mm f/2.8L lens, ISO 100, 1/640 second at f/9. ©Serge Timacheff.*

Many telephoto lenses integrate Canon's innovative IS, or Image Stabilizer, technology to ensure sharper images. The longer the lens, the more shaky it can be, even at shutter speeds where you could easily and stably hold a normal or wide-angle lens — such as 1/125 or 1/250 second. If you've ever watched a space shuttle launch on TV, where they use *very* long super-telephoto lenses with video cameras, you've undoubtedly seen the shakiness even when those cameras and lenses are being tilted smoothly on a tripod. Your telephoto lens benefits from the IS feature, especially with longer exposure times. With the IS turned on, you can put your ear against the lens and depress the shutter release to the metering point and actually hear the motor whirring. This is a proprietary Canon gyroscopic technology using two vibration gyros to take measurements and a microcomputer to actually shift optical elements in the lens at an inverse ratio to the lens movement. This keeps the position of incoming light stable, preventing blur.

Some of the Canon telephoto lenses, such as the EF 70-200mm f/2.8L IS USM, also include a switch that lets you limit the focal range at the minimum focusing distance. For example, it lets you set the minimum distance from 1.3 meters to 3 meters; this actually speeds the lens's time to autofocus given it doesn't have to gauge as much of the lower range. Natural-looking shots are possible with telephoto lenses, as well, as long as there is not too much depth in the image (which compresses it). It's very possible to take natural, normal-type shots with a telephoto lens with the right exposure and settings, such as in figure 6-21.

ABOUT THIS PHOTO
Often I cannot get close enough to subjects at medal ceremonies, so I must use a telephoto zoom, such as this photo of medalists at the 2006 World Fencing Championships in Torino, Italy. Taken with a 1D Mark IIn, EF 70-200mm f/2.8L lens, 550EX flash, ISO 320, 1/160 second at f/4.
©Serge Timacheff

There are numerous choices you need to make, and questions you want to ask yourself, when choosing a telephoto lens:

- How far away are the subjects I need to shoot?

- Can I use a shorter telephoto lens for most of my work, and occasionally use a lens "extender" to get more focal range if I need it, and to save money?

- Will I need to zoom in and out of subjects quickly, or can I use a prime lens?

- Will images I take be in low light, or can I use a slightly slower telephoto lens?

- How important is the Image Stabilizer technology for my work?

- What is the range compared with my other lenses — is there an overlap or not?

 x-ref For more on lens extenders and other accessories, see Chapter 7.

CANON'S TELEPHOTO LENS LINEUP

Including medium telephoto, telephoto, telephoto zoom, and super-telephoto, Canon offers telephoto lenses for virtually any photographic application where you need to get closer to your subject without moving. Figure 6-22, taken at the 2004 Athens Olympic Games, was shot with a telephoto lens; the athlete, USA's Mariel Zagunis, had no idea I was taking the shot because of my distance from her — which is often very useful for both photographers and athletes.

In the medium telephoto category, Canon offers these prime lenses:

6-22

ABOUT THIS PHOTO *If you need to get close to a subject but it's physically impossible to do so, a telephoto lens will do the trick. This athlete had no idea I was taking this photo at the Olympic Games, but it looks like I'm directly in front of her. Taken with a 1D Mark II, 70-200mm f/2.8L lens, ISO 400, 1/250 second at f/3.2. ©Serge Timacheff*

- EF 85mm f/1.2L II USM
- EF 85mm f/1.8 USM
- EF 100mm f/2 USM

In the straight telephoto category, Canon offers these prime lenses:

- EF 135mm f/2L USM
- EF 135mm f/2.8 with Softfocus
- EF 200mm f/2.8L II USM
- EF 300mm f/4L IS USM

Softfocus is a two-setting lens feature that provides soft-focused shots that, while soft-looking, are not blurry. The lens also takes sharp, nonsoft photos as well.

Canon's telephoto zoom category includes the following lenses (you can also review the list of normal zoom lenses as several of those extend into the telephoto range):

- EF 55-200mm f/4.5-5.6 II USM
- EF 70-200mm f/2.8L IS USM
- EF 70-200mm f/2.8L USM
- EF 70-200mm f/4L IS USM
- EF 70-200mm f/4L USM
- EF 70-300mm f/4-5.6 IS USM
- EF 70-300mm f/4.5-5.6 DO IS USM
- EF 75-300mm f/4-5.6 III USM
- EF 75-300mm f/4-5.6 III
- EF 80-200mm f/4.5-5.6 II
- EF 100-300mm f/4.5-5.6 USM
- EF 100-400mm f/4.5-5.6L IS USM (see 6-23)

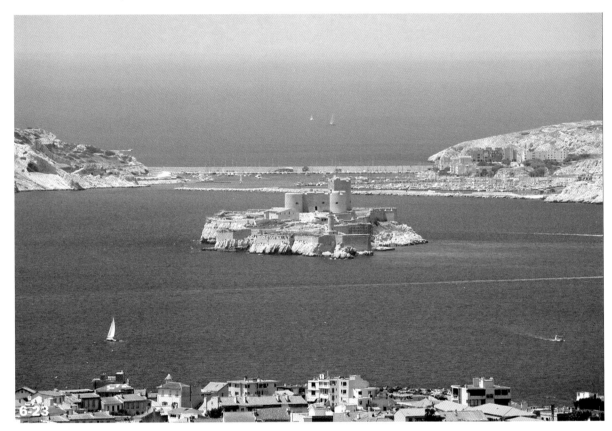

6-23

ABOUT THIS PHOTO *Photos of wide areas, if you are far enough away, require the use of a telephoto lens, such as this image of Marseilles, France, and the famous Chateau d'If. Taken with a 1D Mark IIn using an EF 100-400mm f/4.5-5.6L IS lens, ISO 100, 1/1250 second at f/6.3. ©Serge Timacheff*

note DO in the lens designation stands for diffractive optics, which makes a lens very compact for having such a long focal range. This is accomplished using Canon optical technology to reduce size and increase image quality. If size is a primary issue for you, this lens is an interesting option.

In the super telephoto category, Canon offers these prime options:

- EF 300mm f/2.8L IS USM
- EF 400mm f/2.8L IS USM
- EF 400mm f/4 DO IS USM
- EF 400mm f/5.6L USM
- EF 500mm f/4L IS USM
- EF 600mm f/4L IS USM

TELEPHOTO TIPS

Telephoto lenses can get you close to the action without getting in the way. Here are some general tips and techniques for making the most of a telephoto lens:

- **Remember that using a telephoto lens makes it harder to hold your camera steady.** If you have it, turn on your lens's Image Stabilizer feature, and shoot faster shutter speeds.

- **In addition to IS, use a tripod or, if you're moving around a lot, a monopod.** This reduces arm fatigue from using a heavier lens-camera combination.

GETTING CRISPER IMAGES WITH IMAGE STABILIZATION Canon's IS technology has become the *de facto* standard of image-stabilization features in photography, providing ultraquiet and highly effective stabilization and camera-shake elimination. It's generally thought that most people can stably hold a camera shooting at speeds of 1/250 second or faster; an experienced photographer with a strong arm should be able to hold a camera without shaking down to 1/125 or even 1/60 second — and even, on occasion and with a little luck, down to 1/30 second (but it's not easy).

Image stabilization helps photography at any of these speeds, especially with longer telephoto images. In some cases, and at shorter ranges, image stabilization will allow you to shoot down to 1/15 second without any visible blur — assuming you're pretty stable to begin with (remember, too, that if your subject is moving, such as if you're taking sports images, it's more difficult to take a steady shot because you're moving the camera). According to Canon, using image stabilization allows you to shoot stable images three shutter-speed increments faster than you otherwise could.

I don't suggest relying on image stabilization alone, however; you may need other help as well. Using a tripod, or a monopod if you're moving around a lot, is a good way to complement image stabilization on longer shots. With a monopod, you should be able to get the 1/30 second images with a little practice. With a tripod, obviously, you can take as long an exposure as you like.

- **Consider a DO lens if you don't have a lot of arm strength.** These are ideal if you need to take frequent telephoto shots because they are much smaller and lighter.

- **If you're using a tripod, make sure it's heavy-duty enough to support your camera and lens.**

- **For long telephoto lenses, use the lens-mounted tripod mount.**

- **Hold your camera and lens correctly for the most stable image.** Place your left hand *underneath* the lens, not on the top of it. This is how your camera and lens were designed to be held, and is the most ergonomically correct position.

- **It's easy to shoot tight shots with a telephoto lens, but be careful not to shoot too tight.** Remember that you may need to crop later to fit various print-size aspect ratios, so think about leaving a little margin in your shots.

- **If you're using a variable-aperture zoom lens, don't forget that when you zoom out your f-stop changes.** Especially if you are shooting in manual mode, you'll need to adjust your speed and/or ISO accordingly.

- **Shooting with a flash and a telephoto lens can be tricky, because the effectiveness of the flash isn't designed for great distances.** Remember the Inverse Square law when shooting flash images.

 x-ref
For more about the Inverse Square law, see Chapter 8.

MACRO LENSES

Close-up, or macro, photography requires a lens that is either dedicated to functioning at a close range or that has the ability to take short-distance images along with other features. Several Canon lenses offer a macro function either as an option to other capabilities or as their primary purpose, and they vary according to how specialized you want to be with this unique type of photography.

The primary difference between the various types of macro photography is how far you can be from your subject and how much magnification the lens provides. If you are shooting insects, for example, which in many cases won't let you get a foot or less away from them to shoot, you'll probably need a longer lens to capture them alive in their natural habitat. On the other hand, if you're shooting something that will stand still for you — such as a flower or a small product for a catalog — you can get closer and you won't need a long lens. As for magnification, being able to fill a frame with a close-up image is essential to producing high-resolution images.

CANON'S MACRO LENS LINEUP

Macro lenses vary according to focal length and for the magnification level they can reach; for example, my favorite is the Canon MP-E 65mm f/2.8 1-5x Macro Photo, a dedicated macro lens that can shoot up to five times life-size (1:1) (see 6-24). This means if you adjust it to its maximum macro magnification level (5x), you can get an ant to literally fill your frame. It has outstanding image quality and resolution. And, because it can shoot up to .24 meter (.8 foot) from the subject, you can get *very* close to your subject and still be in focus.

Considering factors of magnification and focal length, the next thing to consider is the actual quality of the macro lens, which of course equates to its price. Of the five lenses with a macro designation in their name, Canon considers the EF-S60 to be the best entry-level model that also functions as a general purpose lens, followed by the EF-50; both of these lenses are reasonably affordable, and the EF-S60 has the most versatile range for a large variety of shooting. From there, you can move up to more specialized capabilities depending on the type of shooting you do and your budget.

For this section, I include a little more information for lenses than in the other focal length sections, because you may want to know about the specifications in more detail (for example, the minimum focusing distance).

The Canon macro lens lineup includes:

- EF 50mm f/2.5 Compact Macro

 > Focusing from infinity to one-half life-size (0.5x)

 > Closest focusing distance: .23 meter (.8 foot)

 > Optional Life Size Converter EF that allows focusing down to life size (1:1), which significantly increases working distance

 > Compatible with Macro Ring Lites and Macro Twin Lite

- EF-S 60mm f/2.8 Macro USM

 > Optimized for EOS 20D, EOS Digital Rebel, and EOS Digital Rebel XT (as with all Canon EF-S lenses, check for updates — Canon updates lenses and camera compatibility frequently)

ABOUT THIS PHOTO
The textured center of a Gerber daisy was captured using the powerful MP-E 65mm f/2.8 1-5x Macro Photo lens and the MT-24EX Macro Twin Lite (on a tripod). Notice the extremely shallow depth of field. Taken with an EOS Digital Rebel XT at 1/2 second, f/4.5, ISO 100. ©Cricket Krengel

6-24

> Closest focusing distance: .2 meter (.65 foot)

> Compatible with Macro Ring Lites and Macro Twin Lite

- MP-E 65mm f/2.8 1-5x Macro Photo

 > Unique, manual focus lens designed specifically for macro photography

 > Ranges from life-size (1x) to 5x

 > Closest focusing distance: .24 meter (.8 foot)

 > Compatible with Macro Ring Lites and Macro Twin Lite (eliminates need for bellows accessories used by many macro photographers)

- EF 100mm f/2.8 Macro USM

 > Inner-focusing lens, which allows a long working distance (5.9 inches) at 1x (life-size)

 > Closest focusing distance: .31 meter (1 foot)

 > Compatible with Macro Ring Lites and Macro Twin Lite

- EF 180mm f/3.5L Macro USM

 > L-series lens, meaning very high-quality optics and minimal aberrations caused by changes in focusing distance

 > Allows life-size (1x) images to be taken at farther distances

 > Closest focusing distance: .48 meter (1.6 feet)

 > Compatible with Macro Ring Lites and Macro Twin Lite (requires Canon Macro Lite Adapter 72C)

UNDERSTANDING MAGNIFICATION AND SUBJECT SIZE

Because macro lenses vary greatly in focal length, and also because many other nondedicated lenses include a macro capability, it's good to understand when, where, and why you would use these different types of lenses.

Dedicated macro lenses let you focus at a 1:1 ratio or better, meaning you can get ultrasharp focus at close range where your tiny subject fills the frame. The shorter focal lengths, such as the 50mm, are what you want to use if you're shooting smaller objects, commercial items (such as for a catalog), or details of larger things (such as the dashboard on a car).

The mid-sized macro lenses, such as the 65mm-100mm range, are good for the smallest-of-the-small subjects, including insects, ultra close-ups of nature in general, jewelry, and so on. This is the most common focal range for a macro lens, and these lenses offer the most versatility.

The longer macro lenses, such as the 180mm, are designed to shoot small to slightly larger objects and nature — but, more importantly, to give you the luxury of having a little extra distance between camera and subject.

You can approximate some of these macro capabilities with zoom lenses featuring a macro function, but they typically do not produce a 1:1 image. While acceptable for some general shots, if you're interested in macro photography professionally, you'll find that they ultimately prove insufficient.

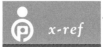 *x-ref* In Chapter 8, I discuss various types of flashes that are specifically designed for macro photography.

TAKING CLOSE-UP SHOTS

Shooting a macro image brings into play some different issues from a standard image at a normal focal length and distance from your subject. As I mentioned earlier in this chapter and as detailed in Chapter 8, using a flash with a telephoto can be difficult because the distance your subject is from the flash is too far for the flash to be effective, and the result is an underexposed image.

Conversely, with a macro image, you are *so* close to your subject, you can easily overexpose it with a flash — or even fire the flash so that it goes over the subject and the light can't effectively reach it. At the very least, if you're using a conventional flash, you need to think about where your subject is in relationship to the lens and the flash. If it's in the flash's direct line of light, then you will likely need to lower the power of the flash. If you're shooting over your subject, then you may want to "bounce" the flash on the ceiling or other surface so that you can get light on it more directly.

Depth of field is serious consideration for macro photography. Are you shooting to show all of a given subject — such as the entire body of an insect — or are you just closing in on a specific detail, such as a diamond in a ring, where the stone and setting are focused but the ring itself is soft? At close range, you can easily get something out of focus when you didn't want that, so you need to be very aware of your aperture setting; depth of field is a significant concern in your composition. Shooting with your camera set to Aperture-priority is very helpful to control depth of field; I don't suggest shooting in Program or Automatic mode when you need to control depth of field.

In macro photography, magnification also affects your depth of field. The more magnification, the shallower the depth of field regardless of your aperture setting. So a lens such as the MP-E 65mm f/2.8 1.5x Macro Photo, which can magnify up to five times, will create very shallow depth-of-field images at increased magnification levels.

If you're shooting something over which you have control, such as a commercial product shot, and you have good lighting equipment, you might want to consider setting up an area where you can carefully position and light your subject. You can even use museum wax, commonly available at art and craft stores, to anchor what you're shooting; it won't damage anything and you can move it around without having overly visible supports. I often use something called a cocoon, which is a translucent container that I can zip open and place things inside to shoot; I can then direct light at the cocoon, which creates a seamless, evenly lighted environment. It also helps reduce the harshness and hard edges of direct flash. These are available commercially from major professional photography dealers such as adorama.com.

If you don't have control over your subject — such as when shooting bumblebees on flowers — then you need to position yourself in such a way that you can get as close as possible without disturbing the natural habitat or scaring the subject away. Using a tripod or other camera-mounting device along with a remote-control shutter release is often useful so that you can keep as still as possible, as well.

MACRO TIPS

Taking macro images can be some of the most interesting and challenging photography you'll find. Here are some general tips and techniques for getting the most out of a macro lens:

- **At close range, there's no room for error.** Make sure your focus and exposure are precisely what you want.

- **Remember that your flash may be too much for your subject, so you may have to manually reduce the flash power.**

- **Alter the angle of the shots, as much as you can, given whatever limitations your subject provides.** At close range, you'll find that different angles can provide vastly different perspectives.

- **Remember to watch depth of field!** Use Aperture-priority to control how much of your image is in (or out) of focus.

- **If you'd like more depth in your image, use angled lighting — just like shooting early or late in the day.** This brings out texture and relief in your subject.

- **Be aware of your background: Does it distract from or complement the photo?** Blurred, colored backgrounds often make the best backdrop for a simple subject.

- **Remember that with increased magnification, your depth of field will become shallower — regardless of aperture settings.**

- **Watch for motion issues and camera shake.** You may want to use the mirror lockup in order to ensure there's no vibration.

- **Shoot at as low an ISO as possible to eliminate any and all digital noise.**

- **Get close and experiment.** Keep the photos interesting with a clear subject, but don't be afraid to close in on details of a small subject.

TILT-AND-SHIFT LENSES

Imagine being able to take a lens in your hand and move it around until it gives you precisely the angle and view that you want, including the depth of field and emphasis on various foreground and background elements. This is essentially what the controls on tilt-and-shift lenses allow you to adjust — you can change various geometric optical factors common to and frustrating with other lenses. Have you ever tried to take a photo of a building and been frustrated by converging edges of walls that make it look angled instead of straight? Tilt-and-shift lenses correct that effect, working to realign images by changing trapezoidal angles on a focal plane, and, in some cases, virtually eliminating geometric aberrations and convergence — which is why architects, in particular, love them. The lenses use a very special, precision, floating optical system.

While often used in wide-angle types of shots, tilt-and-shift lenses actually come in a variety of focal lengths. Canon's are available in three focal lengths:

- TS-E 24mm f/3.5L

- TS-E 45mm f/2.8

- TS-E 90mm f/2.8

Canon tilt-and-shift lenses only offer manual focusing (which is why they do not feature an EF in their names) and you can tilt the axis of the lens's focal plane as well as shift perpendicular to the axis using small knobs on the lens (see 6-25). Essentially, they carry the simple effect you can get by tilting a wide-angle lens, eliminating the bending of the center line to a much greater extent to affect a variety of lines throughout the image. For example, you could straighten vertical

6-25

ABOUT THIS PHOTO *The Canon TS-E 24mm f/3.5L tilt-and-shift lens. Note the tilt knob on the top of the lens and the shift knob on the side. ©Serge Timacheff*

lines on the side of a building, effectively eliminating convergence, or you could flatten a horizontal line across the image, such as the one of the fencers shown earlier in figure 6-15.

Tilt-and-shift lenses also let you play with the depth of field in an image, extending it by changing how the lens is focusing so that even with a wide aperture, you can adjust the axis of focus to various nonstandard elements of the photo.

Why would you use a tilt-and-shift lens? You would if you're trying to take a photo of a house or building, for example, and you want to get as much of it in the image as possible without suffering from the bent edges typical in a wide-angle shot that would

get cut out in image editing. Or you may have a straight element in one corner of an image — say, for example, a street sign — that you want to appear straight while a building or other element in another part of the image needs to remain equally undistorted. Normally this would take layering in Photoshop or another program in order to overcome the effect; with tilt-and-shift, the original image can be corrected when it's shot.

> *tip* For an excellent interactive description of tilt-and-shift lenses, go to the Canon Professional Network online at Canon Europe (http://cpn.canon-europe.com/content/infobank/lenses/tilt_and_shift_lenses.do).

Assignment

Exploring the Same Subject with Different Lenses

In this assignment, use the most extreme ranges your lenses can manage and shoot two frames of the same subject. For example, if you have an EF 20mm wide-angle lens and an EF 70mm-300mm zoom telephoto lens, you'll be shooting one image of the same subject at 20mm and another at 300mm.

Select a small subject that is stable and nonmoving, such as a plant, something in your yard, or an element of a building. It can be almost anything so long as you can replicate the photo while you change lenses and move around. Then get ready to shoot the object at close range with the widest angle your lens collection has to offer.

Download the two images to your computer. What are the differences that you see between these images? Are there any? Is the depth of field different? Does the telephoto image seem more compressed than the wide-angle shot? Post the images and list the lenses or lens settings used. Also include which image you prefer and why. For the left image I used an EF 70-200mm f/2.8L lens at a focal length of 200mm. The image on the right was taken with an EF 24-70mm f/2.8L lens at a focal length of 24mm. Both shots were taken at 1/250 second at f/8, ISO 250.

 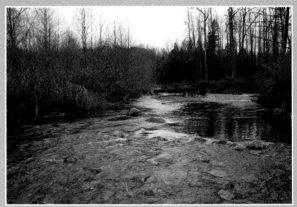

©Serge Timacheff

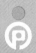
Remember to visit www.pwassignments.com when you complete this assignment and share your favorite photo! It's a community of enthusiastic photographers and a great place to view what other readers have created. You can also post comments and read other encouraging suggestions and feedback.

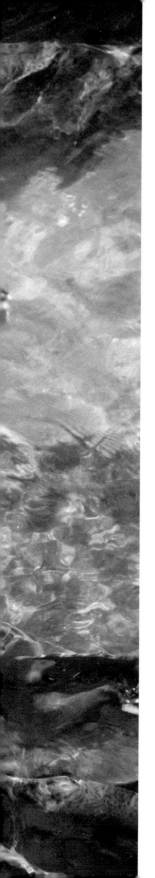

©Michael A. Johnson

As with cameras, lenses can be complemented by a variety of accessories that improve, extend, and or alter their performance. A variety of products exist that you may want to consider, depending on how and when you are using your lenses.

Additionally, a number of products have been designed to help you care for lenses and keep them in top condition. Fortunately, Canon lenses are remarkably durable and able to withstand rigorous use anywhere in the world. However, it's worth knowing how to ensure they work at their peak capability and provide you with the best-possible image quality.

EXTEND THE RANGE OF L SERIES LENSES

Suppose you've invested in a Canon EF 200mm f/2L IS USM lens, and you're finding that you'd like just a little more length on the focal length. One good option, barring going out and buying a longer lens, is to consider one of Canon's lens *extenders*. These are small devices that you mount to your camera just as you do a lens, and then you mount your lens onto them.

Canon offers two extenders that effectively extend the range of your lens by factors of 1.4x and 2.0x, the Extender EF 1.4x II and the Extender EF 2x II,

ABOUT THIS PHOTO
*The Canon Extender EF 2x II attaches in-between your lens and camera and increases the lens's range by a factor of two. The extender in this photo is attached to the base of an EF 70-200mm f/2.8L lens.
©Serge Timacheff*

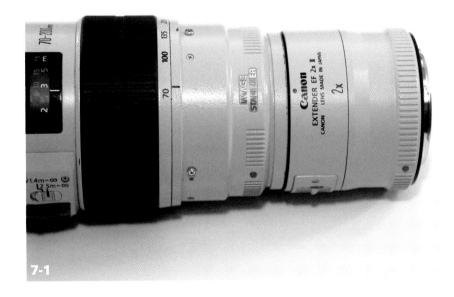

7-1

shown in 7-1. Thus, you can extend the focal range of your 200mm L-series lens to 280mm with the 1.4 extender and to 400mm with the 2.0 model — at a fraction of the price of buying a new lens.

These Canon extenders can be used with a variety of both fixed-focus and zoom lenses, including the following:

- EF 70-200mm f/2.8L
- EF 70-200mm f/2.8L IS
- EF 70-200mm f/4.0L
- EF 70-200mm f/4.0L IS USM
- EF 100-400mm f/4.5-5.6L IS
- Any fixed-focus lens that is 135mm or longer (except for the 135mm f/2.8 Softfocus)

With an extender attached, the lens operates normally with a couple of notable exceptions. The autofocus will operate with any EOS body as long as the lens has a maximum aperture of f/2.8 or faster for the 2.0 extender and f/4.0 for the 1.4.

| note | Lenses with an image-stabilization capability maintain the feature even with an extender. |

The most significant tradeoff, however, is that using an extender reduces the lens aperture rating by one stop for the 1.4x and two stops for the 2.0x model. If you're a photographer who shoots fast subjects in low light, you may find this an unacceptable degradation of lens speed.

Other than these factors, the extenders operate optically very well and feature the same weather-resistance and antireflection internal construction as other L series lenses (which is new in the II models). And their small size makes carrying them an easy option for getting a lot more out of your lenses without having to carry another big lens.

CONSIDER A CLOSE-UP LENS

Close-up, or macro, photography requires either a lens dedicated to functioning at close range or one that has the ability to take short-distance images along with other features. Several Canon lenses offer a macro function either as an option to other capabilities or as their primary purpose, and they vary according to how specialized you want to be with this unique type of photography.

The primary difference between the various types of macro photography is how far you can be from your subject. If you are shooting insects, for example, which in many cases won't let you get a foot or less away from them to shoot, you'll probably need a longer lens to capture them alive in their natural habitat. On the other hand, if you're shooting something that will stand still for you — such as a flower or a small product for a catalog (see 7-2) — you can get closer and you won't need a long lens, which is often more expensive. With these factors in mind, the next thing to consider is the actual quality of the macro lens, which of course will have a strong bearing on its price.

Of the five lenses with a macro designation in their name, Canon considers the EF-S60 to be the best entry-level model that also functions as a

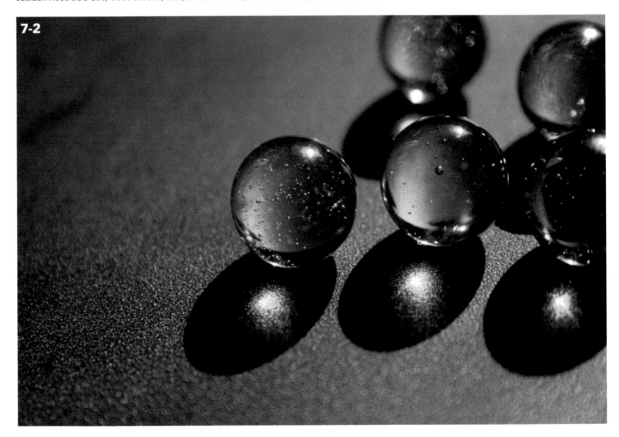

7-2

general purpose lens, followed by the EF-50; both of these lenses are reasonably affordable, and the EF-S60 has the most versatile range for a large variety of shooting. From there, you can move up to more specialized capabilities depending on the type of shooting you do and your budget.

CONSIDER A FILTER

Using filters is a great way to extend the functionality of your lens, whether you're adding a special effect, eliminating hazy conditions, or optimizing sunlight using polarization (filters are covered in more detail later in the chapter).

However, the way you attach a filter to your camera lens varies depending on the lens size.

For most lenses up to about 200mm in focal length, you can purchase a screw-mount filter that attaches to the end of your lens. You purchase filters according to the size (measured in millimeters) of the *diameter* of your lens — *not* the focal length. For example, if you're buying a haze filter for the Canon EF 24-70mm f/2.8L USM, the size for a filter for that lens is 77mm, which is the diameter of the camera's lens at the end where threads exist to attach the filter.

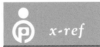

x-ref For a detailed look at the specifications on macro lenses, see Chapter 6.

For very large lenses, such as the Canon EF 500mm f/4L IS USM, the diameter at the front of the lens is far too large (5.8 inches) to accommodate a screw-mounted filter. Instead, these lenses include a special drop-in compartment close to the rear of the lens that holds the filter (usually 48 or 52mm size) and a filter holder.

Other types of filter holders for big lenses, which are often included/integrated with the lens, support square filter *gels*, which are optical gel materials that you simply slip into the holder to create the desired effect.

> *tip* You can also mount larger lenses to monopods — something you see very frequently at sports events, for example. It is often much easier to carry the camera and lens this way.

CONSIDER A TRIPOD MOUNT FOR SPECIALTY LENSES

Every camera comes with the ability to be mounted to a tripod using the screw mount on the bottom of the body. However, when using larger lenses, which place a significant amount of weight onto the overall camera and lens combination, having a tripod or monopod attached to the bottom of the camera body isn't the best point at which to balance the camera because of the lens's forward weight. By mounting the lens to the tripod instead of the camera body, it makes the camera and lens more stable and less likely to tip over.

Most larger Canon lenses, and even some of the medium-large ones such as the 70-200mm f/2.8L USM EF model, include a tripod mount with the lens, as shown in 7-3. You can also purchase tripod mounts separately. Tripod mounts are detachable in case you don't want to use them or if you need to make the lens more compact for transport.

ABOUT THIS PHOTO
When using a telephoto lens as large as this one, the EF800 f/5.6 IS, it's essential to use a tripod or monopod attached to the lens's tripod mount to obtain stable images — even with the Image Stabilizer feature. Additionally, the lens's length makes the tripod mount a necessary balance point, where using the mount on the camera would not be practical (and could even damage the camera's screw mount). Photo courtesy of Canon USA.

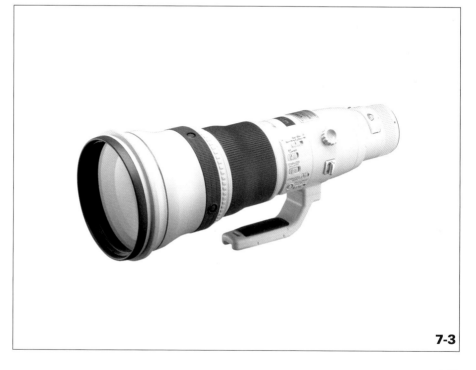

7-3

Lens tripod mounts are attached to a clamped, rotating ring that holds onto the lens (and that can be removed). This actually gives you an advantage by allowing you to rotate the camera and lens on the tripod (such as for vertical shots). To achieve the same thing using the camera body mounted to the tripod would require you to rotate the tripod head, which would be very cumbersome with such a large lens.

 caution When using a tripod mount ring on a larger lens, be sure it is tightly secured. Rings turn easily if not properly attached, and some types can even open completely, potentially causing the camera to fall.

FILTERS WORTH CONSIDERING

Lens filters — whether they're dropped in at the back-end of a long super-telephoto lens or screw-mounted onto the front of the most common lenses — can be very useful for a variety of photographic purposes and can even save you a lot of money in the event of a lens accident. From colored filters to creative-effects filters to clear filters designed to reduce environmental haze, there are many types available for your Canon dSLR (see 7-4). The next sections take a look at some of the more common filters and why you might want to give them a try.

OKAY PHOTOGRAPHERS, MOUNT UP! The photography world is rife with clever inventions and devices allowing you a great amount of versatility to configure and mount cameras and lenses on virtually anything, from a car window to a tree. For example, the oddly named Groofwin Pod (it stands for "ground-roof-window") gives you a highly stable platform to photograph from while attached to a car window or a vehicle roof or rack, or placed on the ground. This is really useful if you're on a photo safari in Africa where most of your shooting is done from a vehicle, for example, and is a good alternative to other specialized heads onto which you mount your camera on a car window.

When you dare venture out of the car to photograph the lion's pride, you'll probably want to climb a tree and use the Joby Gorillapod — which provides a way to wrap flexible, gripping tripod legs around virtually any object. Then there's the Sticky Pod Camera Mount, which uses industrial-strength suction cups to anchor your camera to the side of a moving vehicle — even a boat or airplane (it's even been tested on a drag racer).

One of my favorite items is a convertible monopod-to-tripod; there are several designs available primarily from Bogen-Manfrotto that allow three feet to slide out and expand from the bottom of the monopod. While this isn't as stable as a conventional tripod, it is very useful when traveling and for giving your wrist an occasional rest while holding a camera on a monopod for long periods.

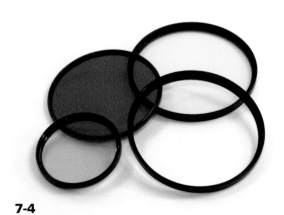

7-4

ABOUT THIS PHOTO *Filters can protect your lens and create a variety of effects in your photos. Here, pictured clockwise from red: Red and yellow (K2) filters used primarily to enhance contrast and tonality in black-and-white images; a UV/haze (clear) filter used to reduce haze and as basic lens protection; and a warming filter that is very helpful in portraiture to warm the skin tones of your subject. ©Serge Timacheff*

PROTECTIVE AND UV/HAZE FILTERS

Basic *protective* filters, also known as neutral filters, offer no additional protection or filtration for your lens. They are made of pure optical glass and are widely available from various filter manufacturers such as Tiffen and B&W. Note that technically these are not actually filters because they aren't filtering anything, but they usually are grouped with filters.

While a basic protective filter does protect your lens, you may find that using a *UV/haze* filter is more useful because it also slightly improves a hazy image by removing some of the nonvisible (ultraviolet) effects of sunlight that, when exposed to a camera, records as a bluish hue in your image. Additionally, you can buy a haze filter and a UV filter separately, but really the two are essentially the same. You can use UV/haze filter on your camera

virtually all the time without any detectable effect to your images. The other good thing about UV is that if your lens has any chromatic aberration, this filter will help colors be truer.

Both clear protective and UV/haze filters can act more as a protective device for your lens than anything else, keeping dust and moisture out, preventing scratches, and breaking on impact instead of your lens being damaged. For example, a few years ago I suffered a lens incident with a wide-angle lens while stopping my car on the side of the road to shoot a particularly stunning landscape in northern California. The lens I thought I had safely set onto the hood of the car suddenly slid off and onto the asphalt with a sickening crunch.

I thought the lens was totaled. However, on closer examination, it turned out that the protective UV/haze filter I had mounted to the front had taken the hit, and had shattered. I carefully removed the filter ring and broken glass, gently cleaned the glass shards off the lens so as not to mar the protective coating, and used a bulb-blower to get rid of anything I couldn't see. I then used a liquid lens cleaner to wash anything off that I still hadn't gotten before using a lens cloth. The lens suffered no damage at all. The filter served as a crash helmet for my lens, taking the hit instead of the lens itself — and saving me a lot of money.

Some studio and fine art photographers choose not to use any filters, including protective ones, so as to eliminate any variables that could potentially get in-between the subject and the image sensor. However, unless you are one of these specialists (or you have a limitless lens budget), I don't believe the difference is noticeable enough for most photographic applications to warrant going without the protection.

SKYLIGHT AND WARMING FILTERS

A *skylight* filter helps you moderate what can be too much blue in your image, especially on sunny days with an excessive amount of blue sky. It's a subtle effect, providing just enough filtration to your image that the color is much better balanced; it is especially effective in a shady area under a cloudless, blue sky. While UV/haze filters are clear, skylight filters have a slight pinkish tone to them, which is what helps to offset too much blue in a photo taken on a very sunny day, for example. Like UV/haze filters, photographers often keep skylight filters on their cameras nearly all the time, especially if they shoot outdoors frequently; however, it's uncommon to have both types on a lens at the same time.

A *warming* filter will also cut some of the blue color in an image, especially when it's taken outdoors in sunny weather — which gives the colors in your photo a warmer, more balanced effect. It's especially effective in cloudy conditions, however, or in a shaded area on a sunny day. And, it provides additional warmth to a portrait and helps alleviate the bluish tone you sometimes get in a flash-illuminated image.

POLARIZING FILTERS

Polarizing filters are like sunglasses for your camera (see 7-5), and they are one of the few filters that feature the capability to rotate one of the two optical elements to achieve the best effect. A polarizer reduces the glare in an image, while improving the contrast in your photo. Colors appear more saturated and even a little more clear, depending upon the point to which you rotate the glass.

These filters are quite fun and can be very useful, especially for improving images that include water and/or sky — although they can be used to the point that the effect is almost too pronounced and the world begins to look artificially enhanced.

ABOUT THIS PHOTO *Polarizing filters eliminate glare and emphasize water and sky. This filter includes two layers of glass, one of which rotates so that you can adjust the various levels of polarization effect in your image. ©Serge Timacheff*

7-5

Polarizing filters work differently depending on the angle of the sun and how it's hitting your lens. You see the greatest effect of a polarizing filter when your subject is at a right angle to the rays of the sun; the more direct the sunlight, the less the effect. So if you have the luxury of changing your position when shooting, be aware that the sun's position will also change in relation, meaning that you'll want to use a different rotational setting on your polarizing filter.

When looking for a polarizing filter, you will find that there are two types: linear and circular. Circular polarizing filters are what you want to use exclusively with your dSLR. Linear polarizers are used with film cameras in manual focus; used in a modern digital camera they can cause incorrect auto focusing and metering.

One thing to note: It's difficult to use a rotating polarizing filter with a lens hood because you may need to physically turn the filter. To do so, you have to remove the hood, turn the polarizer to the point where you want it, and then replace the hood.

COLORED FILTERS

There are a number of filters that provide varying levels of color that can affect your image. While many of the colored filters were designed originally to filter colors that would be rendered onto film, today's digital capabilities — both in the camera and the software — mitigate the need to use them. One of the most obsolete filters today is the tungsten filter, which of course was used to help the color effects of tungsten light onto conventional film. Now this is simply a white-balance setting in your camera.

Some color filters, however, can be useful and fun to use. An extreme version of the skylight filter is the yellow, or K2, filter. This slightly yellow filter

dramatically increases contrast in an outdoor image, especially among clouds, landscape, and sky. You can also use it for shooting people to achieve a more natural skin tone.

The G filter is orange, and is especially useful when you're using a telephoto lens and shooting sunsets. It increases the contrast between reds and oranges in your image, making any sunset more intensely colored.

INFRARED FILTERS

Infrared photography has become very popular, especially since it's been discovered that digital image sensors are very sensitive to what's called the *near-infrared* spectrum. This is light that's just outside of visible red light, where nothing that's illuminated by thermal radiation can be seen. Infrared filters are very dark, and make the world appear as an icy, almost ghostly stark landscape, like something out of a science fiction movie.

Most modern dSLRs, including Canon, have infrared filters in front of their image sensors; some of these filters are stronger than others. There are a couple of ways to shoot an IR image. The first is to use an infrared filter; these are very dark and block most of the visible light in a scene, so you have to take very, very long exposures — and your camera's IR filter still may end up blocking lots of the IR light, so you will have to test your particular camera to see if you can achieve the results you want.

If you're really serious about producing IR images, the second way is to have your camera's image sensor professionally altered to remove the low-pass filter that normally protects it from infrared light. This is an expensive process, and most photographers use an older backup camera for this purpose because not only does it physically alter

the camera permanently, it invalidates the warranty. LifePixel (www.LifePixel.com) is one such company that provides this service.

I suggest you experiment with an infrared filter first and see what your results are like before paying to have your camera altered. Using an infrared filter requires you to adjust your f-stop settings by several stops — and to have a much longer exposure. You also should use a tripod for a shot, and run the lowest ISO possible to avoid digital noise in your photo. You'll also want to pay attention to your depth of field, which will change because infrared light tends to diffract more than other types, meaning an IR shot will end up having a shallower depth of field, and you'll probably want to try a deeper depth-of-field setting first.

NEUTRAL DENSITY FILTERS

Neutral density filters, often just called ND filters, effectively reduce the amount of light reaching your image sensor, but do not affect the color. Why are they useful, you might wonder? In particularly bright conditions, they are very practical and allow you to shoot longer exposures. For example, if you want to shoot a waterfall with a long exposure to achieve a blurring effect, a neutral-density filter allows you to have the aperture open longer than you would if you weren't using it (see figure 7-6). This can also be really useful when you're shooting in the snow, and it also enables you to open up your aperture for a more-pronounced narrow depth of field.

A *graduated* neutral-density filter is one where (typically) one half of the filter is darkened and the other half is uncoated, plain optical glass. You'll find graduated filters where one half is a specific color, for creating unusual effects, but mostly (and most usefully) they are gray/neutral.

There are a number of uses for these filters, not the least notable of which is outdoor photography. Because there's often a marked contrast between sky and earth in a landscape shot, for example, using a neutral density filter where the upper half of the filter is used on the sky (which is brighter) and the lower part on the earth will help even out the shot for a more consistent exposure throughout. This allows you to have more detail in both areas. Often, using a neutral density filter and shooting in RAW produces a very wide range of tonality that provides nearly endless editing opportunities.

When using a graduated filter, the best way to determine your exposure is to meter without the filter on the lens and fill the frame with that area. Use this as a starting point for your exposure when you put the filter on the lens and shoot both the ground and the sky, and then make adjustments after you've taken some test shots and see what happens.

SOFTMAT (SOFT-FOCUS) FILTERS

Sometimes it is desirable to gain a soft-focus effect on the parts of your image that surround the subject, but not to be as blurry as you see in a narrow-depth-of-field image. A Softmat, or soft-focus, filter provides this effect using diffracted light, and it is especially useful in certain types of portraits as well as landscapes.

There are several types of soft-focus filters, with varying degrees of softness. These are usually graded at 1, 2, and 3 levels of softness, with 1 being the least soft. However, remember to exercise caution in what works for you so as not to soften an image more or less than you desire.

OTHER TYPES OF FILTERS

There are a large variety of other filters, ranging from those offering a variety of colors to ones with various special effects. Cross-screen, or starburst,

ABOUT THIS PHOTO *Oregon waterfall shot using a 0.6 ND filter offering a 2-stop reduction in light. Taken with a Canon EOS 1D Mark III using an EF 24-70mm 2.8L USM lens. ISO 100, f/13 for 8 seconds. ©Michael Guncheon*

7-6

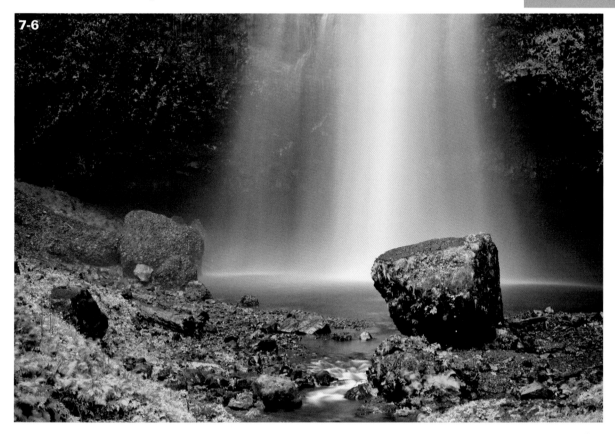

filters have etched glass and create the effect of sparkling light; the number of etches on the glass affects how many reflections are visible. These are often used in wedding and other low-light images where bright points of light can be emphasized and enhanced with this effect; they should be used with caution, however, because when over-used they tend to cheapen an image and make it look overedited to the point of distraction.

Close-up filters can increase the macro function of your lens by adding levels of magnification settings to your lens. These are a quick and easy, although a slightly lower-quality, way to take close-up images without buying another lens. They come in graduated ratings such as +1, +2, +5, and so on to indicate the relative strength of increased magnifi-

cation. You can stack them for combined effect, and you should do so by using the strongest filter closest to the lens. It is important to note that they decrease your depth of field.

USING LENS HOODS

Many lenses ship with a hood, which is advisable to use in a number of photographic situations. A lens hood provides protection for the lens, such as from bumping into things or if the lens is dropped, and it can prevent things, such as raindrops, from getting onto your lens and affecting an image as well. If your lens did not come with a hood, Canon makes several from which you can choose.

Generally, hoods mount to a lens *bayonet style* (meaning they don't require screw threads, they attach by turning and locking them into place, similarly to how a lens attaches to a camera). Canon hoods are notorious for varying as to how tightly they secure to the lens, so you may want to adjust yours by using a dab of museum wax (available in most art stores, used to help secure things like vases or small objects to a counter or ledge) to tighten and/or smooth the mounting action. If your lens hood mounts loosely, in particular, it's best not to handle the lens by the hood. Also, be careful when mounting the lens hood not to thread it incorrectly when you twist it on — you'll be able to tell if you've done so by looking at the side of the lens; the hood will be obviously misaligned.

Perhaps the most important purpose of a lens hood from a purely photographic standpoint is that it helps to prevent lens flare by preventing too much light from coming in from the wrong angle. Lens flare is quite difficult to edit out of a digital image, so preventing it is key to ensuring unwanted light doesn't affect your photograph.

x-ref For more specifics on lens flare, see Chapter 5.

A rubber lens hood, as shown in 7-7, is especially worth considering, and it has a special purpose: It can protect your subject as well your lens. In a number of sports venues where photographers are shooting very close to the action — such as on

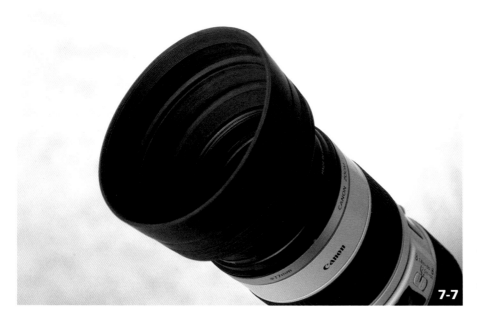

ABOUT THIS PHOTO
This lens has been fitted with a rubber lens hood, which helps protect it both from extraneous light as well as from bumps and knocks. ©Serge Timacheff

7-7

the sidelines of pro basketball games — photographers are required to attach these soft lens hoods to their lenses. This protects the athletes from injury against a hard camera lens or hood if they happen to run full-force into a photographer located in the wrong place at the wrong time. Because I shoot in many crowded international places, such as open markets and sports crowds, I also find a rubber lens hood to be much friendlier if I bump into people with a camera dangling from my shoulder. An added bonus is that rubber hoods tend to be significantly less expensive than the hard-plastic type.

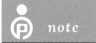

note The curved notches designed into some hoods do more than add a camera cool factor — they are patterned exactly to the rectangular shape of your CMOS and the images it reads, allowing light to be accurately and evenly cast onto the sensor. Typically, petal-shaped hoods are most effective with wide-angle lenses.

CLEANING AND STORING LENSES

It's easy to become obsessed with keeping a clean lens, doing everything you can to keep even the smallest speck of dust off of the glass. However, while it's of course advisable to keep lenses reasonably clean of dust and certainly devoid of oily smudges such as fingerprints, in reality a bit of dust isn't going to affect your image. Additionally, the wider angle the lens, the less likely you are to see any of the dust in the image because you're compressing a much larger surface area into the same imaging space on your image sensor.

x-ref Spots and dust on your image sensor are a significantly bigger issue and are more involved to clean (see Chapter 10 for more on image sensor care).

You can remove most dust with a bulb blower and a specialized camera lens brush, or a dust-free microfiber cloth. Even an eyeglass cleaning cloth, such as that available from an optician, works very well. Lenses are coated with a delicate, protective optical film that you do not want to harm in any way, and fingerprints are one of the worst things for them.

The first thing to ascertain is whether you actually have something on your lens that you need to clean. Many photographers have mistaken dust or smudges on their viewfinders or mirrors for something on the lens; of course, anything on the viewfinder or mirror isn't going to appear in your image!

If you do get a smudge on the surface of the lens, follow these steps:

1. **Blow and brush the lens to get rid of any larger particles that could potentially scratch the glass when you clean it further.**

2. **Place a drop of lens-cleaning fluid on a special lens tissue (available at any camera store) and gently clean the lens with the damp tissue.** Be careful not to squeeze any liquid from it that would flow onto the lens. Wipe in a circular, even motion.

3. **Wipe the lens with a dry tissue to remove any remaining dampness or residue.**

How you store your lenses largely depends upon the type of shooting you do. The primary issue for storing your glass is to keep it away from the elements as much as possible. If your lens came with a storage case or bag, use it where practical. Some studio photographers keep lenses in garage-mechanic-style metal cabinets designed to hold tools. If you're on the road with your gear, often the original storage cases can be unwieldy and ill-fitting in a cam-

era bag, so you'll want to just store them as-is in the bag — protected, of course, by the soft, cushioned compartments in your camera bag.

I like to keep desiccant packs with my lenses, especially if I'm shooting somewhere humid. Desiccant (which is silica gel) is available in rechargeable packs from most professional camera equipment stores and suppliers (see 7-8).

And the final word on lenses is to keep and use your lens caps! If you're traveling frequently, have some extra lens caps, both front and rear, handy in case you lose one.

7-8 ABOUT THIS PHOTO
This small, vented plastic case contains several hundred tiny blue silica balls. You simply place the case into your camera bag, and after a few weeks to a month or so, the balls will saturate with humidity and turn pink. You then place them into the microwave for about 15 seconds, which recharges them by removing the moisture they've absorbed. ©Serge Timacheff

Assignment

Improving Outdoor Photos with a Polarizing Filter

A polarizing filter can dramatically enhance your photos. Pick a nice sunny day to shoot outdoors with your polarizing filter. Ideally you can shoot where you have lots of sky or water (or both) in your shot, which is where your polarizing filter is really going to show its capabilities.

Take at least three photos: one without your filter, one with the filter at its least amount of filtration, and one with the filter with its greatest amount of filtration. This will allow you to see how much the polarization can really affect the level of blue. If you shoot with your camera on a manual setting, you may also want to adjust your exposure by a stop or a little more to prevent it from being underexposed. Otherwise, the polarizing filter makes the image darker.

Choose the image you like the best and post it to the Web site with your explanation.

In the example here, you see a photo of a statue of Joan of Arc in Orleans taken on a bright, sunny morning. The polarizing filter was rotated to optimize the deep, rich blue of the sky. Taken with a 1D Mark IIn using an EF 70-200mm f/2.8L lens at 1/2000 second, f/2.8, ISO 50.

©Serge Timacheff

 Remember to visit www.pwassignments.com when you complete this assignment and share your favorite photo! It's a community of enthusiastic photographers and a great place to view what other readers have created. You can also post comments and read other encouraging suggestions and feedback.

FLASH BASICS AND MORE

©Amy A. Timacheff

Flashes can be your best or worst friend, depending on the situation, ambient lighting, and what you know about how your flash operates. Many photographers opt to not use a flash if it's at all possible because natural light is softer and usually provides the best tonality and depth to an image. Yet a flash is necessary in many instances, and it's important to know how and when to use one; furthermore, there are many technological features as well as methods for using flashes to obtain the very best possible and most creative results (see 8-1), and to overcome some of their inherent drawbacks.

Historically, there have been many limitations of flash photography for which photographers have invented a wide variety of innovative gimmicks and rigs. However, today's flashes now integrate incredibly sophisticated features that render these homemade devices largely unnecessary. Canon offers a wide variety of flash innovations and options, ranging from the simple pop-up on-camera flash common, to many (but not all) dSLRs, to externally mounted Speedlite models. The more you know about how to use the Canon flash capabilities, the better your photos will be and the more confident you'll be in using them the right way at the right time.

The Canon Speedlite flashes offer excellent, Canon-dedicated lighting with very advanced technology. The newest model, the 580EX II, has a noticeably faster recycle time and has been optimized to integrate with your camera's digital sensor for the best-quality images with a flash. Its autofocus- (AF-) assisted beam is compatible with all the Artificial Intelligence Autofocus (AiAF) points on every Canon EOS dSLR. It also communicates white-balance information to the camera so that images have correct colors, and even the body has been optimized to be water-and-dust resistant just like the Mark II and III cameras. If you use it with a Mark III, you can control flash settings and functions from the camera's menu.

8-1

ABOUT THIS PHOTO *This image of a model on the banks of the Neva River in St. Petersburg, Russia, was taken in the middle of the day; however, because I shot it at 1/250 second with a very low ISO (50) and a rather narrow aperture (f/13), without the flash it would have been very underexposed. The results provide an almost nightlike image. Taken with a 1D Mark IIn with a 550EX Speedlite using an EF 24-70mm f/2.8L lens. ©Serge Timacheff*

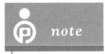

note | After taking a flash shot, *recycle time* is how long it takes the flash to be ready to fire again.

The Speedlite 580EX II (see 8-2) is essential for the widest-possible set of features where a flash is required. Shooting large groups, shooting subjects at a distance, and being able to control the flash's power settings are just a few advantages; additionally, you can add an external power source, use the flash dismounted from the camera, use

multiple/remote flashes using wireless transmission, and bounce the flash off the ceiling or wall and rotate/turn the flash. If you're shooting an event such as a wedding, a medal ceremony at a big sports event, or a news event, then you're certainly going to need the flexibility and power that this external flash provides.

Canon offers two other notable Speedlite flashes that are great considerations for a number of photography applications, as well. The Speedlite 430EX is a very capable external flash, and, while it doesn't provide the complete set of bells and whistles (meaning it doesn't have as many customizable/manual features) that you get with the 580EX II, it's a great flash to use with cameras

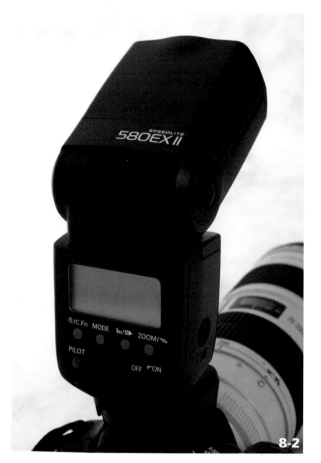

8-2

such as the Rebel series or the 40D. The Speedlite 220EX is the entry-level external flash and, while it cannot be operated manually (or wirelessly), as a simple, very affordable external flash it is still more powerful than an internal flash and will help you avoid problems such as red-eye.

HOW ETTL II TECHNOLOGY WORKS TO YOUR ADVANTAGE

The ability of your camera to intelligently evaluate the photo you are taking and apply flash lighting to it is the result of many years of technology advances and developments. Studio photography with multiple external strobes and lights set and controlled by the photographer, and essentially invisible/unrecognized by the camera, must be metered manually. An on-camera flash, however, has a number of evaluative measurements that the camera and flash manage and that adjust the flash's intensity and area of coverage (the flash adjusts its area of coverage to match the focal length of the camera's lens). Canon's current and most advanced technology today is called *ETTL II*; the acronym stands for evaluative through-the-lens, meaning the camera is reading the subject through the lens for the most accurate evaluation. Canon's higher-end flashes, the 580EX II and the 430EX, both use ETTL II technology, and are backwards-compatible if you've mounted them on an older camera that doesn't support ETTL II.

As part of the flash process, ETTL II uses a virtually invisible preflash and emits a very short flash before the actual image-taking flash takes place. This preflash evaluates and gives information to the camera and flash for a proper exposure based

ABOUT THIS PHOTO *The Canon Speedlite 580EX II is Canon's newest external flash and works with any Canon dSLR. It features a variety of advanced features that give the flash many different ways it can be used, both on and off camera. ©Serge Timacheff*

on the reading. And, as implied by the ETTL definition, the reading taken during the preflash is done through the lens and read by a sensor within the camera. ETTL is smart enough that if the ambient light is bright enough, it adjusts the flash for fill-flash settings, powered-down from what it would shoot in a darker situation. ETTL II, the second-generation of Canon's ETTL technology, adds superior metering capabilities and integrated distance data (its ability to meter distance from the camera to the subject) that is communicated between compatible/supporting EF lenses.

> **note** What's the difference between ETTL and ETTL II? While both modes provide a sophisticated evaluative measurement of your subject so that your image exposes optimally, ETTL II features an improved ability for candid, on-the-fly shooting where you're less likely to have to test your shot or use the Flash Exposure Lock (FEL) setting (see later in this chapter for more on FEL). Generally speaking, it's better at evaluating the scene and setting a more reliable flash.

There are situations where ETTL II adjusts to accommodate the fact that the flash is in a different position, where if kept the same, ETTL II would produce an inaccurate reading for the image being taken (see 8-3). For example, macro photography often requires that you get very close to the subject where traditional flash metering is difficult to accomplish; however, ETTL II technology can adjust the reading accordingly. Another situation is when you're performing a bounce flash (aiming your flash against a ceiling or wall instead of your subject), since the flash is (presumably) pointed away from your subject. Finally, and similar to the bounce-flash, ETTL II

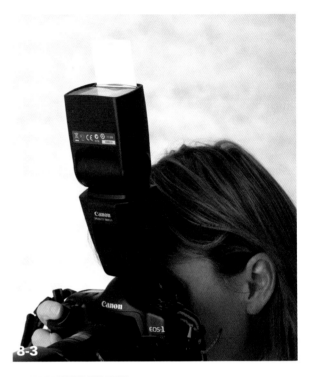

8-3

ABOUT THIS PHOTO *When you configure your flash to bounce light off the ceiling, ETTL II adjusts accordingly because its evaluative metering would not accurately measure what the flash is illuminating. Note the extended white catchlight panel. ©Serge Timacheff*

doesn't work fully automatically when you're using a remote/wireless flash because the flash is not attached to the camera and isn't going to have a relative focal distance to that of the camera's lens.

ETTL will operate with the following Canon digital cameras — it is supported in compact digital cameras and dSLRs:

■ PowerShot G2, G3, G5, and G6

■ PowerShot Pro 1

■ All Canon dSLRs

BUILT-IN FLASH TECHNIQUES

Many of the Canon dSLRs offer a pop-up, built-in flash as part of the camera body. The exceptions to this are the professional Mark II and III models, which do not have a built-in flash and require you to use an external flash. Of course, many studio photographers are also using model and flash lighting systems in addition to or separately from an on-camera flash.

The pop-up flash (see 8-4) will open and work automatically if you are using the Program setting or another automatic setting for the camera, assuming the camera has determined there is insufficient light to take an effective image based on its automatic metering. Using the camera in manual or semiautomatic (Tv or Av) mode

requires you to press the flash button on the side of the camera that opens and engages the flash.

If you are using a mounted external flash (connected via the hot shoe), such as a Canon Speedlite, the camera automatically recognizes that it is attached, and overrides the use of the pop-up flash. The same is true if you attach a wireless device to your hot shoe to use the flash remotely.

At certain times the pop-up flash can be useful, and I've often wished that my Mark II had one to use in a pinch when I don't have my external Speedlite available or when I don't have time to mount it on the camera. But the pop-up flash is limited: It isn't very powerful, uses the battery, and has a very limited shooting range. For snapshots, though, it's perfect.

ABOUT THIS PHOTO
The pop-up flash on Canon dSLRs, such as the one on this Rebel XTi, is useful for many photographic occasions, but is limited in comparison with an external flash.
©Amy A. Timacheff

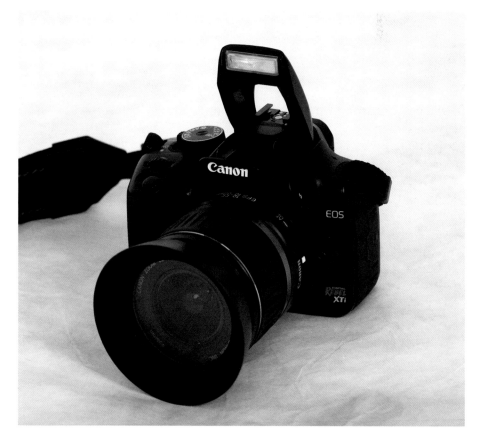

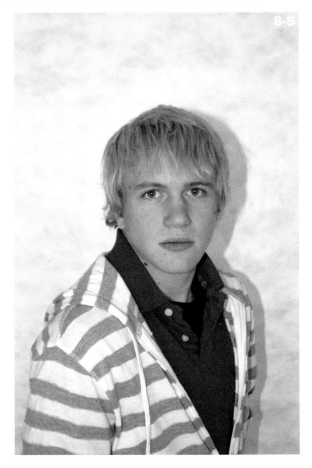

A built-in pop-up internal flash capability is provided with Canon's entry-level and semipro dSLR models. The built-in flash, while limited in power and functionality, can be very useful in situations where an external flash would be awkward and time-consuming.

As with external flashes, Canon cameras use ETTL II with built-in flashes for highly accurate and sophisticated TTL metering. Additionally, features such as the automated flash popup when the camera is in certain automatic program modes and Red-Eye Reduction makes the built-in flash very handy.

One of the best uses is for *fill flash* (meaning to use your flash to fill in light where needed, such as in bright light), especially when shooting portraits outdoors where a little extra light will help illuminate the subject more effectively and evenly. On sunny days with bright, overhead midday light, where your subject may get raccoonlike facial shadowing, pop-up fill flash is nearly perfect.

PORTRAITS

If you are relying on your built-in flash when taking a portrait, severe shadowing will occur if you shoot in a vertical (portrait) orientation if there is a wall or other background close behind the subject, as you can see in figure 8-5. Because you are using a built-in flash, you can't change the direction of the flash head or move it away from the camera. Your best option is to have your subject move farther away from the wall or any objects against which he or she may cast a heavy shadow. If it's not possible to do so, you may be able to position the subject into a corner of a room, where the angle of the wall may help deflect the shadow and can even potentially give you some bounce flash that will lessen the harsh vertical area of darkness.

Another option for avoiding the vertical shadowing is to shoot your image horizontally (as in figure 8-6) and crop it to a vertical image using your image-editing package. Notice how in 8-6 the shadows behind the subject are less prominent. The problem with this, however, is that cropping cuts out a significant portion of the image, meaning your final photo will be lower resolution. If you shoot a subject horizontally and you know it's going to become a portrait shot in the editing process, make sure you shoot at the largest-possible image size or in RAW, so you will have more data to work with later.

8-6

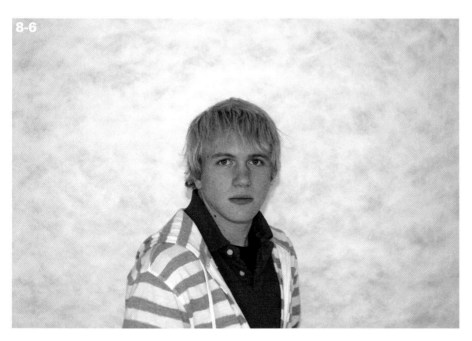

DEALING WITH RED-EYE

One of the most common annoyances of flash photography is when you take a portrait and the subject appears in the photo with glowing, demonlike eyes. Red-eye occurs when a flash reflects against the retina of a subject's eye, and it is more likely to occur when using flash simply because the pupils of the eye enlarge in darker areas to allow more light into the eye — precisely when a flash is needed most. External flashes have less of a problem with this because they project light at the subject from a point farther from the lens, so a wider angle; the pop-up flash, conversely, is in a nearly direct line with the lens, so the reflection can be very pronounced (especially with people who have light eyes). Having your camera's Red-Eye Reduction capability engaged is advisable in most portrait situations.

Red-Eye Reduction works by emitting a short, bright light from the camera's Red-Eye Reduction lamp, causing the subject's pupils to contract —

thereby limiting the amount of light their eyes can absorb during the actual flash, and reducing, or even eliminating, the reflectivity. While not always perfect, Red-Eye Reduction works very well in many instances. The biggest issue with it, however, is that because it takes a bit longer than a second to process, you can easily lose spontaneity in a candid image.

> **tip** If Red-Eye Reduction doesn't eliminate red-eye in your photos or you forgot to turn it on, you can reduce/eliminate red-eye using most image-editing applications.

Sometimes using Red-Eye Reduction isn't very helpful, primarily because it takes longer for the camera to respond and shoot the photo because it has to fire the preflash Red-Eye Reduction strobe. If you're trying to catch quick candids with kids, for example, you can easily lose the moment when using Red-Eye Reduction. In these cases,

you may be able to reduce the red-eye without turning on Red-Eye Reduction by taping some translucent material to the flash, which softens and diffuses its effect — and limits the amount of direct light being shined into the subject's eye. Translucent materials you could use on the flash might be a small piece of white silk or cotton, or even a piece of white tissue paper.

So, in what situations is it *not* advisable to use a pop-up flash?

- **When shooting nonportrait images.** This is especially important to adhere to if your subject is moving because using Red-Eye Reduction can delay the photo being taken.

- **When using large lenses, or lenses with big hoods.** These can obscure your flash area and you'll get a cut-off area of light at the bottom of your image. If you need to use a flash, it's nearly essential that it be an external flash when using this type of equipment.

- **When taking vertical shots.** As discussed with portraits, you're likely to get a big shadow behind your subject.

- **When taking wide-angle shot portraits and scenes, such as of a group of people that stretches to the extent of a wide-angle lens's range (for example, 24mm or wider).** These are difficult to illuminate with a pop-up flash; it just lacks the lateral coverage area as well as the power. Dropping below this can be challenging and generally not advisable.

- **In situations where you need a lot of flash power.** For example, if you are lighting a large group of people or where you're more than ten feet from your subject. While internal flash ranges are specified between a few feet and up to about 30 or more, their power quickly becomes inadequate the farther you are from your subject.

THIRD-PARTY FLASH ADD-ONS There are a number of third-party products available for pop-up and external flashes that allow the flash to be bounced, colored, or diffused, such as those from LumiQuest (www.lumiquest.com) and Gary Fong (www.garyfong.com). You can select from a wide variety of lighting gadgets that attach to your flash in a variety of ways; some are small and simply slip over the end of the flash, while others are rather large and prominent, requiring that you attach Velcro tape to your flash head. Some of the Gary Fong attachments are quite effective in allowing you to shoot vertical portraits with your flash and avoid the nasty vertical shadows that would typically invade your image.

Note that if you use these third-party devices, while you might think that your power output on your flash will be diminished, it is not. As long as you're using ETTL mode, the metering is done through the lens with a preflash, so your camera and flash will automatically set your flash's power based on how it fires and illuminates your subject with the accessory attached. Nonetheless, you'll want to think about your flash's range—even though the power output is the same, any redirecting of the flash may affect the illumination of your subject.

Additionally, you should note that softening a flash (for example, with a diffuser of some kind) will soften the light, but may not significantly diminish the power and brightness.

CANON'S SPEEDLITE LINEUP

Canon's dSLR accessory flash brand is called Speedlite (not to be confused with Nikon's Speedlights). These powerful and sophisticated flashes, with the 580EX II as the flagship model, are filled with features that provide virtually any flash capabilities you'll need short of moving to external studio lighting. For instance, the ability of multiple flashes to integrate as "master" and "slave" units (where one flash causes others to fire wirelessly) means you can set up virtual, portable studiolike lighting almost anywhere. And the power of the flashes has increased to the point that the bulky, heavy third-party flashes that so commonly burdened the traditional wedding photographer are virtually obsolete. Furthermore, flash recycle times are vastly improved from what they used to be and, as batteries have also improved, there's less need for external battery power sources, as well.

While the name "Speedlite" is a branded term, the specific model *number* refers directly to the flash's *guide number*, which is the measurement of the flash's power; higher guide numbers mean a more powerful flash. A guide number tells you how well your flash will be able to illuminate a given area at maximum flash-to-subject distance (typically measured in meters).

For example, Canon's 580EX II has a maximum guide number of 58 meters at a 105mm focal length setting and the 430EX has a guide number of 43. Internally, the guide number is a calculation made by the flash's on-board computer using the aperture and distance (measured by the infrared meter on the flash). That calculation then applies to the flash's settings for firing at the correct intensity.

Canon currently offers three Speedlite external flashes for digital cameras: the Speedlite 580EX II, 430EX, and 220EX.

SPEEDLITE 580EX II

Canon's latest-generation and flagship flash, the 580EX II, is a highly capable flash that can be used with any of the Canon dSLRs. However, it has been optimized to take full advantage of the EOS-1D Mark III camera's capabilities, as well as to match the camera's functionality and durability (other Canon flashes were somewhat of a weak link). Because this camera (and the Mark II series) is used so extensively in adverse conditions, this new flash adds significantly improved water- and dust-resistance and body strength.

Technologically, the 580EX II also works at a deeper level of integration with the camera (the EOS-1D Mark III, specifically) than any previous flash Canon has offered, and allows you to control flash functions and settings from the camera's LCD menu. Additionally, Canon has improved communication reliability through its direct contacts, has quieted the device, and has increased recycle time by 20 percent.

The flash's AF-assist beam, used to meter a subject, is effective up to almost 30 feet (10 meters) from its center, and up to 16.4 feet peripherally, allowing it to cover all the EOS camera's focus points (a maximum of 45). Also, the 580EX II provides 14 rather technical custom functions settable on the Speedlite's LCD panel, including things such as various powering-down options, ETTL II auto flash settings, flash-exposure sequences, and recharging conditions when using an external power supply.

The 580EX II has a white, retractable panel recessed above the face of the flash. It slides in and out of the flash housing, alongside the retractable wide panel (for more on the wide panel, see the bounce flash section later in this chapter). The white panel is technically called a Catchlight Panel, designed to add catchlight into subject's eyes. Using your 580EX II for fill flash can be optimized with the Catchlight Panel to add life and brightness a portrait, even on a bright day. To do so, you need to point your flash up at 90-degrees or a little less so that light bounces against the panel.

Because you have complete manual control over this flash, you can adjust its power to whatever you want to meet your photographic needs — whether you need only a slight amount of fill flash, or you want to provide a remarkable amount of light to a dark subject. Plus, you can easily use this flash as a slave unit triggered optically (through a sensor in the flash) by another flash.

Here are the key features of the Speedlite 580EX II:

- It features an approximately 20-percent faster recycling time than the 580EX.

- If offers a metal foot for higher rigidity, and a hot-shoe lock that operates with a single levered action (instead of the previous ring-style tightener).

- The Wide-Angle Pull-Down Panel allows you to expand the flash's ability to work with wide-angle lenses and full-frame sensors.

- The flash head can swivel 180 degrees in both horizontal directions, and it can tilt 90 degrees vertically.

- The maximum guide number is 58 at a 105mm setting and ISO 100.

- It has a wide-angle pull-down panel that covers a 14mm lens on a full-frame camera.

- The white pull-down Catchlight Panel enhances the flash's capability to capture catchlight reflections in subjects' eyes (the white "twinkle" in a person's eyes, reflecting the flash).

- It has auto conversion of flash coverage with compatible dSLR cameras (meaning it adapts to various image sensor sizes for different cameras).

- White-balance information is communicated immediately to compatible dSLR cameras.

- It features a flash range at ISO 100 with a 50mm f/1.4 lens that is approximately 1.6 to 98.4 feet (0.5 to 30 meters).

- The AF-assist beam is compatible with all AiAF points on every EOS dSLR.

SPEEDLITE 430EX

Replacing the 420EX, Canon's 430EX (see 8-7) is a more affordable (by about $100) flash than the 580EX II and is designed as a great companion with many of the mid-range dSLR models — most of which feature an internal flash as well. It is also smaller and lighter than the 580EX II.

If you find that your Rebel XT's or 40D's pop-up isn't enough for every flash situation, the 430EX is a great flash to consider if you want to add an external flash capability.

8-7

ABOUT THIS PHOTO *The Canon Speedlite 430EX*
©Serge Timacheff

The 430EX offers manual control over flash compensation and its settings, allowing you to adjust power from 1/64 up to its full capacity in logical increments. You can also use the flash as a slave unit because it has a sensor to detect another flash source. In fact, if you want to set up a master-slave set of flashes, you may want to consider using the 580EX II as the master and the 430EX as a slave.

The flash's AF-assist beam, which covers up to nine AF points, is effective up to almost 33 feet (10 meters) from its center, and up to 16.4 feet peripherally.

Here are the key features of the Speedlite 430EX:

- The LCD panel on the rear of the flash offers easy control of six custom fuctions.

- The wide-angle pull-down panel gives you additional flash coverage for wide-angle shots.

- The maximum guide number is 43 at a 105mm setting.

- The flash head can swivel horizontally 90 degrees right and 180 degrees left, and it can tilt 90 degrees vertically.

- It has auto conversion of flash zoom coverage.

- The flash range at ISO 100 with 50mm f/1.4 lens is approximately 2.3 to 79.7 feet (0.7 to 24.3 meters).

- The white-balance information is communicated immediately to the camera.

SPEEDLITE 220EX

The most affordable and lightweight Speedlite (about $100 less than the 430EX), the 220EX only operates automatically. If you are at the point where your pop-up flash just isn't enough but you don't need or care about having lots of technical control over an external flash, this is a great option — a very inexpensive and surprisingly intelligent work of flash technology (see 8-8).

The Speedlite 220EX, just like its more sophisticated but pricier siblings, integrates with your camera to use basic ETTL technology (it does not support ETTL II) to evaluate and set the flash for near-perfect flash-illuminated exposures. As a semimanual feature, you can also use your camera's flash exposure (FE) lock for additional creative control over your photos using this flash. Because it is completely automatic, you cannot set this flash to operate as a slave unit.

Another limitation of this flash is that you cannot swivel or tilt it, so bouncing the flash is difficult if not virtually impossible.

You should note that the Speedlite 220EX offers ETTL capability only with the EOS IX, EOS ELAN II/IIE, and EOS Rebel G models, and basic TTL operation with all other EOS cameras.

The flash's AF-assist beam, which is linked to the camera's center focusing point, is effective up to 16.4 feet (5 meters); it is linked to center-point focusing only (and consequently the 220EX does not have a "peripheral" effective rating).

Here are the key features of the Speedlite 220EX:

- The flash range at ISO 100 is approximately 2.3 to 63 feet (0.7 to 22 meters).

- It supports the ETTL preflash auto-flash system (but not ETTL II).

- It has a hot-shoe lock with a single motion. The 580EX II has this; the 430EX does not.

ABOUT THIS PHOTO *The Canon Speedlite 220EX* *©Serge Timacheff*

BATTERIES AND FLASHES All three Canon Speedlite flashes require four AA batteries to operate, which usually provide at least a few hundred flashes. Canon's specifications range widely on how many shots you can get out of a set of batteries because battery life can vary from brand to brand, and because how your flash is operating drains the batteries differently (meaning how much power is being used per shot). Canon's specs for the 580EX II, for example, state that the approximate flash count is between 100 and 700 — a very broad range, indeed.

It's best to use good-quality alkaline batteries, and you should note that your recycling time will shorten as the battery life depletes — both for the quick flash (when you fire the flash with the green light on, meaning the flash is not fully recycled; this has reduced power) as well as the normal flash. When it's completely ready, the green light turns to red.

The Speedlites also support rechargeable batteries; you can use NiMH (nickel-metal hydride) or lithium batteries; however, you should not use cheaper, nonalkaline, non-rechargeable batteries.

OTHER FLASH EQUIPMENT

Canon offers three specific flash accessories beyond its Speedlite flashes; however, a wide variety of flash accessories exists for Canon flashes beyond those offered specifically by Canon, including different products that help you bounce and diffuse flashes, and that bracket-mount the flash (a separate mechanical device on which you mount your flash and that lets you swivel it for optimal positioning for vertical and horizontal camera shots), and that provide external power sources.

Another handy device for flash photography is the Off Shoe Camera Cord OC-E3. It is a coiled cable that connects at one end to your camera's hot shoe, and at the other end to your flash. This lets you mount or hold your flash separately from your camera, giving you a lot of flexibility for firing the flash from a variety of positions.

> **tip** You should check with major camera product retailers such as B&H Photo (www.bhphotovideo.com) and Adorama (www.adorama.com) to see the wide variety of accessories beyond the Canon offerings.

Canon also offers minor accessories, such as cable extensions, macro light adapters, and other utility products that are commonly available from multiple vendors.

MASTERS AND SLAVES

The terms *master* and *slave* in flash photography refer to a single light (master) that, when it fires, causes other flashes (slaves) to fire instantaneously with it; this is how studios use multiple lights for lighting a subject. External Canon flashes can be used in this way as well, using and setting the 580EX II as a master. You can then use other 580EX II flashes or the 430EX set as slaves to fire when the master flashes (the 430EX only operates in slave mode). You can also use previous versions of these flashes, such as the 550EX (which can also act as a master or a slave). In this way, you can have a very portable, near-studio lighting environment set up. For example, if you're shooting formal wedding images at a church or reception hall, using a 580EX II master with one or two slaves provides excellent lighting.

SPEEDLITE TRANSMITTER ST-E2

Another option is to use a wireless flash-triggering device, the Speedlite Transmitter ST-E2, attached to your camera's hot shoe (see 8-9). When you take a photograph, a wireless infrared pulse signal is emitted that fires any flashes in range that have been set to slave mode; this is an alternative to having a master flash mounted on the camera that would also flash. Any other non-Canon studio flashes that have the capability to be fired by a flash with an infrared flash receiver may also be set off (assuming they are also in slave mode). Note, however, that Canon flashes set in slave mode will not fire with a third-party infrared transmitter; you must use the Speedlite Transmitter. This is actually a very good feature, because it means that the flashes will not be triggered by other flash sources (such as a family member taking a point-and-shoot flash snapshot over your shoulder at a wedding).

Also, note that flashes need to be within your line of sight to fire using infrared technology (as opposed to large studio flashes, which are often triggered using radio signals).

The Speedlite Transmitter ST-E2 will work with all recent Canon flashes that support slave mode, including the 550EX, 430EX, 580EX, and 580EX II.

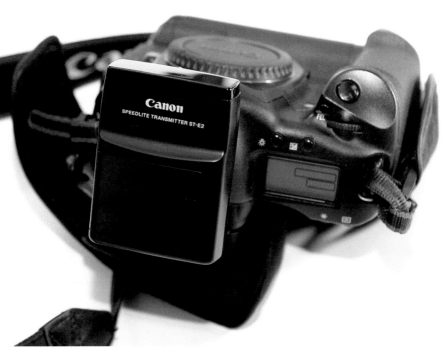

8-9 ABOUT THIS PHOTO
*The Canon Speedlite
Transmitter ST-E2
©Serge Timacheff*

The ST-E2 transmitter is ETTL-compatible, and includes a built-in AF-assist beam that works with your camera to evaluate distance and light for optimal flash strength. It also supports high-speed sync, also known as FP flash, which allows flashes to synchronize with your camera's shutter speed. This is especially useful for using Aperture-priority (Av) mode for fill-flash portrait images.

The transmitter's maximum range varies between indoors (about 40 to 50 feet) and outdoors (about 26 to 33 feet).

EXPLORING CANON SPEEDLITE FLASH CAPABILITIES

While Canon Speedlite flashes can be used in master/slave configurations where multiple units are set up in a studio-lighting manner, by far the most common way photographers use these hot-shoe mounted flashes is as a single unit atop their cameras. You may have recently upgraded to an external flash after having decided that the built-in flash just wasn't powerful enough for the types

> *note* While reasonably reliable, infrared transmitters in general can be a little persnickety to use and occasionally do not fire when you need and expect them to do so. For more absolute reliability, I recommend using a radio type of transmitter with studio lights or a dedicated cable (the 580EX II can accept a direct cable).

of photos you shoot, or perhaps your camera doesn't have a built-in flash at all. Whichever your situation, you need to know about some of the Speedlite's capabilities to make the most of everything you can do with them.

That said, Canon has added so many features to the sophisticated devices that it would take a complete book to cover all of them; this section is simply intended to give you an introduction to the various features and functionality and lay a path for you to explore, flash, and shoot to your heart's content.

Your Speedlite 430EX and 580EX II have a number of features that can be accessed from the flash's LCD screen (if you are using a 1D Mark III, they can also be set from the camera with the 580EX II). Using the LCD screen, you can cycle through ETTL and manual modes.

> **tip** For more specifics on using and setting up all the possible configurations of your Speedlites, pick up a copy of the *Canon Speedlite System Digital Field Guide,* also from Wiley.

With a Speedlite attached to your camera's hot shoe, your camera will be significantly heavier and more awkward than without one. In particular, it's especially difficult to shoot vertically with your flash attached, even if you have a camera with dual controls that are normally quite accessible in a vertical configuration (which is standard on the 1D Mark III and included on the extra battery grip accessory for other dSLRs) — you'll find that it's really tough to access those controls. Most photographers who frequently shoot vertically with a flash opt to add an external

flash-mounting bracket that permits them to easily shift between horizontal and vertical modes. This also mitigates the problem of flash-shadow that you get from tilting the flash sideways, as shown earlier in this chapter.

The following sections look at some flash features as well as single-flash techniques to offer you a good overview of what a single Speedlite on your camera can do.

FLASH EXPOSURE COMPENSATION

Sometimes the amount of flash illuminated on a subject just might not be right, no matter how smart ETTL might be; for example, when there are extreme levels of light or dark in your photo causing the flash to misinterpret and try to compensate. Or, perhaps you want to tone down the effect of the flash for a softer lighting in your image. Often when flash images are a bit blown-out or have an unnaturally lighted look, ETTL didn't completely do its job. In cases like this, you can adjust the Speedlite's Flash Exposure Compensation (FEC) feature, which lets you manually increase or decrease the flash's output by incremental steps to provide more or less light on your subject.

The incremental FEC settings are somewhat limited by your camera's exposure compensation; for example, while the 580EX II is capable of 1/3-stop increment settings (as shown in 8-10 through 8-12), if your camera is only capable of 1/2-stop increments in exposure compensation, then your flash is limited to that as well. You can set FEC up to plus/minus three stops.

ABOUT THESE PHOTOS *For this subject, I used a 1D Mark IIn with a 580EX II Speedlite set to normal (8-10), +2/3 FEC (8-11), and -2/3 FEC (8-12). All three images taken with an EF 50mm f/1.4 lens, 1/60 second, f/6.3 at ISO 400. ©Serge Timacheff*

FLASH EXPOSURE BRACKETING

Bracketing in photography means you take several shots of the same subject — typically three — where you increase and descrease the aperture by one or more stops. For example, you might shoot an f/4.5 image at f/2.8, f/4.5, and f/5.6 to be sure you have the right exposure; your dSLR will let you set and shoot these bracketed shots automatically. Similar to the way bracketing works for exposures on your camera, you can also set your Speedlite to automatically bracket flash intensity for three shots, which is a great tool if you're unsure about a given subject or setting and you

want to ensure that you easily and quickly can get multiple flash exposures, each with varying amounts of light. I use Flash Exposure Bracketing (FEB) when I'm shooting important photos in RAW, because I have so much tonal control over images in the RAW format. This gives me even more tonal range to work with in my image-editing program later, especially if there are a lot of contrast extremes in the image (dark blacks and light whites, such as in a wedding). While I end up generating more shots when using FEB, I'm reasonably certain I've covered all the exposure bases to ensure I have the critical shot I need.

8-12

FEB capability ranges from plus/minus 1/3-stop increments up to plus/minus three stops (if the camera can only do 1/2-stop increments, then the flash is also limited). In the higher-end flashes, you can use the custom functions to change the FEB shooting sequence, also.

FLASH EXPOSURE LOCK

Sometimes you may want to lock in on a particular exposure or a specific flash setting and then change your position for the shot and still shoot with that setting. To lock in on a specific exposure, you'll want to use your dSLR's Exposure

Lock. You can also lock in on a specific flash setting, but not the exposure. To do so, you use the Flash Exposure Lock button on your camera, designated by the acronym FEL (Flash Exposure Lock) beside the button (see 8-13), and the camera and flash will remember the setting you had before you recomposed the shot. This is also useful in mixed-light conditions where the main area of your exposure, if used with the default flash exposure as metered by the camera and flash, would render a photo that's incorrectly exposed. You may want to alter the flash exposure for artistic purposes, or the default exposure may simply be incorrect if a part of the subject is too light or dark where the metering is taking place.

Let's say you want your flash to fire at a subject that is backlit from a window. When you take a normal photo with your flash on, there's so much light coming from the window that the flash evaluates incorrectly to effectively illuminate your subject. To operate the FEL feature, you would point your camera at a darker area — similar to the lighting on the subject — and press the FEL button. It fires the flash, but the camera does not take a photo. You then have about a quarter of a minute to recompose your shot with your subject and take the shot normally — and your flash will illuminate as if it were facing the previous, darker area.

It's important to note that because your camera and flash use ETTL II to evaluate and meter a flash exposure, you must be in ETTL (not manual) mode on your flash in order to be able to use the FE Lock capability.

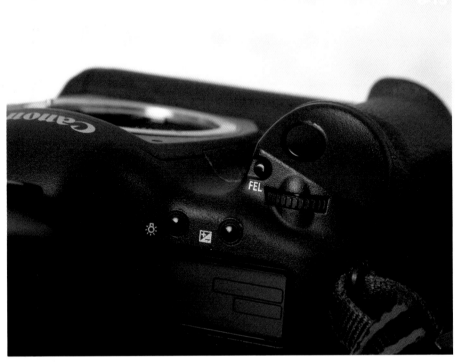

HIGH-SPEED SYNC

Normally, flashes are set to operate with a camera shutter speed of 1/250 second or slower. If you have a flash attached to your Canon dSLR, you will not be able to set the shutter speed on your camera to a speed faster than 1/250 second. Your camera's shutter needs a little time to open and close its two "curtains" that allow the image to be exposed onto the sensor. 1/250 is the fastest that it can normally create an exposure and synchronize the flash with it.

However, there may be some instances where you will want to use your flash with a faster shutter speed. For example, what if you want to add a little light to a subject's face on a very sunny day as fill flash (extra light meant to offset shadows or other darker areas of a normally well-lit subject)? In this situation, you might very well have your shutter speed set for 1/500 second or faster.

Enter high-speed sync, or FP (focal plane) flash. This is an override setting that allows you to shoot a flash at shutter speeds beyond your camera's limit of 1/250 second. This changes the way your camera's "curtains" open and close and allows you to shoot a flash image at virtually any shutter speed. What do you lose in this situation? Power. Your flash will fire only with diminished power, lower than it would otherwise use for a given exposure. And, since you're running in manual flash mode, your flash and camera won't be using ETTL II.

FP flash works with the 430EX and the 580EX II (and their predecessors), and is controlled by a setting on the back of the flash.

THE INVERSE SQUARE LAW Obviously, the farther you are from your subject, your flash's effectiveness diminishes accordingly. On a bright day, the effect of your flash might be harder to see than if you're using it in a dark setting, so it's good to be cognizant of using it when you're close enough for it to be useful.

A flash's power diminishes with distance, which is the result of the Inverse Square law. It's useful to understand how the principle works so that you can understand how your flash operates, because it's not immediately obvious. The Inverse Square law states that any physical quantity or strength (which includes light) is in inverse proportion to the distance squared (d^2) from the source of the quantity or strength. For example, say you want to take a photo of someone who is standing 5 feet away from your flash, which is running at full power, and you decide that you're too close to them. You move them to 10 feet away. This means that you've doubled the distance your subject is from your flash.

Using the Inverse Square law, here's how you calculate the power your flash now has with the new distance:

1. You've moved from 5 to 10 feet.

 a. "1" represents 100 percent of your original distance (5 feet)

 b. "2" represents that you've doubled the distance (10 feet)

2. Divide "1" by "2":

 a. 1 / 2 = .5

3. Now take the result (.5) and square it:

 a. .5 x .5 = .25

With a result of .25, that means that when you double the distance, your flash's power only has 25 percent, or one-fourth, of its effectiveness to illuminate your subject. This increases exponentially, meaning that at four times the distance you will only have 1/16 of the power working.

BOUNCE FLASH

If you're trying to lessen the harshness of a flash shot so your images appear more natural, your flash can operate in a variety of different physical positions that allow light to literally bounce off walls or other nearby obstacles . This is a very common technique used by professional photographers, each of whom seems to have his or her favorite way of positioning a flash for optimal results.

The 430EX and 580EX II flash heads can swivel in each horizontal direction, and 90 degrees up and down, which, by combining these two axial rotations, gives tremendous versatility in the various three-dimensional angles you can achieve (see 8-14). However, it takes some experimentation to find what works best for your flash situations, based on what type of light you want in your photo and how and where the flash is bouncing.

Typically a flat, light-colored surface such as a wall or ceiling produces the best bounce-flash results. The light reflects easily off of it, spreads out, and becomes a larger, softer light shining on your subject, and a more natural, less harshly lit image results. However, you should be sure that the surface from which you are bouncing the light is close enough to produce the results you want — if the light from your flash disperses too much before it bounces, it will result in an under-exposed photograph. Trying to bounce the flash from a surface that isn't sufficiently reflective can also cause underexposure. Be aware if you're setting your flash to bounce against the ceiling, and the ceiling is too high or colored too darkly to be effectively reflective. Additionally, a colored surface may actually create a color cast in the reflected light, which will result in your subject's color also being affected.

8-14

ABOUT THIS PHOTO *A 580EX II flash set to bounce backwards and upwards against a wall behind the photographer and camera. This flash head can swivel 180 degrees both right and left, and can tilt 90 degrees, giving it great flexibility. ©Serge Timacheff*

USING THE WIDE PANEL An option for diffusing some of the light and increasing the flash-lighted area of coverage instead of bouncing the flash is to use your flash's wide panel (which you access by pulling it out; it is otherwise retracted behind the flash head). Available on the 430EX and 580EX II, this panel's purpose is to increase the flash coverage area to expand the focal length to 14mm from its specified maximum width of 24mm, meaning that even wide-angle shots are fully lit, even at the edge of the image. In addition to the expanded width, you may find that the panel serves as a handy way of diffusing the light somewhat so that it doesn't appear quite so harsh.

The wide panel is not intended to work in a couple of configurations that you should know about. The first is that if you are using it to expand focal coverage, it is not compatible with fisheye lenses, specifically with the EF 15mm f/2.8 Fisheye. Second, it is not designed to work with the bounce flash configured; the entire flash LCD panel blinks if you point the flash upward at 90 degrees (the bounce flash mode) and pull out the wide panel at the same time.

SETTING YOUR FLASH MANUALLY

You can manually set the 430EX and 580EX II to fire at a wide range of settings. For example, you can set output on the 580EX II anywhere from 1/128 power to 1/1 (full) power at 1/3-stop increments. If you are doing close-up photography (such as nature, food, or macro subjects), being able to set your flash manually and override the ETTL settings is important.

You can use your flash's guide number (GN) to determine correct manual flash settings. The 580EX II has a GN of 58 (meters) at ISO 100 and the flash head at a 105mm setting; the GN drops as you increase focal width. This number is used, then, with a standard guide-number formula for calculating manual power settings:

Guide Number = f-stop × distance

or

Distance = Guide Number ÷ f-stop

or

F-stop = Guide Number ÷ distance

Usually you will know your f-stop number because you will be deciding if you want to shoot a narrow depth-of-field shot or not. Using the GN formula, then, you can determine how you can set your power manually and how far you can be from your subject — something over which you may or may not have control.

Of course, a guide number is just that: a *guide* — it's not precise and won't work in every photographic lighting scenario. Guide numbers are very good for comparing the relative power of various flashes when you're in the market for a new model. And, while this number gives you some specifics regarding distance, you may, in fact, not want to be the exact distance from your subject that this

formula calculates for you. For example, you are doing a shoot of food at a Japanese restaurant, and you want a nice shallow depth-of-field shot at f/2.8 of a plate of sushi and you need to use a flash. If you're using a 24-70mm lens, and you want to be about five feet from your subject, using the GN formula, here's how the situation calculates:

Guide Number = f-stop × distance

f/2.8 × 5 feet = a Guide Number of 14

A guide number of 14 represents substantially less power than how the camera is rated at its default settings of GN 28 (24mm) to GN 42 (50mm).

So what does that mean? You'll have to lower the power on your flash to a setting that won't overexpose the subject. If you decide you want to shoot the plate of sushi at your lens's wide setting of 24mm, you'll at the very least want to manually set your flash to half of its full power (the 1/2 setting) and then shoot to see if that produces the image you want.

Here's another way to think about this, and a good way to achieve a quick calculation to determine the right aperture for a shot. If you have a flash with a guide number of 43 (such as the 430EX), and you are 10 feet from your subject, your aperture should be f/4.5 (at ISO 100): 43 ÷ 10 = 4.3 (rounded to f/4.5).

While there are ways to perform calculations for the precise power settings you should use, I have found that using this system to know if I'm within range or not at the default ETTL settings, and then experimenting with manual settings from there, is sufficient to achieve very good results. Many of the complicated photographic calculations were more useful in the time of film, where knowing the math and using it meant using less film to achieve a good photo; today it's acceptable to waste some digital shots instead of taking the academic approach.

FAST METERING FOR A SPEEDLITE AND A 1D MARK III It's good to know the scientific theory, but in practice, photography tends to be a soft science and the luxury of digital photography and advanced computer technology allows us some liberty to take the occasional shortcut. Here's one way to do just that: You can manually meter an EX Speedlite flash if you are using it with an EOS 1D-series camera, which is also useful for close-up subjects. To do so, you will need a gray card and to follow these steps:

1. **Set up your camera and subject.** It is most useful to use a tripod to maintain an accurate distance.

2. **Focus your camera on the subject, and use the Manual (M) or Aperture-priority (Av) mode.**

3. **Place the gray card in the same plane of view as your subject, filling the frame as much as possible.**

4. **Press the Flash Exposure Lock (FEL) button, which will fire a preflash.** On the right side of your view inside the viewfinder, an exposure level indicator will display the correct flash exposure.

5. **In manual flash mode, adjust your Speedlite to the flash exposure level for the correct power output setting.** Note that you'll need to adjust to the correct camera aperture setting so that it's exactly aligned in the standard exposure index (which you can see on the right side of your view inside the viewfinder, as well).

6. **Now you can take away the gray card and take the photo, with the flash metered for the subject.**

MODELING FLASH

In a studio, modeling lights are used in combination with strobes, and are often integrated into single light units. These are lights that remain on (unlike a flashing strobe) to help you see how light is falling on a subject before firing the flash. They let you see shadows and highlights as they will appear when the flash is fired and the image is created.

You can achieve something similar with your dSLR and flash, to illuminate a scene before you actually take the photo. To preview how your flash will look when the image is taken, press your camera's depth-of-field button (see 8-15), which briefly fires the flash—an effect called a "modeling flash." The flash goes on just long enough that you can preview your subject and how the flash will illuminate it.

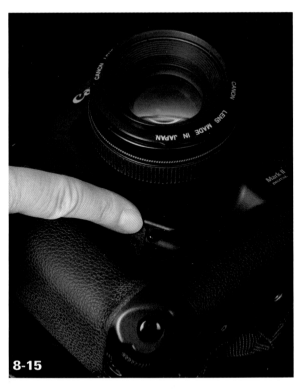

8-15

ABOUT THIS PHOTO *The depth-of-field button, used to fire a modeling flash shot with a flash attached to the camera, is located at the lower-left side of the camera's lens mount (in the lower-center of this photo). ©Alexander A. Timacheff*

Remember, the depth-of-field button only provides a short-duration flash (unlike a true modeling light, which stays on), so you need to pay attention when it fires! Also, note that using it too much depletes battery life in both the camera and the flash.

> **note** You cannot set the flash to full power in Stroboscopic (Multi) mode, or even to half power; the power output option begins at 1/4.

STROBOSCOPIC (MULTI) FLASH

This special-effect feature of the 430EX and 580EX II allows you to fire a series of flashes from a single Speedlite during one exposure — for example, showing a subject moving within a single photograph (see 8-16).

To use the stroboscopic function, you need to decide what kind of a photo you want to take — how many images of your subject you want in your photo, and the composition. So, if you know that you want eight images of your subject in the photo, this means your flash needs to fire eight times for one exposure. Consider the following formula when trying to determine how to set your Speedlite and camera:

Number of flashes/firing frequency = shutter speed

So, if you're shooting eight flashes and the frequency is four per second, you need a shutter speed of two seconds (8 ÷ 4 = 2).

In the Canon Instruction Manual for the Speedlite 430EX and 580EX II, there is a chart for maximum stroboscopic flashes that you will need to set your flash. Expressed in hertz (Hz), the firing frequency number or number of flashes per second ranges up to nine.

Depending on the flash output you select, you can reference a corresponding number on the chart in the manual that you must enter into the flash.

The most effective images taken using the multi-flash feature are those where the subject is quite reflective, against a contrasting, dark background.

8-16

ABOUT THIS PHOTO *In this image, the model moved her head throughout the two-second duration of the photo, which was taken outside on a dark night. The flash was pointed directly at her, and it took a couple of tries to get her to move her head at about the right pace for the three shots. Using a bounce flash or diffusing device on the flash could help eliminate some areas being more exposed than others and make the exposure more even. Taken with a 1D Mark IIn using an EF 24-70mm f/2.8L lens at ISO 50, 2 seconds, f/5.6. ©Serge Timacheff*

And, while you can technically set your camera to a long setting or even Bulb and set the flash to keep firing indefinitely, this can cause the flash to overheat. Note that you don't want to fire the flash more than ten times in succession because the flash contains an automatic mechanism that causes it to shut down to protect itself if it becomes too hot. If it shuts down, you must let it rest for at least 15 minutes before attempting to use it again.

SECOND-CURTAIN SYNC

Your camera uses mechanical devices called *curtains* to open and close its shutter. The default setting is for your Speedlite to fire at the beginning of the exposure, called *first-curtain sync*. In most cases this is just fine; however, when taking long exposures of a moving subject when using flash, the result is the subject is illuminated at the left side of the photo (assuming it is moving from left to right), and a long trail of light going

from left to right *in front* of the moving subject makes the subject look like it is going backward. This is a situation that can occur with any photo taken where the flash takes significantly less time than the exposure.

Second-curtain sync overcomes this problem by forcing your flash to fire *at the end* of the exposure. The trail of light then comes behind the subject, illuminating at the end of the image, and it appears on the right-hand side (when moving from left to right across the frame).

You will probably want to use FEL with this type of an image to avoid a preflash, which can meter incorrectly if your subject will be in a different place in your image between the beginning and end of the exposure. Using Bulb mode can work well with second-curtain sync, as well. Note also that you cannot use a stroboscopic effect with the second-curtain sync mode.

USING MULTIPLE WIRELESS SPEEDLITES

You can use the 430EX or 580EX II wirelessly to create a multilighting effect much like you would have in a professional studio lighting setup. To do so, you need to set a single flash attached to your camera as the master unit and set the receiving flash(es) as slave units. The master flash utilizes ETTL to obtain the best-possible image. This capability should help you be able to extend flash range, and, if configured properly, overcome some of the limitations caused by the Inverse Square law.

The 580EX II is the only unit that can be used as a master or slave device, while the 430EX can be used as a slave only. The 220EX cannot be used as either. The Macro Ring Lite MR-14EX,

Macro Twin Lite MT-24EX, and Speedlite Transmitter ST-E2 can also be used as master devices.

You can use virtually any flash exposure capability in this manner, including FP flash, FE lock, FEB, manual flash, and even the stroboscopic settings. All settings are automatically transmitted from the master to the slave units, meaning you only have to change settings on your master.

To turn a Speedlite into a master unit, you either flip a switch at the base of the flash that you manually switch from normal to master or slave settings, or in the case of the 580EX II, you use the Speedlite's LCD panel by holding down the Zoom button for two seconds for access. In all cases, you need to have your master flash set to the ETTL setting.

> **note** If you are using an on-camera flash with studio flashes that are operated as slave units that are triggered by a master flash, ETTL II can cause the flashes to misfire. Because ETTL II fires a preflash, the slave lights may interpret that as their signal to flash — thereby rendering them in a recharge state when the *actual* flash occurs that is supposed to cause them to fire. The result will be an underexposed image devoid of the flash light intended for the shot. If you do want to use the on-camera flash with studio flashes, and they are in a flash-triggered slave mode, turn off ETTL II in your flash menu.

If for any reason there are multiple Canon wireless flash systems operating in close proximity to one another, you can also change the wireless channel on which yours operate so they aren't on the same channel as others in a different system.

To be able to set the slave flashes in the proper location, you can either use the stand that comes with the flash (it slips onto the hot-shoe mount), or you can set the flash onto a tripod using the

tripod socket on the stand. You need to position the lower body of a slave flash facing toward the master unit so that it can receive the transmission; any obstacles between master and slave can interrupt the signal and prevent the slave flash from firing.

If you have two or more slave units, you may want to fire them only and *not* the master unit, which is possible because you can set the master unit flash to Off using the LCD panel. This may provide a better simulation of standard studio lighting for you, where you would typically not be using a camera-mounted flash. Note, however, that the master unit will *still* fire a preflash signal to be able to transmit the wireless information.

With the current units, you can set multiple slave units using flash *ratios*, which simply means different units can fire at different flash power settings. This ratio number is what appears in the LCD panel where you can select your setting. The numbers on the bottom are the 1/2-stop increments, which are settable by selecting the dot that appears in the LCD panel.

You can have up to three groups of slave units, each containing one or several flashes, indicated as groups A, B, and C. You can control the ratios in all three groups, although C is used only for

background light; you set the flash ratio output for each slave unit group from the master.

If your camera has a depth-of-field (modeling flash) preview button, you can use this to fire your entire flash configuration to see how your flashes will fire when you actually take a photo.

SHOOTING MACRO IMAGES WITH A FLASH

For macro images that need a flash, you can use your Speedlite. However, because you need to get so close to the subject, sometimes the flash goes over the subject and does not illuminate it properly, or the flash overexposes the image. If you don't happen to have one of Canon's two flash units designed specifically for macro photography (the Macro Twin Lite MT-24EX or Macro Ring Light MR-14EX) and you want to use the Speedlite for macro shots, you need to make some adjustments.

You want to be able to shoot your flash set apart from the camera, which you can set up a few different ways:

■ Use the Speedlite Transmitter ST-E2.

■ Set up a master and slave where the master on-camera flash is set to Off.

■ Use a flash connected to the hot shoe using the OC-E3 EOS Dedicated TTL Off-Camera Shoe Cord.

Any of these will allow you to have an ETTL II-capable flash that operates separately from the camera.

You may also need to lower the output power of your flash manually because you are photographing much closer than the typical photo the flash and camera will meter.

MACRO RING LITE MR-14EX

The Macro Ring Lite MR-14EX is a specialty macro flash light that provides flash illumination for macro photography. This model is a traditional macro ring light (as shown in figure 8-17). Its ring contains two lights, but you cannot separate them from the ring configuration. The device consists of a controller unit that attaches to your camera's hot shoe, which is where you install the batteries and use its LCD panel to set the flash functions. It offers seven custom functions for adjusting various flash features and settings. In spite of the two lights being permanently attached to the ring configuration, it is possible to fire the flashes together or independently and vary their power settings separately at six different levels.

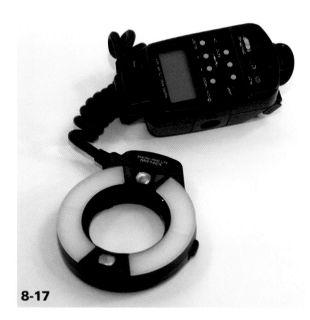

8-17

ABOUT THIS PHOTO *The Canon Macro Ring Lite MR-14EX*
©Serge Timacheff

The Macro Ring Lite MR-14EX also features a modeling flash setting that allows you to preview how your subject will be illuminated before you actually fire the flash, and there are two smaller incandescent focusing lamps to help ensure you focus perfectly on close-up subjects. If you need additional light sources, this light can also act as a master, utilizing the Wireless Autoflash system to fire the 580EX II, 430EX, or other older flashes such as the 550EX or 580EX as slave units.

MACRO TWIN LITE MT-24EX

The Macro Twin Lite MT-24EX is actually two separate, swiveling flashes separated laterally from one another for increased depth and variety in lighting your close-up subject with a controller unit that attaches to your camera's hot shoe (shown in 8-18). This unit gives you more flexibility than the ring-type light for macro photography, although the added functions and features mean that the light is significantly more expensive, as well. One of the biggest drawbacks and complaints about ring lights is that they can produce a very flat light, which the twin-light configuration overcomes quite effectively. You might think about the light from this flash as you would separate studio lights instead of a single flash on a portrait subject (but just at a much smaller scale) to produce a nicely balanced macro image.

With the two flashes physically separated, the heads swivel and can be pointed in a variety of directions, or even used off of their holder and mounted or held separately. You can use the device as a master that fires slave units such as the 550EX, 580EX, or 580EX II. Fully ETTL-compatible, the flash units can operate in-sync or independently at six different levels. As with the ring light, the

Macro Twin Lite MT-24EX includes a modeling light feature as well as incandescent focusing lights to ensure you correctly illuminate your subject before you take an actual photograph. This flash also has nine custom functions you access from the LCD panel on the controller, a few more than the less-expensive ring light. Each flash also has a tripod socket as well as a hot-shoe mount that you can use directly on-camera.

The Macro Twin Lite MT-24EX is the ultimate lighting accessory for macro photography, whether you're in the studio or in the field. Its ability to flex around the lens — with each head being able to rotate around the lens in an 80-degree arc as well as turn inward, outward, up, and down at a 90-degree arc — makes it virtually limitless in what it can do to illuminate a close-up subject and eliminate shadows or lighting problems that frequently make macro images so difficult to achieve.

8-18 ABOUT THIS PHOTO
The Canon Macro Twin Lite MT-24EX ©Serge Timacheff

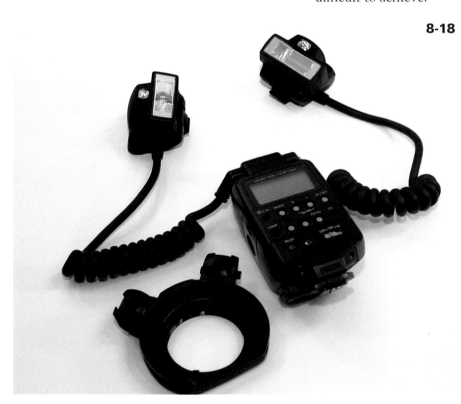

Assignment

A Filling Experience

Using a flash isn't limited to lighting up a dark room. Often you may wish to use it on a sunny day when shooting a subject to eliminate the "raccoon" look of shadows beneath their eyes.

There are several ways to use fill flash, and in part the different methods depend upon what type of flash you have. If you're using a higher-end flash, such as the 580EX II or the 430EX, then you'll want to switch it to manual mode on the LCD panel and drop the flash's power to half or one-fourth of its full strength. If you cannot set your flash manually, such as if you're using the 220EX or an internal flash, then you will need to force your flash to fire even though it's sunny.

Experiment with a subject on a sunny day with as much overhead light as possible. First, try the photo with no flash and see what happens with shadows. Now, try the shot with your flash using the settings described. When you get it right, you should have enough light that shadows go away, but not so much that you lose detail.

When Amy Timacheff shoots portraits, such as this one of a graduating senior, often she'll use a natural setting. And, an image using only the light coming through the trees can often be improved by using fill flash, such as the example here illustrates. Adding flash not only diminished the shadows under the subject's eyes, it also increased the catchlight in his eyes and the overall color of his skin and depth of the image. The flash's intensity was lowered manually so the light wasn't too strong, and the Catchlight Panel was extended. The flash was directed upward and slightly forward. Both taken with an EOS 20D and an EF 50mm f/1.4 lens — the left image at ISO 800, 1/125 second, f/2.5; the right at ISO 800, 1/60 second, f/4.

©Amy A. Timacheff

Remember to visit www.pwassignments.com when you complete this assignment and share your favorite photo! It's a community of enthusiastic photographers and a great place to view what other readers have created. You can also post comments and read other encouraging suggestions and feedback.

181

INTEGRATED WORKFLOW WITH YOUR CANON DSLR

©Michael A. Johnson

Beyond putting together your camera, lenses, and other components, a nearly endless number of activities, products, and techniques can help you optimize your photography workflow and results. Here I cover those that I think are important for you to consider as you move ahead and use your equipment to its fullest potential.

Some of these accessories are already integrated in your camera, such as one to help you make the most of Picture Styles, while others may require that you add them on or use software. All of them, however, fall under the umbrella of establishing a consistent workflow and system for managing, editing, storing, and accessing images.

WORKFLOW: THE FOUNDATION OF GREAT PHOTOGRAPHY

The concept of digital photography workflow involves far more than image editing in a specific application such as Digital Photo Professional or Photoshop. Rather, it encompasses your photography from the inception of a shoot to its ultimate completion — whether as a framed print on a wall, an image on a Web site, or part of a digital slide show or Flash presentation. However your photo shoot begins and wherever it ends up is all part of workflow.

Workflow is a concept and best practice that allows you to consistently process and produce images, customized to your skills, interests, and preferences. A defined, consistent workflow is an intellectual property asset for you, the photographer, and can be used effectively in your marketing and sales efforts to assure professionalism and credibility to your clients. It is often what markedly differentiates a true professional photographer from an amateur or enthusiast — yet every photographer, professional or not, can benefit from what an established workflow has to offer.

There are two main phases to digital photography workflow, and they are broadly broken into the *prepixel* and *postpixel* phases. The prepixel phase includes everything you do before an image reaches the sensor and is converted to a digital image: planning the shoot, setting it up, preparing your equipment and lighting, working with subjects and models, setting your exposure, composing your shot, and taking the picture. The postpixel phase is everything that happens to a digital image once it has *become* digital: storing it on flash cards, transferring it to a computer, backing it up and archiving it, processing and editing it, preparing it for final use and distribution, and fulfilling its intended use. These two phases are further broken down into five essential stages:

1. **Preparing for the shoot**

 > Planning where, what, when, how, and whom to shoot

 > Getting resources, permissions, access, and so on, as needed

 > Checking, cleaning, and preparing equipment and, if necessary, the studio

 > Planning for how to store images securely until you can transfer them to your computer

2. **The photo shoot**

 > Getting the gear and yourself transported to the shoot, if it's on location

> Positioning your subject(s), or positioning yourself in the right place to shoot

> Determining your best exposure and composition

> Measuring and setting white balance

> If necessary, positioning lighting, props, backdrops, and so on

> Executing the shoot

3. **Transferring and managing images**

> Downloading from the memory card to a portable storage device or computer

> Logically and descriptively renaming and organizing photos for optimal accessibility

> Storing master files that are not modified

> Using metadata tagging

> Sorting and prioritizing

4. **Editing, optimizing, and archiving images**

> Preparing files to be edited

• Backing up JPEG files and preparing working copies so you don't edit an original image

• Optimizing and then converting RAW images to working formats like .PSD or .TIFF

> Image editing and, when needed, optimizing key images for color, sharpness, white balance, exposure, composition, and shadow/highlight

> Touching up images as needed

> Copying and converting images to any required sizes and formats

> Adding text and/or other graphics to images, as necessary

> Storing working and master files for secure permanent archival and accessibility

5. **Fulfilling images in print, on the Web, and for presentation**

> Getting images to a lab for printing, whether by online transfer, disc, or other method

> Uploading files to online galleries for display, and (in some cases) for sale

> Integrating images into a slide show or Flash presentation

> Fulfilling prints to clients or other recipients

This is far from a comprehensive list of activities for each stage, and you can probably list and enumerate many of your own based on the type of photography you pursue. Your order of operations may also differ depending on how you prefer to work, but this is a good guide to start with if you are new to the idea of a set workflow.

Within each of these stages there are various products, techniques, and decisions that are unique to you and how you want to work to produce the best-quality photographs. As you expand and refine your workflow, you will likely further define and modify these stages to ensure consistency and to match them to your working style. If you have other photographers working with you or for you, it will help to share this with them and use it as a standard studio method.

A consistent workflow standard may be as obvious as how you set up your lighting, how you calibrate your monitors, or what products you use for image editing. It may also be quite subtle, such as ensuring that all your cameras are set to the same Picture Style, white balance, and image size.

IMAGE STORAGE AND BACKUP: ON THE ROAD AND IN THE STUDIO

Securely and quickly moving your images from a memory card to a computer takes place in different ways depending on where you are and how you like to work. For example, if you're photographing a day-long wedding with an 8GB flash card, you may be able to shoot and store the entire event on that one card and never take it out of your camera until you're back at your computer. Or, you may be traveling and shooting multiple cards that become full over one or more days, requiring you to transfer images while on the road to a secure form of storage.

When you are on the road or out of the studio, you have several choices for storing images in order to transport them later:

- Portable hard drive
- DVD or CD
- Memory cards (CompactFlash and/or SD)
- Laptop

Any of these may work, depending on what you're doing and what equipment you have with you. When I travel to major world sports events, I always keep redundant (paranoia) backups so

that in the event one storage method fails, I have others. Throughout the day, I usually transfer images from my memory cards onto a portable hard drive that directly accepts CompactFlash and Secure Digital cards because my camera uses both types. At the end of the day, I also back up the entire day's shooting onto a DVD and then store the discs either in the safe in my hotel room or in a safe-deposit box at the front desk. When I travel, I keep the discs in a separate bag from the portable hard drive, just in case something was to happen to either bag.

If you are traveling for multiple days, it's never a bad idea to have a DVD backup of your images if for no other reason than they are rarely damaged by dropping them, by water, or by an electrical surge. Furthermore, a stack of DVDs is far less likely to be stolen from a desk or hotel room than a portable hard drive.

Storing images on memory cards is okay for short-term transportation. The biggest danger with trusting images stored on a card for more than a few hours is that memory cards are easy to lose. And, in spite of stories of occasionally making it through the wash in someone's pocket, don't count on a waterlogged CompactFlash or SD card being fully usable once it's dried out. Another big risk with keeping your images on a memory card is that you might just forget that you haven't downloaded or otherwise stored the images, and accidentally format the card in your camera to take more photos.

PORTABLE HARD DRIVES

The most common and available portable hard drives operate only with a computer through a USB connection. Some are quite small and

powered directly through the USB connection, needing no external power — which can be quite handy at a shoot on location where you might not have access to an AC connection. You can get drives that range from 30GB of storage to 500GB and more (the larger drives typically require AC power).

Some portable hard drives also accept direct input from memory cards (see 9-1), thus skipping the need to use a laptop to download images in the field; later you connect them to a computer to review, manage, and transfer images. These can be very handy and useful, but reliability is a very important issue and you'll want to be sure to test and use the drive so that you completely understand it and trust it before using it for a critical photo shoot. Some drives will display images on an LCD screen, but these devices tend to consume battery time much faster than those that do not.

CD AND DVD STORAGE

Storing images on a CD or DVD is reliable, inexpensive, and safe as long as you are careful not to scratch the discs and you store them in a good-quality zippered case or equivalent container. DVDs hold many more images than CDs, but not every burner is DVD writable. Most laptops today now support DVD writing, but you should double-check to be sure that yours does. DVD+R is a one-time writable format that will let you record your images to the disc and then later read and copy them to your computer (or wherever). DVD+RW is a *rewritable* format, meaning that you can record to the disc multiple times, just like a hard drive. Generally speaking, DVD+RW is less compatible with various DVD writers and readers, so for increased reliability I suggest you stick with DVD+R.

ABOUT THIS PHOTO
The Creative Zen W is a portable media player capable of playing video and music along with presenting photos, receiving FM radio, storing contacts and datebook info, and voice recording. Using the CompactFlash card slot on the side, images can be directly downloaded without having to use a computer; the Zen can also be connected to a PC with its USB connection to back up images or other data. Photo courtesy of Creative Inc.

9-1

There are portable CD burners available that let you insert a memory card into a device that will directly burn to a disc. Because of their very limited ability to confirm the data, combined with the various levels of reliability of burner-disc brand compatibility, I urge caution in using these devices. By far, the most reliable and fastest way to burn CDs and DVDs is by using a laptop or PC; most burning software lets you do a secondary verification pass to ensure the data (images) have burned correctly; alternatively just open your image editor or the file browser on your computer to do a visual check of the images.

MEMORY CARDS

Memory cards, such as CompactFlash and SD, are designed to be a temporary solution for image storage and a way to easily transport images from camera to computer. Keeping your images on memory cards until you can download them to your computer with a USB card reader is a reasonably fast and easy way to download images.

However, as I mentioned in the opening part of this section, it's not a good idea to store memory cards containing critical images for any longer than you must. They are too small and too easily erased to be reliable. If you have a large enough memory card for a full shoot and you want to keep it in your camera until you are at your computer or wherever you will be to back up the images, that's okay. However, I wouldn't suggest keeping them that way for more than a day or so. Many

tourists who have been the victims of street muggings where their cameras were stolen are far more distraught over losing a week's worth of vacation photos than they are over losing their camera.

If you're using more than one memory card, have a consistent location where you store cards that have been filled or used but not yet downloaded. Use a separate memory card case, a zippered pocket in your camera bag, or other secure place where you will not accidentally use the card and format critical and unsaved images.

Be sure to format your memory card in the camera before you use it. Formatting is more thorough than simply erasing the images, and if there's any risk that you used the card in a different type of camera, this process ensures the card is set up properly for the camera. If you forget to format the card, and it's been used in another type of camera, you might see that there is only a very limited amount of space on the card and you won't know why — because it still contains images from the other camera that are not visible on the one where the memory card is being used.

LAPTOP

In the field, you may want to download your images to a laptop both for storage and so you can begin working with and presenting them right away. You can download to your laptop either by using a USB card reader or by connecting your camera directly to your laptop's USB port; using a Firewire connection is also a high-speed option for downloading images if your PC and memory card reader support it.

Still, I suggest that for really important shoots you also back up images onto a CD, DVD, or portable drive in addition to your laptop. It's just too easy to accidentally damage a laptop when you're out and about, so this way you'll at least have a fallback.

WIRELESS FILE TRANSMITTAL

Canon's line of wireless file transmitters lets you send photos directly from some Canon dSLR cameras to any FTP server using a wireless connection (802.11b or 802.11g) or a wired Ethernet connection (see 9-2). They can also connect to various USB 2.0 storage devices so that you can instantly store images to drives that contain much more space than a memory card. For situations where you are actively shooting an event and need to have images immediately sent to someone on a computer, this is the way to go.

■ **WFT-E1A.** This model is compatible with the 1Ds and 1D Mark II, the 1D Mark IIn, the 5D, and the 20D.

■ **WFT-E2A.** This model works with the 1D and 1Ds Mark III. It supports the Mark III's Remote Live View function.

■ **WFT-E3A.** This model works with the 40D.

The Digital Rebel XT and XTi models do not have wireless file transmittal capability.

 note The included antenna has a nearly 150-meter range, and you can optionally buy a more powerful one that reaches almost 500 feet. Unfortunately, the transmitter requires but does not ship with a battery or charger.

ABOUT THIS PHOTO
The Canon WFT-E2 Wireless File Transmitter mounts to the 1D and 1Ds Mark III cameras and provides several ways for you to get photos in real time to a computer locally or at a great distance. Photo courtesy of Canon Inc.

9-2

You will need time, technical expertise, and patience to get the transmitter set up between your camera and computer (unless you're downloading directly using USB 2.0), and most of the photographers using it have reported errors if the setup and use isn't followed carefully. Canon supplies information and software for setting it up, as well as online resources and demos, and there are several configurations you'll need to review, understand, and select.

Interestingly, to set up the camera for use with the transmitter, you load software onto a flash card at your computer, and then load the card into your camera where you run the update — just like doing a firmware update. (Note: This transfer option is only visible in your camera's menu if the transmitter is connected.)

On the camera, you can select the specific images you want to send (RAW, JPEG, or both) or you can just send them all at once. If you fill a card and then transmit images, however, be aware that you won't be able to shoot until the transmission is finished (because your card is full, and you can't remove it because of the transmission taking place).

Another interesting capability the WFT-E2a sports for globe-trotting photographers is the ability to connect to and integrate with portable GPS devices, which enables you to record GPS information (including altitude, UTC, latitude, and longitude) into your image file's metadata — and which can be displayed on the camera's LCD screen.

MANAGING AND ARCHIVING PHOTOS

Once you've transferred your images safely to your digital studio, you need to process and permanently archive them before you begin any editing or fulfillment. You want to keep your images in as pristine a condition as possible — meaning that master images should not be multiple-generations old (especially true for JPEG files) or altered from their original state, for example, and they should not be cropped, color-corrected, or otherwise edited or changed. Furthermore, you will want to name the image files in a way that will let you identify details about the photos, access them, and relate them to further generations of the same image.

There are many applications and methods for managing and archiving images, also known as DAM, or Digital Asset Management. Canon's Digital Photo Professional is a mid-range DAM product, allowing you to accomplish many archival and management capabilities.

MANAGING IMAGES

The problem with digital photos is that it is easy to reproduce them quickly and prolifically, almost to the point that without management, you may have a hard time telling which photo is an original and which is a copy. And, for JPEG images, the more times an image is opened and resaved, the further it degrades in quality because it is a lossy format (one that loses quality over multiple generations). Consequently, it behooves you to manage your images as soon as possible after you have downloaded them to the computer.

Renaming is a first-priority task in image management. You can always keep original filenames and just store images in a file folder that's more descriptively named, but the long-range problem is that when you have duplicate file numbers and you do a broad-based search of your image database, you may encounter redundancy problems.

190

The more consistently you can name files, the better. Come up with a naming formula that suits the type of photography you do and how you may need to access images later. Consider some of the following factors in file naming:

- People's names or specific subjects (for example, Cancun Beach, Portland Air Show, and so on)

- Shoot location

- Date

- Unique file number

- Other unique identifiers

You may find that you can use the same naming scheme for groups of images that each have a unique file number, which allows you to put multiple categories in one file folder. For example, under a file folder titled "Jones Wedding," you might have groups of files named for the ceremony, reception, and rehearsal dinner:

Jones – ceremony – 06-07 – 3325.jpg

Jones – reception – 06-07 – 0127.jpg

Jones – rehearsal – 06-07 – 0010.jpg

In this manner, the filename itself becomes a reference term that you will be able to use to search simply using your operating system's file management feature or a basic file search capability in your image management software. Furthermore, if you upload your images to online galleries where you present and perhaps sell images, each word in the filename becomes a search term, letting customers easily find images. Most DAM products offer database capabilities that catalog your images and let you easily locate and work with them. This is more useful when you have a relatively simple storage configuration such as a single computer and a large external hard drive; database

cataloging becomes more difficult, complicated, and less useful when you have multiple networked computers and multiple storage devices.

After renaming, you can begin to create multiple folders that relate to logical image categories for long-term storage and editing.

IMAGE METADATA

Beyond file naming, there are several ways to uniquely identify files individually and in groups. Every digital image carries with it a set of information known generally as *metadata*. This contains some factors that are unalterable, such as the image exposure, type of camera used, white balance, and so on. However, you can set and use other terms such as keywords, copyright info, captioning, and more to manage the images in various applications.

Most metadata (also called EXIF data, which is Canon-specific) can be found in your image-editing application by viewing Information, Properties, or something similar that is associated with an individual file. For example, images viewed in ACDSee Pro show the photo's EXIF data and basic IPTC data (see 9-3).

Metadata includes several categories of information for a file, including the following:

- **EXIF.** This stands for Exchangeable Image File, which is actually a file format used by most digital cameras; a JPEG file is technically an EXIF that uses JPEG compression on the information in the file. Here you'll find everything from the type of camera that shot the photo (including its serial number!) to the date it was taken.

- **File.** This is file-specific information about your image, including the image name, storage location, creation/modification date history, size and bit depth, and an EXIF summary.

ABOUT THIS FIGURE *Properties and Information are two terms used by image-editing and -management applications such as Digital Photo Professional, Photoshop, and ACDSee Pro to refer to metadata information contained in every digital image. Some information is user-added, such as copyright and photographer information. Other information, such as the type of camera used and the exposure settings, is fixed data that you cannot easily change. This screen is from Canon's Digital Photo Professional.*

9-3

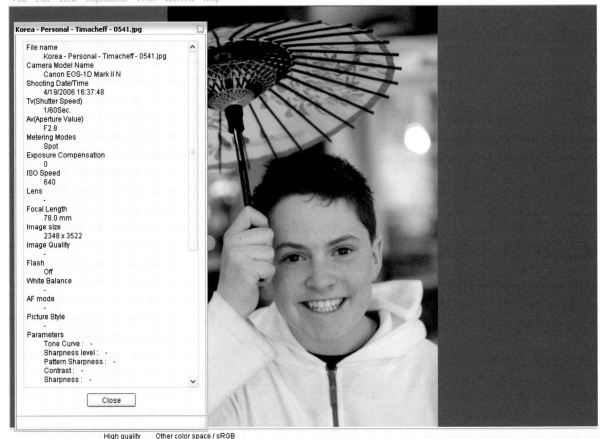

■ **IPTC.** Originally developed by the newspaper industry, the IPTC (which stands for International Press Telecommunications Council) permits you to add information about the image such as a detailed caption, the writer, the photographer, various categories, keywords, copyright information, the location where it was shot, edit status, and more. This information is visible across applications such as Photoshop, ACDSee, and iView, among others.

You can batch-process some metadata in various programs, which allows you to add things such as copyright information, location of a shoot, and other factors to a large group of images.

Keywording is helpful for grouping images as well, and it's especially helpful if you're trying to find similar photos that are stored across multiple folders. The main trick to keywords is to be as consistent as possible in the keywords you use and associate with various images. Remember that some keyword capabilities are application specific, while keywording in IPTC is read across applications.

Most DAM applications let you tag images in a variety of ways so that you can sort and prioritize them. You may be able to simply tag a photo with a checkmark, and then later sort the entire file folder so that the checked images are grouped. Beyond simple tagging, most programs also let you prioritize images using a rating system (see 9-4). For example (and there are many ways to do this), you may want all your best photos in a folder to be "1," your second-best photos to be "2," and so-on (typically five is the most you would have).

ARCHIVING AND PREPARING FOR EDITING

After you've sorted your images, you'll want to edit the best ones and prepare them for fulfilling your project. Furthermore, you'll want to archive images according to how you've named and grouped them so that they'll always be easy to access.

There are many ways to go about the preparation and archiving process, and as you develop your own workflow you will also develop a good method for this process that works for you. To get

9-4

ABOUT THIS FIGURE *Images being prioritized in Digital Photo Professional, using a three-check ranking system. Rated photos can then be sorted accordingly.*

you started in the right direction, I've provided a brief overview of how I archive and prepare images for editing, which is a method that has become an integral part of my workflow, and it has worked for me with nearly one million digital photos over the last five years.

1. **Batch and rename images with a consistent formula.**

2. **Attach any necessary metadata tags and keywords.**

3. **Organize images into logical working master file folders.** Move, do not copy, the files.

4. **Identify the best photos by tagging or rating them.**

5. **Burn these files and folders to a DVD or copy them to a hard drive for secure master storage.** My workflow includes moving these masters to a secure, off-site location such as a safety-deposit box.

6. **Create a subfolder for each of your working master folders to contain the best shots.** These are the images that you plan to edit.

7. **Sort the images in your working master folder according to the rating or tags you added in Step 4.** This ensures that your best photos are grouped together.

8. **Copy the best images into the best shots subfolders you created in Step 6.** Be sure to copy, not move them. You want to have a working original to go back to in case you make an accidental edit that you cannot fix.

Once you edit your best shots, you may want to archive those images. Furthermore, you may create different edited versions of the same image. In this case, you will want to rename those images in such a way that their original unique number is still consistent with your master files; you can do so by adding a dashed extension to the number (or a letter, or whatever you want):

Original: *Badgers Juniors – 03-07 – 8755 .jpg*

Edit: *Badgers Juniors – 03-07 – 8755-01 .jpg*

When you have finished editing your images, you may also want to store the edited images as master files. You can copy these to the same portable hard drive where you stored your masters and place them in corresponding subfolders, or you can copy them to DVDs for storage. Just don't accidentally copy over the originals!

GETTING AND KEEPING THE HIGHEST IMAGE QUALITY

A number of issues factor into getting the highest image quality, and they occur at both the pre-pixel and postpixel phases of your workflow. Some involve common sense, while others may require you to take some specific technical steps to preserve your images and present them in their best possible way.

CAMERA CARE

Whenever possible, it's always best to begin a photo shoot with a clean camera that's free from spots on the image sensor or dirty lens glass. And keeping your gear in good working condition means that you will be able to rely on it more to operate perfectly in any situation. Still, before the shoot you may want to take a test shot and download it to your computer for a quick check.

It's a good idea to clean your lenses and image sensor before any shoot, as well as just after you've finished.

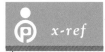

See Chapter 10 for a detailed look at camera care, including cleaning the image sensor.

Ensure that the outside of your camera is wiped free of oils and dust, as well. This ensures that when you change lenses, you don't accidentally get unwanted particles inside the camera. And when you change lenses, do it in a clean, dry, and nonwindy place if at all possible.

OPTIMIZING AND ADAPTING TO YOUR ENVIRONMENT

There are a few factors you need to consider before every shoot that will help you to control your image quality in any situation. You may not always be able to control the light, for example, but you can adjust your camera settings to make the best use of the available light. And, considering the ultimate purpose and use of your photos before you take that first photo can also maximize the quality and usability of your images. Monitoring your white balance, ensuring your camera is set to the right format and image size, and checking your Picture Style settings can all impact your image quality overall, so don't neglect these tasks.

■ **Set and check your lighting in a shoot where you have control over your subject (such as in the studio, where you can use portable lights or even a flash).** Taking the extra time to set things up right the first time pays off. When you control the lights, don't just adjust your camera to suit whatever the lighting happens to be set to from the last shoot (you'd be amazed at how often photographers simply get a little lazy and don't bother!). If you can get the lighting set so

that you can drop your ISO to a lower setting, your image quality will improve and you'll have more range of exposure for the photos.

■ **Know what the potential use of your images will be, and adapt your image size accordingly.** If you know that you're shooting for photos that will only be displayed on the Web, you may not need to be taking large JPEGs, for example, because they are usually only displayed on-screen at around 96 ppi (pixels per inch). However, if you are going to print images, they need to be sufficiently large for how they will ultimately be printed. If it's going to be at least an 8 × 10 or larger, you definitely want to shoot at a large setting; furthermore, if you're going to crop images, you'll want to make sure that the cropped area is sufficiently large (another reason to shoot at a large setting).

■ **If you're shooting where you can't change the lighting, explore where you can stand or situate yourself for the shoot to ensure the best-quality light.** What's the ambient light like? Are any other lights being turned on or off? How close can you get to your subject? Where can you optimize your ability for the best possible exposure and lowest ISO setting? Are you using the right lens for the job, ensuring that you don't have to crop more than necessary out of the final image?

■ **Check and double-check your white balance by taking multiple exposures set to the same balance.** Using your Auto White Balance (AWB) setting can be dicey if there is mixed light as it may not lock on to the type of light for which you want to be balanced. In a variety of light sources, such as sunlight, fluorescent light, and tungsten light, your AWB will adjust to any one of those depending on how the camera measures the subject. If you're walking

through an event taking photos of multiple subjects — say, for example, a wedding reception — then the AWB can be very handy, especially if you don't have time to double-check and retake photos.

If you're photographing in a home for an architectural shoot, for example, where your exposures need to be excellent and the light is similarly variable (sunlight, fluorescent, and tungsten), take the time to use a manual white balance setting and take test shots before shooting final images. Also, shooting in RAW will definitely be an advantage because if all else fails, you can adjust the white balance later in post processing.

■ **Use your Canon Picture Styles to your best advantage.** It will help your colors and white balance, as well as optimize images as they are taken so that you'll have less to do when you begin editing.

OPTIMIZING DIGITAL IMAGE QUALITY

There are essentially two types of file quality within all the digital file formats: lossy and lossless. Lossy files, such as the JPEG format, degrade as they are saved and saved again over multiple generations. Lossless is the opposite — these files do not lose image quality when you save them. TIFF files are lossless and are the format that many photographers use when doing image editing if they will be saving multiple generations of an image. You can save a RAW file to a TIFF.

JPEG is the most common digital image format today, particularly on the Web, and it is produced by virtually all digital cameras. However, when working with JPEGs you have to be sure you

don't keep resaving the same file, lest the quality become noticeably bad. While the difference will be unnoticeable over a few saves, as you can see in 9-5 through 9-8, JPEGs do, in fact, lose quality over time and after multiple saves.

tip If you're shooting in RAW, your image files will already be at their largest possible size. If your images are going to be used for both the Web and for print, you may want to shoot in RAW+medium JPEG so that you already have a JPEG to use for the Web and so the RAW file can be processed for print.

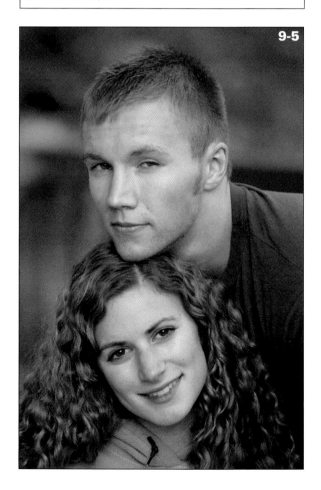
9-5

ABOUT THESE PHOTOS *These four images are from the same JPEG file that has been saved multiple times. 9-5 is the full, original JPEG file as it came out of the camera. 9-6 is a close-up from the original, while 9-7 is the image after being resaved ten times. 9-8 has been resaved 20 times. Note the significant and progressive loss of quality and increased pixilation. Original photo ISO 100, f/3.2, 1/200 second with a 1D Mark IIn and an EF 70-200mm f/2.8L lens. ©Serge Timacheff*

9-6

9-8

9-7

JPEG files compress the data that makes up the image — taking away information that the software deems to be unimportant — so that the image is as small a file size as possible. And while saving a JPEG file a few times won't produce noticeable artifacts, doing it much more than that will. Note that just opening and closing a file won't affect it — it reduces quality as multiple generations of the file are created. So if you copy a JPEG into multiple same-generation images with different filenames, the images in the same generation will have equal quality; however, if you copy and save a file, then copy and save the second file, then copy and save the third file, and so on, you are progressively degrading the image's quality from the original and creating an increasing amount of pixilation.

TIFF is the most common lossless file format. It is widely supported, although not produced by very many cameras primarily because so many cameras now produce RAW files instead, which can be used to create very good TIFF files. In order to retain your very best image quality, and if you will use your images frequently and save and resave them for multiple generations, it's highly recommended that you work in TIFF since it's the most common lossless format. Another great attribute of TIFF is that it supports multiple layers in Photoshop so that if you add various layers of images, text, and so on, you won't have to have the image "flattened" when you save it and you'll be able to go back and make changes that wouldn't be an option from a JPEG file.

Another lossless format is BMP (Windows Bitmap). It has been the standard bitmap storage format used in Microsoft Windows and supported by most image-editing programs, though it is becoming much less common in most applications today.

RAW files are, as implied by the name, "raw" image data that is not compressed, manipulated, or adjusted; essentially, they are images in a format that is as close to how the camera "sees"

the image as possible. The information comes straight from your image sensor. The files are large, and you cannot work on and save a RAW file; you must save it as another format such as TIFF (most commonly) or JPEG.

When you shoot in RAW and you want your image to retain its original quality no matter how many generations of the image are produced, you'll need to save your image in TIFF (or BMP). Although there is a small amount of compression applied to these files, they are much larger than JPEG. For example, the image seen in 9-6 is 1,532KB in JPEG format, 23,981KB in BMP format, and 23,986KB in TIFF.

What that translates to for your day-to-day workflow is that you'll have more flexibility in editing TIFF files for tonal adjustments such as curves and levels, brightness/contrast, white balance, shadows and highlights, and overall exposure. For example, if you photograph a bride and groom, wearing a white dress and a black tuxedo, respectively, when you're editing you may want to selectively edit facial tones as well as bring out highlights in the dress and tuxedo. Shooting in RAW gives you much more flexibility when making adjustments, without causing posterization or other low-bit-quality issues.

SO WHY ARE JPEG FILES SO COMMONLY USED? JPEG is such a common file type for a couple of reasons. JPEGs produce small image sizes so that you can get a lot of them on a memory card, and they can be transported and presented on the Web with a minimal amount of storage space. For most applications, they are perfectly sufficient, and they're very easy to work with. Many photographers shoot all their work in JPEG, including weddings, sports, portraits, and events, and are very successful doing so. Even a number of professional online fulfillment services only offer support for printing from JPEG files — specifically because of the size advantage.

CANON'S DIGITAL PHOTO PROFESSIONAL

Canon EOS digital cameras ship with Digital Photo Professional, which is an image-processing and-management utility especially optimized for RAW image processing and, of course, Canon equipment. As of this writing, the software is in version 3.2.4, has matured over the past few years, and features support for new camera models as they have become available.

While Digital Photo Professional offers a variety of capabilities for managing and editing images, its primary intended application is to process and optimize RAW files, preparing them for use in other applications. While you can accomplish basic tasks in Digital Photo Professional, even moderately advanced editing tasks aren't achievable in the program. It is not intended to replace other image-editing or digital asset management applications, although it certainly features a selection of tools you'll find in those programs.

Because it's relatively simple, easy to learn and use, and very stable, Digital Photo Professional is a program that you may find convenient for getting images processed quickly and efficiently before you start working on them in more depth. On the other hand, you may find applications that provide A-to-Z functionality better to streamline your workflow. Virtually all the features available in Digital Photo Professional are supported by Photoshop, Lightroom, ACDSee Pro, and others.

This application can be a useful (if optional) part of your workflow. The following sections go over some of Digital Photo Professional's major features and operations to get you well on your way to understanding how it can work with your images. While not a comprehensive guide to every feature, you should get a good working feel for the program.

> **note** One of the distinctive anomalies of shooting in RAW is that the software you use to process images must include support specifically for your camera model. Consequently, any application providing support for RAW file processing, editing, or management has to be updated as new cameras are released. If you have taken RAW files with your camera, but a particular software application won't display the files, it may be because you need to update the software to support your camera.

As mentioned, Digital Photo Professional is provided with many Canon cameras, and the Canon Web site offers a variety of frequent updates for Mac and Windows platforms.

> **tip** You can download the full program at the following location, where it is offered in five languages in both Mac and Windows platforms: www.canon-europe.com/Support/software/dpp/.

If you received an application disc, called the Canon EOS Digital Solution Disk, with your camera, you may have Digital Photo Professional on it along with some other applications such as the following:

■ ZoomBrowser EX for Windows

■ ImageBrowser for Macintosh OS X

■ Canon EOS Utility

■ PhotoStitch

INSTALLATION AND UPDATES

If you received the Canon EOS Digital Solution Disk, insert it into your computer and install the software according to instructions. Once installed, check Version Information under the Help menu (or About Digital Photo Professional under the Digital Photo Professional menu) to be sure you are running the latest version. To download updates, go to the Canon Web site download library.

Once you've entered your camera information and the site has loaded, you can select drivers and software for your camera (or it may be the default page), and typically a pop-up page appears with a variety of software download options — including updates for Digital Photo Professional.

You can then download and run the update; this is where the newest versions of the software can be found, including updates to RAW support for newer cameras.

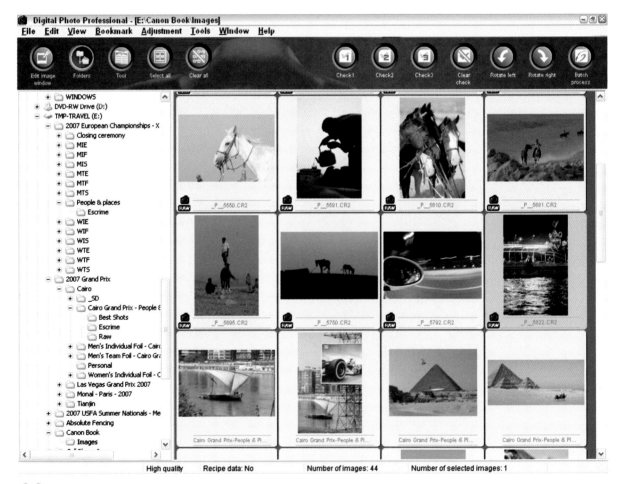

9-9

ABOUT THIS FIGURE *The opening screen of Canon's Digital Photo Professional, featuring thumbnails of images I took in Egypt.*

DIGITAL PHOTO PROFESSIONAL MAIN SCREEN

As an introduction to Digital Photo Professional, I'd like to take you on a brief tour of Egypt. When you launch Digital Photo Professional, the main screen opens, as shown in 9-9. There you'll have a number of options in the form of buttons for managing the program and your images, as well as drop-down menus for operating various features of the program. The main screen is broken into several key sections:

■ The menu and program management buttons are located at the top of the window.

■ A map of your files and folders appears to the left.

■ Thumbnails of images appear prominently on the screen, to the right of the map of files and folders.

You'll find that the drop-down menus such as File, Edit, View, Bookmark, Adjustment, and Tools contain basic application functions (save, print, and so

9-10

ABOUT THIS FIGURE *The image-specific editing window expands the image to (optionally) a full-screen view in Canon's Digital Photo Professional; all the editing features are still available through the drop-down menus and the large buttons.*

on) as well as advanced functions (batch processing, color space adjustments, and editing tools).

The large, round buttons just beneath the menu also provide some quick-access to useful functions. From the main view, you can click the Folders button to remove the folder map portion so you see only the thumbnails. Folders do not reappear until you click the button again, even if you change views and then return to the main view. When you select an image and click the Edit

image button, the view changes to show the selected thumbnail at the left and a large view of the image in the main portion of the window. From here, you can click the Thumbnails button to make the panel with the thumbnails disappear, as shown in the view in 9-10. Click the button again to bring the thumbnails back.

More buttons on the top right-hand-side of the page allow you to check and rank images, rotate them, and perform batch processing.

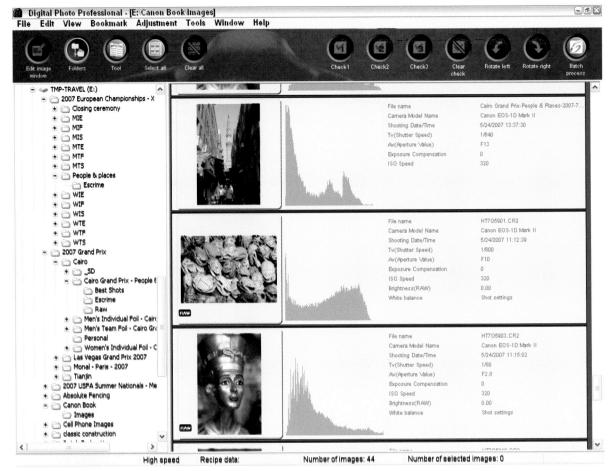

9-11

ABOUT THIS FIGURE *Thumbnail images in Digital Photo Professional displayed with detailed metadata information, which is another selection available from the View drop-down menu.*

Image thumbnails individually list the image file names; RAW files are further identified by a RAW symbol (see 9-11). In the main (opening) screen and by clicking the Thumbnail button from the editing view, thumbnails can optionally be displayed in small, medium, large, or "with information," which includes a histogram and essential metadata tags. At the bottom of the screen, below the thumbnails, there is also general information listed about the thumbnails, including the number of images shown, the viewing mode (you can choose either high-speed or high-quality for display of RAW files), the number of images you may have selected, and the *recipe* data. A Digital Photo Professional recipe is editing data that you have performed on one file and saved so that you can apply it to another image or set of images.

If you want to look at image histograms and metadata along with thumbnails, you can optionally select it from the View drop-down menu.

Digital Photo Professional contains a number of other miscellaneous features that you may find useful for various tasks:

■ **Color Support.** Digital Photo Professional supports sRGB (Standard Red, Green, Blue), Adobe RGB, and Wide Gamut RGB color spaces. If you're using Easy-PhotoPrint and/or PictBridge printers, you can benefit from image layout and printing with Adobe RGB given it's also CMS compatible. You access this and select your desired color space from the Adjustment menu, under the Work Color Space option. Set your default work color space from the Preferences window, found under the Tools menu, and then click the Color Management tab.

■ **RGB Adjustment.** Even though Digital Photo Professional is primarily oriented towards processing RAW files, JPEG files can be adjusted

dynamically using the Tool palette's RGB function (see 9-12). You have full tonal curve adjustment capabilities along with brightness, contrast, hue, saturation, and sharpness controls. A tone curve assist feature also provides automated suggestions for tonal adjustments.

■ **Noise Reduction.** You can reduce digital noise for both JPEG and RAW files from the Tool palette. For RAW files, you can reduce both luminance and chrominance noise. The

9-12

ABOUT THIS FIGURE *Adjusting a JPEG image using the Tool palette's RGB feature.*

reduction is relatively limited in function, offering only a three-point slider. Also, note that you can only adjust noise in RAW files if your preferences are set to display RAW files in high-quality mode (the option is not available in high-speed display mode).

- **Recipes.** Digital Photo Professional allows you to take editing data that has been used with one image and apply it to others. After editing a file, you select Save Recipe in File from the Edit menu, which allows you to save your editing information. You can then apply

this to other images by selecting Read and Paste Recipe from File from the same menu when you're in another file to which you want to apply the same edits.

- **Batch Processing.** This is a button on the main screen. With it, you can apply a variety of changes to a group of images automatically, as shown in 9-13. You can batch process file format changes, output resolution, image size, name, and image transfer settings (for opening files in another application, such as Photoshop).

ABOUT THIS FIGURE *Digital Photo Professional allows you to make multiple changes to a group of images using the Batch Processing feature.*

9-13

■ **Automate.** You can automatically create and print contact sheets from the File menu.

■ **Bookmark.** If you've been reviewing images in a large number of file folders, use the bookmark feature to easily remember and return to their locations.

■ **Display images in real time.** Using the EOS Utility software, you can display images in Digital Photo Professional in real time as they are shot remotely on your camera. In the Tools menu, an option for Start EOS Utility becomes available when the camera is

connected and turned on. This also allows you to download images to Digital Photo Professional and your computer.

MANAGING IMAGES IN DIGITAL PHOTO PROFESSIONAL

You can open an image that you would like to work on by double-clicking on it. For this example, I chose a RAW photo of an Egyptian Bedouin boy galloping a horse up a hill while holding another young horse beside him. I plan to use some basic tools involving cropping and exposure control (see 9-14).

9-14

ABOUT THIS FIGURE *An original RAW photo I selected to be worked on in Digital Photo Professional.*

Notice that the menu items from the main screen are duplicated in the individual image view (the buttons are not). The type of file (for example, RAW) is identified in the bottom of the window. Also notice that I've chosen to use grid lines in the image, dividing it up by vertical and horizontal lines to help me analyze and edit it; you can deselect the grid lines in the View menu.

Just like the main screen is an overall management area from where you can work on individual images, it is from this screen that you manage individual photos. While you won't specifically edit images in this screen, you can access virtually all the editing controls from here.

Begin by using the Tool palette to get the exposure adjusted correctly. While shooting in the desert with exceedingly bright light and difficulty reviewing images very well in the LCD, I often default to a slightly darker underexposure. This way I'm sure to have enough information in the image that I can lighten it by taking some information away from the photo; conversely, if I had overexposed it I would be unable to add information.

You can use the Tool palette to adjust exposures correctly; it is one of my favorite parts of Digital Photo Professional. This is your main control area for working with RAW files and Canon Picture Styles, as well as where you can adjust white balance, color, and brightness. It's got a lot of control packed into one window. Here are some examples of things you can do with it, as seen in figure 9-15:

- Adjust the brightness using the slider

- Change the white balance from Shot to Daylight (or other common white balance settings)

9-15

ABOUT THIS FIGURE *The tear-away Tool palette in Digital Photo Professional, showing an image histogram, white balance adjustment, Canon Picture Styles, and other tonal adjustments.*

- Change Picture Styles, such as from Standard to Landscape

- Increase sharpness using the slider

Image thumbnails edited with the Tool palette reflect what you've done; also, the main image screen changes as in 9-16.

If you want to take a look at what you've done, there's also a Before/After Comparison available under the View menu (see 9-17).

Digital Photo Professional also lets you crop and resize images, which it calls trimming. There are a number of preset sizes as well as the ability to create custom crops, and you can view what you're cropping with an adjustable, darkened area outside of the crop. After you crop, you can view your newly edited image in its full size (9-18 and 9-19).

9-16

ABOUT THIS FIGURE
Changes made in the Tool palette are reflected in the main image.

ABOUT THIS FIGURE
A before/after comparison presented in Digital Photo Professional allows you to review changes before they become permanent.

High speed RAW / Adobe RGB

ABOUT THIS FIGURE
Using Digital Photo Professional, I've custom-cropped to a 5 x 7 format. Optionally, I can adjust the opacity of the darkened area outside the crop.

9-18

ABOUT THIS FIGURE
This is the same photo, after it has been cropped.

9-19

One especially interesting and useful feature in Digital Photo Professional is the ability to view your cropped image in its original form as a thumbnail; once cropped, the thumbnail shows an icon that the image has been cropped. It also shows other changes made to the image, such as the amount of brightness made in the tool palette (indicated by a small camera icon) and an exposure icon showing you've made changes to contrast, brightness, and so on. Figure 9-20 shows my completed image after applying all these adjustments and changes.

Digital Photo Professional also includes a Stamp tool, which lets you touch up images to repair dust on your image sensor, unwanted parts of an

image, facial blemishes, and the like — similar to the Photoshop Healing Brush and Clone tool.

Figure 9-21 is an image of a horse I took in the desert near the Great Pyramids in Egypt. I was struck by its wild eyes, poor-quality tack, and sores on its nose, yet the animal had a profound pride and spirit. The photo has two primary areas I wanted to touch up. One is a subtle but noticeable spot from my image sensor in the upper-left corner, and the other is the horn of the saddle on a camel that was distracting at the bottom of the image.

9-20

ABOUT THIS PHOTO *My final, edited image as processed in Canon's Digital Photo Professional. Taken with an EF 70-200mm f/2.8L lens, ISO 320, 1/640 second at f/5.6. ©Serge Timacheff*

9-21

Digital Photo Professional - [E:\Canon Book\Images_P__5550 edit for book.JPG]
File Edit View Adjustment Tools Window Help

High speed ICC profile / sRGB

ABOUT THIS FIGURE
The horse photo I wanted to touch up; note the image sensor spot in the upper-left corner and the camel's saddle horn in the lower forefront.

Using the Digital Photo Professional Stamp tool (figure 9-22), I removed the image sensor spot and then repaired the horn so that it virtually disappeared.

Once your edits are complete, you will still see the original image in your thumbnail view — just as with cropping. You can then print your completed, edited image (9-23) or you can also use Transfer to Photoshop from the Tools menu, which launches Photoshop for further editing.

PRIORITIZING AND COMPARING PHOTOS

In Digital Photo Professional, you have several options for managing your photos and separating the best shots from the ones you don't want or need:

- The checkmark system, available from the main screen, lets you mark and rank images as priority 1, 2, or 3 (or none at all).

9-22

ABOUT THIS FIGURE *The Digital Photo Professional Stamp tool window, where you can control image repairs.*

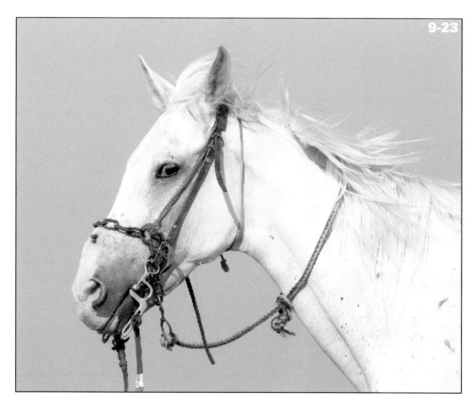

9-23

■ The Quick Check mode, accessed from the Tools menu, quickly displays individual images one at a time so that they can be ranked and viewed in a larger format; they can also be rotated, if necessary.

■ Ranked images can be sorted from the View menu according to their checkmark levels, filename, file type (such as RAW or JPEG), or shooting date/time.

PICTURE STYLES

Canon dSLRs support Picture Styles that provide a way to manage photo colors from shoot to print. When you're using Canon cameras, software, and printers, this proprietary standard allows you to be sure that what you shoot is ultimately what will print, providing you stay with Canon equipment and applications.

In your camera's menu, you can select from several different Picture Styles: Standard, Portrait, Landscape, Neutral, Faithful, Monochrome, or User Defined (for which there are three available settings you can create).

> *note* If your camera features sensor cleaning with the automatic dust delete function, you can use Digital Photo Professional's Stamp tool to erase dust spots in a single operation. If supported, the Apply Dust Delete Data button will appear; simply click it and then accept the changes by clicking OK to complete your spot correction. If I had taken the image in 9-23 with a camera supporting the Dust Delete function, the CMOS spot in the upper-left corner would easily and automatically be repaired.

For a camera produced before the integrated Picture Styles feature was added, load RAW images from it into Digital Photo Professional and apply your Picture Styles to them.

Additionally, you can adjust the parameters of some of the individual Picture Styles to your own settings. The adjustable, user-settable Picture Style parameters include Sharpness, Contrast, Saturation, and Color Tone. Each one is adjustable on a nine-point scale.

When using Picture Styles during shooting, make sure you are using RAW if you plan to use Digital Photo Professional to prepare your RAW files for other programs. In Digital Photo Professional, the Picture Styles do not work with JPEG images.

I opened a photograph I wanted to work with in the Edit window and opened the Tool palette (in the View menu) to do this. Look at how some various Picture Style adjustments might affect my photo (see 9-24).

9-24

ABOUT THIS FIGURE *Canon Picture Styles, which integrate with the camera, software, and printer, are selectable from the center of the Tool palette.*

From the Picture Style drop-down menu, I can select one of the Canon Picture Styles and apply it to the image if, for example, the one I applied in-camera has left a strange color cast on the image. Also available from this Tool palette are adjustments for contrast, color tone, color saturation, and sharpness based on the Picture Style currently applied. In 9-25 I selected Landscape, which changed the colors subtly in the image. If I had chosen monochrome, the change would

9-25

ABOUT THIS FIGURE *The Landscape Picture Style, shown here as selected in the center of the Tool palette, changes tones to emphasize and optimize an outdoor photo. Note that while this image of the desert is certainly a landscape, the presets for this Picture Style are more designed for green-and-blue outdoor scenes than brown and yellow. As a result, I also explored other Picture Styles, one of the distinct advantages of Digital Photo Professional.*

obviously be more profound. You may be happy with the Picture Style that you chose initially when taking the image, but this feature of Digital Photo Professional allows you to try other styles to verify your choice was correct or to enhance the look of the photo with a different style.

Canon has defined what the various non-adjustable Picture Style settings are intended to produce in digital photos:

- **Standard.** The default setting; produces vivid, sharp, and crisp photos.

- **Portrait.** For taking portraits of people; produces good skin tones. Images are somewhat sharp and crisp, and you can adjust skin tones with Color Tone.

- **Landscape.** Emphasizes blue and green tones, producing very sharp, crisp images.

- **Neutral.** No sharpness is applied; uses natural colors to produce subdued images.

- **Faithful.** A colorimetric adjustment that ensures the photograph's color is adjusted to match the subject's. This assumes that the photograph was taken using a color temperature of 5200K. There is no sharpness adjustment in this setting.

- **Monochrome.** Takes away all color, producing a purely black-and-white photograph.

- **Picture Style File Set in Camera.** This is displayed with a photo shot using a Picture Style file that was set in the camera.

- **Picture Style File Loaded.** This is indicated when a Picture Style was selected in Digital Photo Professional using the Browse button (on the Tool palette). This is useful when downloading a preset Picture Style setting, such as from the Canon Web site.

note — Canon offers a useful Web site all about Picture Styles. Go to http://web.canon.jp/imaging/picturestyle/ for a detailed look at examples and details about this function. Here you can also find various preset Picture Styles that you can download either to your camera or to Digital Photo Professional as a RAW image task.

Once you are satisfied with the Picture Style applied to your image, you can use Canon's Print with Easy-PhotoPrint Pro from Digital Photo Professional by choosing Plug-in Printing from the File menu. You then choose Print with Easy-PhotoPrint Pro.

Assignment

Shoot with Style — Pictures Styles!

Canon Picture Styles give you an automatic way to adjust your images from the get-go with contrast, sharpness, saturation, and color tones suited to the kind of images you're taking: portrait, landscape, black-and-white (monochrome), and other styles. You set your camera to a specific style and then it is applied to the photos you shoot; this, in turn, is carried through to Canon's photo software application, Digital Photo Professional. If you're printing your own photos, you can even use it on a Canon printer to ensure balanced colors and tones all the way to prints.

Decide on a type of photo you want to shoot; in my case, I chose landscape. However, for the first shot I just kept my camera at the default setting with no Picture Styles applied. Take your photo. Now, set your camera to the appropriate Picture Style and shoot again.

Do you see a difference in the LCD between the shots? When you download the image to your computer, do you see a difference there? Is it better?

Photographer Natalie Quinn captured this image of a sailboat in Puget Sound with Washington's Mt. Rainier looming high in the background. Because the Landscape Picture Style is optimized for blue and green tones (such as in the sky and foliage) along with increased sharpness, it was a perfect setting for this image. Taken with a 5D and an EF 70-300mm f/4-5.6 IS lens at ISO 250, 1/250 second, and f/6.4.

©Natalie Quinn

Remember to visit www.pwassignments.com when you complete this assignment and share your favorite photo! It's a community of enthusiastic photographers and a great place to view what other readers have created. You can also post comments and read other encouraging suggestions and feedback.

CAMERA CARE AND SENSOR CLEANING

©Michael A. Johnson

Today's cameras are complex instruments with many highly sensitive moving parts and a Complementary Metal Oxide Semiconductor (CMOS) sensor that will show the tiniest of dust particles on its surface. Some cameras, such as the Canon EOS-1D and 1Ds Mark III, are built ruggedly and sealed reasonably well to keep out the elements (although not to the point of being waterproof). Point-and-shoot cameras, while not built to withstand the rigors of a professional single lens reflex (SLR), can be remarkably durable only because they aren't exposed as much due to their fixed lenses that don't allow the body to be opened.

Any camera or lens can be accidentally damaged by dropping it, getting it wet, or opening part of it (even a flash card slot) in poor conditions. While preventing these problems is important, it's important to know how to fix simple problems that occur, to care for and clean your camera and lenses, and to recognize when it's time to seek professional help.

KNOWING AND AVOIDING THE FIVE THINGS THAT DAMAGE YOUR CAMERA GEAR

As I've traveled the world with a digital camera, I've experienced everything from dropping a Canon f/2.8 24-70mm L-series lens onto the cement in a Buddhist temple in a small Chinese village to having a wad of sand land onto my EOS-1D Mark II when it was spit out by a four-wheeler in the Saudi Arabian desert. I've learned to prepare for the unexpected, and I've learned how to manage it when it happens.

While sometimes unavoidable — especially if you work outside of a studio — the five most-evil enemies of digital cameras are ones you'll want to know how to combat and prevent. These various adversaries of photography can affect your camera in a variety of ways, which I cover in each description.

DUST, SAND, AND DIRT

Dust is everywhere, and at some point you're bound to get some of it in your dSLR no matter how perfectly you keep it. Somehow, this pesky stuff just has a way of creeping into your camera and making a beeline for your CMOS sensor, and then appearing where you want it least in your favorite new images. Dust, however, isn't particularly damaging other than it mars an image to the point that you'll need to clean the sensor and then use your image-editing software to get spots out of your photo.

Sand and dirt, conversely, have a harder time getting into your gear because the particles are physically larger than a piece of dust. But if a particle (or more!) does get into your camera, it can wreak havoc on moving parts as well as on your sensor, stopping mechanical movements and scratching a sensor or lens surface. Even just getting it into a shutter release button or CompactFlash or SD slot can be a problem and might literally grind your photography to a halt.

It just makes good sense to keep your equipment protected from dust, sand, and dirt and to limit its exposure to them by using a good-quality camera bag and, in extreme cases, individually protecting the body and lenses with sealed bags or cases. Even zipper-style bags make for good protection in a camera bag that you take into places where

sand and dust are blowing, such as were the conditions in 10-1. Using a lens cap and a haze filter will help protect your lenses, as well.

When changing lenses, if you can, do it in a place that's not windy or even breezy, such as inside a building or a vehicle. You can also add additional protection by covering your lenses and camera body with a jacket or other article of clothing. Make sure you always turn your camera off before dismounting a lens. If you know your camera well enough, you should be able to easily change lenses without looking at them or the camera.

You should also be careful when you open your camera to change flash cards and batteries. CompactFlash cards, especially, can be sensitive because they contain tiny ports into which an array of minute pins is inserted when you put it into your camera.

A particle of sand that is inside the port can clog it, and if it's in-between pins, it can push one to the side — preventing *any* card from working in your camera.

10-1

ABOUT THIS PHOTO *Photographing in conditions and locations where sand and wind are impossible to avoid, such as at the Ancient Pyramids of Giza in Egypt, you need to protect your camera as much as possible. Taken with a 1D Mark IIn using a 24-70mm f/2.8 lens at ISO 100, f/9, and 1/800 second. ©Serge Timacheff*

If you get sand, dust, or dirt in your camera, use a bulb-type blower and a soft brush to remove particles from the outside of your camera, such as those in buttons or the other nooks and crannies of its surface. Use the blower first, and then brush the remaining particles away to avoid scratching anything. Inside the camera, such as on the mirror, be extra careful when you blow and brush; you can also use gravity to your advantage by holding the camera with the open side facing downward so that particles simply fall out when they are loosened by the blower and brush — otherwise, you might simply just move them around in the same space. I discuss how to work with a dirty CMOS later in this chapter in the section on sensor cleaning.

WATER AND MOISTURE

Most technicians agree that water is your camera's greatest enemy. Serious water penetration can be very harmful, if not fatal, to a camera. Even a heavy rain can permanently damage a camera.

While cameras will tolerate a few raindrops, you'll need an underwater housing to survive complete immersion or a heavy splash. And even small amounts of various liquids, especially sugary soft drinks, can make a shutter or lens ring stick to the point of inoperability.

Moisture, such as what happens while trekking with a camera through a humid jungle or even a tropical climate such as Miami, can have long-term damaging effects on your gear if you don't take care. Furthermore, moisture can cause a lens to fog if you take a camera from a cold environment (such as an air-conditioned room) to a hot one — or vice versa.

While transporting equipment, use desiccant to ensure it stays dry. A larger and reusable version of the small silica gel packets included in shipments of new electrical and photography gear, desiccant is the same substance (silica gel) but in larger quantities. It sits in an enclosed container with your gear and absorbs moisture; if you're doing underwater photography, it's an essential accessory. You can buy refillable containers and gel packets to fill them; you can also get small sealed containers that can be recharged in a microwave when they become saturated.

tip In extreme cold, such as −10°F or colder, you need to take extra measures to protect your camera and lenses from moisture. When transitioning from warm to cold (and vice versa), keep your gear in a sealed zipper-style plastic bag or equivalent freezer bag until its core temperature has adapted to the new temperature to avoid freezing condensation that can be permanently damaging (usually about 15 to 20 minutes is sufficient, depending on the extremes). Also, when you're shooting and your face is close to the camera, watch your breath — it is full of moisture that will freeze and cloud your view. And, finally, remember that in very cold conditions, your battery life will be seriously diminished!

For shooting in the rain, AquaTech and Tenba are two companies producing rain covers for digital SLRs (dSLRs) that allow you to protect your gear — even if you're shooting with large telephoto zoom lenses. It's common to see pro sports photographers using covers like the one shown in 10-2 with their equipment on the sidelines of football games if there is rain or snow. If you shoot outdoors in inclement weather, you'll want to consider using a rain cover to prevent water from damaging your camera.

A camera sustaining a serious splash is going to be better off if it is turned off when it happens, which prevents electrical short-circuits. If your camera is on when a splash occurs, turn it off as quickly as possible before any water potentially reaches any circuits. Take out the batteries and then use a lint-free absorbent cloth to remove as much water as you can reach without damaging or disassembling the camera. Open all the compartments and port covers (for example, the rubber cover over the AC connection). Then you need to let the camera dry *completely* before attempting to turn it on. If at all possible, and if the water penetration seems significant, get it to a professional camera technician before you turn it on again. And time is of the essence, because rust sets in quickly.

SALT

Salt damages camera gear by accelerating oxidation (rust) on metal components, and salt air and saltwater also deposit a messy, oily film onto lenses and photo sensors. When you're shooting on a beach or near saltwater, you'll want to be ready to clean your equipment and protect it from too much exposure when changing lenses or opening card slots.

That said, salt was far more damaging to cameras of yesteryear because they had more metal parts rendering them more susceptible to rust. Today's cameras can be superficially affected by salt, but generally it doesn't hurt too much inside the camera unless you have serious saltwater penetration inside the camera (which is really more water damage than salt).

ABOUT THIS PHOTO
The AquaTech Sport Shield protects your camera and lens from rain, wind, sand, and other elements while allowing full access and control for shooting in poor conditions. Models come in several configurations and styles. Photo courtesy of AquaTech (www.aquatech. com.au).

10-2

The other most common way salt can get into your camera is through long-term exposure to your sweat. If you shoot in warm conditions or if you naturally perspire more than average, you may find that over time various external parts of your camera that come into contact with your skin may deteriorate and wear out faster than areas you don't touch as often.

Some things you may want to consider doing to protect your camera and lens from salt — whether that is from salt air or perspiration — include using an ultraviolet (UV) or haze filter on your lenses to help prevent salt from getting to your lens. Remember though that the filter will still get a film on it from salt air and will need to be cleaned regularly. For superficial exposure to salt-water or heavy perspiration, wipe off your camera with a soft, clean, lint-free cloth. Lenses need to be cleaned carefully, and using a liquid lens cleaner applied to a cloth will normally remove the salty film on their surfaces. One of the big problems with salty areas is they usually come along with bigger problems, such as sand. Make sure you remove any grains of sand on lenses or other components before you begin rubbing them with a cloth.

 caution Never apply liquids of any kind — cleaner or otherwise — directly to any part of your camera or to the lens. Always apply the liquid to a lint-free cloth.

Photo sensors are another story, and require more specialized treatment for a salty film. Obviously, using a bulb blower won't work to remove it, so you will need to use a sensor cleaner that actually comes into direct contact with the CMOS — and it may take several attempts before you really get it clean. I address this later in this chapter in the section on sensor cleaning.

OILS AND CHEMICALS

The types of substances I'm discussing here are not industrial, heavy-duty chemicals, but rather what you might come into contact with on a daily basis: sunscreen, insect repellent, makeup, and body lotions. The list is nearly infinite for what can affect your camera, so I'll deal with some of the most common and general ones here.

Topping the camera-gear enemy list for oils and chemicals is DEET, the substance found in many types of insect repellent. According to Bart Meier, who owns Seattle's Meiers' Photo Technical Service, DEET can wreak havoc with camera plastics. Not only is it incredibly harsh, it actually eats away at the plastic of a camera and eventually can destroy it.

Sugary substances, as well, can harm a camera and gum-up focus and zoom rings, buttons, and other moving parts to the point that they will not operate. These include not only soft drinks, but also wine and beer or any substance that contains sugar. While sugar won't particularly destroy plastic or metal, it acts like a sticky glue that does the opposite of lubricating a moving part.

Body oils and sweat (refer to the previous section on salt) make camera components grimy and can smudge lenses. Makeup often contains oil (or it mixes with the oils in your skin), becoming a mess when in contact with your gear. If you normally wear mascara, you may want to consider not using it when you shoot because, over time, it will accumulate in your viewfinder and is not easy to clean.

Most oils and chemicals come from products that you voluntarily put onto your body, so consider not using them when you're shooting; in other words, prevention is the best way to deal with this issue. However, if you do need to remove any kind of oily or sticky substance from your camera

body or lens, wiping it with a cloth will probably be insufficient. Using a lens-cleaning solution on a cloth (don't apply the liquid directly to the lens or gear) usually removes most substances, as does rubbing alcohol. Be careful not to oversaturate your cloth with the solvent because you don't want it penetrating components — causing a secondary problem.

For sugary and sticky problems, remove as much as you can and attempt to slowly and methodically get the button or lens ring to work again. Keep using the solvent to loosen and dissolve the sugar, again by using a moistened cloth. If this isn't enough to fix the problem, you may need to seek professional help because the camera may need to be at least partially disassembled to clean the parts so that they will operate properly.

PHYSICAL DAMAGE

No matter how careful you are, accidents happen. When I dropped my Canon EF 24-70mm f/2.8L lens while shooting in a temple in a small Chinese village, I didn't have a lot of options for repair and I seriously needed that lens for the trip. I had been very careful when changing lenses, but it simply slipped and the lens fell to the stone floor; while the glass didn't break (I had a UV haze filter on the lens which broke instead), the zoom ring became nearly completely stuck. In that situation, I purchased an inexpensive Leatherman-style tool and sat for nearly two hours (as shown in 10-3), carefully bending the zoom ring until I got it to operate — albeit stiffly, but nonetheless functional. When I returned home, I had a professional camera technician repair it completely.

ABOUT THIS PHOTO
*Sometimes you don't have much choice about your working environment when you need to attempt emergency repairs, such as when I had to work on a damaged 24-70mm f/2.8L series lens on a village street near Shanghai, China. Taken with a 1D Mark IIn using an EF 16-35mm f/2.8L lens at 1/250 second at f/9, at ISO 200.
©Alexander A. Timacheff*

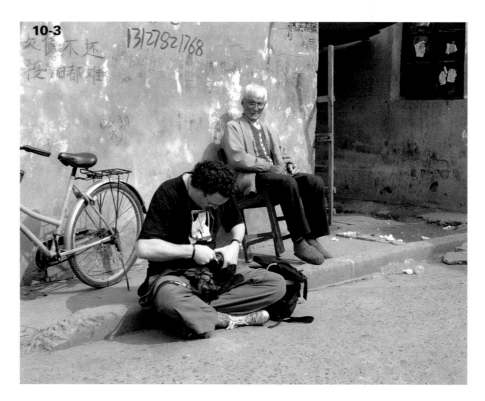

10-3

Some damage to cameras, such as dropping or hitting them on a hard surface, can be fixed, but often it must be done by a technician to reduce the chance of damaging the camera further. Determining whether your camera is field-fixable is risky and should only be attempted in cases of necessity. If you simply must use it and you have no ability to replace it, rent another, or get it repaired, then you might want to try loosening the stuck part just enough to get it to work—even if not at optimal performance. You're unlikely to fix it to its previous state of perfection, and, at worst, you might damage it further.

I have found Canon camera bodies to be remarkably strong and able to withstand surprisingly hard jolts and knocks without any apparent damage. However, you should always wear your camera strap and/or use a hand grip, especially when walking or shooting in a busy or precarious area, because it is one of the best things you have to protect your gear. While it's not practical to shoot with a strap around your neck in every situation, keeping it there for as much shooting as possible can go a long way in preventing a drop, such as when someone accidentally bumps into you while you are taking a photo or you drop it while fumbling to change lenses at a busy time. If you don't like camera straps, consider using a Canon camera grip that wraps around your hand with a leather-and-webbing strap.

Dropping a lens may reveal no external damage, but the complex internal components may have sustained damage. Usually you will know this if the lens doesn't work, or if it seems to be operating but makes noise when it's moved. Without a doubt, this kind of damage will require professional help.

If you're shooting with a tripod, ensure it is durable and strong enough to support your camera. If you have a lightweight tripod with a heavy dSLR, you're asking for trouble. If it's windy or there's a risk of someone bumping into your tripod, secure it with a weight.

Using a filter along with a hood/shade on your lens is the best way to protect it in the event of a drop. Should the hood get knocked off, the filter acts like a crash helmet and breaks, instead of the lens itself breaking. The main danger of the filter breaking is that the broken filter glass can actually scratch the surface of the lens; this, however, can sometimes be polished smooth by a technician.

Also, using a functional camera bag that suits your shooting style will help tremendously in preventing physical damage. If you shoot while standing and moving around, use a design that allows you to access and interchange lenses and flashes safely and easily; typically, these bags are journalist-style designs that store components horizontally on your hip. Accessing a backpack-style pack while standing is a recipe for disaster. I cover more about camera bags later in this chapter in the section on keeping your equipment in top shape.

Unless it is absolutely necessary, do not attempt to disassemble or operate on your camera or lens. If you've bent a lens ring — a common problem — you can sometimes ease it if you very carefully work the ring back to a near-normal position with a knife or needle-nose pliers. However, you can easily break the delicate metal or cause other damage, so I don't suggest this except in extreme situations.

If you break a lens filter, often you can unscrew it, but you want to be very careful that you don't scratch the actual lens. You can lightly use a pair of wide pliers over a soft cloth to help unscrew a broken or stuck filter, but again be really cautious and don't force it. If it's stuck and bent too much, a technician may actually have to use a saw to get the filter off (which, incidentally, doesn't necessarily mean your lens will not be able to accept a filter again).

If you drop a camera and lens combination and cannot remove the lens from the camera, you'll definitely need to get professional help because you can very easily damage the lens mounting hardware if you try, turning a relatively simple problem into a very expensive repair job.

CLEANING YOUR SENSOR

At the heart of your camera is the CMOS sensor, where images that have passed through your lens are converted from analog light to digital information. Arguably the most sensitive and critical component of your camera, if a digital sensor is damaged, your camera's operation and value are seriously compromised.

In front of your CMOS sensor is a thin layer of transparent material called a *low-pass filter*. Technically, this is where dust actually sits when it appears to be on your CMOS, and it is the filter that you clean. Incidentally, this is why dust spots in your images look slightly shadowed — they are not actually directly in contact with the sensor, but sitting very slightly above them. If

your camera has the sensor self-cleaning mechanism, it uses what is called a *piezoelectric element* to literally shake the filter and CMOS using an electrical charge, effectively loosening dust particles so that they fall away.

Because this part of your dSLR gets exposed to dust when you use it normally, such as by changing lenses, this is where dust often accumulates. Additionally, over time, your camera can even generate dust internally as components get older.

Internally, cameras are constructed of exceptionally dust-resistant materials. However, dust still has a way of getting stuck where you don't want it. In many newer cameras, Canon has taken steps to help prevent and deal with dust on your CMOS with a self-cleaning sensor mechanism and an automated dust-delete software that maps dust spots for later identification and removal in the Canon Digital Photo Professional software. While innovative, Canon has received some criticism that the self-cleaning sensor is gimmicky and not very effective, and that the dust-delete software doesn't work well and it must be used with Canon's software program; it won't work with other image-editing applications such as Photoshop, Lightroom, or ACDSee Pro. I've tried it myself with mixed results; it seems that it can work on larger spots, but the smaller ones don't always disappear (although they do sometimes move around a little).

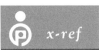 *x-ref* For more information about the automated dust-delete feature and the Canon Digital Photo Professional software, see Chapter 9.

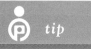

For cameras that do not feature self-cleaning sensors, and for self-cleaning sensors that get stubborn dust particles that won't go away, you'll need to take matters into your own hands. Cleaning a sensor can be a very daunting prospect to many photographers, so if you're not having any luck with the simple dust removal method described next, you may want to consider taking a camera with a dirty CMOS to a professional camera store or repair center for cleaning. Or, if you're a little braver, you may want to try the advanced sensor-cleaning options I cover next.

RECOGNIZING CMOS SPOTS

How do you know when it's dust on your CMOS and not a particle you're seeing on your camera's mirror or lens?

Dust on your mirror won't appear in an image at all; it will just affect what you're seeing through the viewfinder. Conversely, as shown in 10-4 and

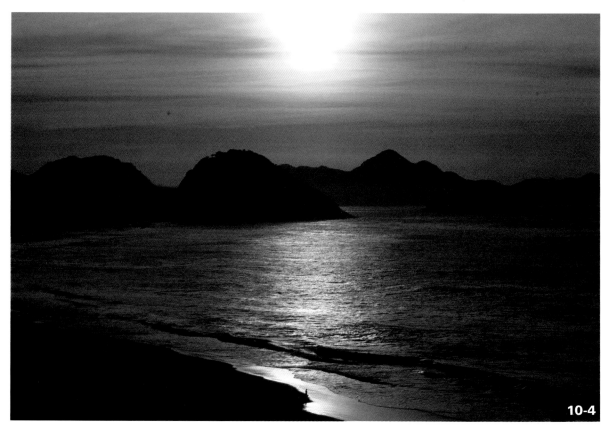

10-4

10-5, the most telling feature of a CMOS dust spot is that it appears consistently from image to image. If you change lenses, it's still in the photo at the same location. And you won't see a CMOS dust spot when you look through the viewfinder — it only appears in the digital image. You can occasionally see a CMOS dust spot when you look at a photo on your camera's LCD screen, but it's usually very difficult to see there.

Dust particles on the CMOS often travel in packs, and you'll see multiple spots in your image. Some will come off easily, while others may persist and require more serious intervention to get them off the sensor.

In many cases, you can use image-editing software to remove dust spots after the fact. Taking a small dust spot out of a blue sky, for example, is a very simple task in Canon Digital Photo

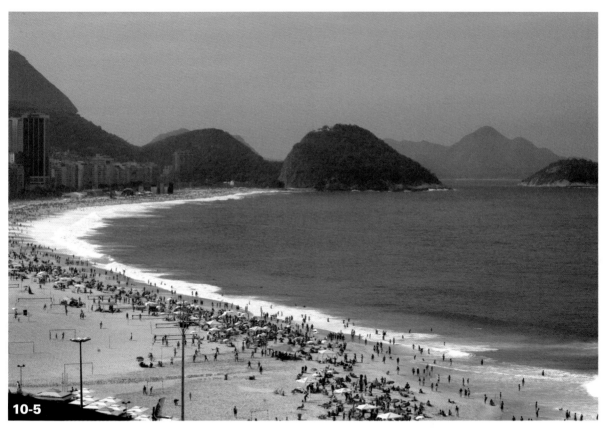

10-5

ABOUT THESE PHOTOS *The two photos in 10-4 and 10-5 were taken at two different times of day from the window of my hotel room on Copacabana Beach in Brazil's Rio de Janeiro. Note that the bright sky is where the spots are most visible. (Can you see other spots other than in the sky, particularly in the daylight image?) Some of the particles are obvious, while some are more subtle; these latter ones are more visible in the daylight image. Both images taken with a 1D Mark IIn and an EF 24-70mm f/2.8L lens. Figure 10-4 was taken at ISO 100, 1/1000 second at f/11, and 10-5 was taken at ISO 100, 1/500 second at f/11. ©Serge Timacheff*

Professional, Photoshop, ACDSee Pro, and other image-editing applications. However, when the dust spots collide with complex elements in your photograph, things get tougher to repair. For example, take a look at this image of Rio de Janeiro's Sugar Loaf Mountain (see 10-6), which features a number of spots on the CMOS. While most are in the clear blue sky and come out easily, the spot that is sitting directly over the gondola cable is anything but easy to remove with software. Almost any alteration you make using a Healing Brush, Clone Stamp, or other tool will cause you as many problems as you try to repair.

Sometimes it's difficult to tell if there's really a spot on your sensor, especially if you're shooting photos with a lot going on in the image (as opposed to, say, a clear sky). If you suspect you have a spot, then you'll want to test to see if it is indeed the case by shooting something bright and clear: a blue sky without clouds, a large light source (if you have a studio soft box, that's perfect), or any subject that provides you with even light against which a dark little particle will show itself. Then download the image and look at it on your computer screen to see the dust.

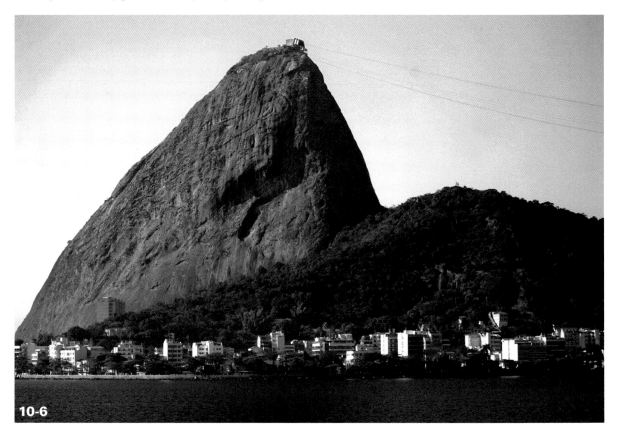

10-6

ABOUT THIS PHOTO *This image of Rio de Janeiro's Pão de Açúcar (Sugar Loaf Mountain) in the early morning is marred by a CMOS spot just over the gondola cable. While it appears to be a simple spot, fixing it using Photoshop's Healing Brush or similar tool is difficult because of how clear the sky is behind it, and because the cable will move and change as it's being fixed. Taken with a 1D Mark IIn using an EF 24-70mm f/2.8L lens at 1/1000 second, f/5.6, at ISO 50. ©Serge Timacheff*

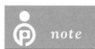

SIMPLE (DRY) SENSOR CLEANING

By far the simplest way to clean a sensor marred by dust spots, and your first course of action, is to use a bulb blower (see 10-7). This is known as a dry method of cleaning a camera. Bulb blowers, which are available at any camera store, allow you to force a strong stream of air into your camera to blow the dust particles off of your CMOS.

Using a bulb blower before every significant use of the camera isn't a bad idea. It will help keep dust particles off the sensor, and hopefully remove as many of them as possible so that they don't adhere after sitting for a long time.

It only takes a minute to perform a simple sensor cleaning, but you must ensure a few things are in place before you do it:

- Find a clean, breezeless, dust-free, and dry area in which to work.

- Make sure your camera's battery is fully charged, or use your AC connector for the camera. If your camera were to lose power during the sensor-cleaning process, the mirror could come down and strike the blower, which would be a serious problem requiring professional assistance.

- You can hold the camera with the opening pointed down while you blow, but be careful not to inadvertently thrust the blower point into the camera too deeply during the motion of blowing it. You can also lay the camera on its back or mount it on a tripod.

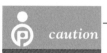

caution | *Never* remove a battery or disconnect the power during sensor cleaning.

note | Most cameras will begin to beep if they are running low on power during the cleaning process.

- Ensure your bulb blower is clean and free of dust. You don't want to blow dust *onto* your sensor!

- Remove any lens you have on the camera. If you want to keep your camera body closed until you're ready to use the bulb blower, use your camera body cap — it will be much easier to remove and replace during the sensor-cleaning process.

note | Never, under any circumstances, use canned air to blow a sensor. It uses a chemical to propel the air that can create a freezing residue and film, permanently damaging your sensor.

You will need to familiarize yourself with your camera's menu controls for the sensor-cleaning process. Typically, here is how it works for most Canon cameras (note that it may vary from model to model and you should consult your user manual for camera-specific operations):

1. **Using the camera's Setup menu, select Sensor Cleaning from the list on your LCD.**

2. **Select Clean Now, then OK, and then Set.** Doing so causes the mirror to lock in an upright position, exposing the CMOS image sensor. Your camera is now ready to have the sensor cleaned with the bulb blower.

3. **Place or hold the camera stably and remove the body cap.** Once removed, you will see that the mirror is up and the sensor will be visible at the back of the open space.

4. **Carefully hold the bulb blower so that its tip is inserted into the camera body, but keep the end at least an inch above the surface of the sensor (see figure 10-7).** When you press the bulb to blow air on the sensor, the tip will move; you do not want to risk

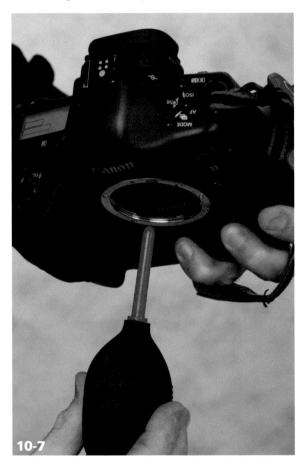

10-7

ABOUT THIS PHOTO *It takes a steady, strong hand to use a bulb blower so that you get enough air blown onto the CMOS to remove dust particles, but avoid getting the tip too deep into the camera where it risks touching the sensor. (Taken with an EOS 5D using an EF 100mm f/2.8L Macro lens at ISO 200, 1/160 second, f/16.) ©Serge Timacheff*

having it scratch the sensor. Get it close enough to do the job, but far-enough away to be used safely.

5. **Squeeze the blower with quick, strong bursts.** As you squeeze, air blows onto the sensor. You can move the tip back and forth above the sensor to ensure full coverage of the sensor, but there's no need to move it up and down. About five or ten strong squeezes should be sufficient to remove any loose dust that can be removed by this method.

6. **After you have finished, replace the cap on the camera and turn it off.** You will hear the mirror drop into its normal resting position. You have now completed the sensor cleaning, and you should take some test images to see if your cleaning has succeeded in removing the dust particles.

If after cleaning you still see dust spots on your CMOS, you may have noticed that at the very least some of them have moved around. This is actually a good sign, meaning that even though they didn't come off in your first attempt, they have not adhered to the surface. Following these steps one more time may do the trick to get the sensor clean.

SENSOR-CLEANING BRUSHES

A more aggressive, but still dry-method of cleaning involves using a specialized brush to clean the sensor. You carefully sweep the sensor with the brush, which effectively cleans off more stubborn dust particles. These brushes are available from professional photography suppliers, and you can find a variety of models. Some of them are designed to use static electricity to help attract dust particles, while others are simply high-quality brushes.

You should never use anything but a professional brush designed to clean the sensor in your camera. Other types of brushes may scratch the sensor, or leave their own particles inside the camera.

Use the brush according to the instructions that come with it (they vary among different models), using the sensor-cleaning method to expose your CMOS as described in the previous section. After using the brush, you may also want to combine your cleaning session with some bulb blowing to remove any particles that the brush loosened but may have been left behind.

Once finished, keep your brush in a clean, dry, dust-free place. Some come in special containers, or you can simply keep it in your camera bag in a small zipper-style bag.

ADVANCED (WET) SENSOR CLEANING

Dry cleaning is often effective for the majority of CMOS dust spots. However, over time, you'll likely encounter some spots that just don't go away, that have seemingly become stuck to your sensor. Additionally, because the sensor is an electrically charged component, it may easily re-attract dust particles that have been blown or brushed aside during a dry cleaning process. You will undoubtedly come to a point where it is necessary to clean your sensor by wiping it with a chemical solvent — a wet solution that can loosen virtually any particle.

You can always choose to have your camera cleaned professionally by Canon or a Canon-qualified technician. The advantage to doing so is that you take on no liability for accidentally damaging the camera, and they always clean many other components in the camera as well that you most likely do not have the tools or skills to address. Even if you do clean your own

caution Canon, like a number of other camera manufacturers, does not recommend or endorse the use of any cleaning method that physically touches the sensor — dry or wet — and, in theory, doing so voids the warranty on your camera. The only sensor-cleaning method Canon supports is using the handheld bulb blower. Beyond that they recommend having the camera serviced by qualified Canon technicians. Still, many photographers use the wet method to clean their sensors, and at least one of the sensor-cleaning products (Photographic Solutions Inc.) actually comes with a guarantee that you will not hurt your camera when using their product as instructed.

sensor using a method that physically touches it, I still recommend having your camera professionally cleaned annually if you use it frequently.

A number of wet method products are available, each with pros and cons. A few use alcohol as the solvent, but most use methanol as the key ingredient to rid the sensor of dust. You simply wipe the sensor gently with the chemical-saturated swab, and allow it to dry (which is nearly instantaneous). Most sensor-cleaning kits come with various sizes of swabs to fit various sizes of sensors. Many also include a carbon dioxide (CO_2) cartridge and device to safely blow clean your sensor with a very controllable stream of gas. (Note that this differs from the canned air that you should *never* use, as I mentioned earlier.)

One of the best resources I've found for information on sensor cleaning is Fargo Enterprises, which sells products as well as provides a tremendous amount of information about sensor cleaning — wet and dry — and the many types of products available on their Web site (www.fargo-ent.com). They have researched numerous Web sites, camera manufacturers, and other sources to provide a comprehensive one-stop plethora of information. If you plan to do your own sensor cleaning — wet or dry — I suggest you consult their site to be completely informed.

According to Fargo Enterprises, the most commonly used sensor-cleaning product is Sensor Swab Eclipse, from Photographic Solutions Inc. (www.photosol.com) — the only company to unconditionally guarantee that you will not harm your sensor or they will pay for your camera repairs. You use the product with Eclipse, a methanol-based cleaning solution you put onto the swabs (see 10-8).

10-8

ABOUT THIS PHOTO *Photographic Solutions Inc. offers a kit containing several Sensor Swabs, Eclipse cleaning solution, and a set of Pec Pads for cleaning lenses and other components. (Pec Pads are not designed for sensors.) Note that you will need to use a swab that is sized correctly for your camera's sensor. Photo courtesy of Photographic Solutions Inc.*

To clean your sensor with this product (which is similar to others, but be sure to read any specific instructions with the product you buy), you first get rid of any loose dust particles with a bulb blower (or CO_2 blower), and then disperse a few drops of methanol from the supplied bottle onto a swab and use it to wipe the sensor (or, technically, the low-pass filter in front of the sensor, as I previously discussed). You wipe once in each direction, back and forth (horizontally). After wiping the sensor, you will want to check to see how effective your job has been by testing a few shots for any remaining particles. You can then repeat the process, if necessary, but frequently one time is highly effective.

Beware of one thing regarding the usage of methanol: It is highly flammable and cannot be shipped by air. If you order it via the Web, it will have to be shipped by ground. Furthermore, because it is considered a hazardous/flammable material and a solvent, you cannot take it with you on a plane in carry-on or checked baggage.

KEEPING YOUR EQUIPMENT IN TOP CONDITION

When first shooting the Olympic Games, I was surprised to see various photographers walking around the venue with open camera bodies dangling from their shoulders, seldom is ever using lens caps, and carrying multiple cameras without protection — all banging against each other throughout the day. This equipment, usually provided by news agencies, benefited from regular professional cleaning and maintenance. This is both expensive and severely limits the life of the equipment, something which the average photographer probably cannot afford to do.

While Canon products are made to very high standards and are capable of withstanding rigorous use, camera equipment is delicate, with many moving and finely engineered precision parts. Keeping it as clean and well protected as possible ensures the camera will operate properly without fail for many years of operation.

CAMERA BAGS

The best protection for your camera is a good-quality camera bag that's suited to both your equipment and your needs. Bag designs have changed dramatically over the last few years, and there are a wide variety of styles, shapes, and sizes available today. Here are some features to consider when shopping for a bag that will work for you and your equipment:

- **Size.** How much equipment do you need to carry with you? Do you plan to add to your gear significantly, such as by buying a large lens? Can you reconfigure the bag to accommodate your carrying needs for various outings?

- **Configuration.** Do you want a photojournalist-style fanny pack that lets you access gear from your hip? Do you want a backpack that you need to remove to access equipment? Do you want a shoulder-style bag that can act as both?

- **Portability.** Do you need to fit a lot of things into a small space, such as if you must take your bag as carry-on luggage on a plane? Are you comfortable carrying it on your back, or do you only want to do that some of the time (or at all)? Do you want it to have wheels and an extendable handle so you can roll it?

- **Ruggedness.** How well is the bag built? Will the material hold up to how you'll be using it? Are the zippers high-quality? If it has wheels and a handle, do they seem like they will last? Is the cushioning for your camera, lenses, and other gear sufficient to fully protect it from outside forces as well as from other equipment

in the bag? Are points of high friction (for example, the bottom of a rolling bag) well-made and likely to withstand a lot of use?

- **Weather-resistance.** Is there protection from the elements, such as rain, sand, dust, snow, and other potential hazards, for your equipment? Are the zippers protected by a water-resistant flap? Are there integrated rain and ground covers? How protected is your gear when you open the bag (for example, can you use the flap as a wind breaker, or does it have alternative outside access points)?

- **Features, storage, and accessories.** What extra features do you want in a bag that will make your life easier? Some options include the ability to carry a laptop, flash card storage, outside pockets for lots of stuff you need, or a portable office to easily store and access a notebook, pens, and the like.

AFTER USE

Keeping your equipment clean is an ongoing task. It's a good idea to get in the habit of checking it over and at least doing a quick bulb blowing of your CMOS along with dusting off your lenses after every shoot — even if it's just a quick outing — so you'll be ready for the next one, no matter when it occurs.

After a shoot, and especially if you've been outdoors, you'll want to clean your lenses and camera body with a fine brush and lint-free cloth to remove any oils or other potential contaminants. Remove the lenses and clean the mounts, as well.

Be sure to use a lens cap on any exposed glass, and a body cap on a camera body without a mounted lens. And don't forget to clean your camera bag — lots of dust and dirt can hide there and get into your gear while you're transporting it.

Check for CMOS spots and clean your sensor, if necessary, so that you'll be ready for your next shoot.

When you're not on the road, it's a good idea to keep your camera equipment in your zipped bag in a dry part of your home. If you have desiccant, refresh it in the microwave or use new and keep it with the gear. If you plan to not use your camera for a long period, such as a month or more, remove the battery, or batteries, from the flash and the body.

Assignment

Simple CMOS Spot Removal

You're bound to get a CMOS spot on your sensor, sooner or later, and it's good to know how to simply clean your CMOS, ridding it of movable dust particles. Take your time and carefully follow the instructions in this chapter and in your camera's manual. Assuming you've determined your camera indeed has spots on the CMOS (don't put them there just to try this assignment!), take a photo of something that you can easily reproduce, such as of a clear blue sky. Review the images on the computer and check for spots. Are they in the same location from image to image? If so, you are ready to begin the cleaning process. Using the simple sensor-cleaning method described in this chapter, use a bulb blower to clean your sensor.

Once again, take several shots — preferably of the same subject with the same exposure. Once again, check to see if the spots are gone, still there, or perhaps in a different location in the image. Were you successful? Have you determined that you need to do more to clean the sensor, such as using the wet method, or taking it to a technician?

While in the desert outside of Cairo, Egypt, I was shooting for a long time and somehow a large dust particle — highly visible on my LCD — got onto my image sensor. I had many more shots to take and didn't want my sensor dirty. While riding a camel, I chose a nonwindy moment, and, underneath my jacket, used a bulb blower to clean the sensor on my 1D Mark IIn. You can see the shots I took just before and after performing this operation. (First image, ISO 100, 1/400 second, f/9; second image, ISO 100, 1/400, f/10; taken with a 1D Mark IIn and an EF 24-70mm f/2.8L lens.)

©Serge Timacheff

Remember to visit www.pwassignments.com when you complete this assignment and share your favorite photo! It's a community of enthusiastic photographers and a great place to view what other readers have created. You can also post comments and read other encouraging suggestions and feedback.

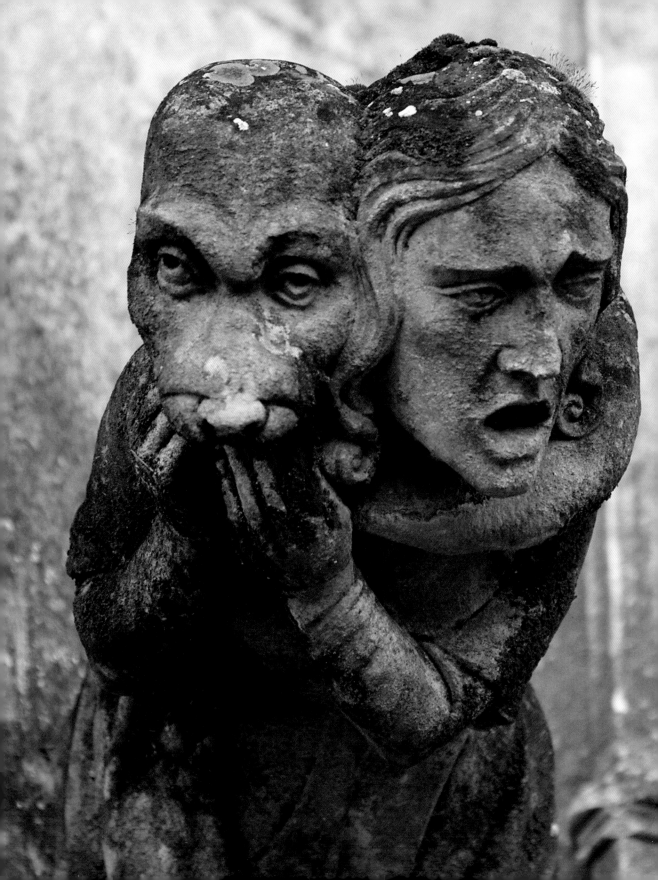

THE BUSINESS OF PHOTOGRAPHY: Q & A

GEARING UP

SHOWING OFF YOUR WORK

BUSINESS DETAILS

©Serge Timacheff

Whether you're an aspiring photography enthusiast, a semipro beginning to sell your work, or an amateur just thinking about what you might be able to do when you combine your equipment with your creativity, you're bound to have many questions about the business of photography. With the fast-changing world of technology, there are always new developments in equipment that will give you the opportunity to sell and upgrade your gear. Few recreational or professional pursuits are as equipment intensive as digital photography, and you'll quickly find that the amount of gadgets, tools, and upgrades to your existing gear are virtually limitless.

Additionally, you'll most likely want to know what it takes to present and (perhaps) sell your work, ranging from tools for making your photography look its best to ensuring you're legally covered.

This chapter provides an overview of some of these issues, a primer to get you going on the right track. Partnered with your Canon dSLR, the opportunities are nearly limitless as to what you can do with your talents and enthusiasm, so it's good to familiarize yourself with some of the business aspects of photography.

GEARING UP

Every photographer gets excited about equipment, and relishes the time spent behind the viewfinder. Today, with computer technology so deeply integrated with photography, equipment issues extend far beyond cameras, lenses, and lights to the unending choices and innovations you'll want to consider in your digital studio.

In the context of this book, it's important to consider whether your camera gear is right for you in terms of what you want to create, produce, and

present. This may have to do with the quality of lenses you buy, or the types of features or accessories you want with a particular camera. Perhaps you are keenly interested in macro photography, and you need a flash specifically designed for the work. Or maybe you're shooting sports, and you need a camera and lens fast enough to catch that one perfect moment in time.

WHEN SHOULD YOU UPGRADE GEAR?

You've probably asked yourself this question already, and I'm sure it will come up again as your photography career continues. With new equipment being introduced every year at the very least, you could spend all your time and money investigating new equipment. But you need to do what makes the most sense for your resources and needs, and for producing the very best photos.

Here's one situation when I addressed this problem based on my needs: I began shooting international fencing championships in 2003 with a fast Canon EOS film camera along with a 10D dSLR. With the Olympic Games coming the next year, I very quickly determined that film was out of the question for me, and that the 10D was too slow to do the job. I was using fast lenses — the 24-70mm f/2.8L series and 70-200mm f/2.8L series — so that side was sufficient. The 1D Mark II had just been announced, and I managed to get an early unit in time to become familiar with it before heading to Greece for the Olympics. So I took it with me, using the 10D as an emergency backup and occasional snapshot camera.

The next year, the 1D Mark IIn came out, and it had enough innovations useful to me (especially the larger LCD and increased frame buffer) that I

decided to buy it and relegate my 1D Mark II to being a backup. At that point, I had realized that the 10D was insufficient as a backup to shoot ultrafast, world-class fencing should my 1D MarkII suffer an accident. So the 10D went into proverbial mothballs — at least for world travels. Today I use it for teaching photography and it's a great teaching camera. My wife, also a photographer who focuses on portraiture and commercial work, uses the full-frame and lighter-weight 5D with a 20D as a backup. So there are multiple generations of cameras in our studio (figure 11-1).

Now I am faced with a similar issue as I gear up for the 2008 Olympic Games in Beijing. The 1D Mark III has been introduced and, yet again, offers some innovations I would love to use, such as the even larger LCD, a faster frames per second (fps) rate, a larger megapixel size, an improved full-coverage viewfinder, and a greatly enhanced ability to shoot low-noise images in diminished light. So my thoughts currently are to sell my 1D Mark II and make the 1D Mark IIn the backup — and also sell a lens or two that I don't need or use to cover the price.

11-1

ABOUT THIS PHOTO *Multiple generations and a range of sophistication of Canon cameras and lenses. When is the right time to make an equipment move? All these cameras, from those used in photography classes to ones I've taken on world shoots, have a useful function in the studio. ©Serge Timacheff*

If you've been a photographer for a few years, you might find that this thought process and equipment wrangling rings true in the context of your own experience. For you, upgrading will likely consist of multiple factors you'll need to consider; here are a few:

■ **What types of images are you photographing, and what specific equipment needs do they require?**

> **Lenses:** fast, wide, long, macro, special?

> **Cameras:** large megapixcl, full-frame, fast fps, wide ISO range?

> **Flashes:** powerful, range of features (for example, stroboscopic, master/slave, and so on), additional external flashes or studio lights, battery packs?

> **Accessories:** filters, wireless capabilities, tripods/monopods, weather/water protection, battery grips, remote switches?

■ **What are your resources?**

> What is your budget to acquire new equipment that you either must have or that would make your work significantly easier?

> How can you prioritize your equipment needs against your resources? For example, a new flash may be really tempting, but if you've been doing without an important type of lens that can produce revenue shots, the priority is clear.

> What do you have that you can sell? What is it worth? What can you do without in order to have something you absolutely need?

> Are your computer technology and camera equipment needs competing for your resources? What's more important: the ability to acquire the images at the best-possible quality or the ability to process them faster and better?

> Are there different types of equipment that you perhaps use only on occasion that you could more easily and affordably rent instead of buy?

> If you are buying equipment, do you have to have it new, or can you buy it used?

■ **What types of equipment are currently available or have recently been announced?**

> Is there new equipment that significantly improves or enhances your work?

> If you upgrade to new gear, what will you do with your current equipment?

> What will you lose by trading up to new gear in terms of money as well as the time it will take to become proficient if you'll need to learn new features?

> Is the equipment you will keep compatible with the new gear you'll get?

The answer to equipment upgrades ultimately is that it is up to you to decide what makes the most sense for your situation. Unless your resources are unlimited, the launch of a new camera or lens, as tempting as it might be, shouldn't be the only reason that you're ordering new gear or jettisoning your existing cameras, lenses, and other tools.

HOW DO I DECIDE WHEN TO SELL EXISTING GEAR?

A variety of ways exist to sell cameras and photography equipment today, not the least of which is on the Web. Selling equipment by putting an ad in the newspaper is slower, more expensive, and doesn't reach nearly as many qualified buyers. In this section, I'll focus on eBay and Craigslist, which both have dramatically changed how photographers trade gear today, to the point that they have become the default solution for the challenge of getting the most money for what you perceive your gear to be worth.

The good news about selling photography equipment is that typically it holds its value much better than computers and peripherals. Selling a three-year-old computer is difficult (if you want to get more than a pittance compared with what you originally paid), while a good-quality dSLR that's the same age is likely to yield much better results and have a far more acceptable resale value.

I am frequently asked about old camera gear (sometimes 20, 30, and more years old) and how to sell it. Most of these products, obviously from the days of film photography, are much more difficult to sell unless they have some collector's value as interesting or unusual devices. You can try listing these items on eBay or Craigslist, but generally speaking, don't expect too much, and think twice before trying to adapt them to your digital gear.

> **note** There are some products that will let you adapt an older lens to a modern camera. In my experience, however, this always has a tradeoff of some kind and rarely produces the type of photographic results you really want.

How do you determine what your gear is worth? First, if the product is still available as a new product, then what it's selling for new obviously gives you a reference point. Don't be surprised to find that cameras, lenses, and flashes for which newer models have been introduced may be selling *new* for far less than when they were first on the market. From there, you can look at eBay or Craigslist to see the prices listed for the same thing you're selling. If you don't see them, then you may want to call around to various camera stores and see what they'd pay you for your item; you can usually mark up your item at least 20 percent from whatever they offer if you plan to list it on the Web. Note that your equipment's condition is a vital factor in its ability to sell — while someone may be willing to buy a camera or lens with some dings, it will be for significantly less than if it's in mint condition. And selling a damaged or inoperable lens or camera almost isn't worth the trouble (unlike a used car!).

The gear you sell and expect to get a decent return on should be reasonably new, meaning about five years old or less, unless it's something unusual or not affected by digital upgrades and innovations. Certain lenses, for example, have been around as workhorse standards for several years and, in good condition, can hold their value very well.

The more original parts and pieces you have for your gear, the better you can present it for sale. Even if you don't have the original box, having the manual and warranty card is a good start.

When selling on Craigslist or eBay, be sure to take and use good photos of what you're offering! Especially given that you're a photographer, a photo of your equipment is essential for someone to effectively evaluate its worth on the Web.

Also, be careful to list your equipment with the correct product name and spelling so that it can be found easily, and in the right category. Before listing your item, take a look at how similar or identical products are selling, and if they're selling better at various pricing strategies (such as starting with a low asking price but with a "reserve" price, for example).

When selling in an online auction, such as eBay, you may be tempted to simply list a starting bid that's rather high to ensure you don't sell your equipment for too little. However, this can be a bad idea; you're much better off to start with a very low bid (for example, $5 or $10) and to use a reserve price. That means that you aren't willing to sell the product for less than the reserve price, but that price won't be shown until the bidding reaches that level. If the real minimum price you're asking for the product appears, it may scare people away; if it doesn't, you might be able to get a few folks into a bidding war.

One of the problems with Craigslist is the "garage-sale" aspect: You may have to meet whomever wants to buy your gear in person, and you may be hesitant or unwilling to have strangers in your studio or home when you're offering something obviously expensive. Instead, offer to bring the equipment to a public place like a coffee shop or restaurant where you can more securely show it to them. If you are selling a camera, you may want to bring a laptop, take a photo with the camera, and download the image to present the quality on the spot.

Craigslist, however, has some advantages over eBay: It's free, it's local (no shipping!), and it's fast — you don't need to list something in an auction and wait for bidding to end. eBay has more recourse for failed payments with the use of PayPal, but it's hard to beat a quick-and-dirty cash sale when you have something that others obviously want.

Some local professional photography stores will buy and sell used equipment, and it may be worth it for you to consider this if you're in a hurry. However, they have to resell the gear, so, like a used-car dealer, don't expect to get top dollar for your camera or lenses; their first priority is to make a profit and to sell, not to buy, equipment. Some of the online photography megastores, like B&H Photo, also buy used gear; while their trade-in offers are perhaps a little better than local stores, they're still going to be buying your gear for less than what you'd get by selling it yourself directly to an end-user photographer.

SHOWING OFF YOUR WORK

It's great to be appreciated for your talents, and today there are a wide variety of ways to get your images to an interested audience. However, to do so, you want to have your images prepared properly for however and wherever you intend to show them. Then, you need a way to sell or, at the very least, a way to produce and deliver them to your customers, friends, or family.

WHAT ARE SOME GOOD WAYS TO CREATE A PORTFOLIO?

A portfolio of your images might mean that you present them in a traditional, physical photography portfolio, as shown in 11-2. There's almost no substitute for being able to show images in this way, and the resolution you get with a high-quality photographic print always presents a photo very well.

11-2

ABOUT THIS PHOTO *A traditional full-sized photography portfolio, such as this one belonging to my wife, Amy (who is also a photographer), lets people view prints of your photos at close range. There's something about seeing a photo printed in real life that just can't be replicated on a computer screen. Taken with a 1D Mark II and an EF 24-70mm f/2.8L lens at ISO 125, 1/250 second, f/10. ©Serge Timacheff*

However, how you go about preparing a print portfolio depends on whether you have digital printing equipment, such as a high-quality photo printer, or use a lab to produce your digital images on paper. If you're printing the image yourself, and if it's for a portfolio or other high-quality display purpose (just as it is to sell the print to a customer), you'll want to be sure you use the best-quality paper and ensure your color calibration is accurate. The most difficult thing about printing images yourself is getting the colors absolutely correct — if you have them printed

commercially and you're not happy, you can demand they be reprinted; however, if you print them yourself and you're not happy with your initial results and must print multiple copies to get them right, you've paid for the bad prints as well as the good ones.

I typically use online lab services, as well as some very high quality local printers. Printroom (printroom.com) is a professional online lab that hosts the galleries on my Web sites and also prints the images and fulfills (they manage payments,

245

shipping, and so on) my clients' orders from those sites. The good thing about this is that I can also use Printroom to print images I want to use for my portfolio or other purposes, and I can buy them at a very good price. They offer specialized types of paper, including a variety of textures (for example, pro-lustre), black-and-white (Ilford), and Kodak Metallic products. For many types of prints, they will print up to a 40 × 60-inch size. I have stocked my portfolio with images they have printed (as shown in 11-3), which gives me the chance to show my customers the quality that they will receive when they order from my online galleries.

You may want to look at Printroom or some of the other online lab services, such as Shutterfly, Snapfish, Pictage, PhotoReflect, PhotoBucket, Flickr, SmugMug, Kodak, and others (see 11-4 and 11-5). Printroom, PhotoReflect, and Pictage are oriented towards professional photographers, allowing them a way to sell online and make money, while the others offer services for consumers and, in some limited cases, for pros also. Alternatively, you can get surprisingly good results by using photo-printing services at major retail centers such as Costco (in person or online), but I hesitate to recommend them or the consumer-oriented Web sites for true portfolio-quality images where you may want to have a highly trained technician give your prints personal attention.

ABOUT THIS FIGURE
Printroom provides semipro and professional photographers a way to host, present, and sell digital images online, fulfilled by a professional lab. A number of similar services are available both for pros as well as consumers.

11-3

ABOUT THIS FIGURE

Shutterfly offers consumers a wide range of photo printing options, as well as ways to display and share images in galleries. You can even have your own Web address using their hosting service.

11-4

ABOUT THIS FIGURE

SmugMug provides user, power-user, and pro accounts for a wide variety of online presentation and display services.

11-5

Another portfolio idea that combines online services with printing is to have a *flush-mount* book produced of your images (see 11-6), which is a book of photos where the images have been printed professionally onto pages and the book has been bound in the form of a coffee-table style hardback book. Most of the Web photo printing services, as well as some dedicated online self-publishing services such as Lulu.com, offer a reasonably priced way for you to have your images printed in a hard- or soft-bound book. While often used as part of a wedding photography package or other higher-end photography offering, they also make great portfolio tools.

Beyond paper, having an online portfolio in the form of your own Web site is necessary if you're selling photography today, and it's a nice thing to have if you just want to show your work to the world. If you're in the latter group, Flickr and PhotoBucket let you do that, and a variety of online services such as Yahoo! do, as well; many of these are simply galleries with your name and contact information. You can also create a minimal Web site with a number of services, such as with Yahoo!'s Geocities (http://geocities.yahoo.com) service; lets you upgrade to higher-level Web sites if you get ambitious.

I also like to use slide shows to present my work. ACDSee Pro includes a slide-show capability that is relatively basic but it works quickly and easily, and you can even put images onto a disk as an .exe file so that you don't put original photos onto a disk where they can be copied. However, the best program I've found for producing truly

ABOUT THIS PHOTO *A flush mount book of your images is great for presenting your portfolio as well as for offering an excellent product to your clients.*

11-6

professional slide shows with a plethora of features and capabilities is Photodex ProShow Producer (www.photodex.com), shown in 11-7. It is the top-of-the-line product in a series of slide-show applications that begin with Photodex ProShow, a basic consumer slide show package; pricing for the software applications ranges from about $30 for the basic version (ProShow Standard) up to $250 for Producer.

Producer lets you develop very advanced slide shows, ranging from a simple set of images synchronized with music all the way to sets of images where multiple images appear on individual slides, complete with integrated motion effects and several ways to render the show onto disk for computer, TV (DVD), and even Macromedia Flash. You can brand and watermark your work, as well as provide timeouts and links for demo

11-7

ABOUT THIS FIGURE *Photodex ProShow Producer offers a wide range of features and capabilities to create, present, and distribute professional-quality slide shows.*

disks you may want to use to present and share your work with potential customers. Many photographers are using slide shows today with LCD projectors to present their images in larger-than-life shows complete with music and a home theater type of setting.

WHERE DO I START WHEN I SELL MY WORK OR CHARGE FOR MY SERVICES?

As with all forms of artistic and creative endeavors, selling photography is a tricky business, and how and what you can sell, and to whom, ranges widely. Being specialized and finding niche markets is often the best formula for success unless you want to go to work for a major wedding photography business, youth sports team, or school picture company and begin climbing the ladder. However, if you want to create your own business, you have many choices in a photography career as to what you shoot and how you generate revenue with it.

The average photographer tends to be a jack-of-all-trades who has tried a wide variety of photography styles and subjects, although he or she may have settled in to a specific type where the most success has occurred. For example, it is common to find independent photographers who shoot everything from senior portraits, to weddings, to family portraits; however, this is a highly competitive area and anything but a way to get rich quick. Other photographers go after commercial business, shooting everything from architecture to product photos for brochures and catalogs. And then there are artistic photographers who eke out a living showing their photography in galleries as well as in shows and various fairs and festivals. Still others focus on creating stock

photography presented on the Web by stock agencies or used and purchased editorially by various print publications and Web sites.

The bottom line is you *can* sell photography, but if you intend to make a living at it, you need to treat it as a business so you do not simply become yet another starving artist. Specializing in an area requires that you go against the grain of creativity somewhat, because you may not be able to pursue a wide variety of photography styles, which is what many photographers love about it. The more specialized you get in a photography niche, the more limited your images can be, but, ironically, the more earning potential you may find that you have.

It's critical that you focus on the business aspects of what you do — not just the artistic aspects — which is the hardest part for most photographers. Nonetheless, if you can run a small business and you can work your way into a specialized area of photography, you may very well find yourself able to make a good living at what you love. Here are a few areas that are more specialized, among many others; even these, however, may have already-established competitors ready to outbid you for work. The primary emphasis in this short list is to present areas of photography that can generate revenue, are easier to sell, and do not just offer purely creative opportunities:

- Real estate
- Restaurants and bars
- Aerial
- Automobile dealers
- Alternative youth sports (for example, gymnastics, martial arts, extreme sports)
- Stock photography
- Church membership photography

- Insurance photography (documenting business and personal assets)

- Small business executive portraits

note Stock photography is specialized because you need to shoot generic shots, devoid of any brand names or recognizable features/characters.

Another thing to note is that some of these areas of photography may require that you have specialized equipment to shoot, or have the ability to provide school packages or other printing services.

Selling your work may vary from providing a disc of images to a client, to hosting an online gallery where customers buy prints directly, to selling prints in a gallery or other venue. How you sell will depend on whom you need to reach, but to sell photos in today's market, a nice-looking online gallery is almost essential to optimize sales — and it's absolutely necessary if you intend to sell your images outside a given geographical region.

note Many art and regional festivals provide spaces for booths where you can sell your work, as well, but you'll need to have your work, complete with framing, ready a setup for selling and showing photographs, and a staff. You'll also have to pay for the space — or give the festival a percentage of your sales. Some festivals further require that you submit a proposal because they may take only a limited number of each type of artistry; they may even require that your images fit within a particular theme, style, or regional slant.

For commercial and personal photography, it's important to understand how to fairly and competitively charge for your work. If you overrate

yourself and charge too much, you might find business hard to come by; on the other hand, if you charge too little, you might find yourself working very hard for little or no profit. Every successful photographer must find a "sweet spot" for pricing that both attracts customers and also pays the bills.

The first thing to do is to canvas your city or area to see what others are charging. Some photographers list pricing on their Web sites, while others require that you meet with them to get quotes. Generally it's a better idea to be able to provide custom quotes than it is to list prices for shoots on a Web site, which lets anyone else undercut your prices and also lets customers price shop too easily. The prices in an online gallery are misleading in terms of the cost for a shoot, given the prices are only for the actual products, not the entire service; for example, a wedding photographer may have charged several thousand dollars for the actual photography of a wedding, and the images are for sale separately in an online gallery to guests.

Commercial photography rates can vary widely, and there's really no excellent way to set a standard for pricing other than by gaining experience in a market or by talking with photographers in similar nearby areas or cities. You should join the Professional Photographers of America (PPA) (www.ppa.com) and/or its local affiliates in your region and spend time with other photographers to learn more about what's available in your area, and to learn about the going rates. Furthermore, you can then use membership in the PPA as a marketing asset to give your business credibility. It has an extensive Web site (figure 11-8) with myriad resources for photographers, as well as a referral system.

I recommend attending at least one or more of their seminars on selling and marketing photography, which take place at various times and places, and always at their conventions/trade shows. It's a great way to spend time with other actual and aspiring professionals who are addressing the same issues as you. Furthermore, their magazine, *Professional Photographer,* is very useful and is filled with great information about the business of selling photography.

11-8

ABOUT THIS FIGURE *The Professional Photographers of America organization (www.ppa.com) offers a wide variety of services for professional photographers.*

BUSINESS DETAILS

To run a photography business, you have to do more than just take great images. You must be adept at managing sales, marketing, administration, accounting, and customer relations. When you're a small-business owner, you do virtually all the work, which can make it challenging to get enough time behind the viewfinder.

It's important to have as many people as possible providing you with services that take up your time. This is why I use an online photography fulfillment service (Printroom), so that I do not have to worry as much about creating prints, shipping them, and processing payments. Of course, I still spend a substantial amount of time with customers, and I do a lot of custom pricing and jobs, as well — so I still have to do it all, but the online fulfillment service takes care of a lot of the details. I also have outside services provide accounting.

Marketing and sales, as well as customer relations, however, tend to be very personal aspects of business management. While most photographers typically have no qualms with outsourcing their accounting, when it comes to advertising, updating their Web sites, or interacting with customers, it's hard to let someone else take the proverbial reins. Yet as a photography business grows, inevitably others must become involved, and even the most involved, micromanaging photographers cannot do everything themselves.

When setting up a photography business, I recommend you seriously consider addressing these issues beforehand:

- Develop, define, and articulate a standard workflow methodology for your studio.

- Research and open an account with an online fulfillment service/lab that has a strong track record and experience in working with photographers that shoot what you shoot. The service should provide you with personal attention, account management, and support.

- Find an accounting/bookkeeping service and standardize the system they suggest (for example, QuickBooks, and so on).

- Consider some dedicated photography management applications to manage the business aspects of workflow, from scheduling shoots to managing accounting and billing. Applications include SuccessWare (www.SuccessWare.net), Pro Invoice/Estimate (PI/E) (www.Pie Software.com), FotoBiz (www.FotoQuote. com), Granite Bear's Photo One Software (www.PhotoOneSoftware.com), or StudioPlus (www.studioplussoftware.com).

- Decide what aspects of your business you can realistically delegate to others who work for you or with you, or to outsourcing services.

- Build a navigable, informative, articulate, and attractive Web site, and make sure to integrate it with your online fulfillment and gallery service. Don't settle for less, even if you need to pay someone to do it.

- Join the PPA, and make use of it. They also have business, legal, and marketing services available to you that you'll want to at least consider using.

- Research the market, and know what your competitors are doing, how they price their work, and how they represent themselves. Determine how you can differentiate yourself from them, yet work in the same market.

- Have a good way of showcasing your work, whether that is online, in person, or in a space in your studio (or all of these!).

- Create an inventory of your equipment, and have your equipment insured. The PPA offers a great program for this.

- Have backups of all your images kept in a secure, separate place from your studio (for example, in a bank safe-deposit box).

- You can't do it all, so determine your strongest area of photography and practice it diligently. Keep up to speed on the latest methods, trends, and technology.

- Articulate and make use of your brand identity.

HOW DO I ESTABLISH A BRAND IDENTITY?

A *brand identity* represents everything about you as a photographer, and how the world perceives your business and you. I spent a great deal of my career in brand development, and I co-wrote the book *From Bricks to Clicks: 5 Steps to a Durable Online Brand* (McGraw-Hill Companies, 2001), currently in use by numerous MBA programs. A brand is far more than just a logo or a name; it encompasses and touches virtually every part of your business.

Many photographers use their own names for their businesses; this can be a pitfall unless you have an extremely memorable or well-known name. More often, using a regionally relevant name (such as using a city or local geographical landmark) works better, and perhaps using one that's combined with what you specifically do (for example, Green Lake Aerial Photography).

Having a *tagline*, which is the permanent subreference to your name, is most important and useful when it helps identify a less descriptive company name. If your name is "Bob's Shots," then a tagline might be "Professional Portrait Photography," or something similar that helps people understand specifically what you do. Don't be redundant: If your business name says "photography," for example, it doesn't make sense to repeat it in the tagline. If your business name is descriptive, then you can be more abstract in your tagline. A *slogan* is different from your tagline — it is a short-term advertising or Web statement that gets people excited about something you're doing.

Having a logo is not a necessity. In my opinion, many photographers spend too much time and money having a logo developed, when building the name of their studio (whether that's their personal name or something else) is far more important. It's your name and reputation most often (not a logo) that people will and should remember. Your name, not the logo, should be placed on your highest-quality images, providing a permanent signature for your work.

Remember that your brand identity is a valuable asset and you need to be ever-vigilant in staying on top of how it's represented and perceived. Something as simple as a misspelling in an ad can deteriorate people's perception of your brand quality. Frequency and familiarity are the biggest elements in brand recognition and recall — just because you're the best doesn't mean you'll be the first name that comes to mind with random consumers in your market. It takes time and effort to build a name and keep it fresh.

Branding is a big part of your business, and is worth spending time studying and understanding it in order to make it work for you. In a small business, often you are almost synonymous with your business and brand, so bear that in mind. Try to create an image for your business that is in-sync with your personality.

WHAT DO I NEED TO KNOW ABOUT INTELLECTUAL PROPERTY?

Your photographs are the most important *intellectual property* you own as a photographer. You own what you capture with your camera, just as an artist owns what he or she paints, an author owns what he or she writes, and a musician owns what he or she composes.

Very simply, if your work is your own, then you own it as what is called an *original work of authorship*, whether it has been published or not. If someone else uses it with your permission, you still own it unless you specifically state in writing that you are assigning ownership to that person (typically for some form of compensation, which is also stated). Even if you assign someone *exclusive* use of an image, you still own the copyright unless otherwise articulated in writing (see figure 11-9).

If someone else uses your photo in a way that you did not approve, or without your knowledge or permission, they have violated U.S. (and perhaps international) copyright laws, and you have the right to pursue legal action against that person. Registering a copyright for a single photo costs $45, so obviously it can become quite expensive if you formally register a lot of images with the United States Copyright Office. To that end, the PPA provides online copyright information and resources, including a downloadable Copyright Kit available free for members.

Most professional labs are very respectful and cognizant of copyrights, and will question customers about image ownership if they believe that a photo being submitted for printing is owned by another photographer. This may be because they see a photographer's name or studio name in the filename, on a disk, or even in the metadata. They also may question it if the image appears to be a professional photograph.

A good practice in your workflow is to place a copyright symbol, your studio and/or personal name, and a date into each image's filename — especially if you are providing digital images to customers. Many wedding photographers, for example, commonly provide a disc of high-resolution images to customers after a wedding, and include it in the package price for the wedding. This does *not* mean they are releasing the copyright to the bride and groom, but rather assigning limited (and perhaps exclusive) rights to them to be able to make their own prints — either on their own printers or at a professional lab. Here is a typical file-naming protocol in a situation such as this, with SmithPhotos as the name of the photographer and Davis as the name of the customer:

> Original File Name (as numbered by the camera): img_5773.jpg
>
> Photographer's File Name (as archived): Davis Wedding-2008-5773.jpg
>
> Customer's File Name (as provided on-disk): ©SmithPhotos-Davis-2008-5773.jpg

Consequently, when the Davis family takes this digital image to be printed at a lab or retailer such as Costco, it is obvious that the image is copyrighted (even if the lab is printing an image that was submitted online). They will then require that the customer provide proof that he

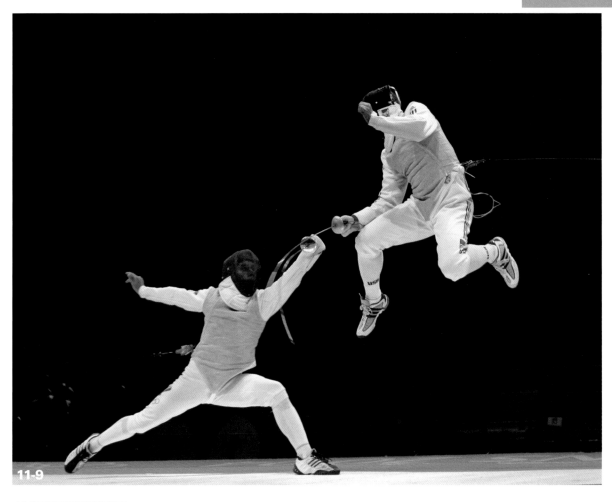

11-9

ABOUT THIS PHOTO *Popular images are frequently copied illegally and used on personal Web sites, on cell phones, and in various publications for personal and business uses — often without the person using them even being aware that they've violated anything. Taken at the Athens 2004 Olympic Games, this fencing image has become one of the world's most popular, and it is frequently knowingly and unknowingly stolen by businesses, organizations, and individuals; as a result, I typically have to send a letter to those I discover are using it demanding that they stop. Taken with a 1D Mark II and an EF 70-200mm f/2.8L lens at ISO 500, 1/500 second, f/2.8. ©Serge Timacheff*

or she has permission to have the image printed, and they will normally provide the customer with a form that you, the photographer, will need to sign in order for Costco to do the job.

You can make things easier for your customers, if you like, by giving them a signed letter on your studio letterhead, assigning them permission to have the image(s) printed. That is normally sufficient for most labs to be able to proceed, and it makes things a lot easier for your customers. It also makes it very clear to your customer that providing a disc of high-resolution images does not constitute giving them any ownership of the

image, but rather a license to use them. Here is a sample of text you could use in such a letter (printed on your company letterhead):

(Date)

To Whom It May Concern:

The images contained in this disc with file names containing (your studio name) are copyrighted and owned solely by the same. This letter constitutes a limited, noncommercial license for (customer name) to print these images for personal use only. Prints may be made by the customer at home, or by a professional lab.

The images may not be sold, distributed, shared, or e-mailed. They may be used in a personal Web site or presentation, and they may be copied only for personal archival purposes.

If you have any questions about ownership or permission, please e-mail or call me.

Sincerely,

(Your Name)

Be sure to include your phone number, address, Web address, and e-mail address in the letter. Professional labs typically will not honor letters that lack these points of credibility.

There are other aspects of your work that constitute intellectual property, as well, and I believe that your workflow is arguably the most important (after your images). If you have a well-defined workflow that takes your photography from concept to shoot to print/presentation, it is a marketable and legal asset that you should use to not only run, but to promote and to protect, your business. Workflow is often one of the most

distinctive factors in differentiating a professional business from amateurs who reinvent their process and workflow for each shoot. When presenting your photography services to new clients, I suggest including information about how you integrate a defined and consistent professional workflow that ensures the best possible quality for every shoot, from the customer experience in the studio all the way to the quality of the prints they ultimately receive. This kind of professional business behavior especially rings true with commercial photography customers given it communicates excellence in business practices.

WHEN DO I NEED TO SEEK MODEL AND PROPERTY RELEASES?

Model and property releases give you permission to take someone's photograph and use it for commercial purposes. If you're taking photos for a newspaper or magazine, meaning they are for editorial use, then a release is not required. Advertising use, however, where a commercial product or service is being promoted, *does* constitute commercial use and requires a release — even though it may be appearing in a newspaper or other publication that contains editorial content. Individuals are legally entitled to privacy, which means, also, that you can't take someone's photo and use it commercially.

This doesn't mean that the images you're taking are only of models posing for you; if you're going to use a photo for anything other than editorial purposes — essentially meaning you're promoting something with it (such as your business) — then getting a model release is a good idea. If the person is not recognizable in the photo, then a release is not required (just because they can recognize *themselves* doesn't count).

> **note** A model or property release will help protect you in the event of a lawsuit. However, it's not a guarantee that one will not take place and that a claim cannot be made against you. The PPA offers very good legal counsel and support for its members in the event of a problem.

The same applies to photos of property that belongs to others, again if the photo is for non-editorial use. Property isn't just a building; it can be someone's car, home, or even their dog or horse. Public properties don't need releases, unless there's a security issue. (I wouldn't suggest going out of your way to take snapshots of the Pentagon without permission, for example, unless you're on a public tour and cameras are allowed.)

If you are an official photographer for an event, then, typically, even by merely purchasing a ticket or attending, individuals are consenting to have their images used for publicity purposes, so a model release is not required; likewise, athletes have agreed that their images may be used in specific ways by official photographers. However, if you do *not* have an official designation — say, for example, if you attend a baseball game and take some photos — then this release does not apply. Technically, even though the event is open to the public, it's still a private event and you've agreed to their terms by purchasing a ticket (this is usually stated in one way or another in the fine print on the ticket). While you can take a photo, you can't sell or distribute it.

Incidentally, editorial use is subject to some discussion, as well. Most newspapers, for example, will gladly sell the photos that they have taken, and in some cases published, to individuals or businesses. They frequently offer the images for sale in online galleries, or from a photo library. So, editorial use doesn't necessarily mean solely that the images taken are only being sold as an integrated part of media content.

Furthermore, while the Web is a form of media and publishing, if you are putting images onto a Web site that exists only for commercial purposes — such as a specific site for a business — then use of a photo is not valid editorial use. A business that publishes qualified news stories or photos about events, however, is different — even if the business also has other commercial interests.

Normally you need to use a different model release for a minor than for an adult; at the very least, if you photograph a child, then you need to have their parent or guardian sign an adult release, and you need to handwrite and initial a note about the child. Conversely, if your image contains any adult material (for example, nudity), then you need to have a release that's even more specific and that includes documentation proving that the subject is 18 years old or older.

Pocket model releases are shortened versions of full (often multipaged) model releases that you can quickly use in the field. While they don't necessarily cover every possible legal contingency, they at least give you proof that you were allowed to take and use the photo.

You can find many samples of model releases online. If you're a member of the PPA, you can download them for free (including one for minors) from their Web site. The *Popular Photography* Web site (www.popphoto.com) also provides a nice selection of free releases, including pocket, adult, simplified adult, and minor versions.

Generally speaking, if you think you *might* need a model or property release, it's always better to get one.

Assignment

Sell Some Gear!

At some point you're probably going to want to sell a camera or lens, and a good place to do it is on Craiglist.com or eBay.com. So how should you do it, and what's the best way to optimize the sale? Without a doubt, items sell better online with at least one good, full-item photo so that the potential buyers can see what they're getting and know that it's in good condition.

As a photographer, you try to take the best shots possible. Start with a good backdrop — something plain and professional. Spend some time getting the lighting right and balanced, and if you have the accessories and box with your item, include them in the image. Let people know how old the camera or lens is, and be honest about its condition; sometimes, telling them the number of hours it's been used is helpful. Once you have your photo taken, downsize for the Web to the specified size demands of the service you're using to sell the item. The resolution of your image should be 72 or 96 dpi (that's Web/screen resolution) and whatever dimensions are required (such as 2 × 3 inches).

I photographed my EF 100mm f/2.8 Macro lens with its box, warranty card, and accessory lens hood. I set it on a backdrop in my studio and used a diffused softbox flash to light it for a nice, high-key effect. I then downloaded it into ACDSee Pro and converted it into a 4- × 6-inch, 72-dpi image to place the item for sale on eBay. Taken at ISO 50, 1/125 second, f/22, with an EF 24-70mm f/2.8L lens using a 1D Mark IIn.

©Serge Timacheff

Remember to visit www.pwassignments.com when you complete this assignment and share your favorite photo! It's a community of enthusiastic photographers and a great place to view what other readers have created. You can also post comments and read other encouraging suggestions and feedback.

PHOTOGRAPHY RESOURCES

ONLINE SOURCES FOR BUYING CANON EQUIPMENT

©Serge Timacheff

There's a tremendous Canon user community to join, which you can participate in at virtually any level. While much of it happens online, Canon photographers have a tacit camaraderie worldwide. For example, while photographing the 2007 Pan American Games in Rio de Janeiro, I had an hour-long discussion with another agency photographer about our cameras, how they were performing, how they were dealing with some of the lighting challenges we had there, and the types of lenses we were using to shoot the same subjects. You'll find you can garner a world of information by sharing your experiences with others, whether you're at a national photography show, on the Web, or at a local event. Almost like Harley-Davidson riders are about their bikes, few photographers are as die-hard fanatics about their gear as Canon owners. This appendix offers you a quick overview of some of my favorite Canon and photography resources.

PHOTOGRAPHY RESOURCES

CANON'S OFFICIAL WEB SITE

www.canon.com

Canon has a region-specific Web site for a number of areas throughout the world. Broadly, it is divided into the Americas, Europe (including Africa and Middle East), Asia, Japan, and Oceania. You can reach any of these regions' Web sites at www.canon.com, where you are then redirected to your area of interest. I have found Canon USA (www.usa.canon.com) and Canon Europe (www.canon-europe.com) to be the most useful of all the Web sites.

Each site is a definitive information source for photographers in those areas, with up-to-date information about new Canon products, discontinued models, drivers, updates, tutorials/how-to's,

and other online resources for photographers. You can even shop online for Canon gear.

PROFESSIONAL PHOTOGRAPHER OF AMERICA

www.ppa.com

The Professional Photographers of America (PPA) is a national organization dedicated to professional photography in the United States. Their Web site is comprehensive and includes legal information, downloads, photographer listings, information exchanges, news, and more.

PHOTO.NET

http://photo.net

This well-established (since 1993), comprehensive site is a place photographers can share information and photographs online, learn more about photography and cameras, and get news. More than a half-million members belong.

PHOTOWORKSHOP.COM

www.photoworkshop.com

Photoworkshop.com offers an interactive photography community with a variety of very strong photography talent as well as a place to share images and the results of various assignments from the books in the *Photo Workshop* series from Wiley. There are also forums to find tips and tricks for virtually any type of shoot.

PHOTOCRITIC.ORG

www.photocritic.org

This interesting informational and educational site covers virtually any and every topic in photography in a blog format — both discussions and

tutorials. You can find topics ranging from abstract smoke photography to setting up a studio to nudes to understanding white balance. It's the brainchild of Haje Jan Kamps, author of *Macro Photography Photo Workshop* (Wiley, 2007).

PHOTOGRAPHYBLOG.COM

www.photographyblog.com

This U.K.-based blog site covers the latest news and info about photography, as well as provides an interesting editorial and opinion side to it. It's a great site if you're a gadget fanatic.

CLEANINGDIGITALCAMERAS.COM

www.cleaningdigitalcameras.com

Run by camera technicians extraordinaire, Fargo Enterprises, this site has virtually all you need to know about getting rid of CMOS spots, cleaning dirty lenses, and more.

DPREVIEW.COM

www.dpreview.com

The Digital Photography Review is a huge forum on every possible issue related to digital photography, including reviews, forums, news, and lots more.

FREDMIRANDA.COM

www.fredmiranda.com

For a one-man show, this site is amazing, filled with interesting information, and it is a forum about shooting any type of photography. Formerly from Brazil, and now a California-based photographer, Miranda has accomplished a lot with his site and has built a great reputation.

PHOTOGRAPHYREVIEW.COM

www.photographyreview.com

This simple but information-packed forum and interactive Web site on photography has a Canon-specific area and excellent discussion threads.

DPCHALLENGE

http://dpchallenge.com

Originally designed as a site with weekly photography challenges, this site has attracted a large number of photography contributors and still maintains a strong element of constructive criticism and critiques of a wide variety of photography.

STROBIST

www.strobist.blogspot.com

This blog site is dedicated to digital photography using small (meaning nonstudio) flashes. It contains lots of advice and discussion threads.

PDNONLINE

www.pdnonline.com

The online site of the popular pro-photography monthly industry magazine, *Photo District News*, covers a lot about what's going on in the photography business as well as product news. PDNonline.com is a comprehensive industry resource listing of labs, manufacturers, retailers, and so on.

SHUTTERBUG.COM

www.shutterbug.com

This Web site for the popular magazine of the same name has lots of tips and tricks, resources, galleries, contests, and forums with more of a consumer/pro-sumer bent.

PHOTOJOJO

www.photojojo.com

A twice weekly online newsletter dedicated to the zanier side of photography. Nonetheless, this site has some great info, threads, and offbeat images.

PHOTOS-OF-THE-YEAR.COM

www.photos-of-the-year.com

This site has challenges, critiques, galleries, contests, and a blog, as well as a stock photo section for members.

DIGITAL OUTBACK PHOTO

www.outbackphoto.com

An interesting site that's mostly about fine art photography, Digital Outback Photo is a good resource for shooting without getting too bogged down in tech talk.

DPHOTO.US

www.dphoto.us

This online forum includes information exchange, reviews, and news about digital photography. The Today's Photos forum is lots of fun and a good place to spend time reviewing and looking at photos. (And who doesn't like doing that?)

IMAGING RESOURCE

www.imaging-resource.com

This is a very thorough, technical site about cameras and related gear with informative and authoritative reviews, comparisons, and photographic research.

THE LUMINOUS LANDSCAPE

www.luminous-landscape.com

You can find columns, essays, information, journals, and techniques about photography on this fun site.

STEVE'S DIGICAMS

www.steves-digicams.com

Steve's Digicams is rich with information about all aspects of digital photography. It's a great, well-organized resource for beginners and pros alike.

ONLINE SOURCES FOR BUYING CANON EQUIPMENT

While hundreds, if not thousands, of online shopping sites sell Canon equipment, there are a few you may want to review or at least know about. Given there are so many, and because you can get mixed results if you're not careful, I've listed these because I've had personal experience with each one and am willing to personally recommend them.

B&H PHOTO

www.bhphotovideo.com

B&H Photo is one of the most comprehensive sites for photography equipment of almost any kind you can imagine, and has a huge Canon inventory.

ADORAMA

www.adorama.com

As big as B&H photo, Adorama has the best-organized Web site when it comes to finding precisely anything you want for photography. They also have a great used equipment buying-and-selling program.

FOTO CLUB

www.fotoclubinc.com

FotoClub is a higher-end retailer that carries studio-quality pro gear as well as a selection of enthusiast/semipro equipment.

SAMY'S CAMERA

www.samys.com

Samy's Camera is a Southern California retailer with a big online presence and lots of gear for sale. It has a limited selection of used gear, as well.

RITZ CAMERA

www.ritzcamera.com

This is the online site for the retailer of the same name. It has a large selection of camera gear, especially in the consumer/pro-sumer/enthusiast range.

PRICEGRABBER.COM

www.pricegrabber.com

Not specifically for photography, PriceGrabber compares the lowest prices from a variety of vendors. The photography section is large and contains lots of surprisingly low prices from highly competitive online retailers.

BIZRATE

www.bizrate.com

Like PriceGrabber, this is a site where you can compare prices from multiple merchants and then order from the one with the best price and the best customer satisfaction rate.

OVERSTOCK.COM

www.overstock.com

While this site doesn't have a lot of camera gear, what it does have tends to be dirt cheap. If you're in the market for a Digital Rebel XT/XTi or other entry-level dSLR, take a look.

BUY.COM

www.buy.com

This is an online department store where you can find a large selection of Canon dSLR equipment, but it's not as comprehensive as the photography-specific sites.

EBAY

www.ebay.com

An online auction site where you can find pretty much any photography equipment you want, new or used. Beware of offshore sales of photography equipment, however — they can come with useless warranties or, worse yet, not come at all even though you've sent your money in good faith. Nonetheless, I've had good luck with eBay, both buying and selling, and it's a good way to sell your gear for a top price.

©Serge Timacheff

In addition to the many accessories discussed throughout the book, Canon offers a number of other accessories for its dSLR cameras that can enhance your photography and make life easier whether you're shooting in the studio or the field. And, while there are also many third-party products manufactured for Canon dSLRs, you can never go wrong by first considering original Canon accessories that are designed specifically for Canon cameras.

It would be impossible to list all of the many Canon accessories here, so, just because you don't see it here, doesn't mean Canon doesn't make it. You can find all of the Canon products at www.usa.canon.com. You can also find Canon accessories online at major photography retailers such as B&H Photo (www.bhphoto.com) or Adorama (www.adorama.com).

REMOTE SHUTTER RELEASE DEVICES

Canon offers a variety of ways for you to release the shutter without actually touching the camera. Here I've listed three of the more popular options:

- **Cable release adapter (T3).** This device allows you to attach a mechanical plunger-type cable release to your camera's electronic shutter release port. Some photographers prefer the more physical, tactile feel of a traditional cable release, and this does the trick.

- **Remote switch (RS-80N3).** This electronic switch attaches via a cable to your camera's electronic shutter release port. Connected to the camera, it works just like your shutter release — if you press the switch half-way down, it lets you autofocus.

- **Timer remote controller (TC-80N3).** In addition to being a remote shutter release, this device lets you control timed exposures on your camera remotely via a cable. It is made up of a remote switch and cable which includes a self-timer, interval timer, long-exposure timer, and exposure-count setting feature, and is operated from an LCD panel and dial on the unit.

WIRELESS TRANSMITTERS

Wireless transmitters are designed to allow you to control cameras and flashes, or to transmit files using radio signals or infrared signals. Wireless controllers are useful when your camera is mounted in a difficult position that's too far away or inaccessible to you. The flash transmitter lets you control single or multiple flashes without a flash being mounted to your camera.

- **Wireless controller (LC-5).** This wireless radio device lets you control a camera from a distance of up to 330 feet. It controls a variety of functions, including shutter release (in several modes), and it offers several channels so as not to interfere with any other wireless controllers within range.

- **Speedlite transmitter (ST-E2).** Attached to your dSLR's hot shoe, this transmitter acts as a master and will fire one or more slave flashes using an infrared signal. It works with the Speedlite 580EX II and the 430EX, as well as predecessor models (such as the 550EX). It does not work with non-Canon flashes.

- **Wireless file transmitter (WFT-E2A, WFT-E1A, WFT-E3A).** These transmit files wirelessly or using a cable (USB or Ethernet) from a camera to a personal computer and/or network.

VIEWFINDER AND EYE ACCESSORIES

If you wear glasses or you prefer a different way to view or focus your dSLR, then you might find one of these accessories useful:

- **Eyecup.** This is a simple replacement for your existing eyecup, should it become damaged or lost. An anti-fog eyecup is also available.

- **Angle finder.** Attached to your viewfinder bracket, this device allows you to take waist-level photos with your dSLR and shoot from a variety of non-standard angles that would be impossible or very difficult when using a conventional viewfinder. It's an excellent accessory for eyeglass wearers.

- **Dioptric adjustment lenses.** These are integrated with eyecups to provide different amounts of magnification for viewing through the lens (for eyeglass wearers who need to look through the viewfinder without glasses).

- **Focusing screens.** These screens mount inside your dSLR's mirror mechanism and allow you to focus differently; for example, you can select a split-screen focus, a matte with a grid, or a microprism.

OTHER ACCESSORIES

Obviously, Canon makes a plethora of accessories — far too many to list here. However, there are few other accessories that you should consider. These accessories are more camera specific or don't exactly fit into the previous categories.

- **Battery grip.** The Rebel line, 40D, and 5D cameras (and predecessors) can have twice the battery power and extended shooting time with a battery grip. This grip also provides redundant camera controls for comfortable vertical shooting.

- **Hand strap.** This strap attaches to the side of your camera, allowing you to hold it securely using a leather and webbing combination that surrounds your hand. Hand straps for the Rebel line, 40D, and 5D require use of the battery grip to be able to attach the hand strap.

- **Off-camera shoe cord.** This spiral cord attaches to your dSLR's hot shoe, and then you attach your external flash to the cord. This is useful if want to hold your flash in your hand to have complete control over where the light is directed or if it needs to be in a different location from your camera (such as on the side or back of a macro subject, for example). The flash has complete functionality when mounted to the camera via the hot-shoe cord, just as if it were mounted directly onto the camera.

- **Camera straps.** Canon offers several camera strap models, which are wider than the normal strap that comes with most cameras. This allows for increased comfort when transporting and using your camera during long stretches of shooting.

> **note** Because accessories, availability, and support for specific dSLRs can change, always check with the Canon Web site or your dealer to be sure your camera model is supported by the specific product before purchase.

Adobe Makers of Photoshop, Photoshop Elements, Photoshop Lightroom, Illustrator, and other photography, multimedia, Web design, and graphics software applications.

AEB automatic exposure bracketing. See *automatic exposure bracketing.*

AE Lock A way to lock the exposure in your camera so that if you change the composition, the exposure remains the same.

AI Servo A mode letting you focus dynamically, where the lens continually changes its focus as a subject moves closer or farther.

ambient light The light that occurs in an environment without you adding flash or other lighting to it. Also called available light.

aperture 1) Overlapping, mechanical leaves in your camera that open to a precise diameter to allow light to be exposed onto the image sensor. Measured in f-stops, the aperture has larger numbers for smaller openings (for example, f/22 is a small aperture opening; f/2.8 is a large one). A large aperture is essential for creating narrow depth-of-field images. 2) A digital photography workflow application from Apple Inc.

Aperture-priority Setting your camera so that it has a fixed aperture size; the shutter speed is adjusted automatically depending upon the amount of light. This mode is indicated on Canon cameras with an Av, which stands for aperture value.

aspect ratio The ratio between an image's width and height. For example, a 4 × 6 photo or print has an aspect ratio of 2:3, while an 8 × 10 has an aspect ratio of 4:5.

autofocus Focusing on a subject using the camera's metering system and an autofocus device in the lens. Autofocusing can be spot (a single point) or a wider segment of what's seen through the lens.

automatic exposure A setting that allows your camera to determine the best exposure. It includes setting the ISO (only on full automatic), aperture, shutter speed, and white balance.

automatic exposure bracketing Setting your camera to take three images, two of which bracket on the main setting. Of the two, one exposes more, one less. The amount of difference between the brackets is set by you (for example, a half-stop, a full-stop, or more) in order to get the best possible image when you're not sure what the perfect setting will be.

available light See *ambient light.*

backlight Bright light coming from behind your subject, which can cause your subject to be underexposed if the light is not manually adjusted.

bayonet mount The type of mounting system used by Canon to attach lenses to cameras. A quick twist locks the lens securely to the camera, and a simple push button releases it.

bokeh Japanese term referring to the aesthetic quality of the out-of-focus areas of an image and the ability of a lens to produce it, especially such as those in a shallow depth-of-field photograph.

card reader A device used to transfer images from your CompactFlash, Secure Digital (SD), or other type of memory card to your computer.

catchlight The bright, small reflective spots, seen in a subject's eyes in a photo, that can come from a flash or natural light. These help the subject appear more natural.

close-up filter A lens-mounted diopter that gives your lens narrower depth of field and reduced focal length, which helps for macro photography.

CMOS (Complementary Metal Oxide Semiconductor) The image-sensing chip used in Canon cameras where the analog light becomes digital information. The CMOS chip is the gateway between the prepixel and postpixel stages of digital photography workflow.

CMOS spot A spot of dust on your image sensor, usually noted by its consistent appearance in the same place as a shadowy dot among a series of photos, even with multiple lenses being used.

CMYK See *RGB*.

color temperature Different types of light have different temperatures, which are measured on the Kelvin scale. Depending on the type of light illuminating a subject, colors in your photo may be accurate based on how you've set your camera's white balance. This is especially true of shades of white, which will most noticeably be correct or not. See also *white balance*.

CompactFlash A type of memory card onto which images are recorded in your camera and then transferred to the computer using a CompactFlash card reader.

contrast Every image has a range from dark to light, and this difference is called the contrast. High contrast means a lot of difference between the brightest and darkest areas of your image.

crop To cut an image down by removing/cutting out segments of the image, typically done in an image-editing package. This can help to emphasize a subject more, or to remove unwanted areas of an image.

crop factor Image sensors in many digital cameras are smaller than a 35mm film frame. As a result, the image seen through the lens is smaller than what the lens is capable of showing with 35mm film or with a full-frame sensor (a sensor equivalent to 35mm size). Therefore, the smaller image is measured by what is called crop factor because part of the potential image is cropped by the smaller sensor.

depth of field The amount of range in an image that is in focus. A shallow depth-of-field image only has a small part of the image — usually the subject — in focus; all other areas are blurry. Depth of field is controlled by the size of the aperture — a wide aperture (for example, f/2.8) produces a shallow depth of field.

diffuser A lighting control device that diffuses light so that it is softer and less harsh, and with edges that are not such high-contrast. This can be small and placed onto a flash, or can be in the form of a large softbox studio flash.

digital darkroom An computer-based environment optimized for processing digital photography workflow, from downloading images to a computer to producing them in their final form — be that online, in print, or recorded onto media.

digital noise See *noise*.

Digital Photo Professional Canon's image-processing application, especially adept at managing RAW files.

dioptric adjustment A small wheel near the viewfinder that lets you adjust your camera's viewfinder to match your vision.

directional light Light emanating from a specific direction. A flash, for example, is a form of direct light.

drop-in filter A lens filter mounted at the rear of the lens. Usually intended for use with long super-telephoto lenses given the front of the lens is impractically large for a screw-on filter.

dSLR Digital Single-Lens Reflex camera. A system that lets the photographer see through the lens using a mirroring system.

dynamic range What an image sensor can capture, measured in the range of light from absolute black to absolute white.

EF Series lens A series of Canon lenses designed to mount to EOS cameras using a bayonet-style attachment. EF (electrofocus) lenses have special electronic contacts that communicate with the camera for functions such as autofocus and aperture settings.

EF-S Series lens A Canon lens series based on the EF Series that is designed to work with cameras using APS-C-sized image sensors, including the EOS 40D, EOS 30D, EOS 20D, and the EOS Digital Rebel family. EF-S lenses will not work on other Canon dSLRs.

ETTL (evaluative through-the-lens) The technology that Canon innovated to meter and control flash exposures. ETTL II is Canon's latest upgrade to the standard.

exposure The inter-related and specific settings used to capture a given image, including shutter speed, aperture, and ISO.

external flash A flash that isn't built into the camera but that can be mounted onto the camera's hot shoe or used separately (such as wirelessly or with on an cable extension, such as if it is mounted on a flash bracket).

FEB (Flash Exposure Bracketing) A way to control the flash so that it fires at three different settings to give various exposures when you're uncertain of which is correct.

fill flash Using a flash to fill in darker areas of an image, such as shadows on subjects' faces cast by bright overhead sunlight.

filter An add-on element to a lens, altering its optical characteristics. It can be used to limit haze, reduce glare, optimize sunlight, or emphasize various colors or elements of an image. Typically a filter is mounted to the front of a lens; for long super-telephoto lenses, filters are called drop-in filters and are mounted to the back of the lens. Software filters are also included in various image-editing applications to provide an even greater variety of effects.

fisheye lens A type of wide-angle lens with an extremely wide field of view that provides significant distortion — especially at the edges of the image.

fixed-focal lens Also called a *prime lens*, or one that has a fixed focal length. The opposite of a zoom lens, these are sometimes considered to produce better-quality, sharper images.

flash An internal or external strobe light that illuminates your subject when turned on. External flashes are mounted to the hot shoe or used in a variety of other ways involving a cable or even wireless firing. In Canon cameras, ETTL controls flash exposures automatically.

focal distance/focal length The length of a lens from the center of its primary lens element to the CMOS sensor, measured in millimeters.

focal plane The area of an image where the image is in focus.

focus The ability of a camera and lens to create a sharp, concentrated reproduction of a subject.

focusing screen A screen in your camera, seen through the viewfinder, where you view your image as well as camera exposure and setting information. Higher-end dSLRs, such as the EOS-1Ds Mark III, can have optional focusing screens that allow you to see a different type of focusing element through the viewfinder, such as a split-screen focus.

FP flash See *high-speed sync.*

frame The rectangular-shaped area that constitutes your digital image, and is representative of the size of your image sensor.

f-stop The setting and measurement of your lens's aperture, set on the camera.

gray card A useful device for correctly setting your camera's white balance. Average light in any given place is 18 percent gray if you combine all lighted areas in a given "scene" and average their color temperature between complete black and white. Setting a custom white balance based on taking a photo of the gray card and then setting a custom white balance in your camera allows you to have perfect white balance in any light.

high-speed sync The ability of the flash to synchronize with the camera's shutter speed. Also called FP flash.

histogram Seen on your LCD display, as well as in image-editing software, a histogram is a graph that represents the highlights, midtones, and shadows of your exposure. Some applications also show color histograms, dividing the graph into red, green, and blue. Using a histogram can help you understand your exposures and ensure they are correct.

hot shoe The mounting plate on your camera, onto which you attach an external flash or wireless flash device. It provides an electrical contact where information passes between the camera and flash.

image sensor The CMOS chip that senses light and converts it into digital information. The gateway between prepixel and postpixel digital photography workflow.

incandescent light The range of light coming from normal household light bulbs; also referred to as tungsten light.

Inverse Square law A physics principle that, when applied to photography, refers to how light from a flash falls off over a given distance. Measured using the formula $(1/distance)^2$, meaning if a subject moves to twice the distance of a perfectly lighted flash exposure, they will only get one-fourth the light.

ISO The setting on your camera that makes it more or less sensitive to light. In bright daylight, you should use a low ISO setting like 100 or 200; in low-light, you might use a setting of 1000, 1600, or even 3200, depending on how dark it is and your camera's available settings.

JPEG (Joint Photographic Experts Group) The standard image-file format used by digital cameras. A reliable format, it compresses images into manageable sizes with very good quality. However, it is a lossy format that loses quality and becomes increasingly pixilated when saved and resaved multiple times, as opposed to TIFF images or the RAW format.

LCD (Liquid Crystal Display) The flat lighted panel on your camera where you view images and your control menu. On some lower-end cameras, this is also a substitute for the viewfinder.

lens flare Light that intrudes into your lens, causing optic distortions and aberrations such as haze, geometric reflections of lens elements, and other problems. It can also be used as an artistic effect.

lossless A lossless image file does not compress the data of an image, thus it does not lose quality or become pixilated after repeated saves. File types that are considered lossless include TIFF and EPS.

lossy A lossy image file loses quality and becomes pixilated after it has been repeatedly compressed by saving and resaving multiple times, losing data from the file. JPEG is considered to be a lossy file type.

L Series lens Canon's line of professional, very high quality lenses. The L (luxury) lenses are characterized by a telltale red ring around the front end of the lens.

macro lens A lens meant for taking close-up, sharply focused images. Some other lenses include a macro setting, as well, allowing them to approximate what a dedicated macro lens can accomplish.

macro photography Taking close-up images.

manual Operating your camera on manual means you set the aperture, ISO, and shutter speed; setting your lens to Manual means you focus it manually.

master A master is the flash that is designated to control other flash units in a group. If your camera has a built-in flash, it can be used as a master. Some Speedlites are also able to function as a master. See also *slave*.

megapixel One million pixels. See also *pixel*.

memory card A card onto which digital images are recorded, and then used to transfer the images to a computer or other storage device.

micro photography Another name for macro, or close-up, photography.

mirror lockup Setting your camera's mirror to lock in an upright setting while a photo is taken, instead of raising and dropping just before and after the image is exposed. This prevents any minute camera shake that could potentially cause a slight blur in the image.

monopod A telescoping, single-legged pole onto which you can mount a camera and lens in order to hold it more stably while shooting. It will not stand on its own, unlike a tripod. See also *tripod*.

multi A flash mode where multiple flashes can be fired for one image, giving the effect of multiple exposures of a subject in one image. Also called a stroboscopic image.

noise A grainy appearance, often in an underexposed image or one taken in a very dark setting. The aberrations of pixels is often caused by low-light, high ISO shooting where the camera attempts to interpolate dark parts of the image.

normal lens A lens that produces a natural, realistic image, limiting any distortion of the subject. Typically, these lenses range in the 35-70mm focal lengths. A normal lens views the world very similarly to the range of vision of the human eye.

omni-directional light Light that is emanating from multiple sources (for example, a window, flash, and overhead lighting all at once) or that is highly diffused.

Picture Styles Preset modes in the camera that allow you to shoot with adjustments of contrast, sharpness, and color tone and saturation for specific types of images and subjects, such as portraits, landscapes, and so on, and that can be carried through Canon-specific workflow tools, including software (Digital Photo Professional) and printers.

pixel Literally, "picture element," or the single points that make up a matrix of lighted elements that constitute a digital image. Digital images are measures in pixel dimensions (for example, 2,400 × 3,600), creating the number of megapixels that refer to an image's size (as well as a maximum size for a camera to capture). A camera that can shoot a 2,400 × 3,600 pixel image is producing an 8.6 megapixel image (2,400 times 3,600, rounded off).

pixilation In a low-resolution image, when pixels become too large, it is said to be pixilated. This also comes from lossy format files, such as JPEGs, that have been saved too many times and over-compressed.

polarizing filter A lens filter that lets you decrease glare and emphasize elements of sky and water.

postpixel Everything in the digital photography workflow that happens to an image after it is read by the CMOS sensor and has become digital, from being recorded in the camera onto a flash card to being downloaded, processed, and fulfilled.

prepixel Everything in the digital photography workflow that happens to an image before it hits the CMOS sensor and becomes digital: lighting, composition, focus, and exposure.

prime lens The opposite of a zoom lens, a lens that has a fixed focal length.

RAW The digital recording of an image into a file that is specifically coded to that brand and model of camera. Essentially, it is the image exactly as the camera captured it, with very limited or no alteration or compression (unlike a JPEG file). A RAW image cannot be changed; it can only be imported into an image-editing program and then stored in a common file format such as TIFF or JPEG. Because of its maximum bit depth, tonality, and quality, many photographers choose to shoot in RAW over JPEG, especially if they want to create very high quality images.

rear-curtain sync A way to adjust when the flash fires in a longer exposure, in order to ensure elements of the photo do not appear unnaturally lighted (for example, light streaking in front of a car, instead of behind it as it passes). Using rear-curtain sync means the flash fires at the end, instead of the beginning, of the timed exposure.

red-eye Light from a flash being reflected against a subject's retina, causing the pupil to be a devilish red color. This can be mitigated by using a red-eye reduction setting with the flash (which turns on a redeye reduction lamp that shines a continuous white light at the subject, which makes their pupils contract), or it can be removed later in various image-editing applications, such as Photoshop or ACDSee Pro.

resolution The number of pixels that make up a segment of a photo, measured in pixels per inch (ppi). A low-resolution image looks pixilated.

RGB The colors (red, green, blue) recorded by your camera, in a wide range of tones, that make up color space. Printed images use CMYK (cyan, magenta, yellow, and key — which is black), which is a color space used in color printing, such as by a color inkjet printer or by a professional print lab.

Rule of Thirds A philosophy for composing images where various parts of your image are separated and flow among nine squares, aligned tic-tac-toe style. Normally you center elements of your subject onto cross-points of the vertical and horizontal lines.

shutter Your camera's mechanics that allow it to briefly expose the image sensor to light coming from the lens, involving opening the aperture to a preset, precise diameter for an exact moment.

shutter speed The amount of time it takes for your shutter to open and close, commonly measured in fractions of seconds (for example, 1/125, 1/30, 1/1000).

Shutter-priority Setting your camera so that it has a fixed shutter speed; the aperture is adjusted automatically depending upon the amount of light. This mode is indicated on Canon cameras with a Tv.

slave Also called a remote, slave refers to an external flash that is controlled by a master — either the built-in flash or a Speedlite that can become a master — and fires when the master signals it to fire. See also *master*.

Speedlite The Canon brand of external flashes.

spot metering A pinpoint method of metering your image and focusing on a single point instead of an entire region.

stroboscopic See *multi*.

telephoto A lens or zoom setting with a focal length longer than 50 to 60mm where the object being photographed appears to be closer to the camera than it really is.

thumb focusing Common among pro photographers, and especially sports shooters, thumb focusing refers to setting your camera's custom functions so that the automatic focus is invoked by pressing what was formerly the exposure lock button. This gives a semiautomatic focusing capability that is very useful — and the camera does not refocus each time the shutter release is depressed (which was what used to be the autofocus button, as well).

TIFF (Tagged Image File Format) A lossless image file format. It is not compressed, so TIFF files can be very large, but they are higher quality and can have a higher bit-depth than JPEG files and can also support layers (such as in Photoshop).

tripod Used to mount and hold a camera stably without you having to hold it; characterized by three telescoping legs. See also *monopod*.

TTL (through-the lens) An older version of ETTL, which worked with film cameras before digital ETTL became prevalent in Canon cameras. It refers to exposure metering and not just flash exposure metering. See also *ETTL*.

white balance Your camera has several white balance settings that attempt to automatically sense and reproduce colors correctly. You can either set the camera to adjust it automatically (Auto) or you can set it to a specific type of light, such as fluorescent, tungsten, sunlight, and so on. You can also set a custom white balance by measuring the ambient light temperature (such as by using an 18-percent gray card) or inputting a color-specific temperature. See also *color temperature*.

wide-angle lens A lens that lets you photograph a wide area, typically with short focal lengths. Also see *fisheye lens*.

zoom lens A lens with a variable focal length, such as 24-70mm or 100-400mm, that lets you zoom among the focal lengths to close in on a subject, or to go wide.

continued

continued

G

G (orange) filters, contrast enhancement, 145
Gary Fong, flash add-ons, 160
ghosting, lighting conditions, 90–91
GN (guide number), Speedlites, 173
Granite Bear's Photo One Software, 254
gray cards, flash metering, 174
grid lines, Digital Photo Professional, 206
Groofwin Pod, car window platform, 142
group shots
 built-in flash, 160
 deep depth of field, 67
 wide-angle lenses, 118

H

hand grips, camera gear, 226
hand straps, camera accessories, 271
hard cases, 11–12
hard drives, portable, 187
haze filter
 lens protection, 143, 221
 photography system component, 8
 salt damage protection, 223–224
head shots, normal lenses, 119
high key images, 96–97
high-speed sync, FP (focal plane) flash, 170
histograms
 color evaluation tool, 93–96
 contrast evaluation, 97–99
 luminance, 94
 RGB, 94–96
hot-shoe adapters, 8
HumanSoftware, PhotoFixLens, 117

I

image display units, 11
image editors
 basic photography system component, 9
 dust spot removal, 228–230
 interpolation, 28
 post-pixel workflow phase, 185
 red-eye reduction, 159
image management
 file naming schemes, 191
 keywords, 193
image margins, normal lenses, 123
image quality
 aperture factors, 84–85
 camera care, 195
 environment optimization, 195–196
 fixed (prime) versus variable (zoom) lenses, 57
 focal length factors, 83
 ideal lens characteristic, 85

 optimization techniques, 196–198
 purchasing consideration, 24
image size, crop factors, 60–61
image stabilization (IS)
 in-lens systems, 80–81
 L Series lenses, 111
 telephoto lenses, 124, 127
image storage, planning stage, 184
Image Trends, Fisheye-Hemi, 117
images
 archiving, 194
 batch-renaming, 194
 contrast evaluation, 97–99
 editing preparation, 194
 editorial use, 259
 FEB (flash exposure bracketing), 168–169
 gear upgrade element, 242
 high key, 96–97
 intellectual property rights, 258–260
 limited rights assignment, 256–258
 low key, 96–97
 luminosity, 94
 management planning, 185
 management techniques, 190–191
 metadata, 191–193
 model/property releases, 258–259
 original work of authorship, 256
 portfolios, 244–250
 selling/marketing, 251–254
 storage/transportation devices, 186–188
 transferring, 185
 vignetting, 101
 wireless file transmittal, 189–190
incident light meters, 11
infrared filters, IR images, 145–146
inkjet printers, 45–46
intellectual property rights, photography
 business, 256–258
interface cables, 4
International Press Telecommunications Council (IPTC), 192
Internet
 editorial use images, 259
 resources, 264–266
 selling existing gear, 243–244
interpolation, image editors, 28
Inverse Square law
 flash distance, 170
 telephoto lenses, 128
IR images, infrared filters, 145–146
IS (image stabilization)
 in-lens systems, 80–81
 L Series lenses, 111
 telephoto lenses, 124, 127
ISO Expansion, Custom Function, 48

continued

ABOUT THE DVD

The Canon Digital Rebel Personal Training DVD by Rick Sammon provides a wealth of useful information and tips.

INTRODUCTION

Meet Rick and the Production Team
What You'll Learn

GET STARTED

Setting the Exposure Mode
Using Memory Cards
Battery Handling
LCD Monitor
Holding the Camera/Manual
Digital Workflow

EXPOSURE

Introduction to Exposure Modes
Basic Picture Modes
 Green - Fully Automatic
 Portrait
 Landscape
 Close-up
 Sports
 Night Portrait
 Flash-Off
Creative
 Program
 Tv - Time Value (Shutter Priority)
 AV - Aperture Value (Aperture Priority)
 M - Manual
 A-DEP (Automatic Depth of Field)
Exposure
 Three Metering Modes
 Exposure Lock
 Manual Exposure Compensation
 Auto Focus
 Auto Focus/AI Servo
 Lenses
Zoom Lens for Enhanced Creativity

GETTING A GREAT SHOT

Sports Shooting
Indoor Natural Light Portraiture
White Balance
Sunrise/Sunset Shooting
Accessories - Reflectors and Diffusers
IS (Image Stabilization) Lenses

FLASH PHOTOGRAPHY

Adding a Flash Accessory
Daylight Fill-in Flash
Reducing Flash Reflections
Using the Built-in Flash

RICK SAMMON'S PHOTOGRAPHIC TIPS AND TRICKS

Name of the Game is to Fill the Frame
Envision the End Result
Be Aware of the Background
Depth and Dimension
Frame It
Tell the Whole Story
Learn How to See the Light
RAW Rules!
Take a Hike
Always Look Down, Back, and Up

DVD INSTALLATION INSTRUCTIONS

Insert the DVD into your DVD-ROM drive or DVD player, and press Play.

SYSTEM REQUIREMENTS

TV DVD player or Windows 2000, XP, or Vista; DVD drive and 512 MB of RAM or Mac OSX 10.3.9 or 10.4; DVD drive and 512 MB of RAM

WILEY PRODUCT TECHNICAL SUPPORT

For technical support, please visit http://support.wiley.com. For telephone support, please contact us at:

1-800-762-2974 (U.S.)

1-317-572-3994 (International)

8:00 am to 8:00 pm EST, Monday through Friday

CUSTOMER NOTE:
PLEASE READ THE FOLLOWING BEFORE OPENING THE PACKAGE.

Develop your talent.

Go behind the lens with Wiley's Photo Workshop series, and learn the basics of how to shoot great photos from the start! Each full-color book provides clear instructions, ample photography examples, and end-of-chapter assignments that you can upload to pwassignments.com for input from others.

978-0-470-11433-9

978-0-470-11876-4

978-0-470-11436-0

978-0-470-14785-6

978-0-470-11435-3

978-0-470-11955-6

Available wherever books are sold.